Erotica Universalis
Gilles Néret

Cover | Umschlag | Couverture:

Anonymous Engraving for *Dom Bougre ou Le Portier des Chatreux*, Frankfurt, 1748

This book was printed on 100% chlorine-free bleached paper in accordance with the TCF standard.

© 1994 Benedikt Taschen Verlag GmbH, Hohenzollernring 53, D–50672 Köln

© 1994 for Salvador Dali: DEMART PRO ARTE B.V.
© 1994 VG Bild-Kunst, Bonn for the following artists: Hans Bellmer, Jean Dubuffet, George Grosz, Alfred Kubin, Aristide Maillol, André Masson, Pablo Picasso
Conception: Gilles Néret
Design: Mark Thomson
Cover design: Mark Thomson and Angelika Muthesius
English translation: Chris Miller
German translation: Helga Weigelt

Printed in Germany
ISBN 3–8228–8963–6

Erotica Universalis
Gilles Néret

Benedikt Taschen

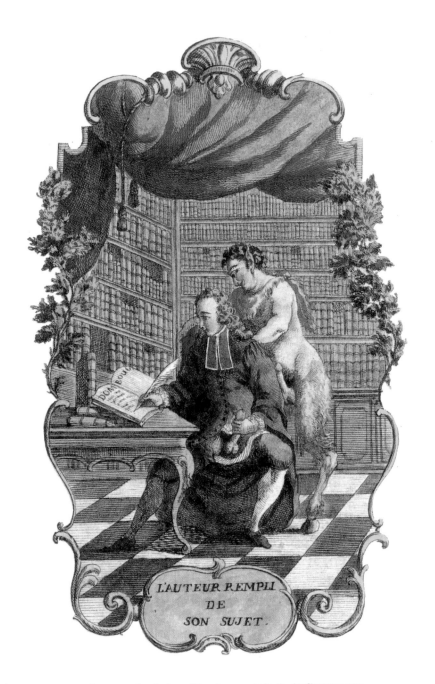

L'AUTEUR REMPLI
DE
SON SUJET.

Anonymous Frontispiece of *Dom Bougre ou Le Portier des Chartreux*, 1741

The Cerne Abbas Giant. Phallic figure drawn in the chalk of a hillside near Dorchester, England

The Joys of Eros

There is only one real antidote to the anguish engendered in humanity by its awareness of inevitable death: erotic joy. Eros, the god of love, is considered a principle of creation; sprung from the original chaos, he is a vital element of the world. The artist is in search of eternal, imperishable beauty; he thus makes of woman's thighs the columns of a temple through which one passes to enter Heaven. And despite the Inquisitors, he knows an opening in a shrubby, animal pelt that gives onto life, death, love and God.

It was Leonardo da Vinci who said: "The first painting was the outline of a man's shadow thrown upon a wall by the sun". And it happens that this man's phallus was erect, as though in defiance of his fears. Thus erect, he unwittingly illustrated the neo-Platonic theories according to which love is the source of all creation. But the artist also knows that he owes everything to woman. For the artist, woman is "the origin of the world" (Courbet) or its "navel" (Rodin). Bacchant or courtesan, maenad or houri, dancer or sorceress, it is she who begets the earth. And thus the artist's studio becomes an orgiastic temple, a mystic brothel, a cathedral of the eye. And should we be forbidden our part in these banquets of love? Should we be forbidden access to the immortality offered by erotic joy? Can we allow museums to bury these innumerable treasures in their vaults, hiding them from the common man's sight? No. It is time, now that taboos and prohibitions have little by little ceased to overshadow them, to do justice to certain masterpieces hitherto little known or whose reputation has disfigured and marginalised them. For they bear witness to the entire history of humanity, from changes in habit to sociological phenomena: period fetishism, the evolution of fashion or interior decoration, the persistence of myths... They thus constitute a veritable treatise of erotic systems from the stone age to our own times.

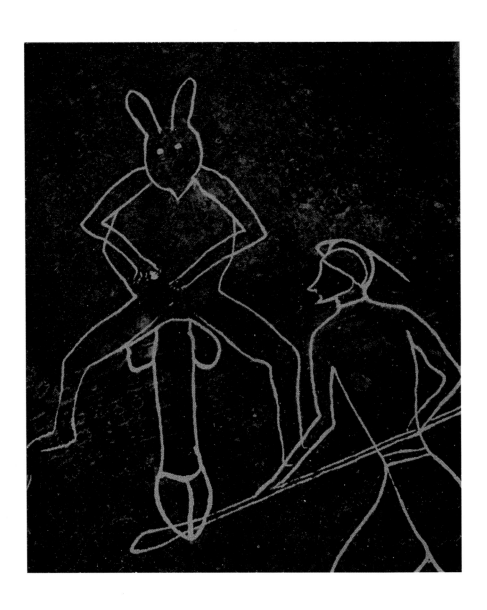

Rock drawings. Ti-n-Lalan, Fezzan, 5000 BC

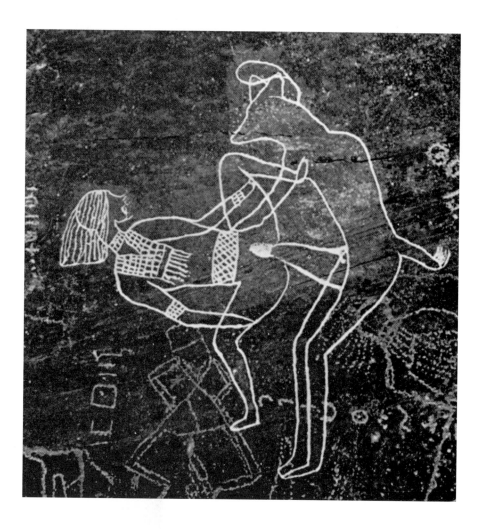

Lust am Eros

Das einzige Mittel gegen die Angst des Menschen vor seinem unabwendbaren Tod ist die Liebeslust. Eros, der Gott der Liebe, gilt als ein Schöpfergott, der aus dem Urchaos erwachsen ist; er gehört zu den wesentlichsten Elementen dieser Erde. Der Künstler, ständig auf der Suche nach der ewigen und unvergänglichen Schönheit, verwandelt die Schenkel der Frau in Tempelsäulen, die man passieren muß, um in den Himmel zu gelangen. Und allen Inquisitoren zum Trotz weiß er auch von einer Spalte, von einem buschigen Vlies, hinter dem sich das Tor zum Leben öffnet, zur Liebe, zu Gott. Leonardo da Vinci sagte einmal:»Das erste Gemälde war der Schattenriß eines Mannes, den die Sonne auf eine Mauer geworfen hatte.« Nun hatte dieser Mann eine Erektion, als könne er damit seine Angst bezwingen. Er bestätigte so unbewußt jene neoplatonischen Theorien, die die Liebe als eigentliche Quelle der Schöpfung beschreiben. Aber der Künstler weiß auch, daß er alles der Frau verdankt. Für ihn ist sie »der Ursprung der Welt« (Courbet) oder auch ihr »Nabel« (Rodin). Bacchantin oder Kurtisane, Mänade oder Huri, Tänzerin oder Zauberin, sie bringt die gesamte Erde hervor; somit wird das Atelier des Künstlers zum orgiastischen Tempel, zum mystischen Bordell, oder zur Kathedrale für das Auge. Und da wollte man uns verbieten, an diesen Festgelagen teilzunehmen, wollte uns hindern, ebenfalls durch die erotische Lust in die Unsterblichkeit einzugehen? Dürfen die Museen diese Kleinodien in ihre Truhen versenken, um sie vor uns gewöhnlichen Sterblichen zu verstecken? Nein, die Zeit ist gekommen, da Tabus und Vorurteile allmählich ihre Macht verloren haben, den unbekannten oder verkannten Meisterwerken Gerechtigkeit widerfahren zu lassen. Denn auch sie sind Zeugnis der Menschheitsgeschichte, von der Entwicklung der Sitten bis zu gesellschaftlichen Phänomenen: zeitgenössische Fetische, Strömungen der Mode und Ausstattung, Fortschreibung der Mythen... Sie haben den Stellenwert einer Abhandlung über das erotische Verhalten von der Urzeit bis heute.

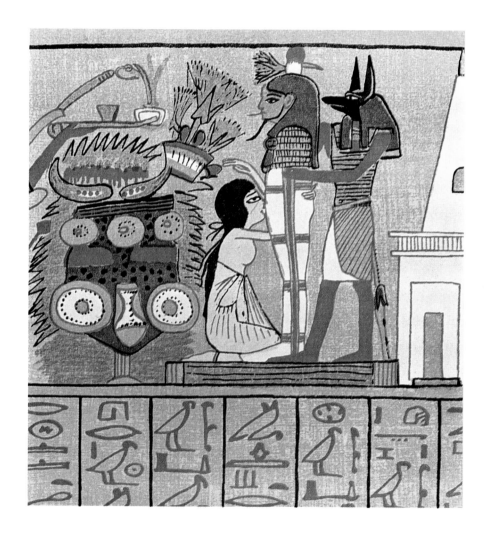

Egypt The Animation of the Phallus. Rite after the Ani Papyrus, 18th Dynasty

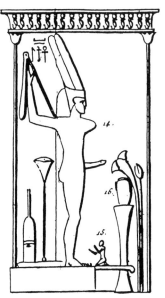

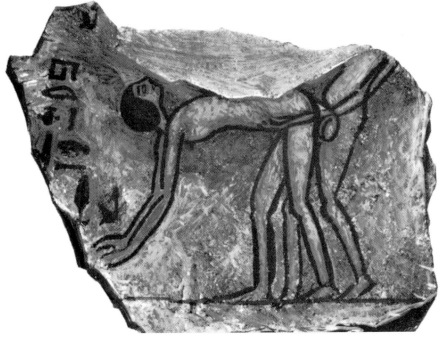

Egypt New Empire votive figure. Copy by Vivan Denon
Egypt Ostracon, New Empire

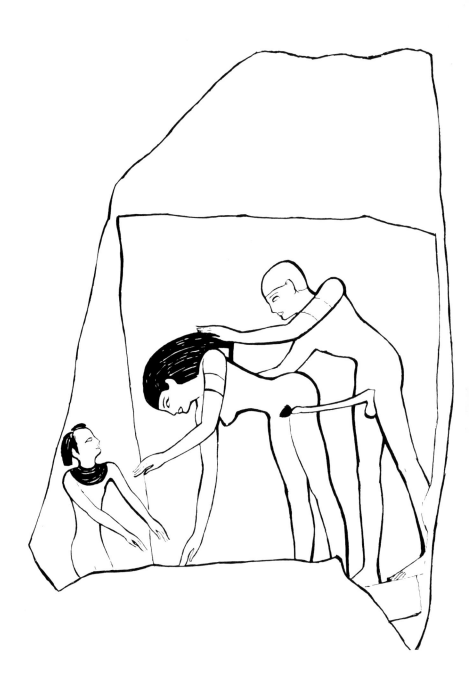

Egypt Ostracon, New Empire

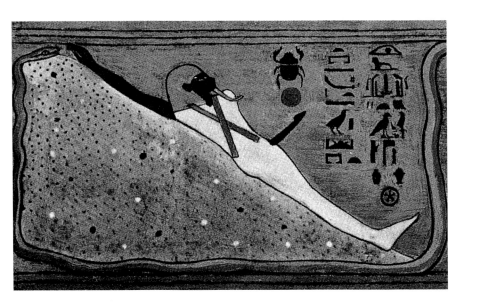

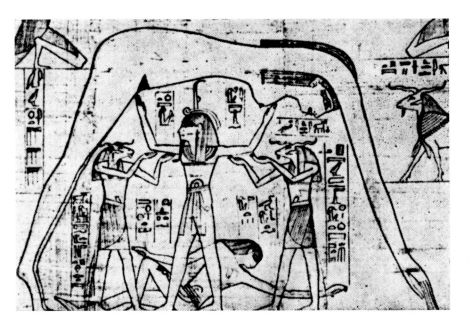

Egypt Votive ostracon, New Empire
Egypt The gods of the Earth, the Air and the Sky, New Empire papyrus

Eros en Joie

Le seul véritable antidote à l'angoisse qu'engendre chez l'homme la connaissance de sa mort inéluctable, c'est la joie érotique. Eros, divinité de l'Amour, est considéré comme un dieu créateur, né du chaos primitif et l'un des éléments primordiaux du monde. Or l'artiste est en quête du beau éternel et impérissable. C'est pourquoi il fait des cuisses d'une femme les colonnes d'un temple qu'il faut franchir pour gagner le Ciel. Et malgré les inquisiteurs, il sait aussi d'une fente, d'une broussailleuse et animale toison, ouvrir la porte à la vie, à la mort, à l'amour, à Dieu.

C'est Léonard de Vinci qui le dit: «La première peinture fut le contour linéaire de l'ombre d'un homme portée sur un mur par le soleil.» Or il se trouve que cet homme était en érection, comme pour défier sa peur, illustrant ainsi, sans le savoir, les théories néoplatoniciennes par lesquelles l'amour est la source même de la création. Mais l'artiste sait aussi qu'il doit tout à la femme. Pour lui, elle est «l'origine du monde» (Courbet), ou son «nombril» (Rodin). Qu'elle soit bacchante ou courtisane, ménade ou houri, danseuse ou sorcière, elle engendre la terre entière. Dès lors, l'atelier de l'artiste devient temple orgiaque, bordel mystique ou église de l'œil. Et l'on voudrait nous interdire de participer à de telles agapes? Nous empêcher d'aller, nous aussi, à l'immortalité par la joie érotique et laisser les musées qui en regorgent, enterrer ces joyaux dans leurs coffres, les cachant ainsi au commun des mortels? Non. Le temps est venu, en effet, maintenant que les tabous et les préventions ont petit à petit cessé de les occulter, de rendre justice à certains chefs-d'œuvre inconnus, méconnus ou que leur réputation a défigurés et rejetés dans l'ombre. Car c'est aussi de toute l'histoire de l'humanité qu'ils témoignent, de l'évolution des mœurs aux phénomènes sociologiques: fétichisme d'époque, évolution de la mode et du décor, persistance des mythes... Ils constituent ainsi un véritable traité des systèmes érotiques depuis l'âge des cavernes jusqu'à notre époque.

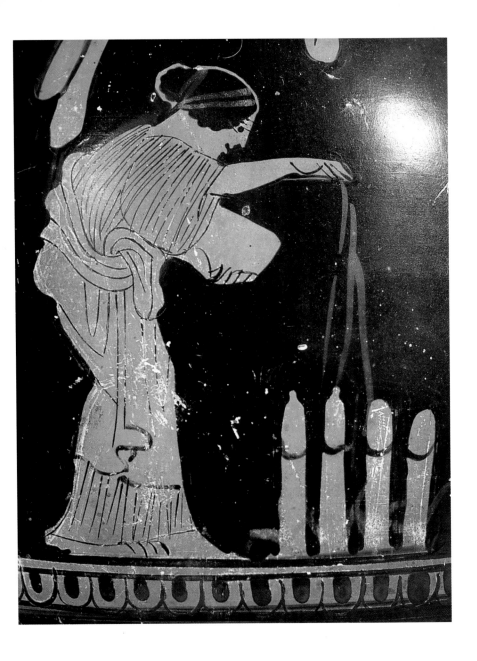

Greece Woman watering phalluses, 430-420 BC

I
Erotica
Antiqua

The Greeks

Death, for the Ancient Greeks, was "hollow and dark like woman". Even with hair removed, the baleful grotto led directly to Hades. For this reason, Aphrodite is always shown as smooth and impenetrable, which, for a goddess of love, is the height of absurdity. For the same reason, there flourished in ancient Greece the "sacred love" between men that Plato describes.

Greek artists have left us, in the form of ex-votos, goblets, vases, amphorae, an inexhaustible catalogue of the frolics and turpitude to which mortals abandoned themselves in imitation of the gods of Olympus.

Die Griechen

Der Tod war für die alten Griechen »hohl und unergründlich wie die Frau«. Und die unheimliche Höhle führte, auch wenn sie rasiert war, direkt in die Hölle. Deshalb zeigt sich Aphrodite in all ihren Darstellungen glatt und undurchdringlich, was für eine Göttin der Liebe unerhört ist. Und daher auch das Aufblühen jener »heiligen Liebe« zwischen Männern, die uns Plato beschrieb.

In Form von Votivbildern, Schalen, Vasen und Amphoren hinterließen uns die griechischen Künstler einen unerschöpflichen Katalog der Ausschweifungen und Schändlichkeiten, denen sich die Götter des Olymp, und nach ihrem Vorbild die Sterblichen, hingaben.

Les Grecs

La Mort, pour les Grecs anciens, était «creuse et obscure comme la femme». Même épilée, la maléfique grotte menait tout droit aux Enfers. C'est pourquoi Aphrodite, dans toutes ses représentations, se montre lisse et impénétrable, ce qui, pour une déesse de l'amour, est un comble. C'est pourquoi l'on voit aussi fleurir dans la Grèce antique cet «amour sacré» entre hommes que décrit Platon.

Sous forme d'ex-voto, de coupes, de vases, d'amphores, les artistes grecs nous ont laissé un catalogue inépuisable des ébats et turpitudes auxquels se livraient les divinités de l'Olympe et les mortels à leur exemple.

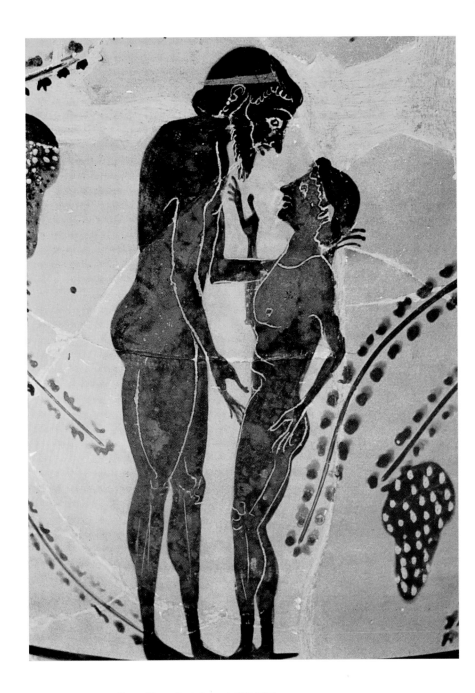

Greece Man and ephebe, end of 6th C BC

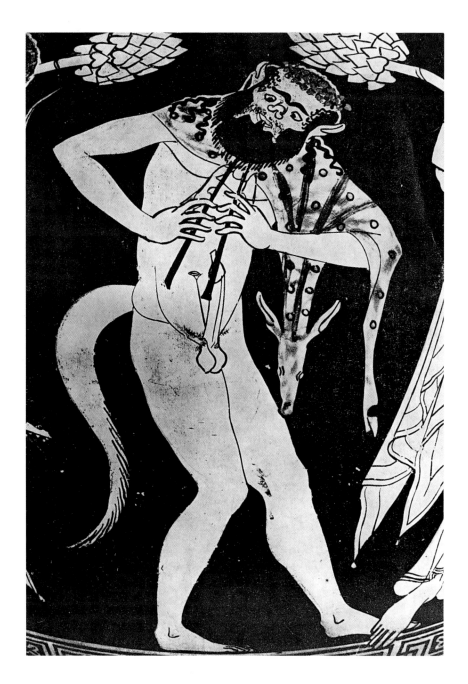

Greece Satyr, 5th C BC

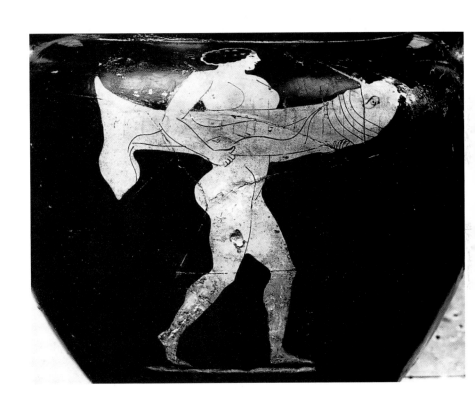

Greece Woman carrying a Phallus, 470 BC

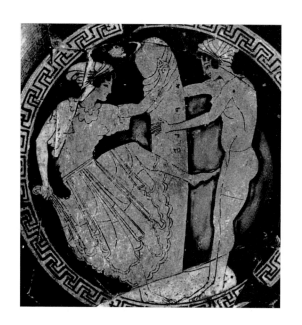

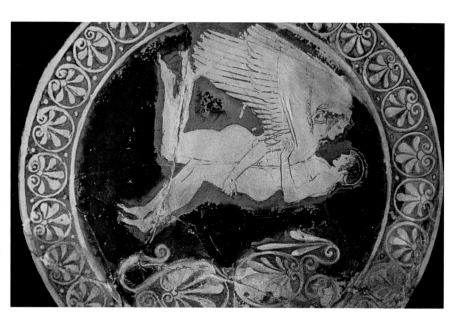

Greece Hetaira dancing around a phallus, 5th C BC
Greece Zephyr and Hyacinth, 480 BC

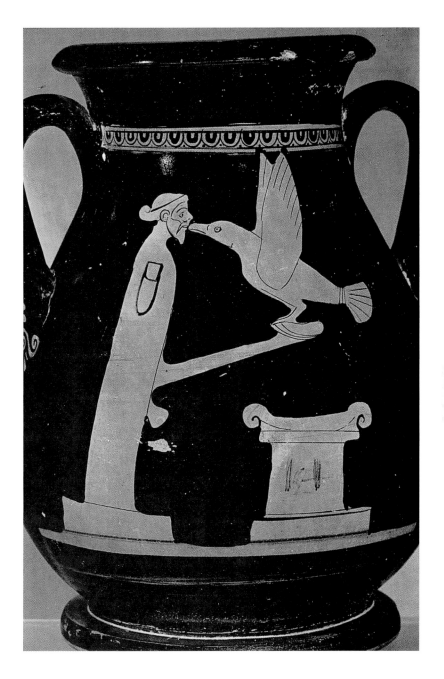

Greece Hermes with a bird perched on his phallus above an altar, 5th C BC

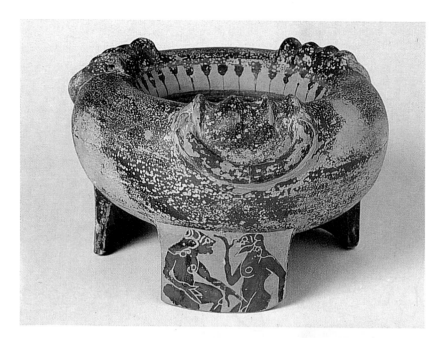

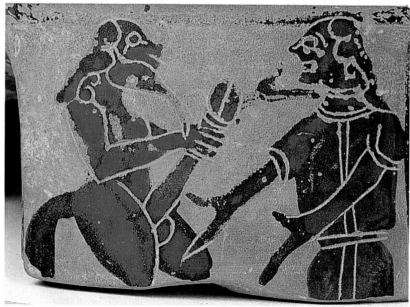

Greece Boeotian terracotta tripod-exaleiptron, 6th C BC

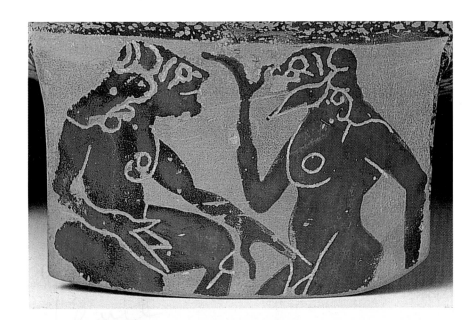

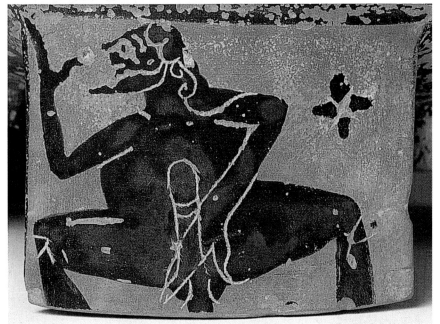

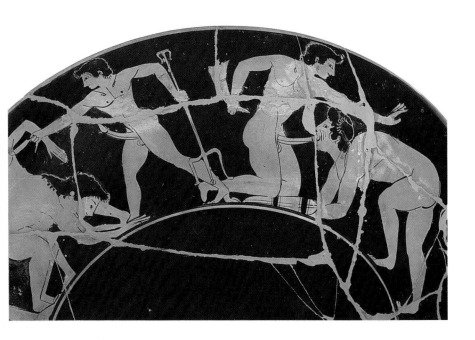

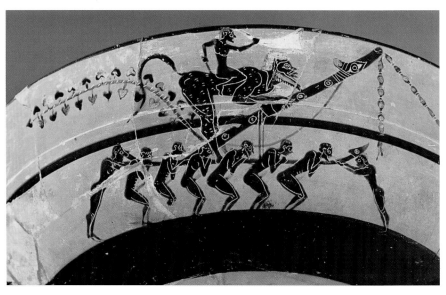

Greece Sodomy, fellatio and sado-masochism. Attic goblet, c. 510 BC
Greece Procession in honour of Dionysus, 560 BC

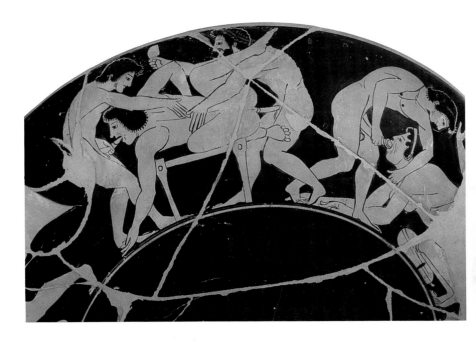

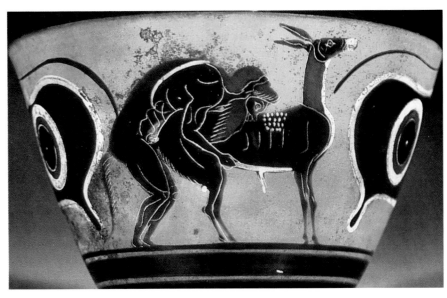

Greece Sodomy, fellatio and sado-masochism. Attic goblet, c. 510 BC
Greece Silenus and bestiality, 560 BC

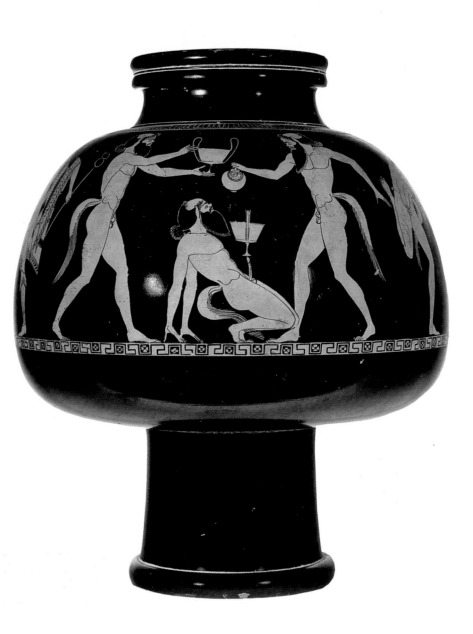

Greece Wine-cooler (psykter). Satyrs' orgy with balancing act, c. 500-470 BC

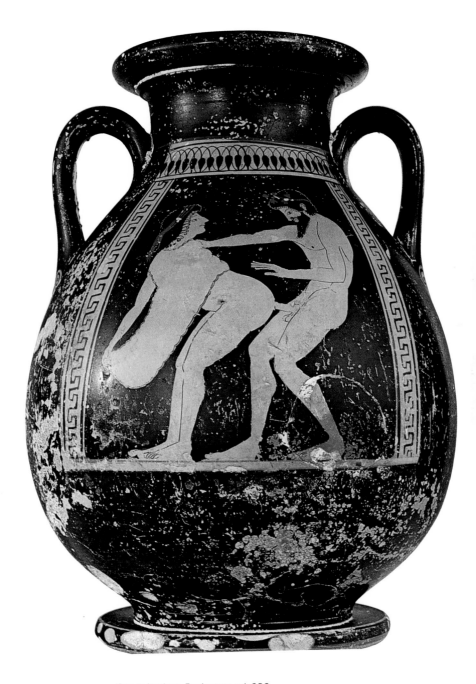

Greece Amphora. Erotic scene, 5th C BC

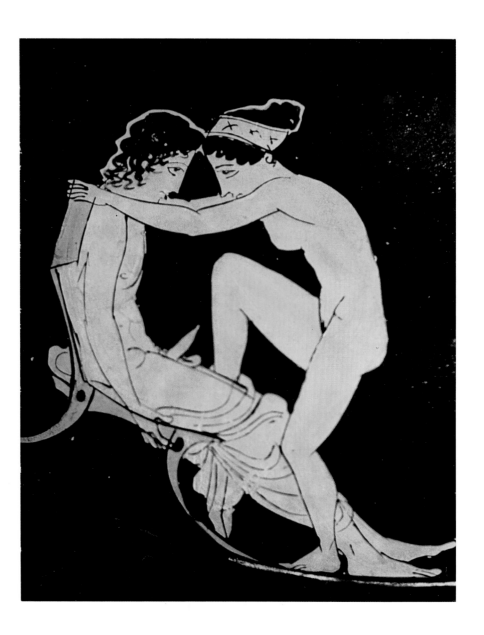

Greece Young woman preparing to straddle a young man, 430-420 BC

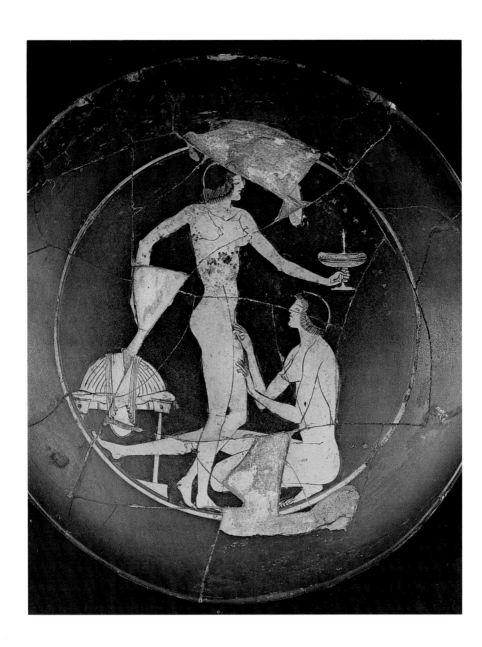

Greece Two hetairai, 500 BC

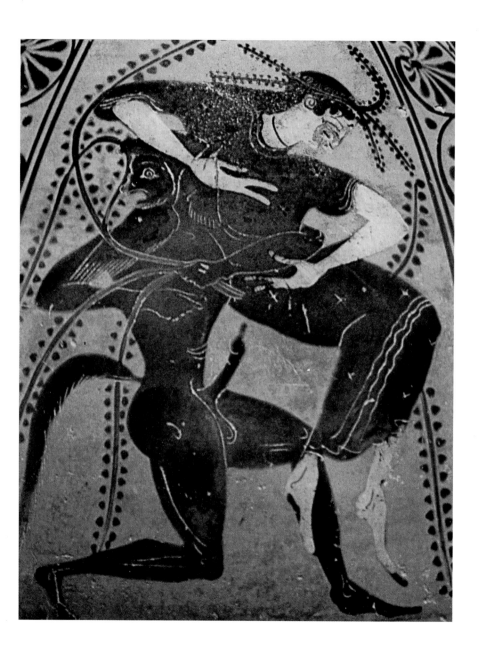

Greece Satyr and maenad, 6th C BC

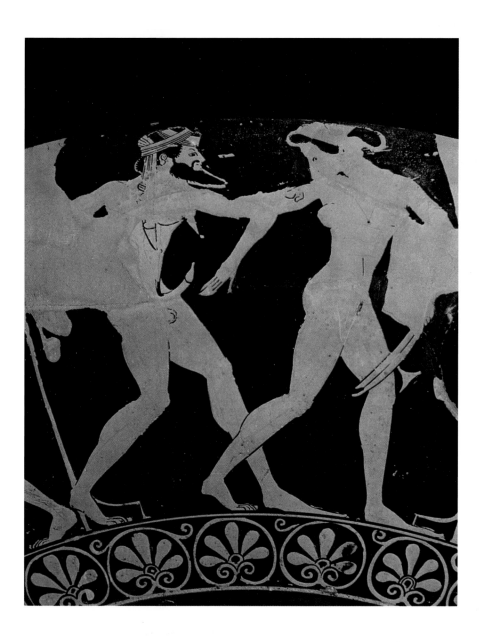

Greece Man and hetaira, 6th C BC

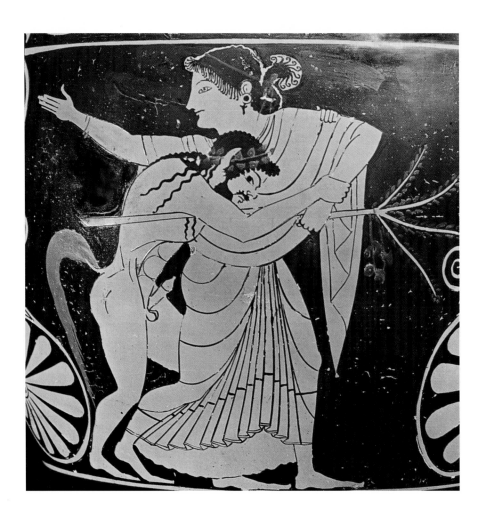

Greece Satyr carrying off maenad, 4th C BC

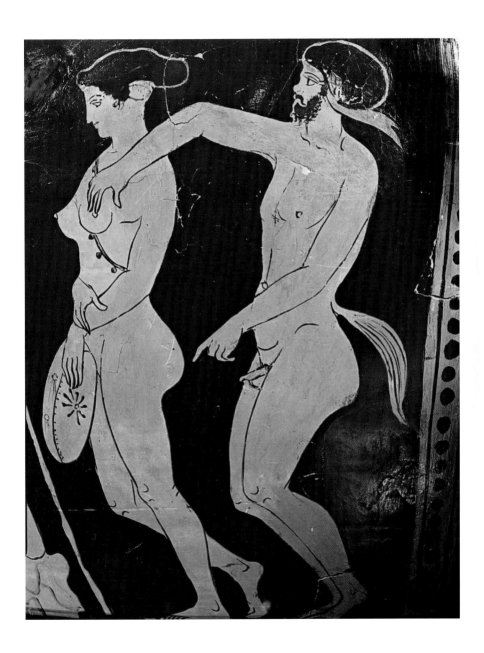

Greece Satyr caressing a maenad, 4th C BC

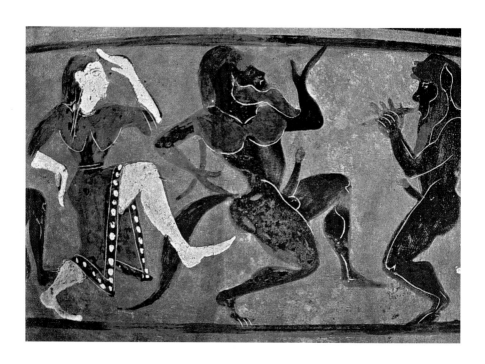

Greece Erotic dances, 6th C BC

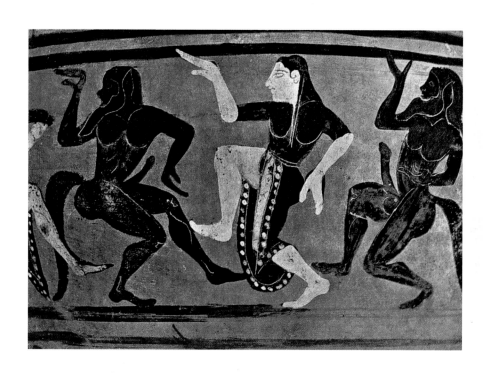

Greece Erotic dances, 6th C BC

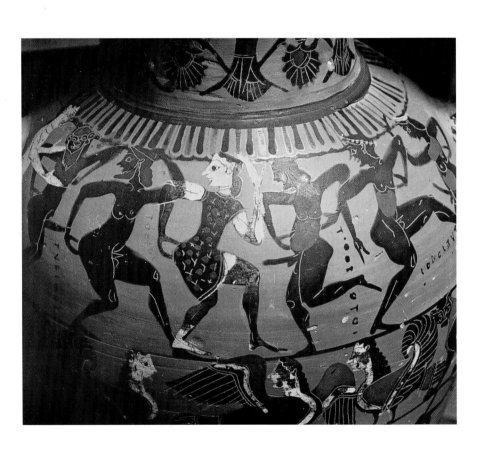

Greece Erotic dances, 6th C BC

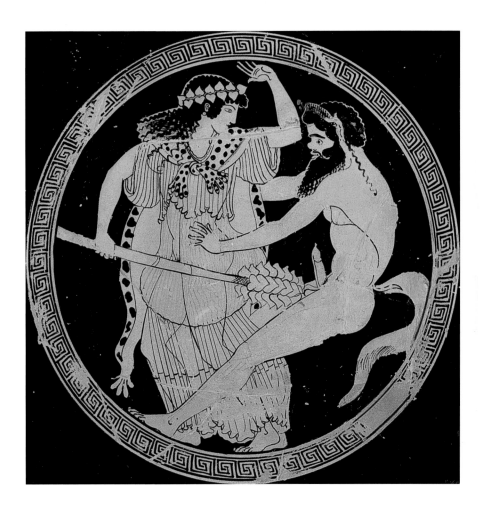

Greece Maenad repelling a satyr with her thyrsus, c. 480 BC

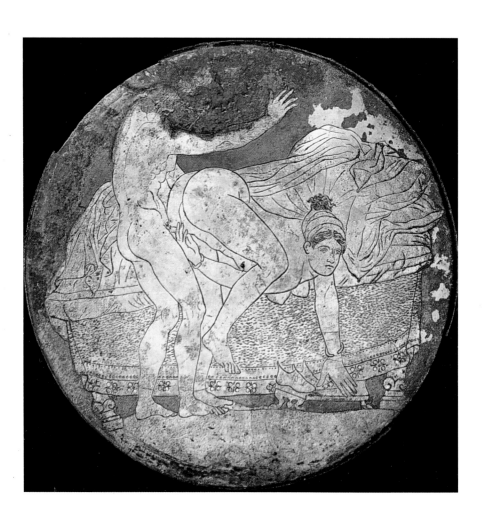

Greece Reverse of a mirror in engraved bronze, mid-4th C BC

Greece Theseus and Ariadne, 6th C BC

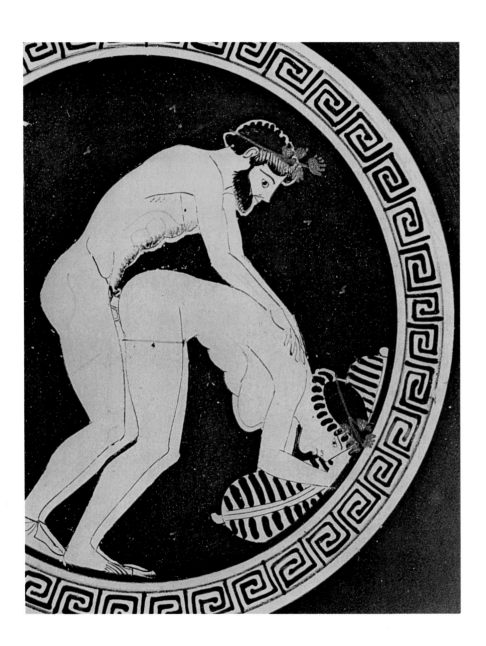

Greece Erotic goblet, 470 BC

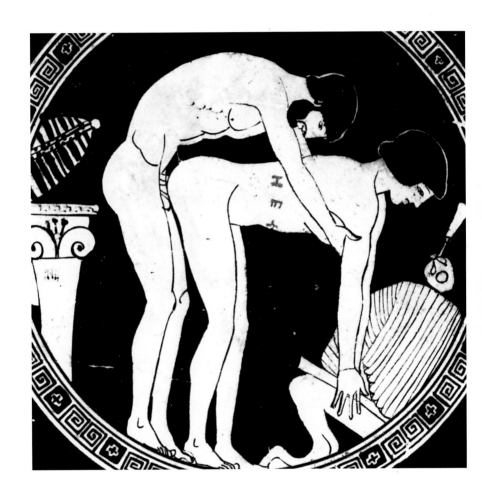

Greece Variation on the theme of rear entry, 500-470 BC

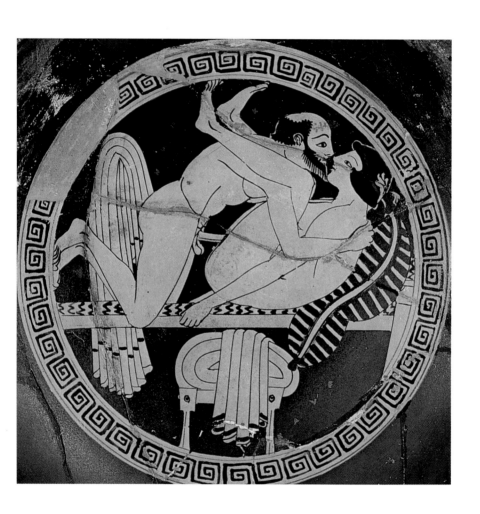

Greece Erotic scene, 470 BC

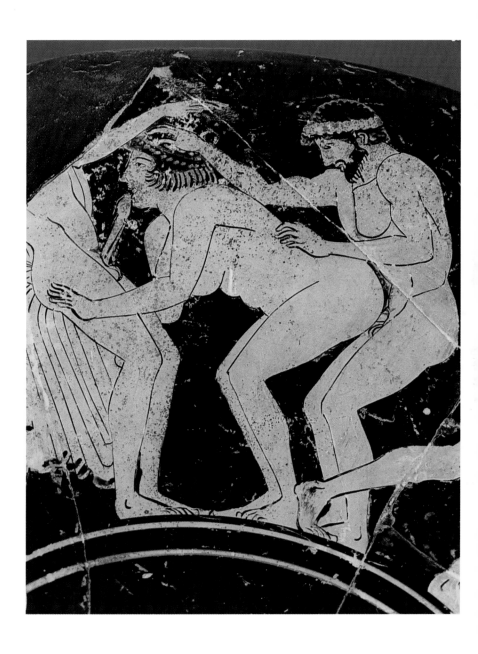

Greece Erotic group, 480 BC
▶ **Greece** Bearded men and hetairai, 430 BC

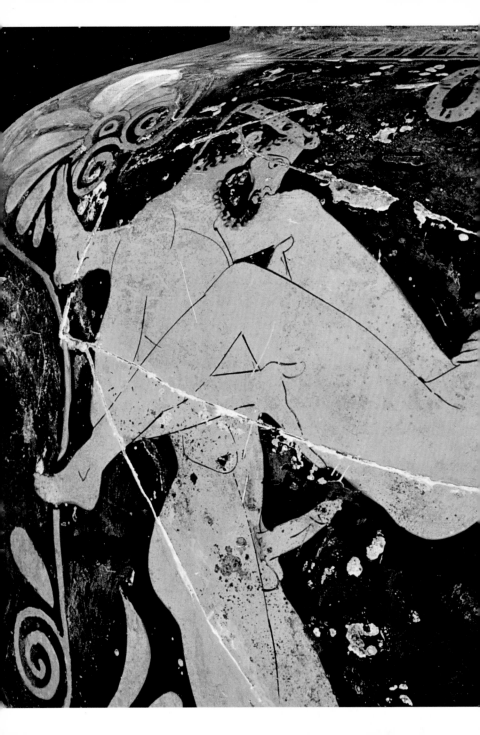

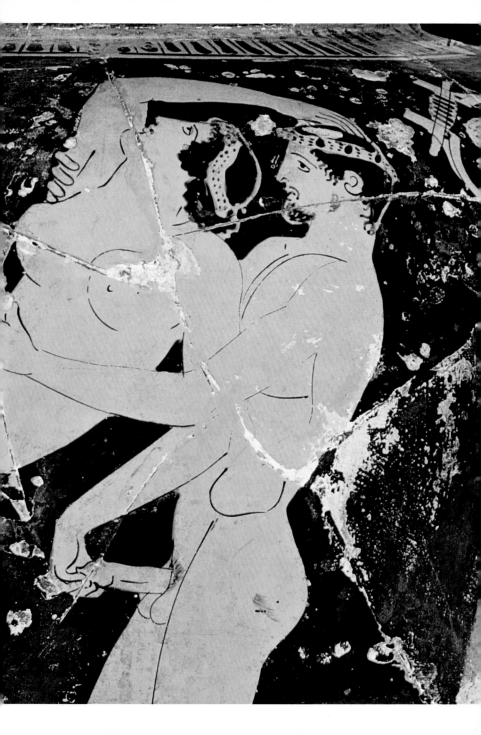

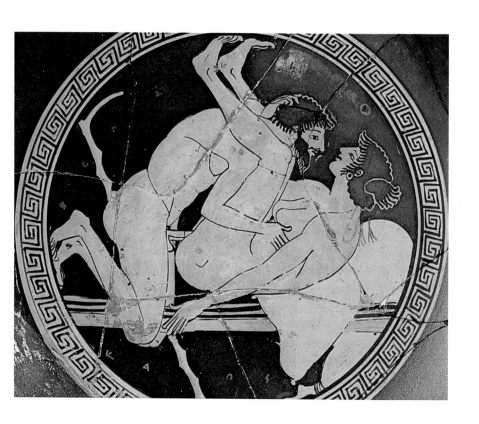

Greece Erotic scene, 470 BC

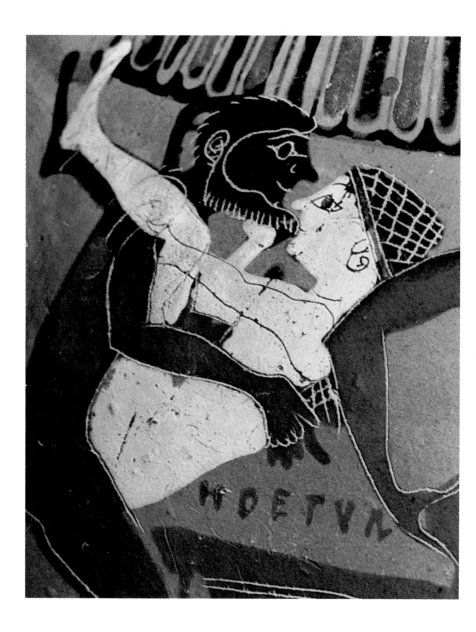

Greece Theseus and Ariadne, 7th C BC

The Romans

Like the Greek vases and goblets, the sublime frescoes of the *Villa dei Misteri* at Pompeii and the mosaics of Naples saved from the ashes of Vesuvius show us the many variations that gods and humans bring to the sexual act. Under the debonair eye of a generous and smiling Priapus, from whose well-endowed member a fountain spurts forth, freshly sodomised bacchantes deliriously perform lascivious dances, and ritual ceremonies in honour of Bacchus are performed. This was the charming epoch in which Julia, the daughter of Augustine, every morning placed upon the head of the deity as many garlands as she had offered sacrifices during the night.

Die Römer

Die wunderbaren Fresken in der Villa dei Misteri in Pompeji oder die aus der Asche des Vesuvs geborgenen Mosaike von Neapel vergegenwärtigen uns ebenso wie die griechischen Vasen und Schalen die vielen Varianten der Lust, denen sich die Menschen und die Götter bei ihrer Paarung hingegeben haben mögen. Unter den nachsichtigen Augen eines großmütig lächelnden Fruchtbarkeitsgottes, aus dessen starkgliedrigem Brunnen es heftig sprudelt, führen Bacchantinnen, hoch im Liebesrausch, lüsterne Tänze auf, nachdem sie sich soeben der Sodomie hingegeben haben, oder sie feiern rituelle Zeremonien zu Ehren des Bacchus. War es nicht eine reizvolle Epoche, in der Julia, die Tochter des Augustus, jeden Morgen so viele Blumengirlanden um den Hals des Gottes wand, als sie ihm in der Nacht Opfer dargebracht hatte?

Les Romains

Les sublimes fresques de la villa des Mystères à Pompéi, ou les mosaïques de Naples sauvées des cendres du Vésuve, retracent, au même titre que les vases et les coupes grecs, les multiples variantes que pouvaient pratiquer dans leurs accouplements les humains et les dieux. Sous l'œil débonnaire d'un Priape généreux et souriant, dont la fontaine bien membrée jaillit, se déroulent danses lascives exécutées par des bacchantes fraîchement sodomisées et en délire, ou cérémonies rituelles à la gloire de Bacchus. Epoque charmante où Julie, la fille d'Auguste, mettait chaque matin au cou du dieu autant de couronnes fleuries qu'elle lui avait offert de sacrifices la nuit.

Pompeii Villa dei Vetii: Priapus weighing his phallus, 1st C

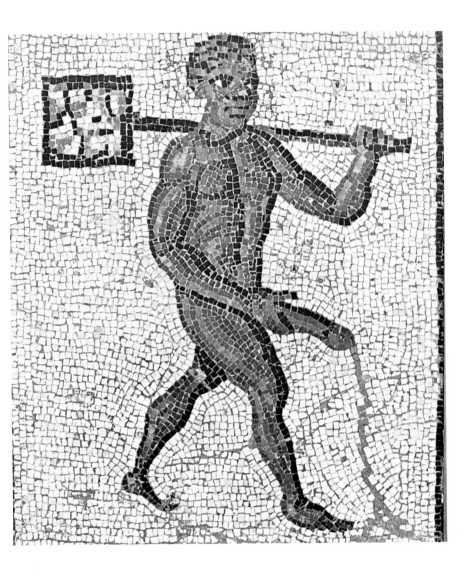

Timgad Erotic mosaic, late 1st C

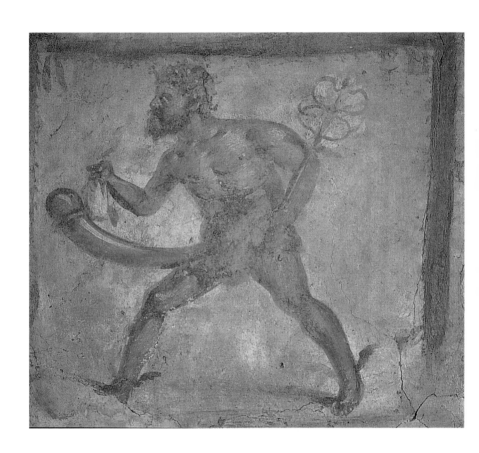

Pompeii The divine phallus, 1st C

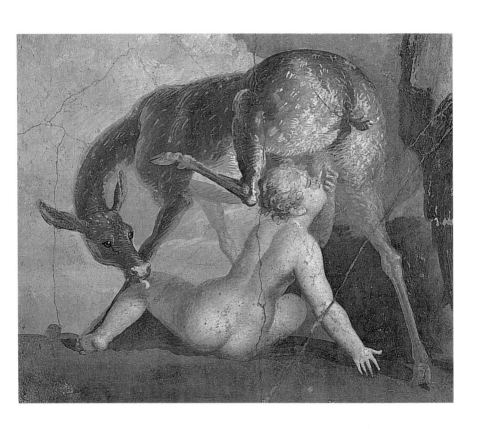

Herculaneum Telephus suckling the doe on Mount Parthenion, 1st C

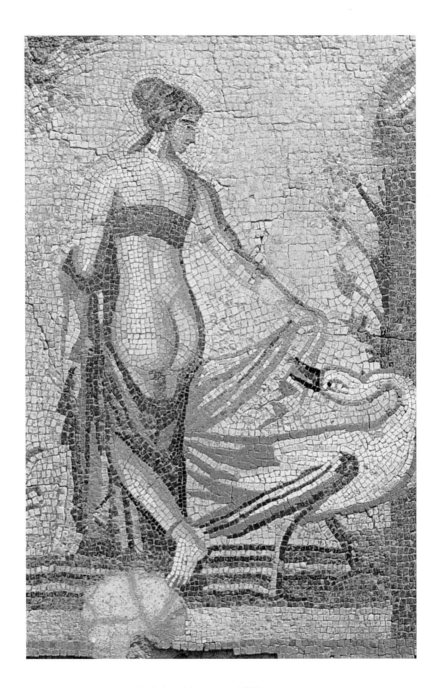

Cyprus Mosaic. Leda and the swan, 3rd C BC

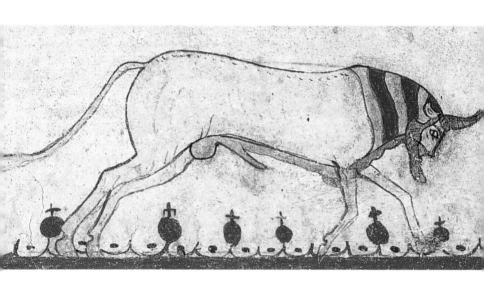

Tarquina The Fresco of the Tomb of the Bulls. Ithyphallic bull and sodomy, c. 540

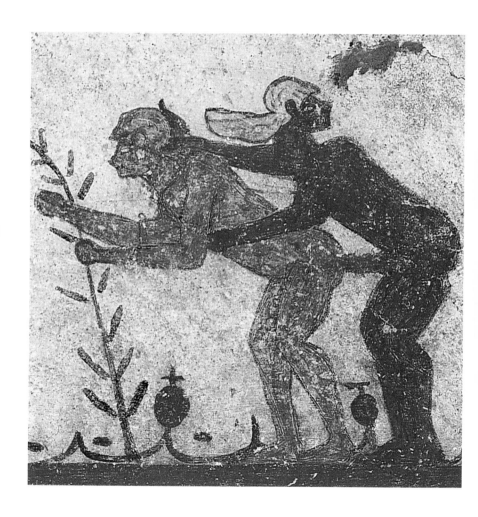

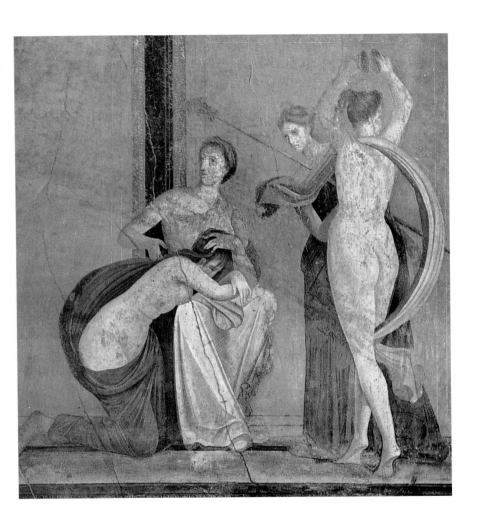

Pompeii Villa dei Misteri: Scene of initiatory flagellation, 1st C BC

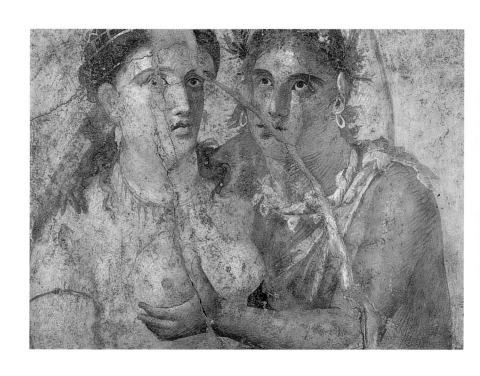

Pompeii Villa of L Caecillius. Maenad caressed by a satyr, 1st C

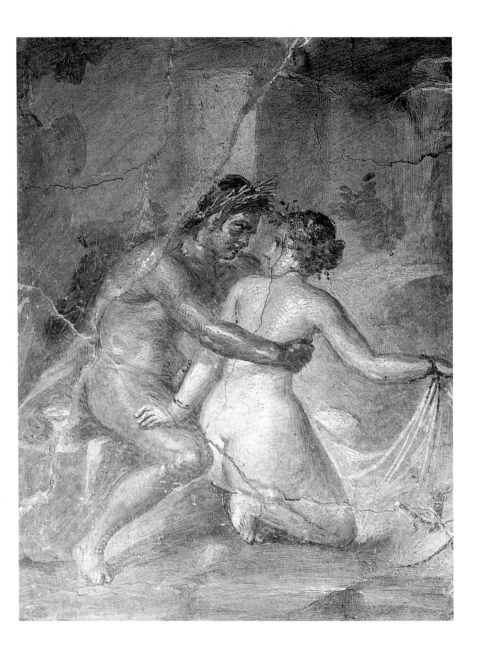

Pompeii: Satyr and maenad, 1st C

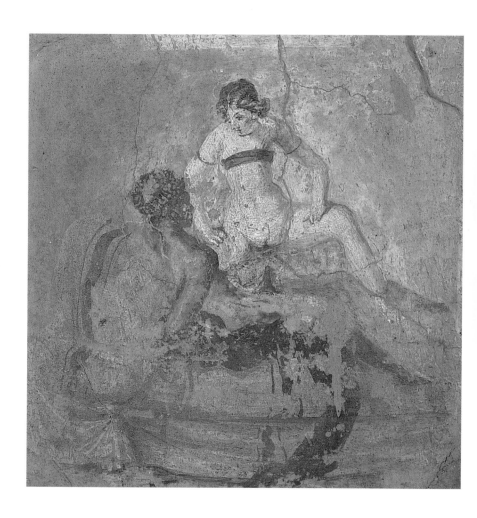

Pompeii Satyr and maenad delighted by each other's sexes, 1st C

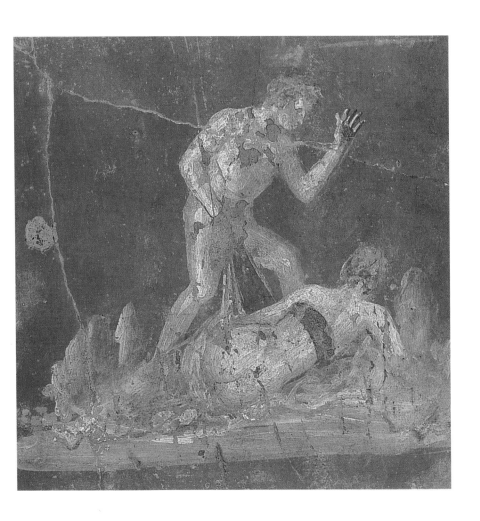

Pompeii Man removing the veil that hides the sex of a woman with bandaged breasts, 1st C

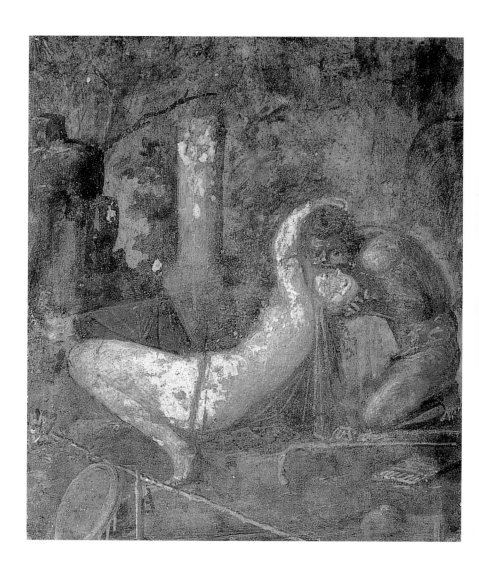

Herculaneum The kiss of the satyr, 1st C

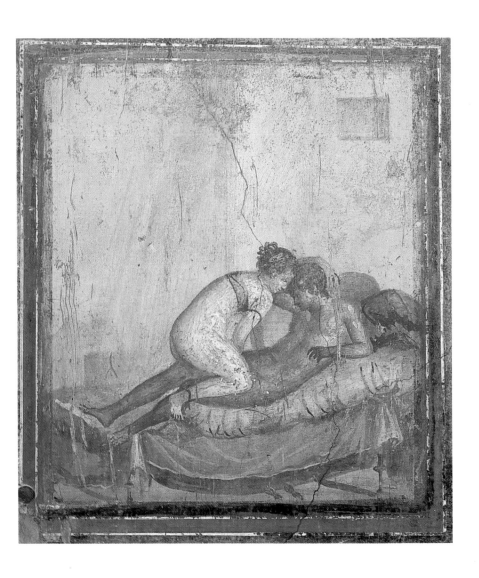

Pompeii Villa of the Centenary: Lovers on a bed, 1st C

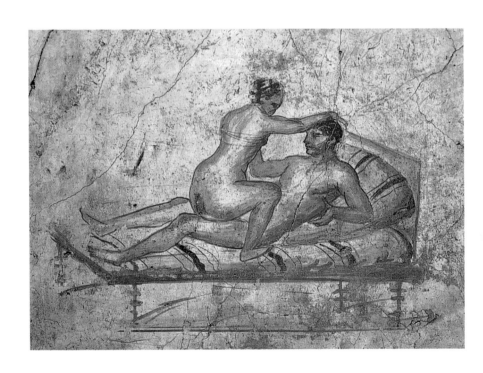

Pompeii Villa dei Vetii: Lovers on a bed, 1st C

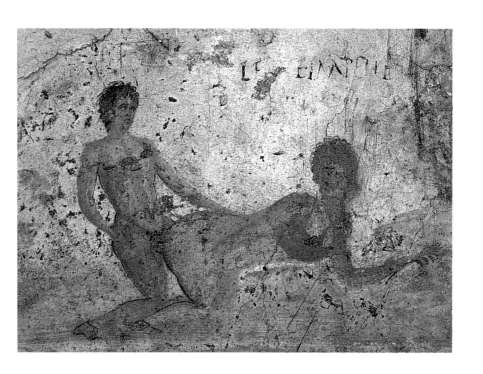

Pompeii Lovers, 1st C

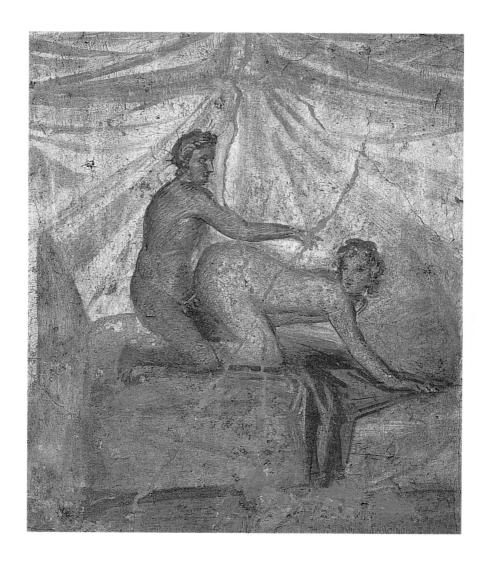

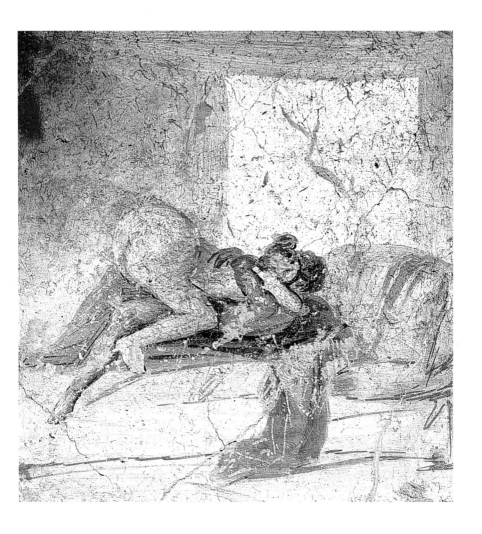

Pompeii Lovers, 1st C

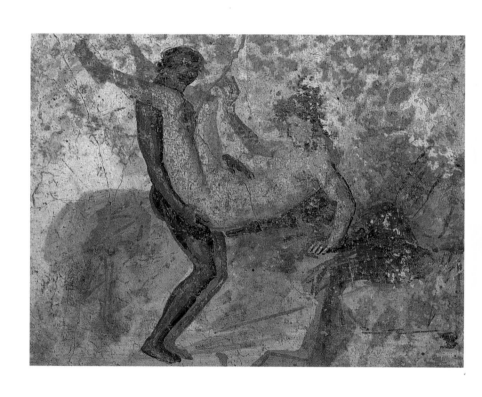

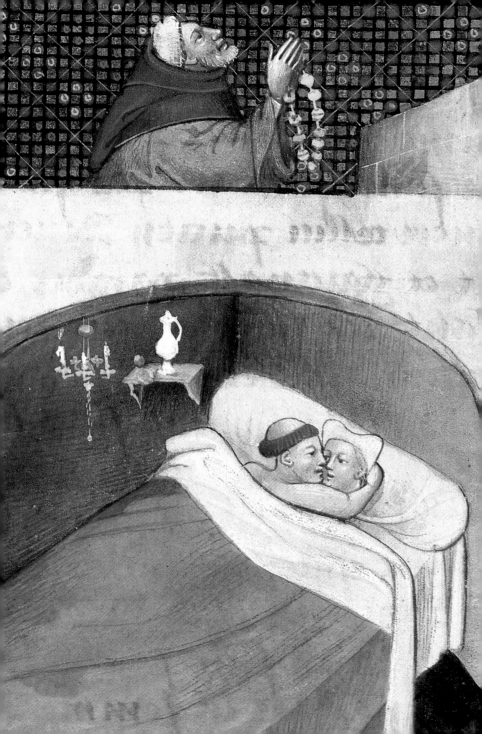

Courtly Love

In the Middle Ages, faith had not yet been replaced by hypocrisy and the believer did not find 'evil' everywhere. On the pediments of the Gothic churches, a hundred carvings fornicate in stone... Pascal, after all, remarked "Sometimes the sight of evil is a better incentive to self-improvement than good example". Under the reign of courtly love, Jupiter and Ganymede are confused with Adam and Eve, Theseus with King Arthur and Helen of Troy with Isolde. But the upshot is the same: the cult of Woman is born. And the beautiful ladies of the period, who were by no means prudes, frequented public baths, and had their portraits made there, nude, legs akimbo, during these watery frolics.

Die Minne

Im Mittelalter, als der Glaube noch nicht durch Heuchelei verdrängt worden war, begegnete der Gläubige nicht auf Schritt und Tritt dem »Bösen«. Hunderte von Menschen, die es miteinander treiben, sind oft im Giebeldreieck gothischer Kirchen in Stein gemeißelt. ... Sagte nicht schon Pascal: »Manchmal bessert man sich eher beim Anblick des Bösen als durch das Beispiel des Guten.« Unter dem Einfluß der »Minne« verwechselte man auch gern Jupiter und Ganymed mit Adam und Eva, Theseus mit König Artus oder Helena von Troja mit Isolde. Doch das Ergebnis blieb das gleiche: Der Kult um die Frau war geboren. Und die schönen Damen jener Zeit, an denen nichts Un-schuldiges war, stiegen in die Schwitzbäder und ließen sich nackt, mit gespreizten Beinen bei diesen munteren Wasserspielen porträtieren.

L'Amour Courtois

Au Moyen Age, la foi n'a pas encore été remplacée par l'hypocrisie et le croyant ne voit pas le «mal» partout. Cent personnages for-niquent, sculptés aux frontons des églises gothiques... Pascal ne dira-t-il pas qu' «on se corrige quelque fois mieux par la vue du mal que par l'exemple du bien»? Sous le règne de «l'amour courtois», on confond bien encore un peu Jupiter et Ganymède avec Adam et Eve, Thésée avec le roi Artus ou Hélène de Troie avec Yseult... Mais le culte de la Femme est né. Et les belles dames de l'époque, qui n'ont rien d'innocent, fréquentent les étuves et se laissent portraiturer nues, fendues, lors de ces ébats nautiques.

◀ Miniature illustrating Boccaccio's *Decameron*, 14th C

Wood engraving for Boccaccio's *Decameron*, 14th C

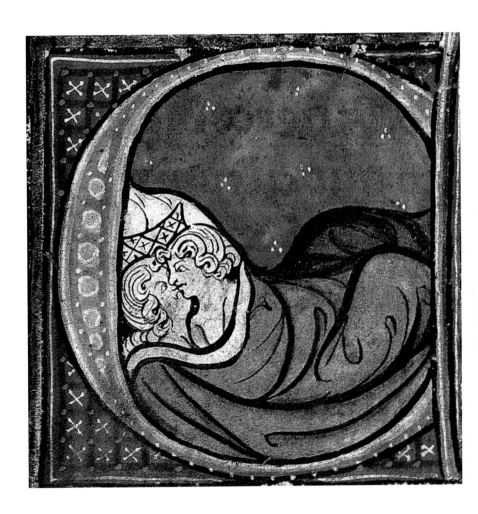

Illuminated letter, 14th C

Illumination for the *Histoire de Merlin*, 14th C

Illumination for Boccaccio's *Decameron*, 14th C

Hans Sebald Beham David and Bathsheba, c. 1525

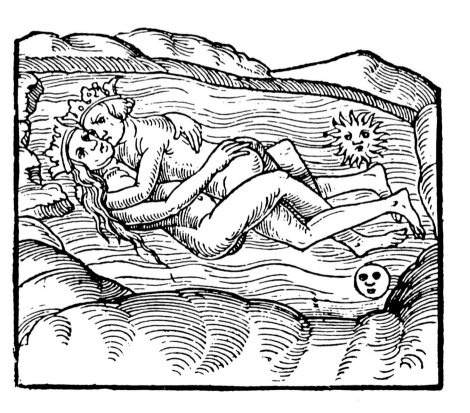

Rosarium Philosophorum, Frankfurt, 1556
▶ *Les Très Riches Heures du duc de Berry,* early 15th C

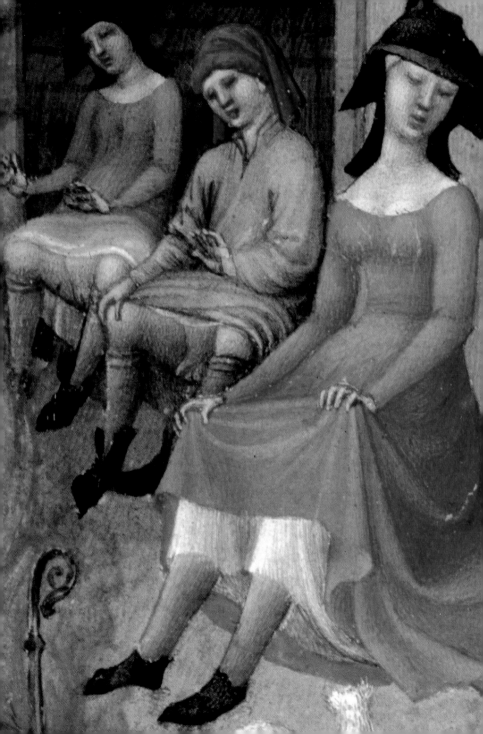

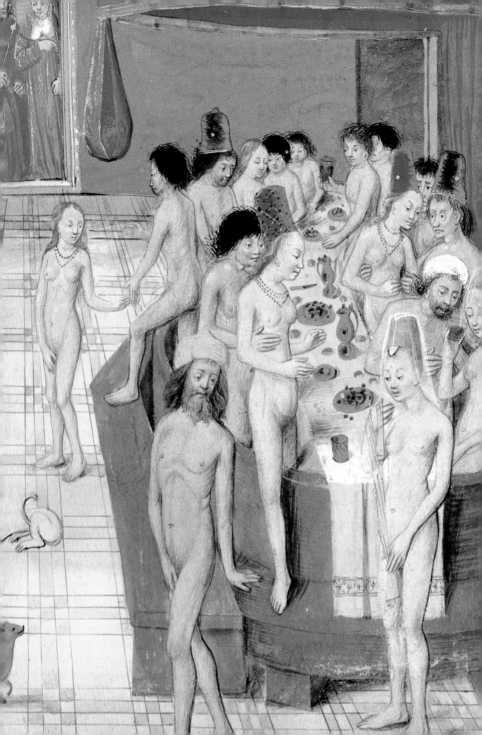

Bortho *The Saxon Chronicle*, Mainz, 1492

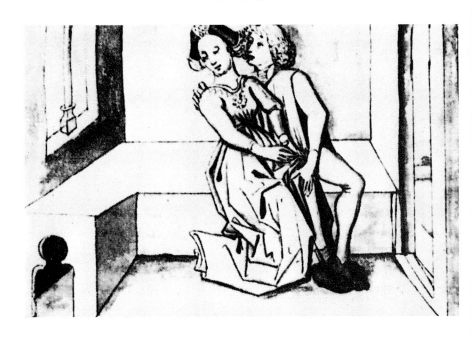

The Newly-Weds, 1470
◄ *The Book of Hours* of Valerius Maximus, 15th C

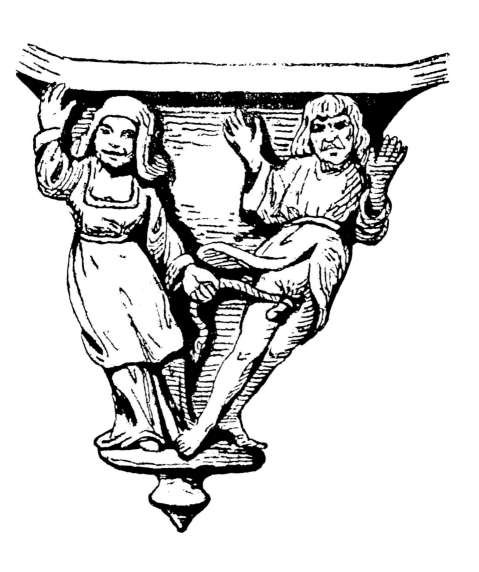

Misericord from the Church of Saint Materne, 15th C (copy)

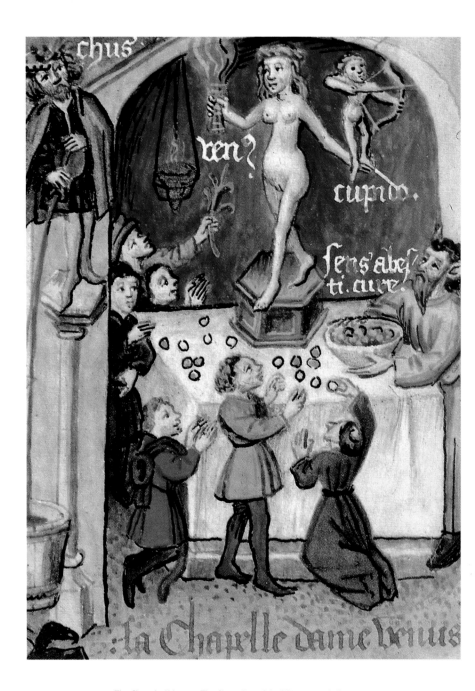

The Chapel of Venus – The Champion of the Women, 15th C

Jacques Callot (1592-1635) Series of engravings for the *Songes drôlatiques de Pantagruel de Rabelais*

Jacques Callot (1592-1635) Series of engravings for the *Songes drôlatiques de Pantagruel de Rabelais*

Jacques Callot (1592-1635) Series of engravings for the *Songes drôlatiques de Pantagruel de Rabelais*

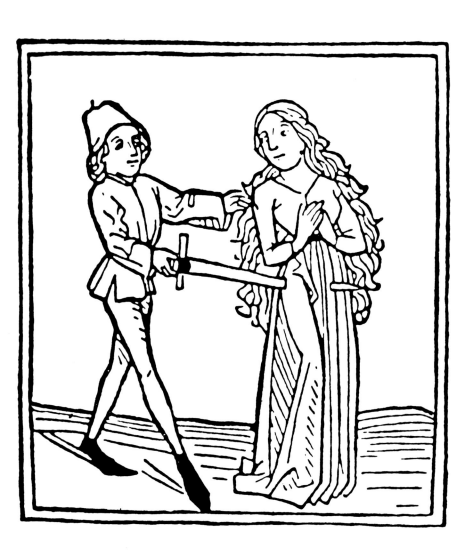

Murder of a Saint (*Ermordung einer Heiligen*), Speyer, 1493

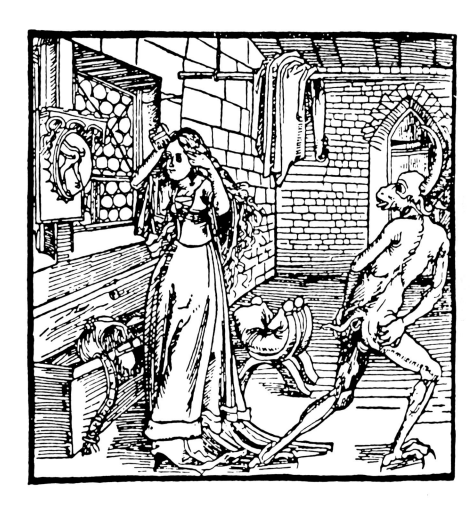

A beauty discovering the devil's arse in her mirror (*Buch des Ritters vom Turm*),
Basel, 1493

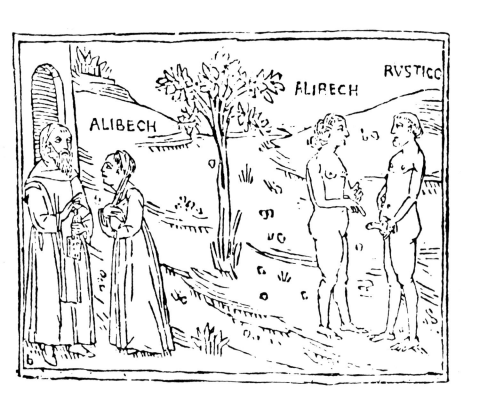

ALIBECH

ALIBECH

RVSTICO

Wood engravings for the original edition of Boccaccio's *Decameron*, 14th C

Jakob von Teramo The New Couple or Belial, Augsburg, 1472

Complete History of Adam and Eve in Paradise, Cologne, 1499

Capital from the cloister of Champeau. Carving, 15th C

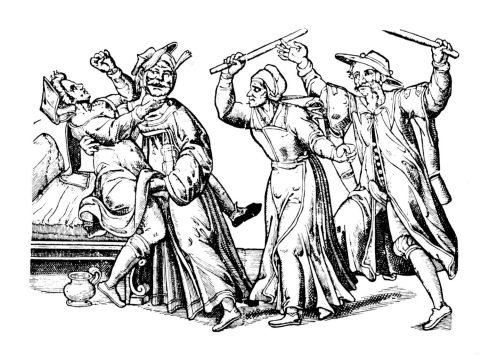

Fossard Collection. Theatre Licence, 1575

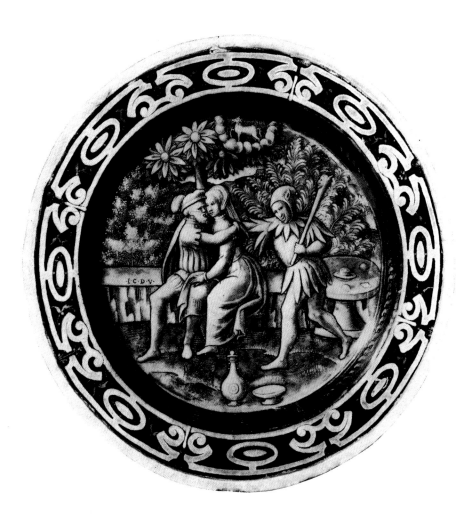

Jehan Court The Innocent Libertine, 15th C

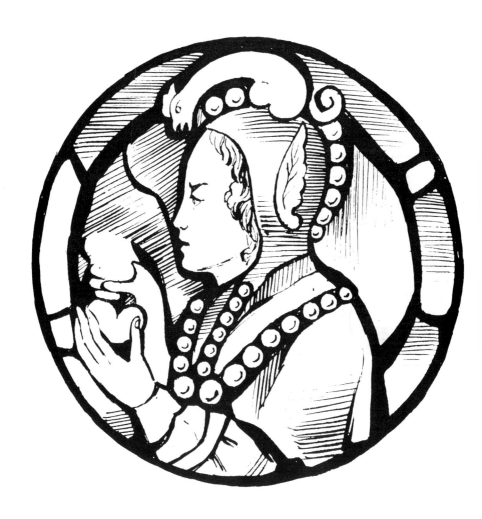

Stained glass window from the church of Saint-Vincent, Aisne, and missal illustration:
Female saint wearing a phallic bonnet, 14th C

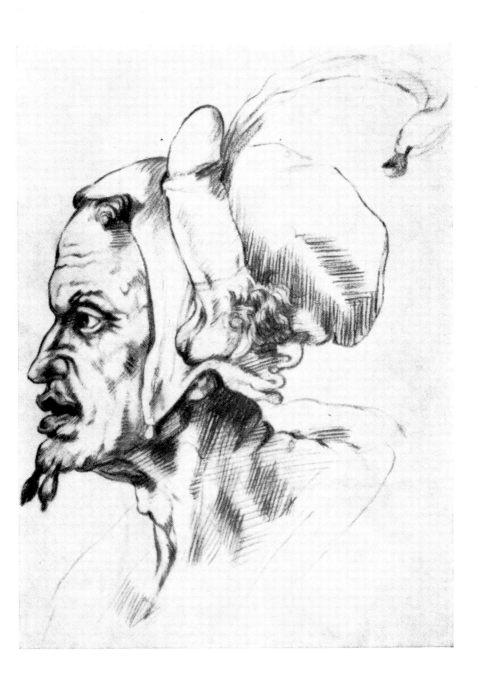

Michelangelo Scherzo, c. 1512

II
Erotica
Classica

The Renaissance and the Golden Age

There are those who respect nothing: Michelangelo proclaimed his homosexuality on the vaults of the Sistine Chapel. Rembrandt was happy to shock the burgers of Amsterdam by portraying himself coupling with his wife or by representing the latter as she pissed; he sold these engravings like postcards. Even the three "saucy painters" – Watteau, Boucher and Fragonard – who bring the 18th Century to a gracious close with roguish paintings executed, ostensibly, for the education of young kings, were intent on showing that beauty is ephemeral, that pleasure is merely an agreeable veil thrown over reality, and that under the surface of voluptuousness lurk solitude and death.

Die Renaissance und das Goldene Jahrhundert in Frankreich

Es gibt Menschen, die vor nichts Respekt haben: ein Michelangelo, der seine Homosexualität an der Decke der Sixtinischen Kapelle verewigte, ein Rembrandt, der die braven Amsterdamer Bürger schockierte, indem er sich beim Geschlechtsverkehr mit seiner Frau darstellte oder sie beim Pinkeln zeigte, und das in Kupferstichen, die er wie Ansichtskarten verkaufte. Selbst die drei Maler schlüpfriger Sujets – Watteau, Boucher, Fragonard –, die das 18. Jahrhundert so anmutig beschließen sollten, nahmen sich zur höheren Bildung ihrer jungen Könige mit List gewagte Themen vor, nur um zu zeigen, daß die Schönheit vergänglich ist, daß der Genuß nur ein angenehmer Schleier ist, den man der Realität überwirft, und daß die Wollust die Maske ist, hinter der sich Einsamkeit und Tod verbergen.

Renaissance et Siècle d'Or

Il y a ceux qui ne respectent rien: un Michel-Ange qui proclame son homosexualité au plafond de la Sixtine. Un Rembrandt qui se réjouit de choquer les bourgeois d'Amsterdam en se représentant copulant avec sa femme ou en montrant celle-ci en train de pisser, gravures qu'il vend comme autant de cartes postales. Même le trio de peintres polissons – Watteau, Boucher, Fragonard – qui clôt avec grâce le XVIIIe siècle en peignant des sujets fripons pour éduquer les jeunes rois, entend montrer que la beauté est éphémère, que le plaisir n'est qu'un voile agréable jeté sur la réalité, et que la volupté est le masque sous lequel se cachent la solitude et la mort.

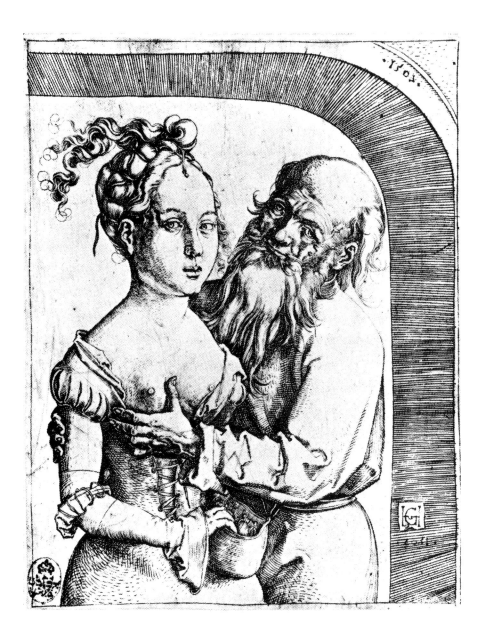

Hans Baldung Grien III - Matched Couple (Ungleiches Paar), 1507

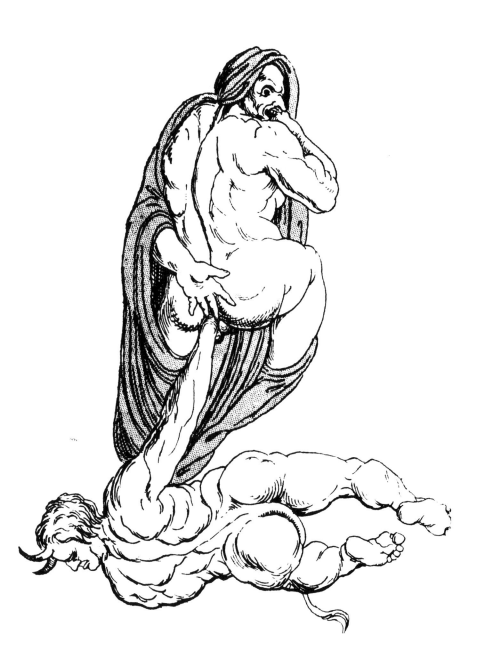

Michelangelo Punishment of Sodomy. Detail of the Last Judgement from the Sistine Chapel, 1536-1541. Copy by Witkowski

The Love of the Gods

Over the course of the centuries, artists great and minor have handed on the torch of revolt in all its forms in the attempt to win for themselves the right to depict the erotic, that touchstone of liberty. They made use of the Bible or mythology, our eternal myths, in their search for 'noble' pretexts that would allow them to give free rein to their impulses without suffering the indignity of censorship. Thus "the loves of the gods" has provided a Trojan horse for artists' obsessions. Inherited from antiquity via Aretino, they inspired Giulio Romano, Raphael and Titian alike. The inspiration of these artists can be traced in this version by Agostino Carracci.

Die Liebe der Götter

Große und weniger bedeutende Künstler haben einander durch die Jahrhunderte die Fackel der Revolte in allen ihren Erscheinungs-formen weitergereicht, immer in dem Bestreben, die Erotik als Faustpfand für die Freiheit zu erobern. Dabei schöpften sie aus der Bibel und der Mythologie, die ewig gültigen Mythen lieferten ihnen »edle« Vorwände, um ihren Regungen freien Lauf zu lassen, ohne der Zensur anheimzufallen. Die durch Aretino aus der Antike überliefer-ten »Liebesgeschichten der Götter«, wahrhaftige Trojanische Pferde für künstlerische Obsessionen, inspirierten Jules Romain zum Beispiel ebenso wie Raphael und Tizian. Dies verbindet sie alle , denn deren Skizzen dienten wiederum einem Agostino Carracci als Inspirations-quelle.

Les Amours des Dieux

De siècle en siècle les artistes, grands ou petits, se sont ainsi transmis le flambeau de la révolte sous toutes ses formes, afin de réaliser la conquête de l'érotisme, gage de liberté, puisant dans la Bible ou la mythologie, dans les mythes éternels les prétextes «nobles» leur permettant de donner libre cours à leurs pulsions sans tomber sous les coups de la censure. Ainsi, «Les Amours des Dieux» – véritable cheval de Troie pour obsessions d'artistes – hérités de l'Antiquité via L'Arétin, ont-ils, par exemple, inspiré et associé dans un même travail aussi bien Jules Romain que Raphaël et Titien dont les diverses esquisses ont servi de base à la version d'Auguste Carrache.

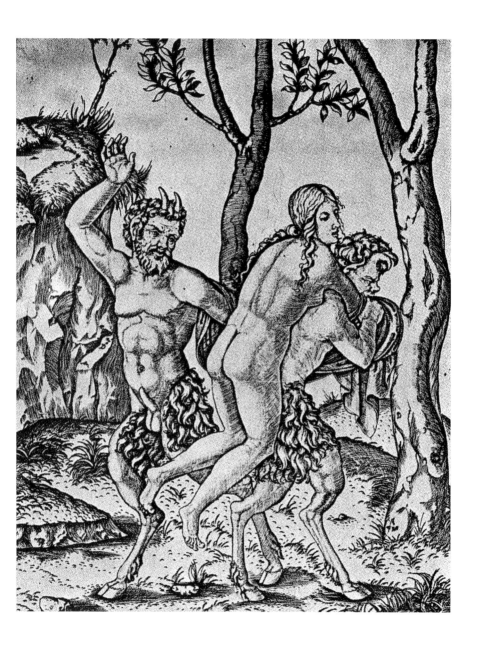

Marc-Antoine Raimondi Nymphs and Satyrs. After Raphael, c. 1514

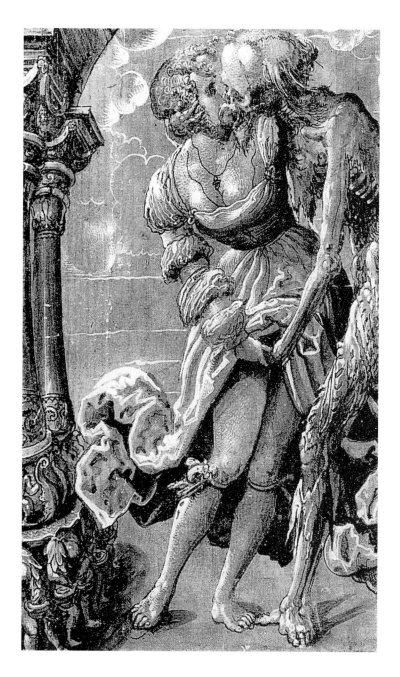

Niklaus Manuel Deutsch Enterprising Death, 1517

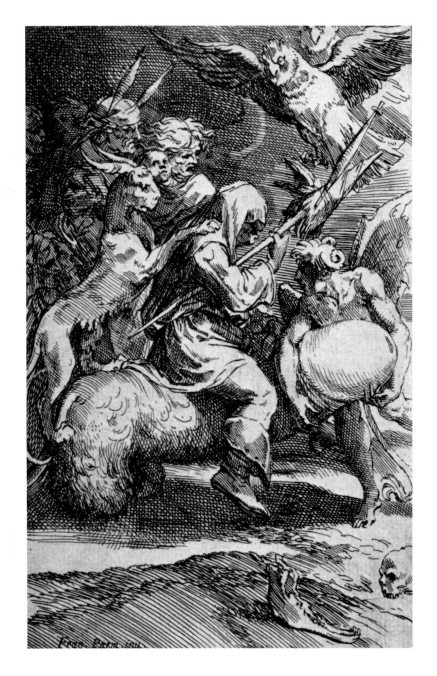

Francesco Parmigianino Witches' Sabbath, 1530

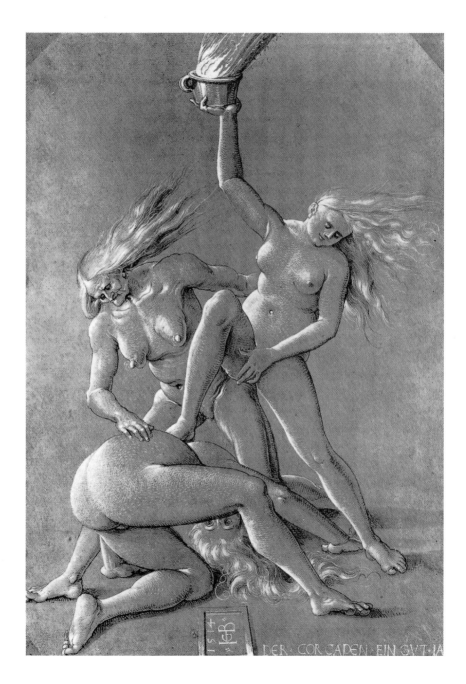

Hans Baldung Grien The Three Witches, 1514

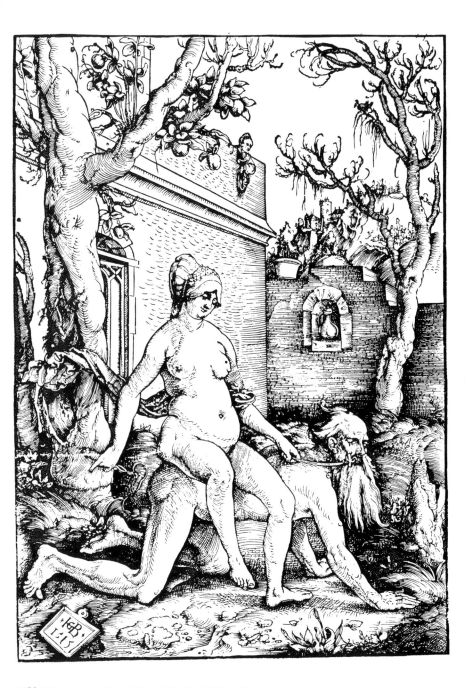

Hans Baldung Grien Phyllis Riding Aristotle, 1513

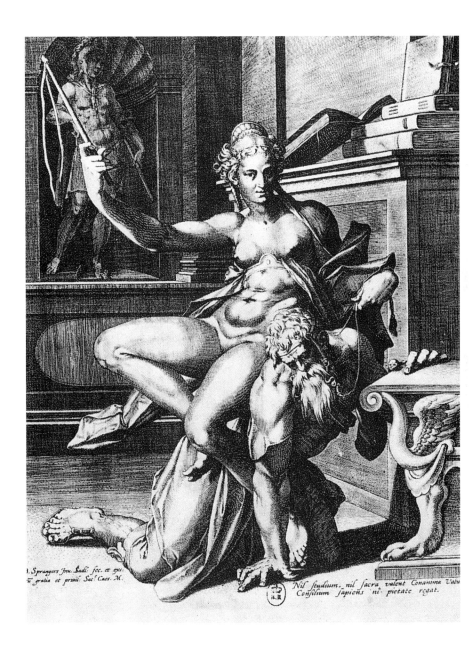

Bartholomaeus Spranger (1546-1611) The Woman and the Philosopher (The Lay of Aristotle)

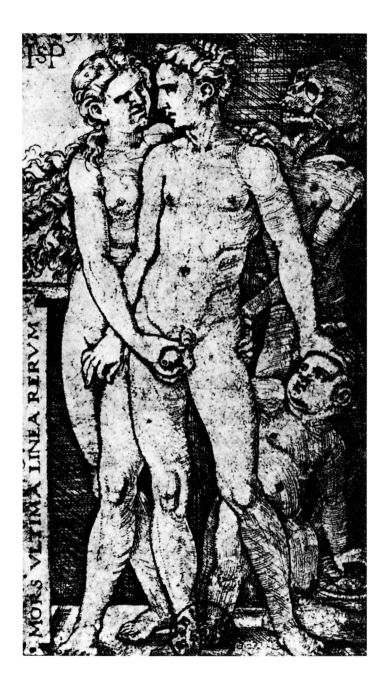

Hans Sebald Beham The Helping Hand, c. 1530

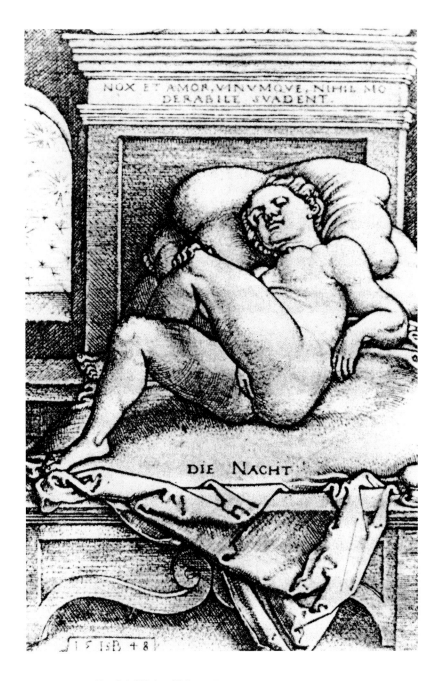

Hans Sebald Beham Night, 1548

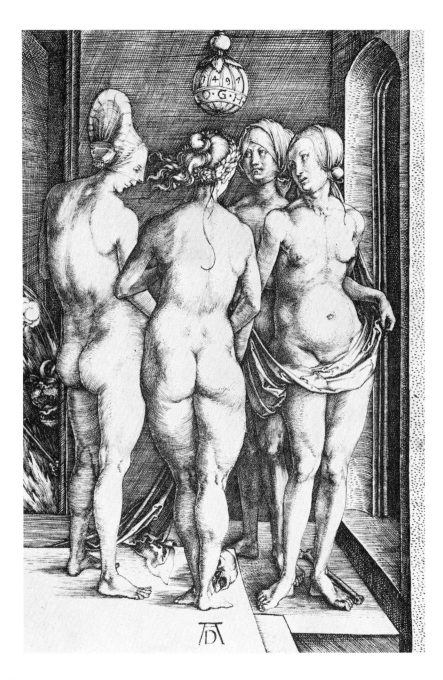

Albrecht Dürer The Four Witches, 1497

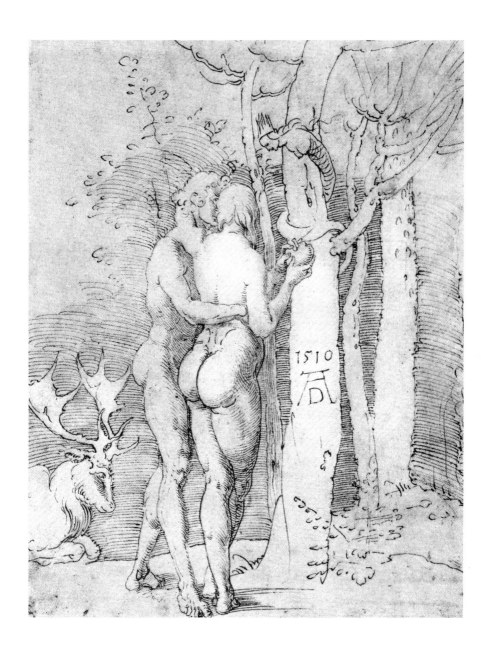

Albrecht Dürer Callipygous Eve and Adoring Adam, 1510

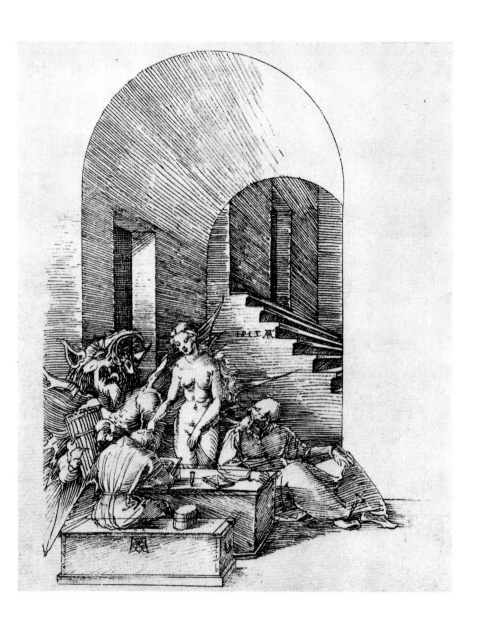

Albrecht Dürer The Temptation of Saint Anthony, 1515

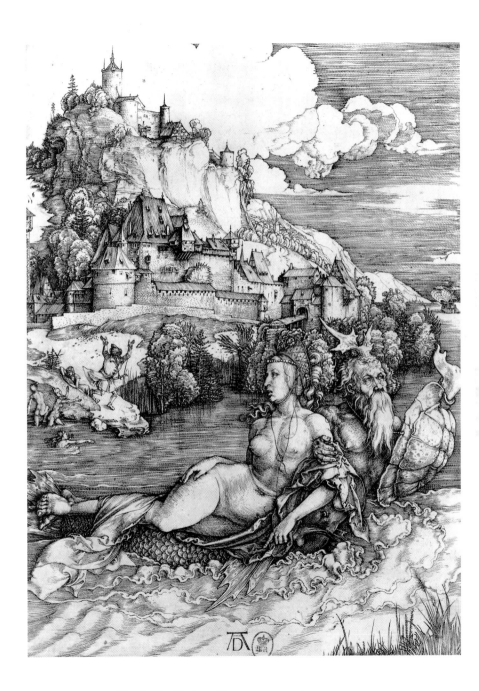

Albrecht Dürer The Rape of Amymone, 1497-1498

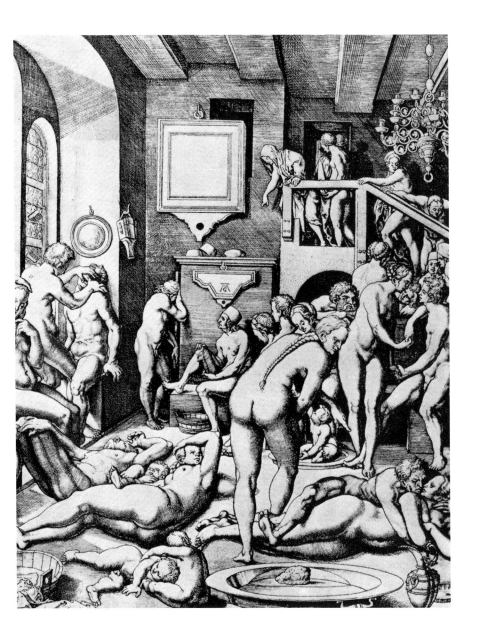

Heinrich Aldegrever The Anabaptists' Bath. Engraved by Virgil Solis, c. 1540

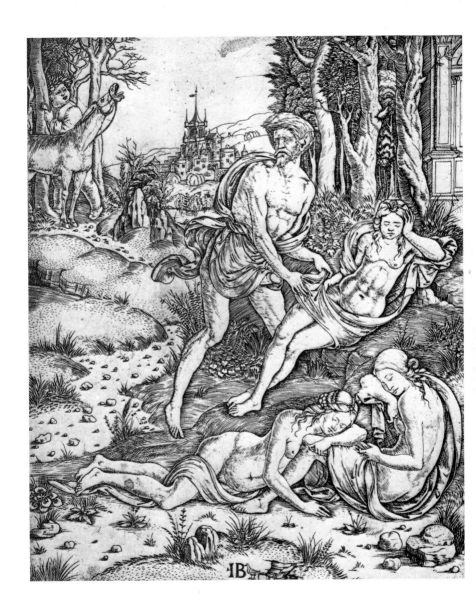

Giovanni Batista del Porto Priapus and Loth, c. 1520

Bernard Picart The Perfumer, 16th C

Les deux Fontaines

Bernard Picart The Two Fountains, 16th C

Anonymous The Piss-pot, 17th C

Anonymous The Piss-pot, 16th C

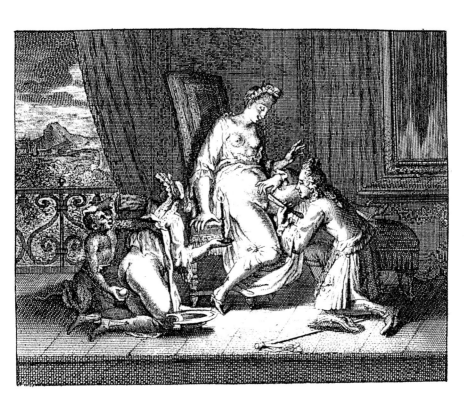

Anonymous The Barber, 16th C

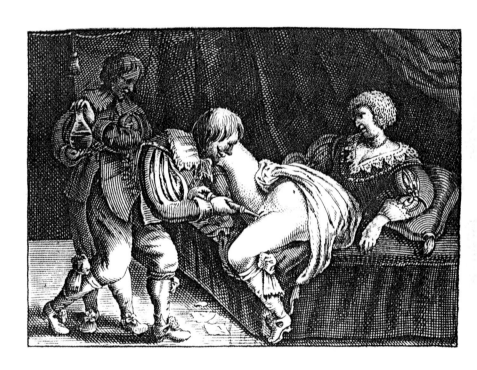

Anonymous The Syringe, 16th C

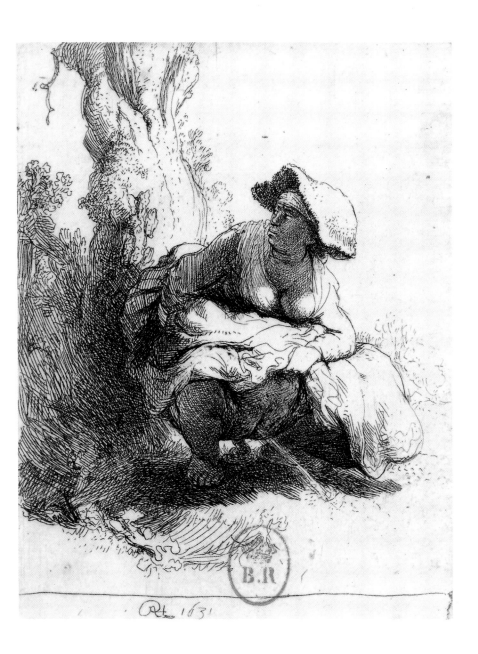

Rembrandt Woman Pissing (thought to be the artist's wife), 1631

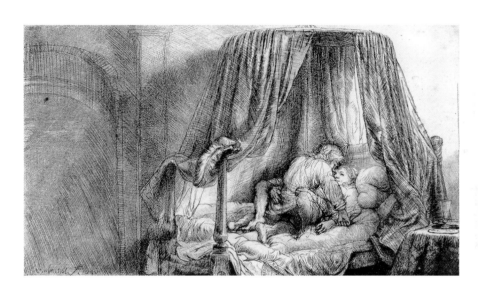

Rembrandt The French-style bed or Happy position (thought to be the artist and his wife), c. 1640

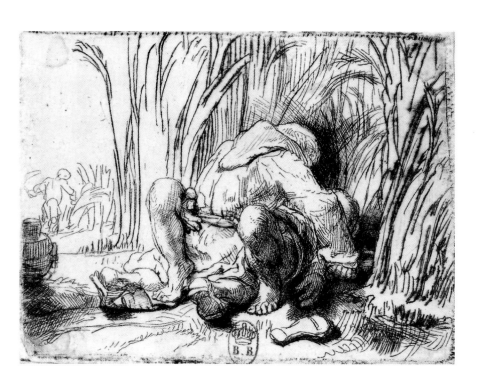

Rembrandt The Monk in the Wheat, 1645

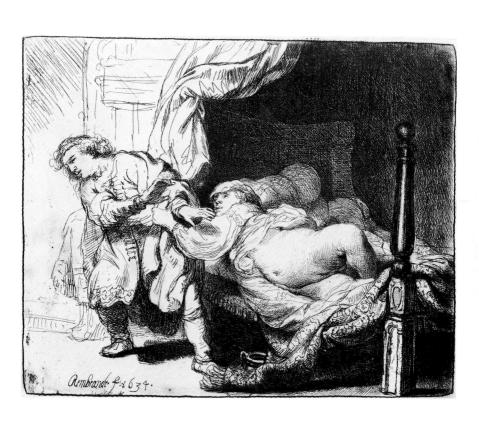

Rembrandt Joseph and Potiphar's Wife, 1634

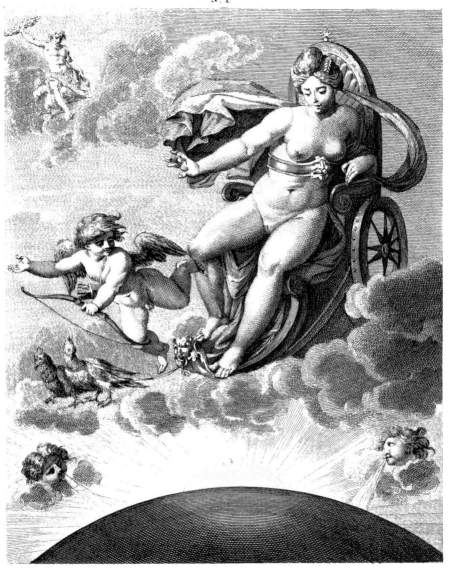

VENUS GÉNITRICE.

Agostino Carracci Aretino or The Loves of the Gods. Sequence after preparatory drawings by Giulio Romano and Raphael's sketches. Engraved by Marc-Antoine Raimondi, c. 1602

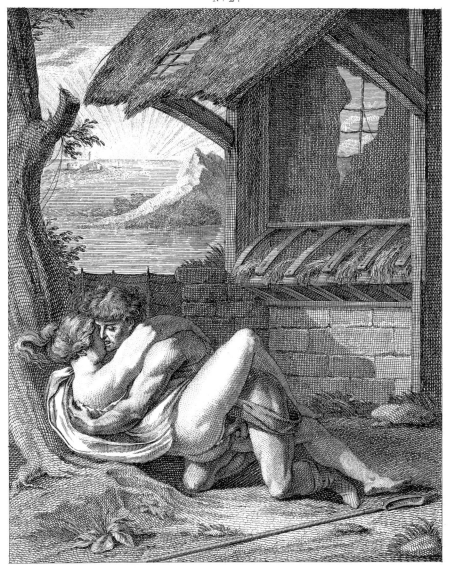

PARIS ET ŒNONE.

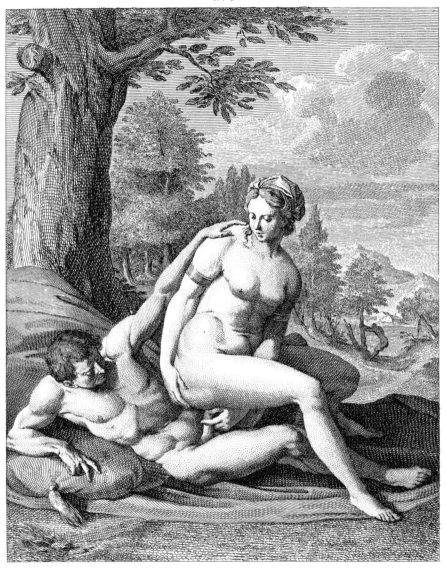

ANGELIQUE ET MEDOR.

Agostino Carracci Aretino or The Loves of the Gods, c. 1602

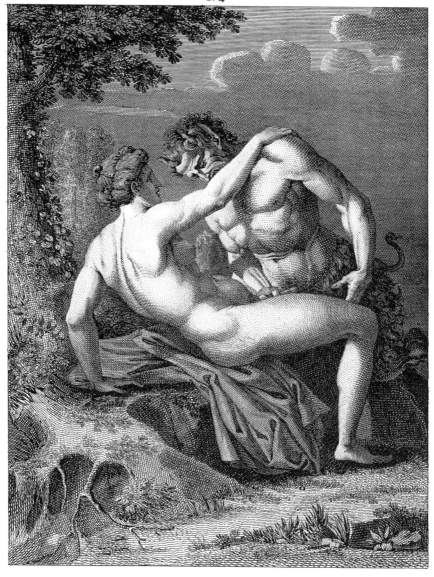

LE SATYRE ET LA NIMPHE.

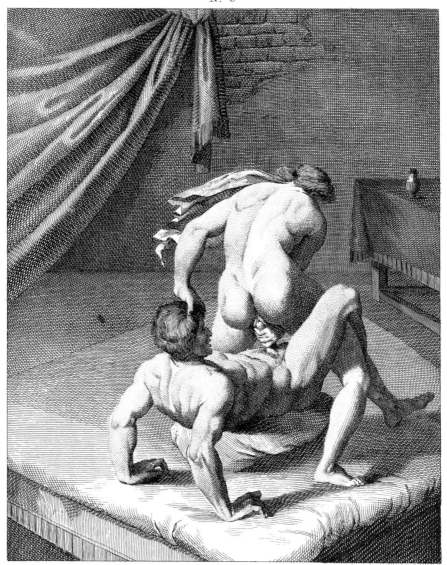

JULIE AVEC UN ATHLETE

Agostino Carracci Aretino or The Loves of the Gods, c. 1602

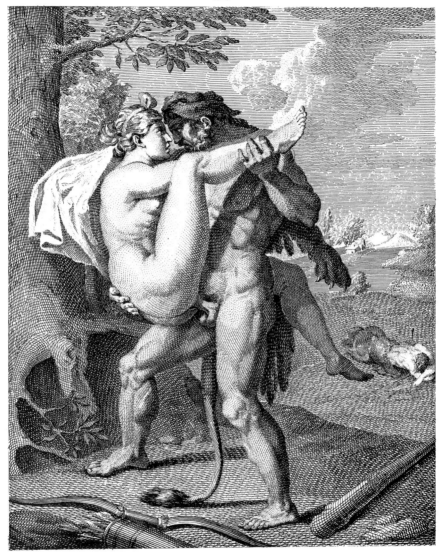

HERCULE ET DEJANIRE

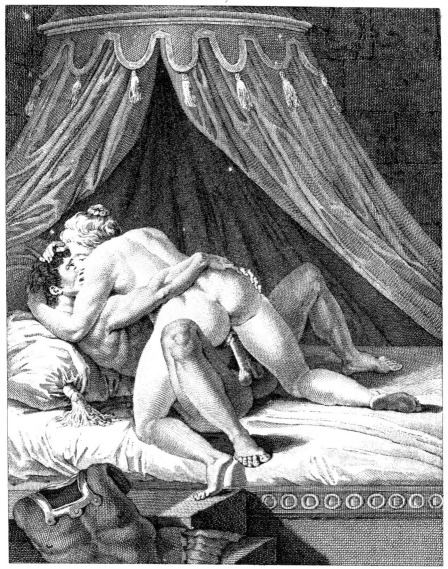

MARS ET VENUS

Agostino Carracci Aretino or The Loves of the Gods, c. 1602

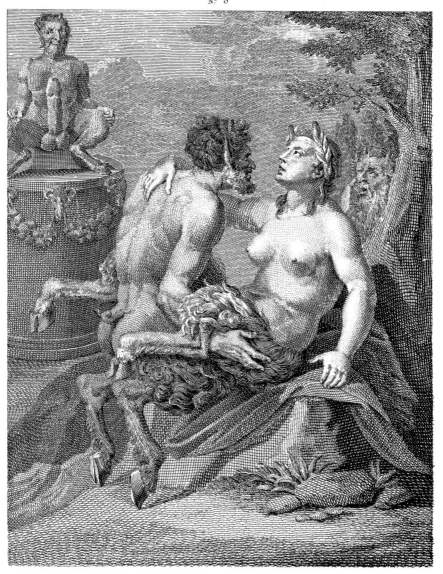

CULTE DE PRIAPE.

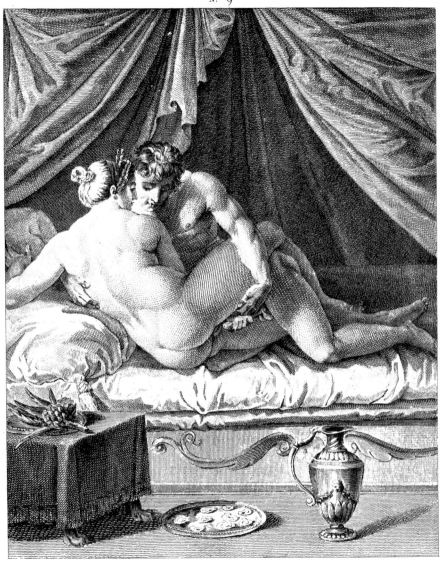

ANTOINE ET CLEOPATRE

Agostino Carracci Aretino or The Loves of the Gods, c. 1602

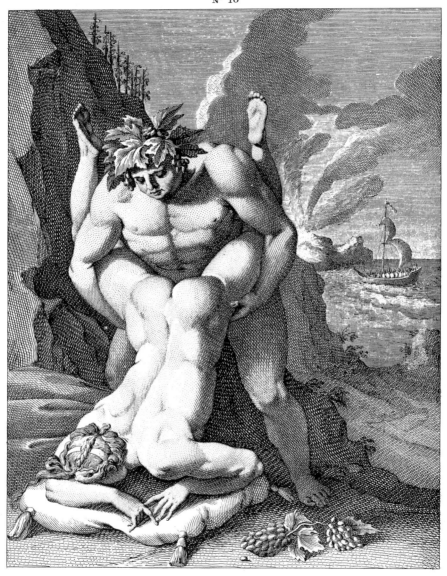

BACHUS ET ARIANE

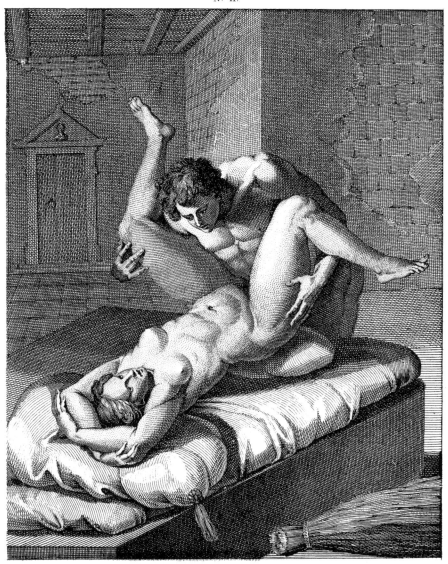

POLYENOS ET CHRISIS

Agostino Carracci Aretino or The Loves of the Gods, c. 1602

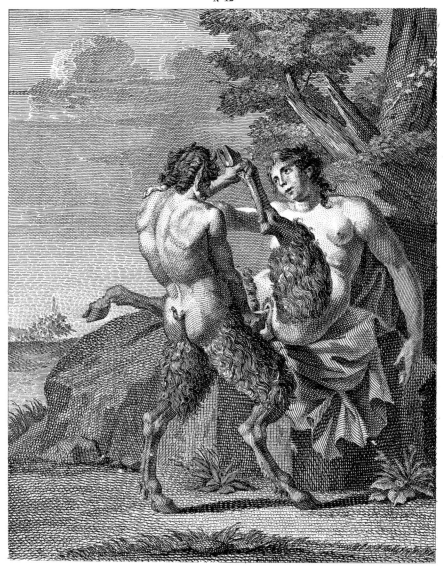

LE SATIRE ET SA FEMME

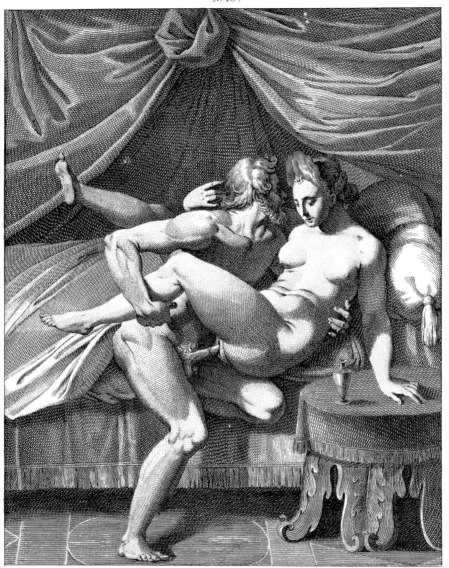

JUPITER ET JUNON

Agostino Carracci Aretino or The Loves of the Gods, c. 1602

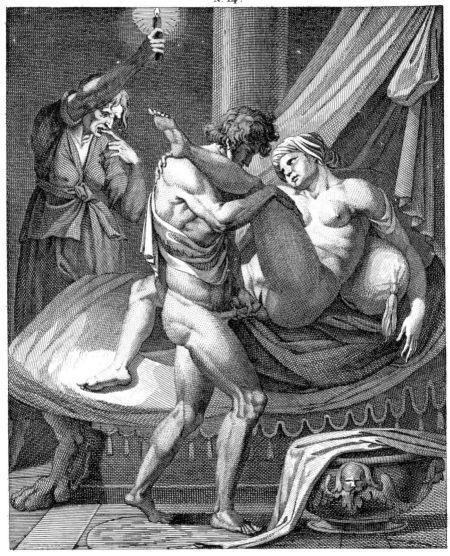

MESSALINE DANS LA LOGE DE LISISCA

ACHILLE ET BRISEIS

Agostino Carracci Aretino or The Loves of the Gods, c. 1602

OVIDE ET CORINE.

ENÉE ET DIDON

Agostino Carracci Aretino or The Loves of the Gods, c. 1602

ALCIBIADE ET GLYCERE

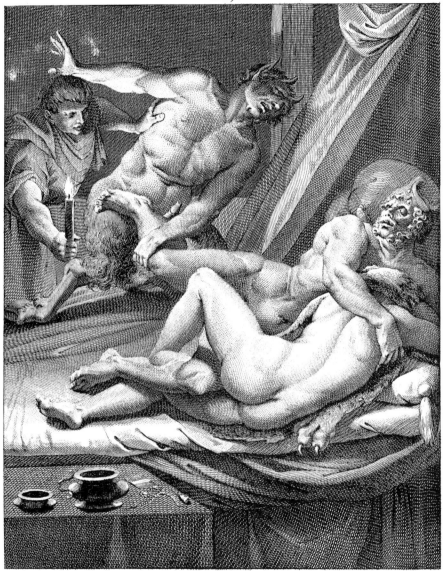

PANDORE

Agostino Carracci Aretino or The Loves of the Gods, c. 1602

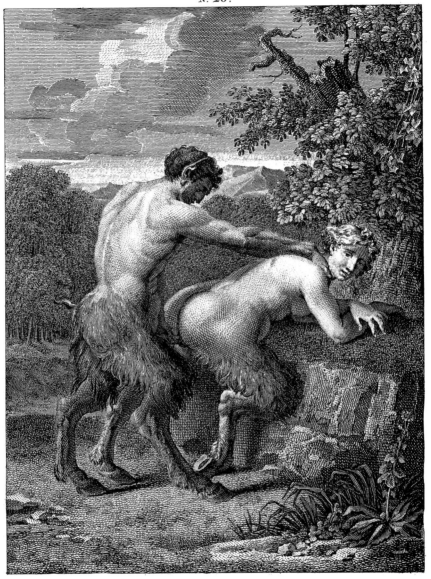

LE SATYRE SAILLISSANT.

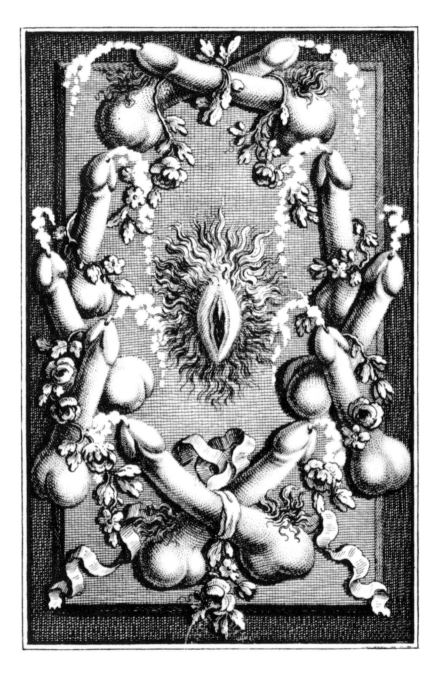

Borel, engraved by **Elluin**: The French Aretino. In the style of Agostino Carracci.
Published in London, 1787

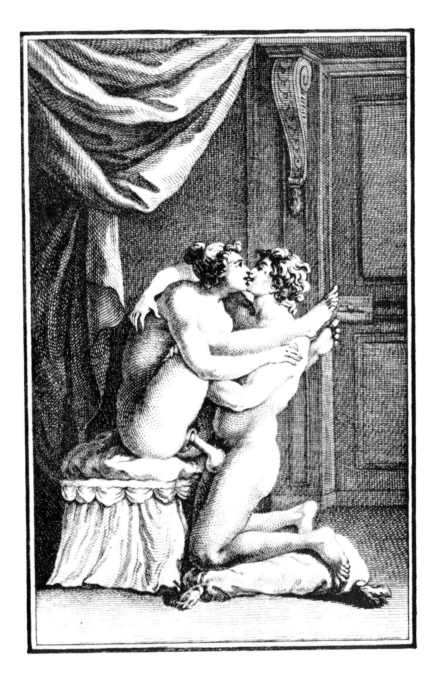

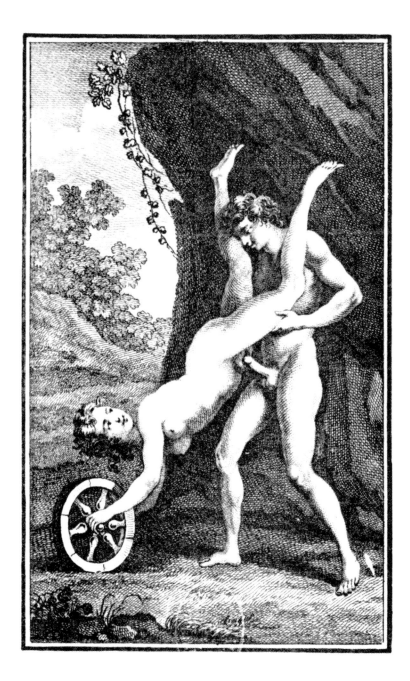

Borel, engraved by **Elluin**: The French Aretino, 1787

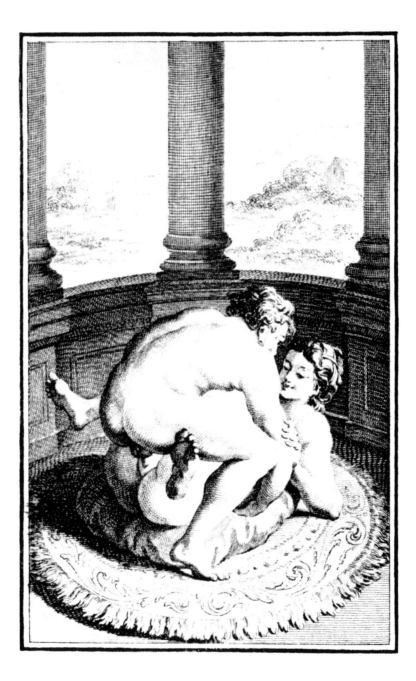

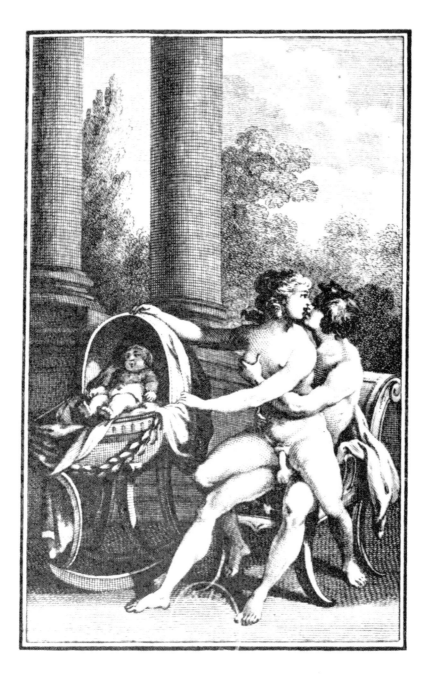

Borel, engraved by **Elluin**: The French Aretino, 1787

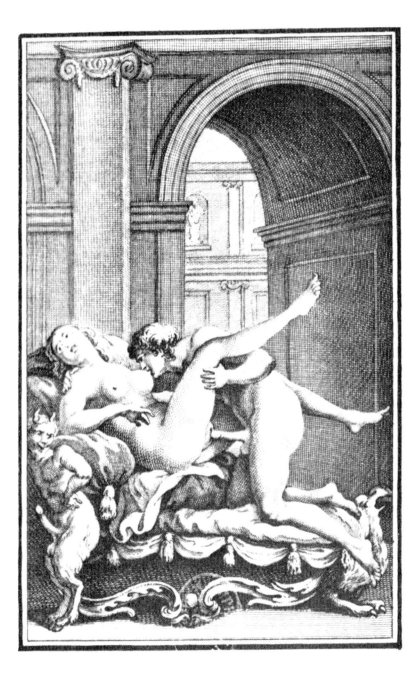

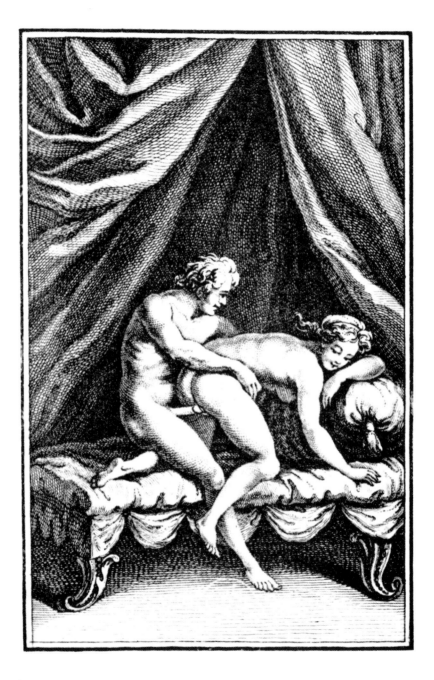

Borel, engraved by **Elluin**: The French Aretino, 1787

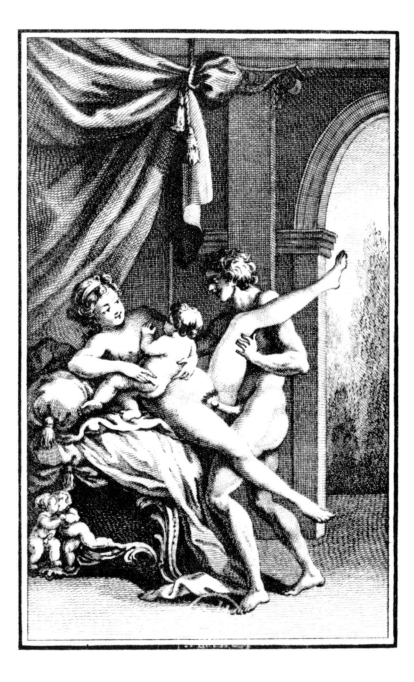

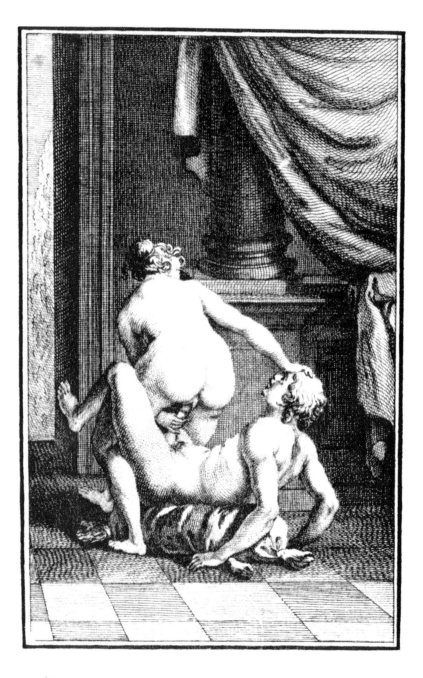

Borel, engraved by **Elluin**: The French Aretino, 1787

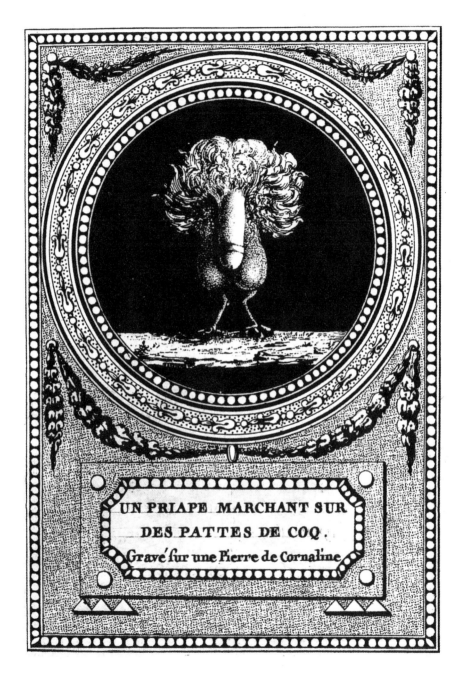

UN PRIAPE MARCHANT SUR

DES PATTES DE COQ.

Gravé sur une Pierre de Cornaline

F. Hugues, also known as **d'Hancarville**: Monuments of the Secret Cult of Roman Ladies.
Rome, the Vatican Press (!), 1787. The classical cameos said to have inspired these pro-

UN DIEU PRIAPE A CÔTÉ
D'UNE COLONNE
Gravé fur une Sardoine.

ductions did not, of course, exist, except in the imagination of this amiable prankster

UN BERGER CARESSANT
UNE CHEVRE
Gravé en Cornaline

F. Hugues, also known as **d'Hancarville**: Monuments of the Secret Cult of Roman Ladies. Rome, 1787

SACRIFICE AU DIEU PRIAPE
Gravé ſur un Onyx.

F. Hugues, also known as **d'Hancarville**: Monuments of the Secret Cult of Roman Ladies.
Rome, 1787

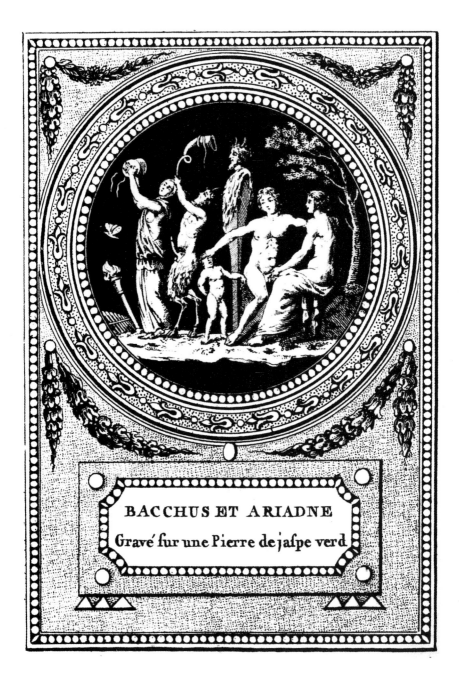

BACCHUS ET ARIADNE

Gravé fur une Pierre de jafpe verd

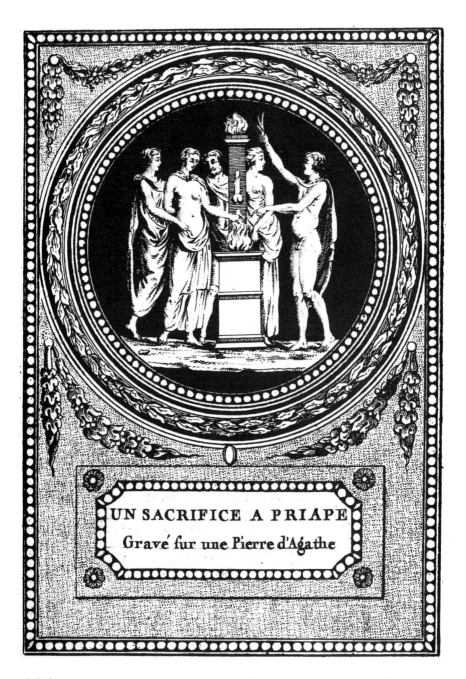

UN SACRIFICE A PRIAPE

Gravé sur une Pierre d'Agathe

F. Hugues, also known as **d'Hancarville**: Monuments of the Secret Cult of Roman Ladies. Rome, 1787

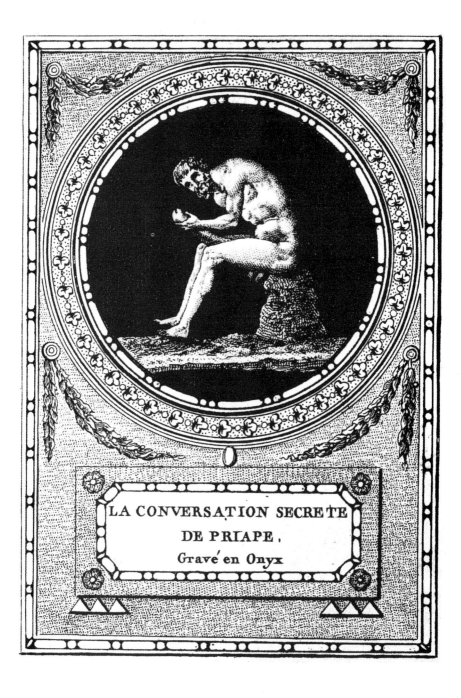

LA CONVERSATION SECRETE

DE PRIAPE,

Gravé en Onyx

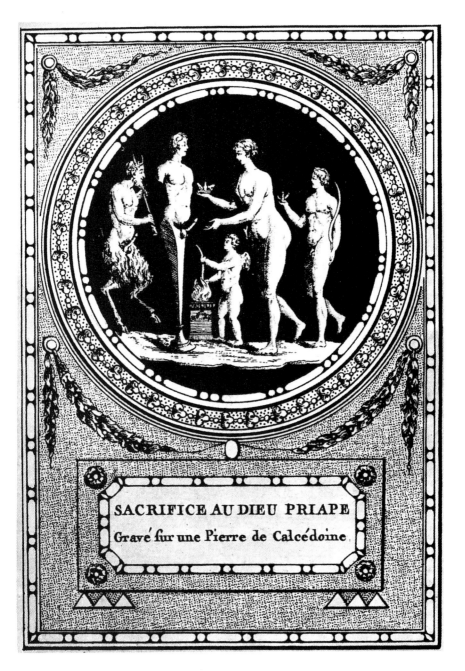

SACRIFICE AU DIEU PRIAPE

Gravé sur une Pierre de Calcédoine

F. Hugues, also known as **d'Hancarville**: Monuments of the Secret Cult of Roman Ladies. Rome, 1787

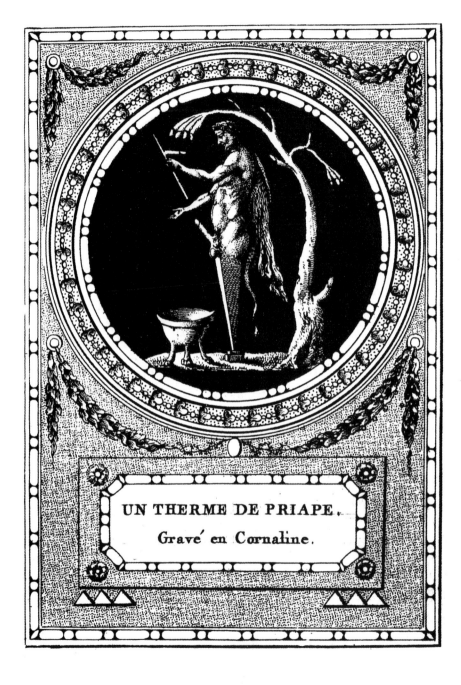

UN THERME DE PRIAPE.

Gravé en Cornaline.

Anonymous The Academy of Ladies. Published in Venice, at Pierre Arretin's (!), 1680

De Constantinople

Anonymous The Academy of Ladies, 1680

Anonymous The Academy of Ladies, 1680

Anonymous The Academy of Ladies, 1680

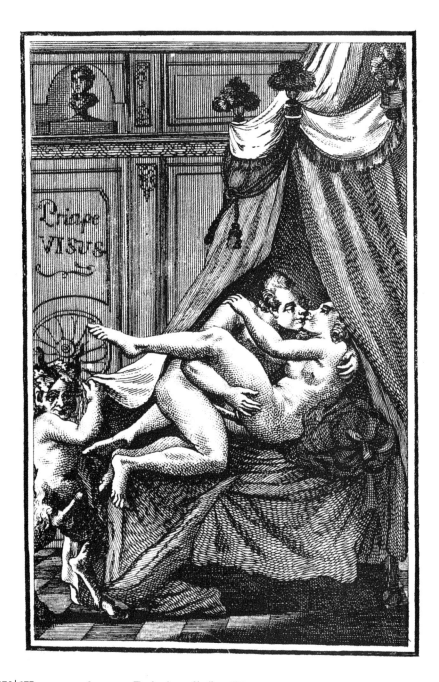

Priape
visus

Anonymous The Academy of Ladies, 1680

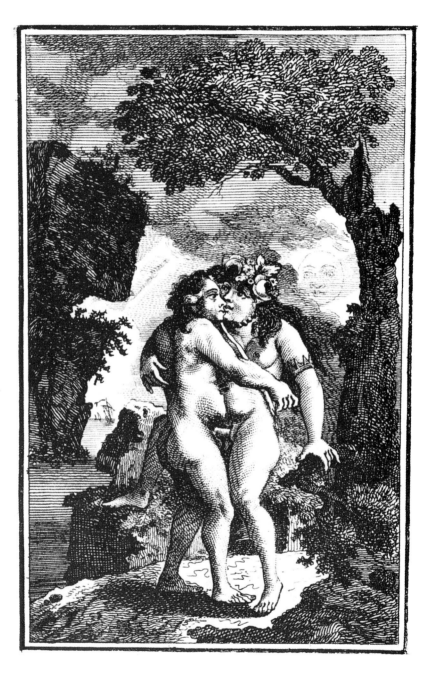

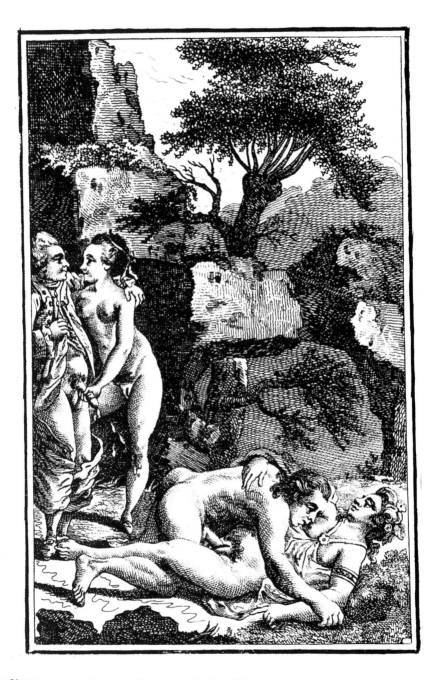

Anonymous The Academy of Ladies, 1680

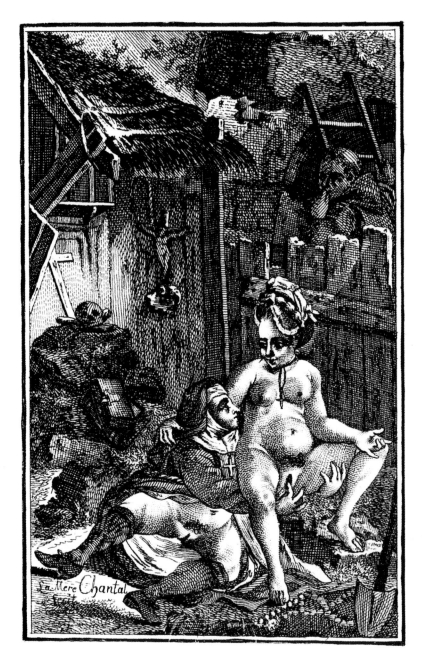

Sa Mere Chantal

Anonymous The Academy of Ladies, 1680

Anonymous The Academy of Ladies, 1680

L'espagnollete fecit

Anonymous The Academy of Ladies, 1680

Anonymous The Academy of Ladies, 1680

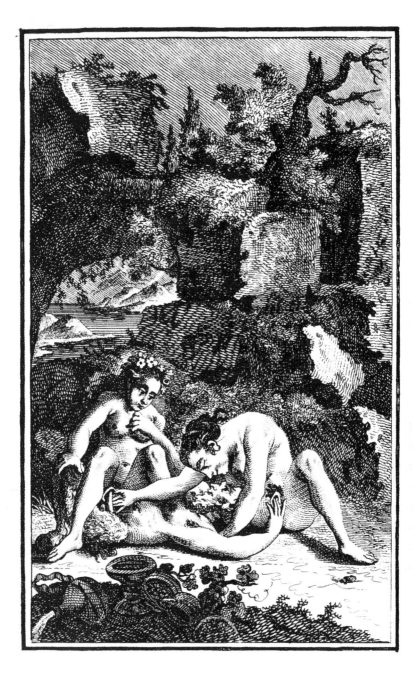

Anonymous The Academy of Ladies, 1680

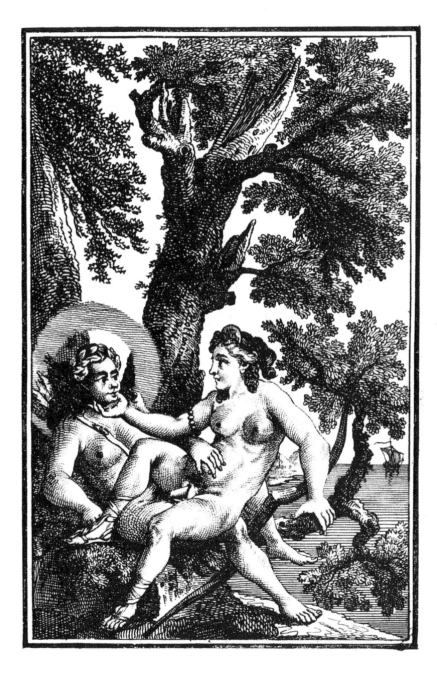

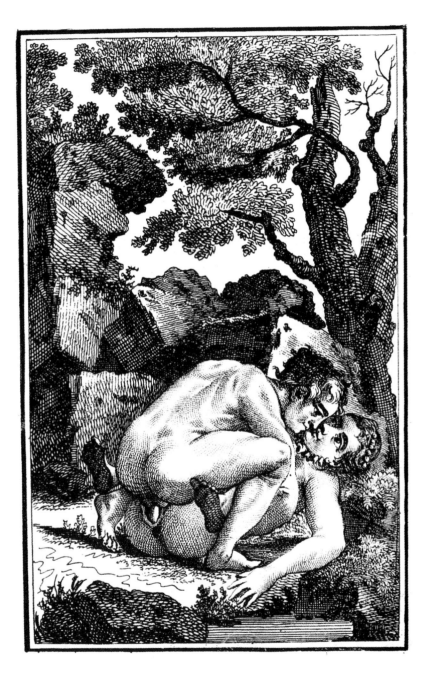

Anonymous The Academy of Ladies, 1680

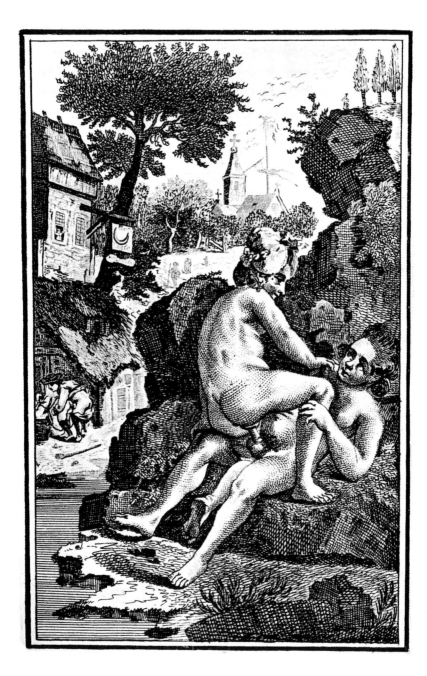

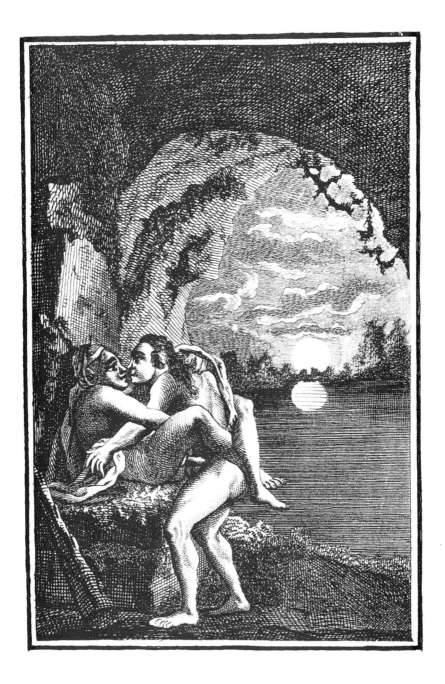

Anonymous The Academy of Ladies, 1680

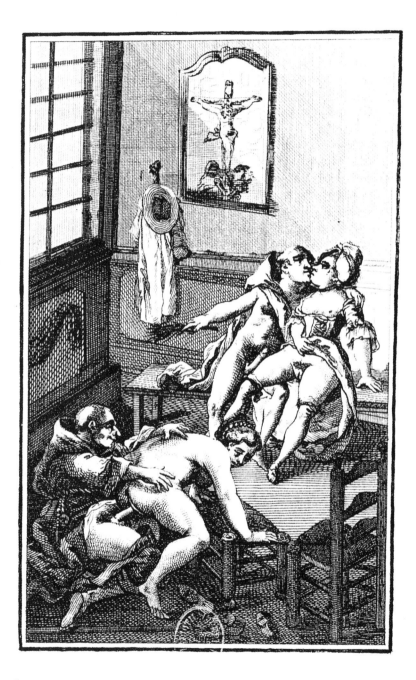

Anonymous The Academy of Ladies, 1680

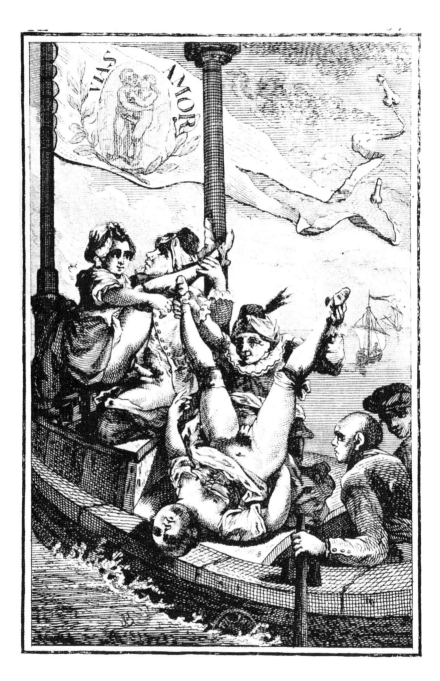

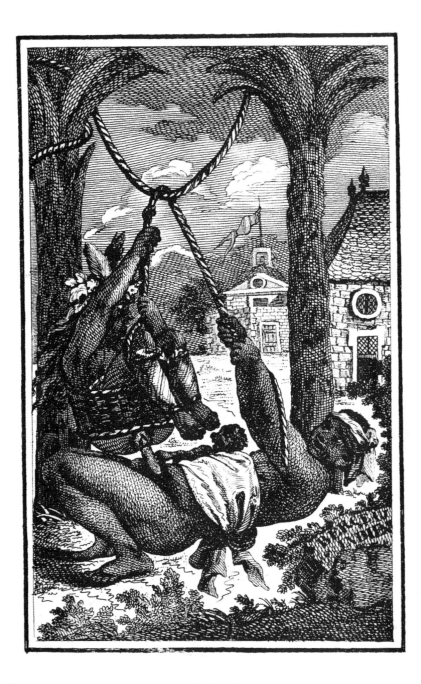

Anonymous The Academy of Ladies, 1680

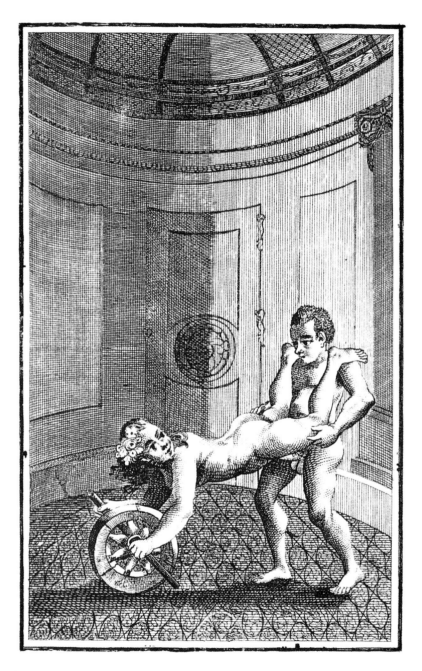

Anonymous The Academy of Ladies, 1680

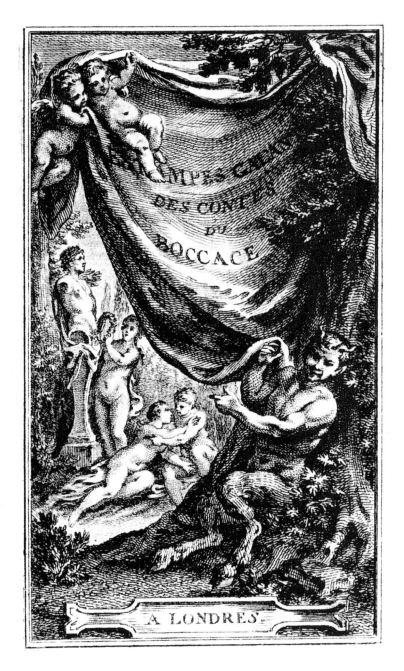

ESTAMPES GALANT

DES CONTES

DU

BOCCACE

A LONDRES.

Anonymous Bawdy prints for Boccaccio's *Decameron*, translated at the request of Queen
Marguerite de Navarre, sister of François I, and published in London in 1757–1761

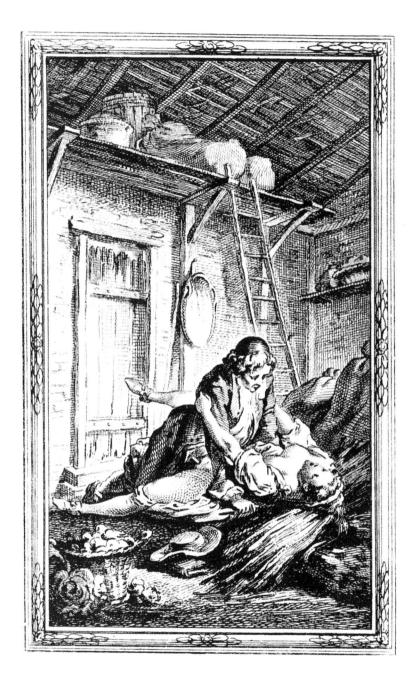

Anonymous Bawdy prints for Boccaccio's *Decameron*, 1757–1761

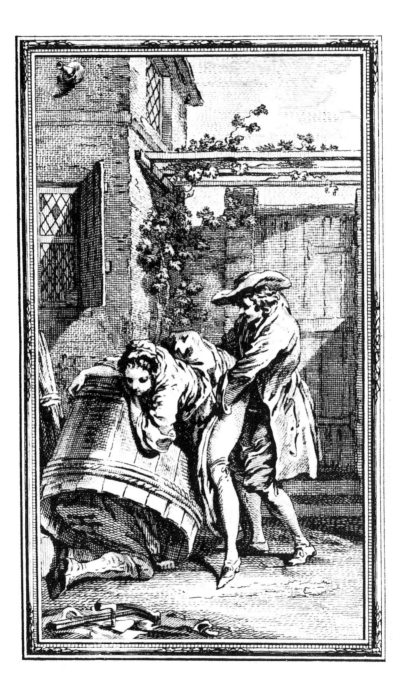

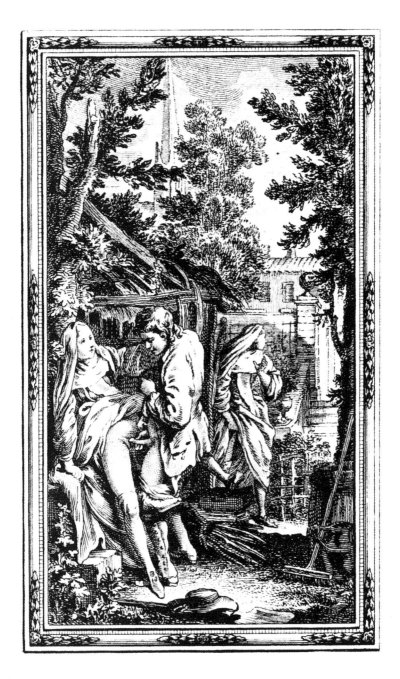

Anonymous Bawdy prints for Boccaccio's *Decameron*, 1757–1761

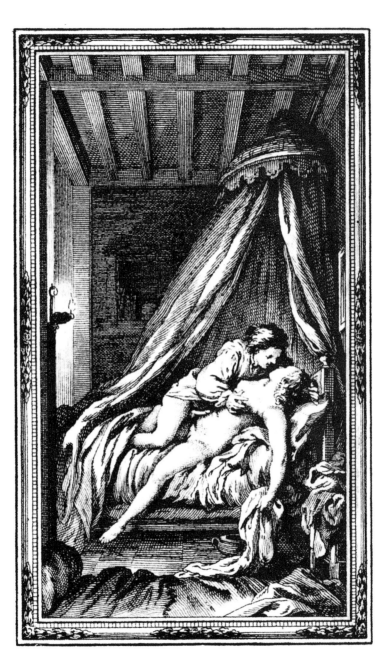

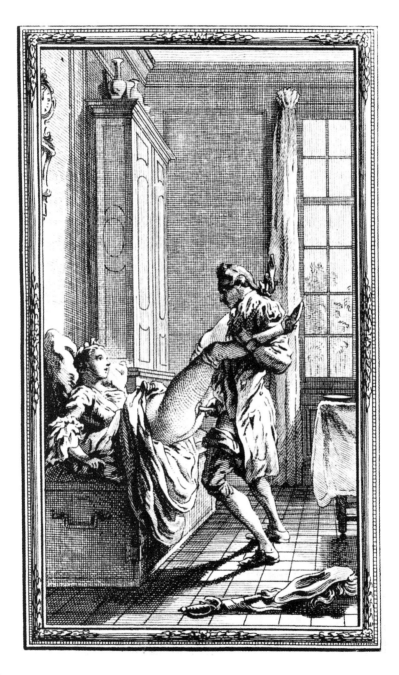

Anonymous Bawdy prints for Boccaccio's *Decameron*, 1757–1761

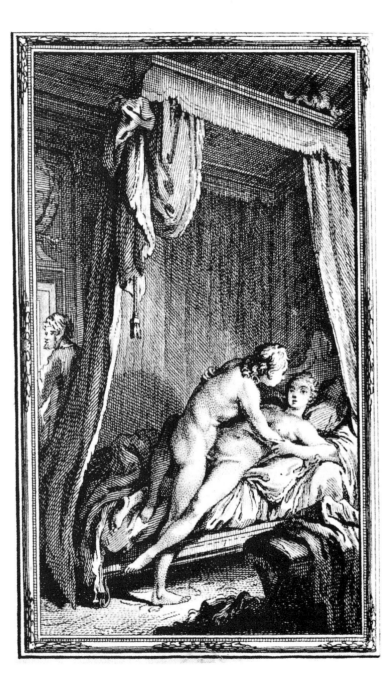

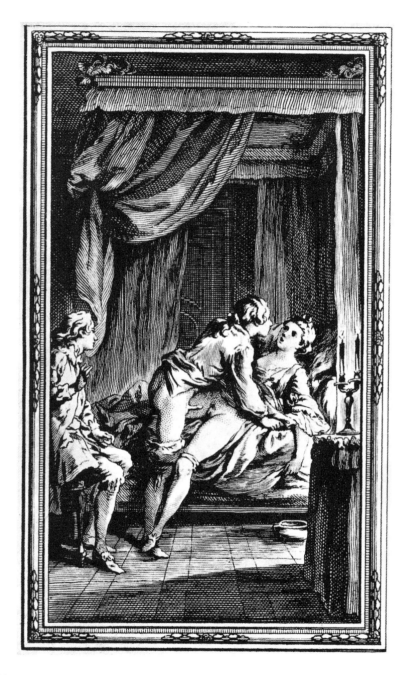

Anonymous Bawdy prints for Boccaccio's *Decameron*, 1757–1761

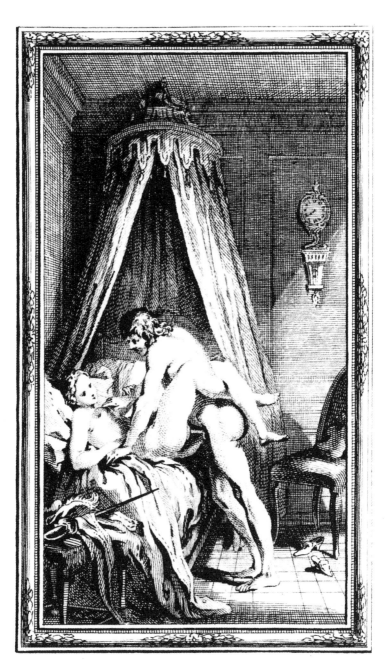

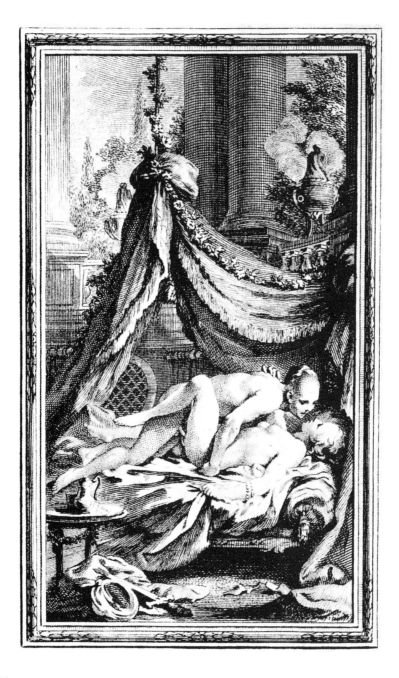

Anonymous Bawdy prints for Boccaccio's *Decameron*, 1757–1761

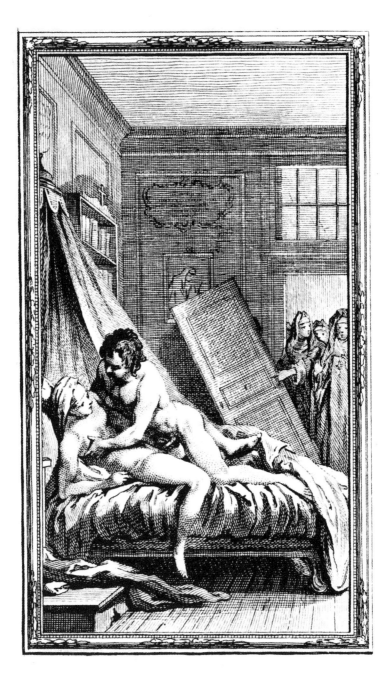

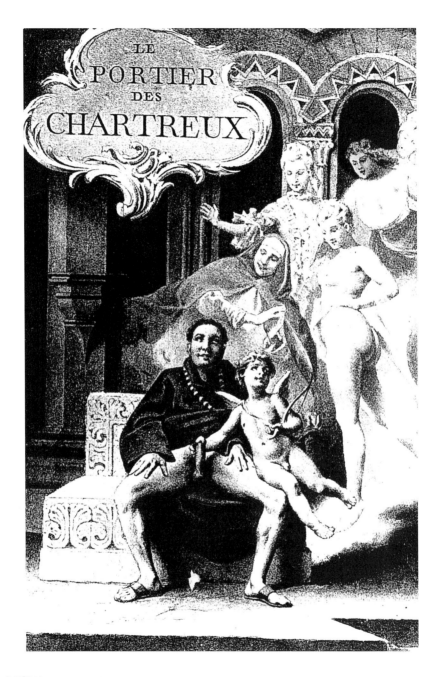

Anonymous Engravings for *Dom Bougre ou Le Portier des Chartreux*, 1741

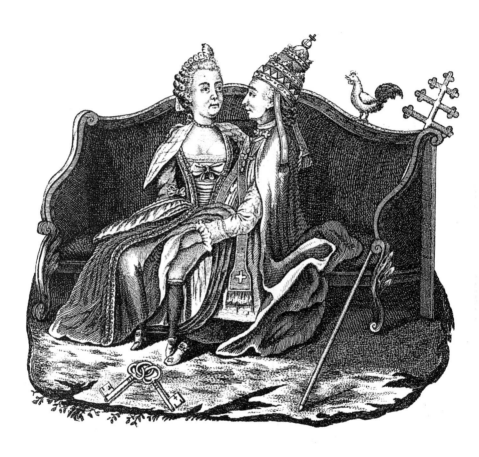

Suspected to be the author of this book, Restif de la Bretonne was imprisoned in the Bastille

Anonymous Engravings for *Dom Bougre ou Le Portier des Chartreux*, 1741

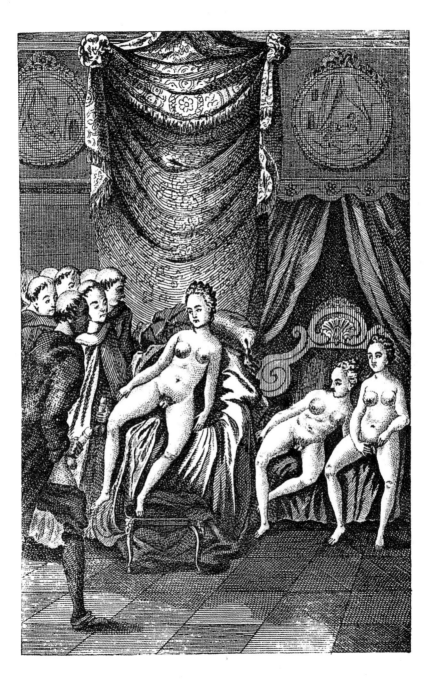

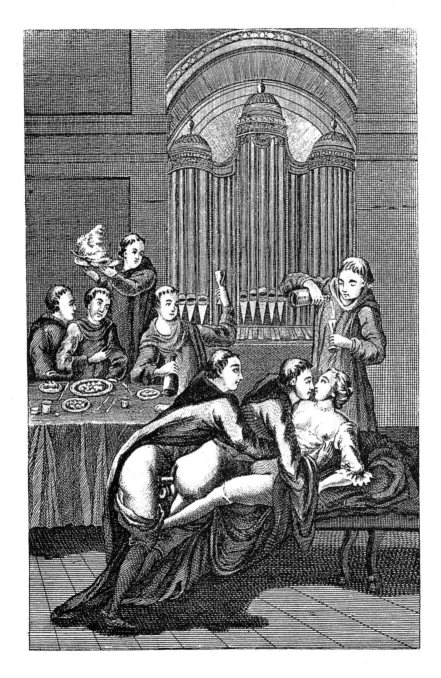

Anonymous Engravings for *Dom Bougre ou Le Portier des Chartreux*, 1741

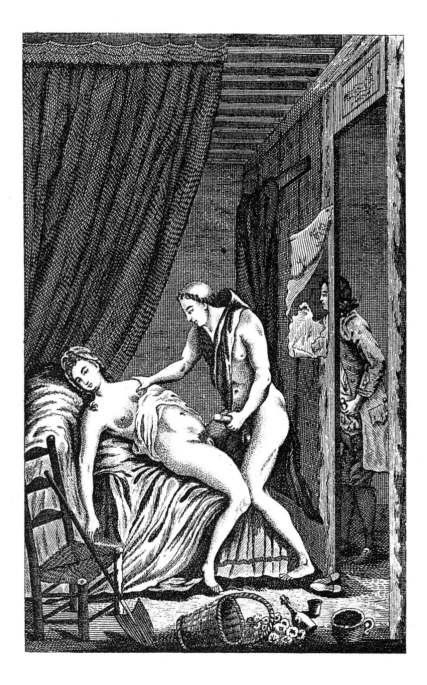

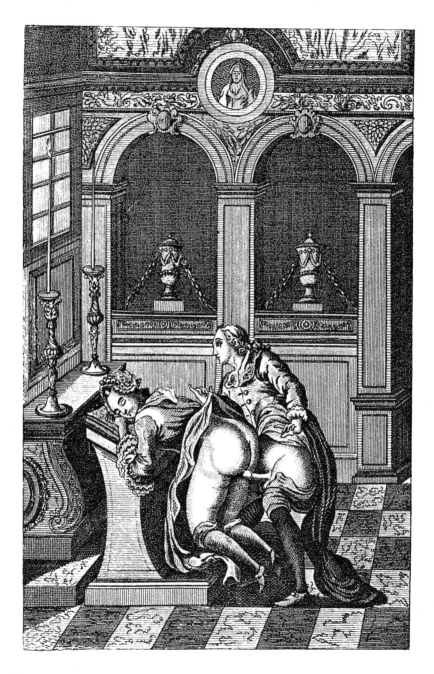

Anonymous Engravings for *Dom Bougre ou Le Portier des Chartreux*, 1741

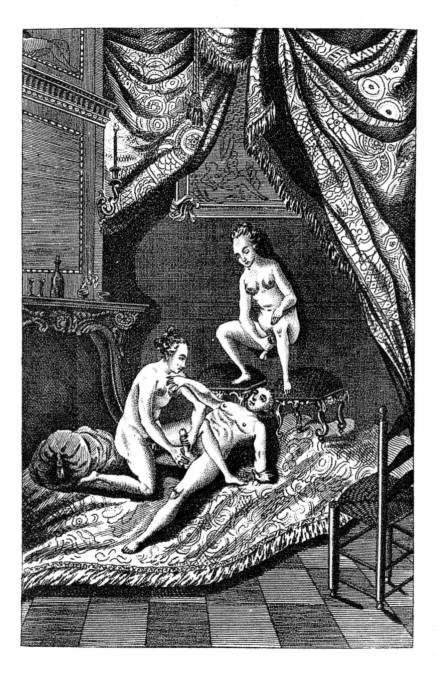

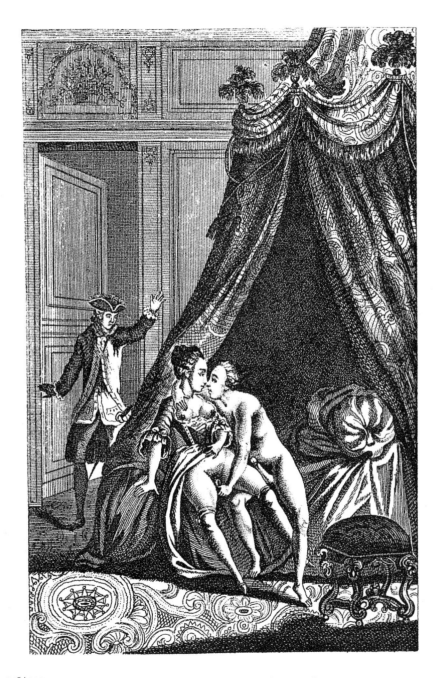

Anonymous Engravings for *Dom Bougre ou Le Portier des Chartreux*, 1741

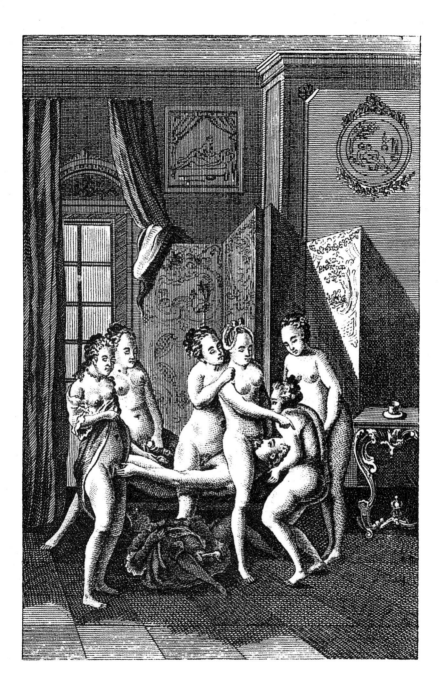

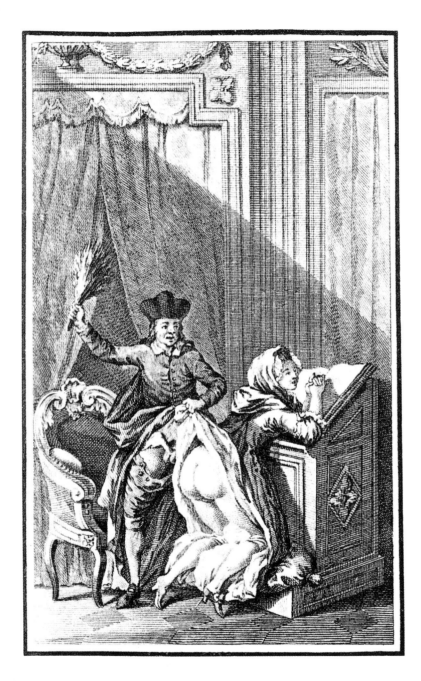

Drawings by **Borel** and engravings by **Elluin** for *Thérèse Philosophe* attributed to Diderot, 1785

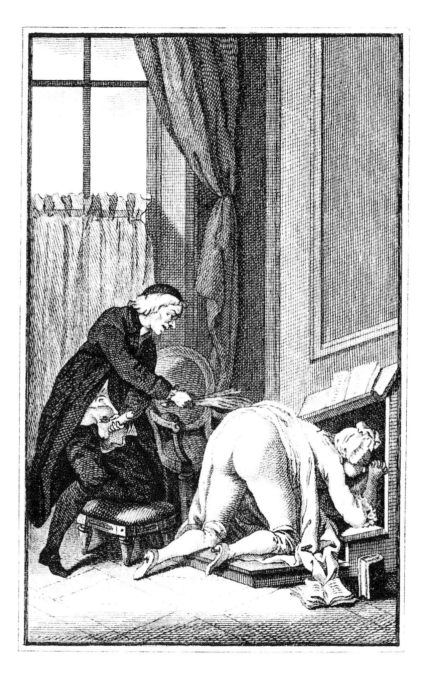

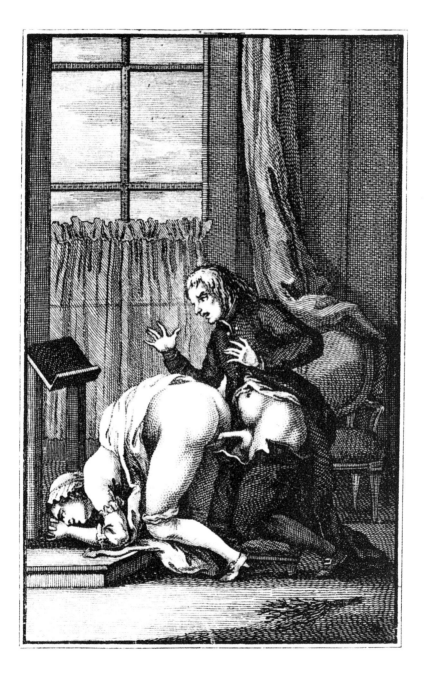

Drawings by **Borel** and engravings by **Elluin** for *Thérèse Philosophe* attributed to Diderot, 1785

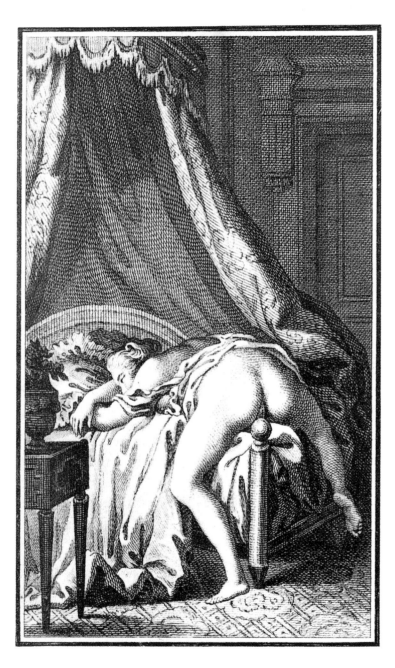

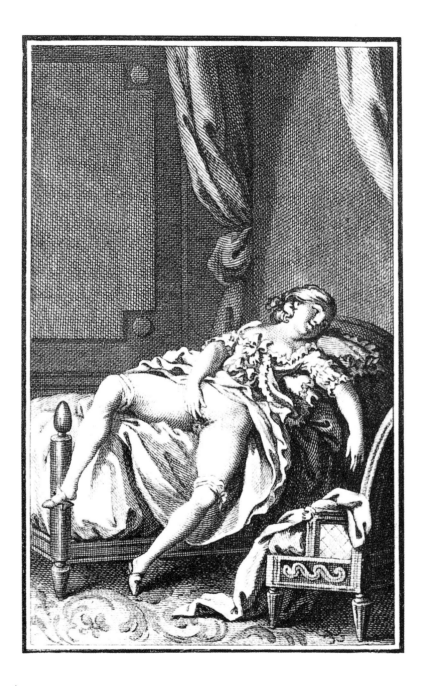

Drawings by **Borel** and engravings by **Elluin** for *Thérèse Philosophe* attributed to Diderot, 1785

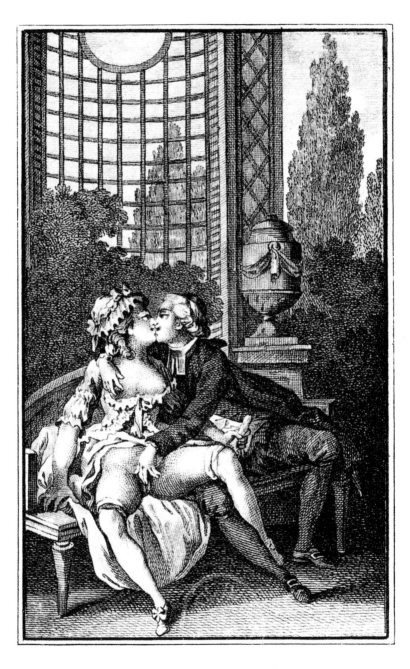

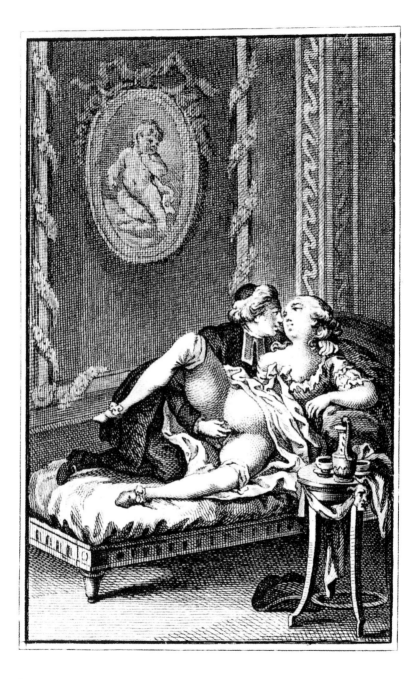

Drawings by **Borel** and engravings by **Elluin** for *Thérèse Philosophe* attributed to Diderot, 1785

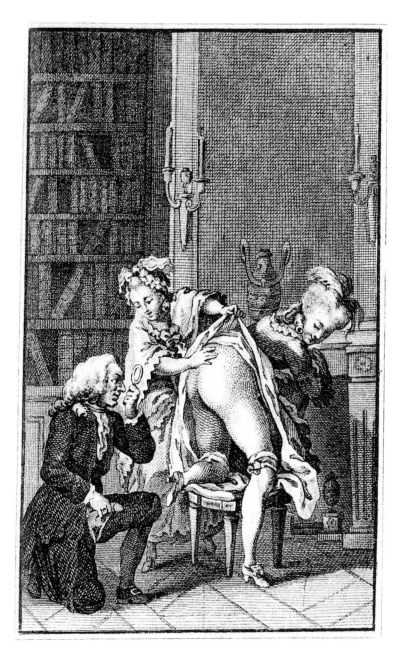

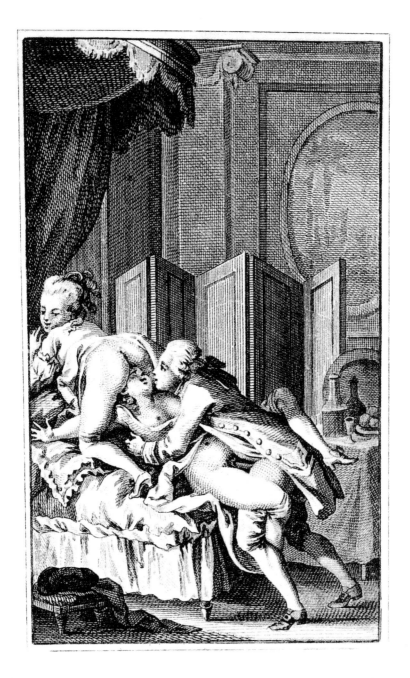

Drawings by **Borel** and engravings by **Elluin** for *Thérèse Philosophe* attributed to Diderot, 1785

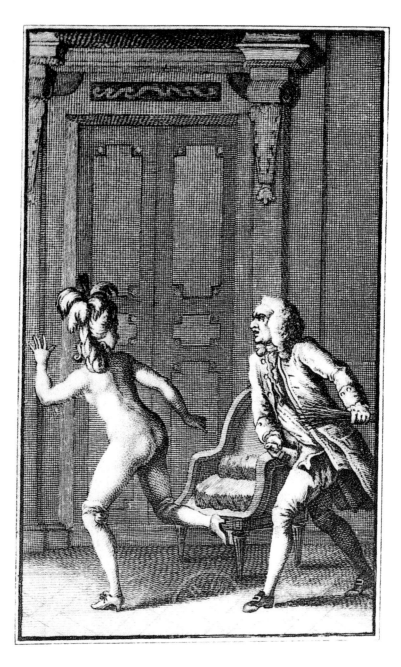

Drawings by **Borel** and engravings by **Elluin** for *Thérèse Philosophe* attributed to Diderot, 1785

Borel and **Elluin** Engravings for *Les Mémoires de Saturnin ou Le Portier des Chartreux,* 1787

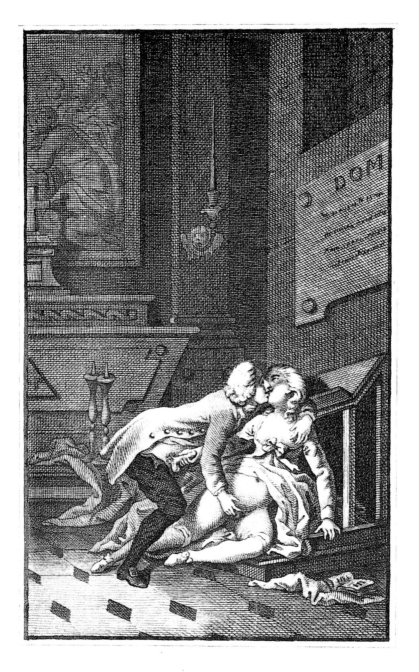

Borel and **Elluin** Engravings for *Les Mémoires de Saturnin ou Le Portier des Chartreux,* 1787

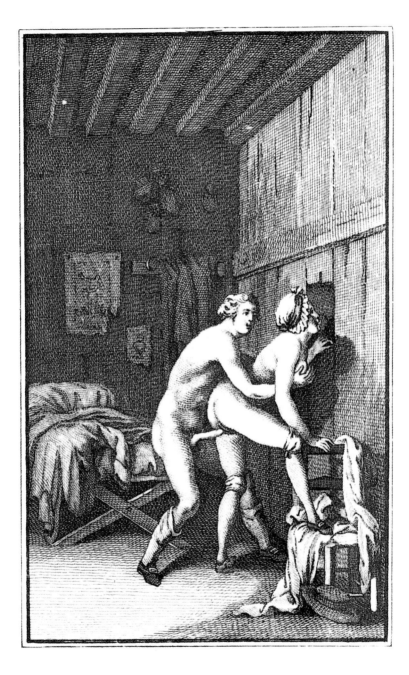

Borel and **Elluin** Engravings for *Les Mémoires de Saturnin ou Le Portier des Chartreux,* 1787

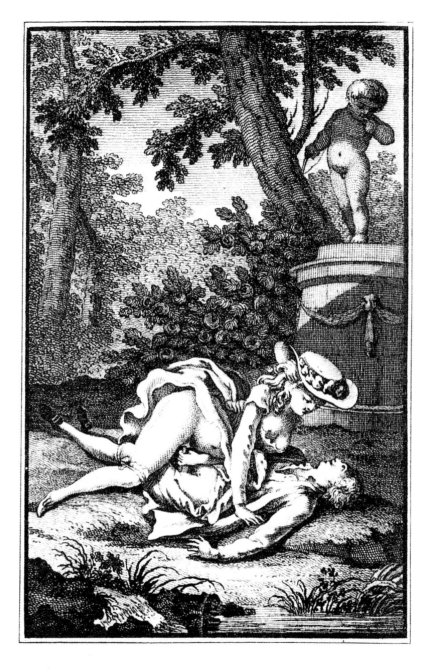

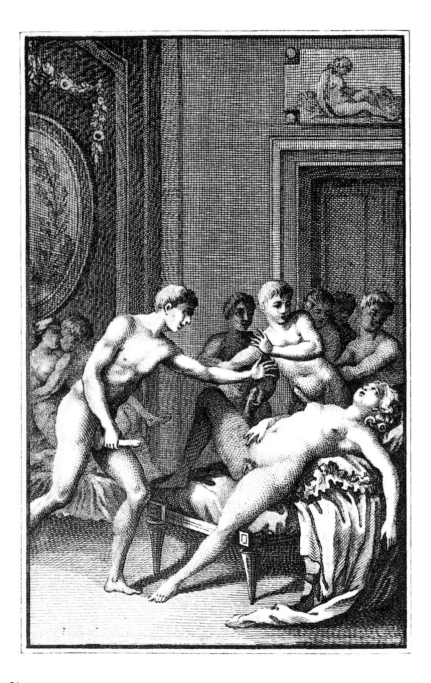

Borel and **Elluin** Engravings for *Les Mémoires de Saturnin ou Le Portier des Chartreux,* 1787

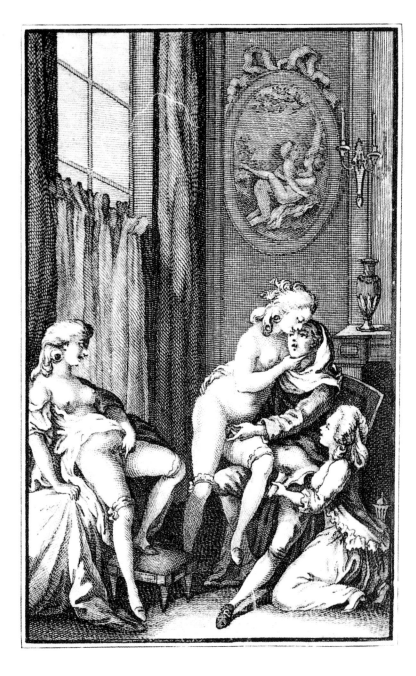

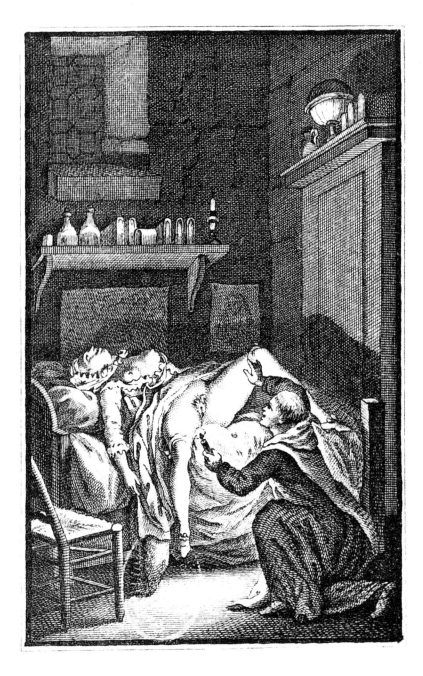

Borel and **Elluin** Engravings for *Les Mémoires de Saturnin ou Le Portier des Chartreux,* 1787

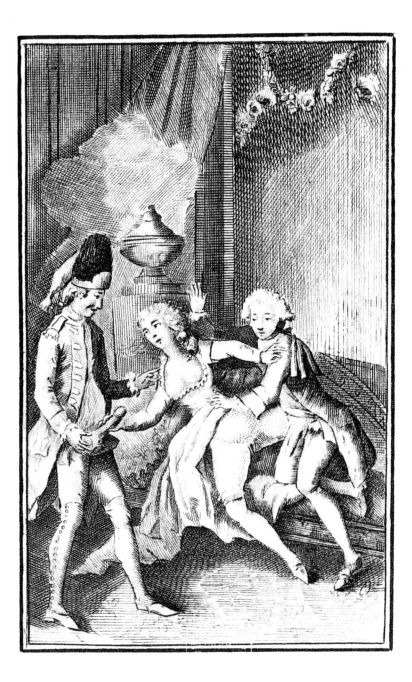

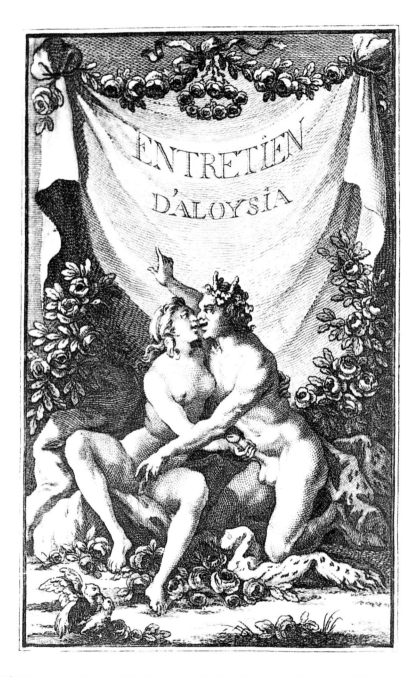

ENTRETIEN
D'ALOYSIA

Borel and **Elluin** Engravings for the *Meursius français or Aloysia's Bawdy Dialogue*, 1782

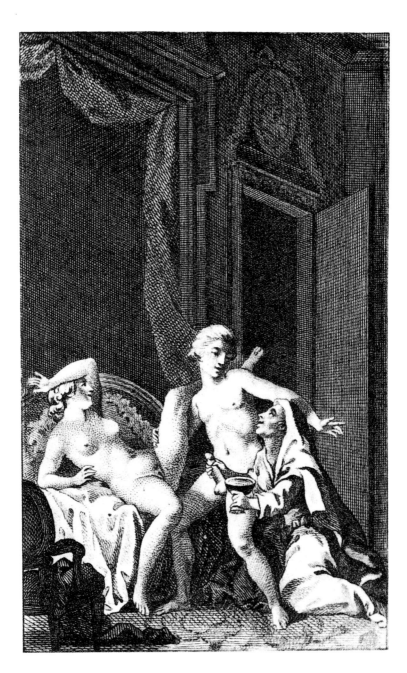

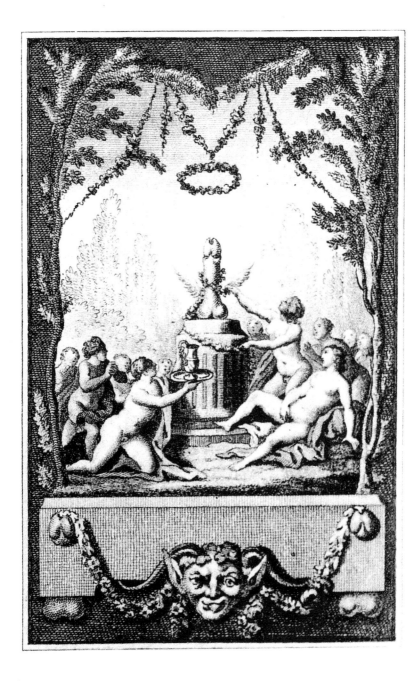

Borel and **Elluin** Engravings for *Parapilla*, 1782

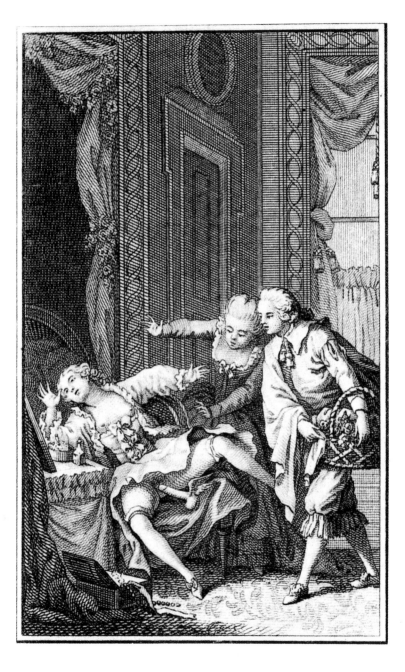

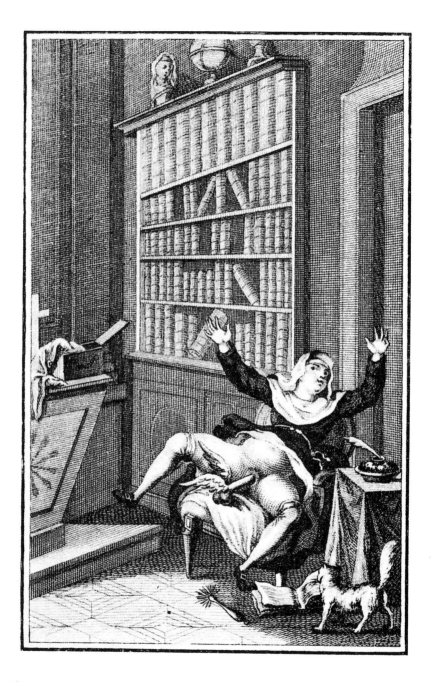

Borel and **Elluin** Engravings for *Parapilla*, 1782

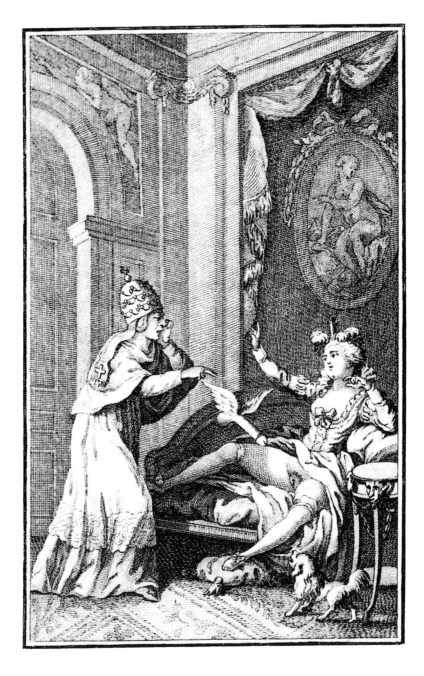

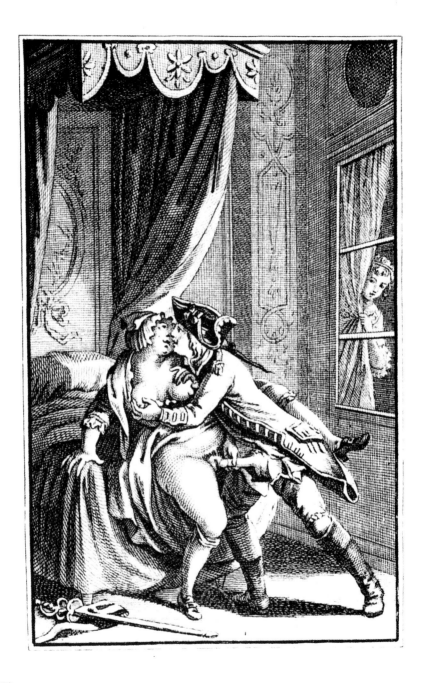

Borel and **Elluin** Engravings for *A Woman of Pleasure* by John Cleland, 1776

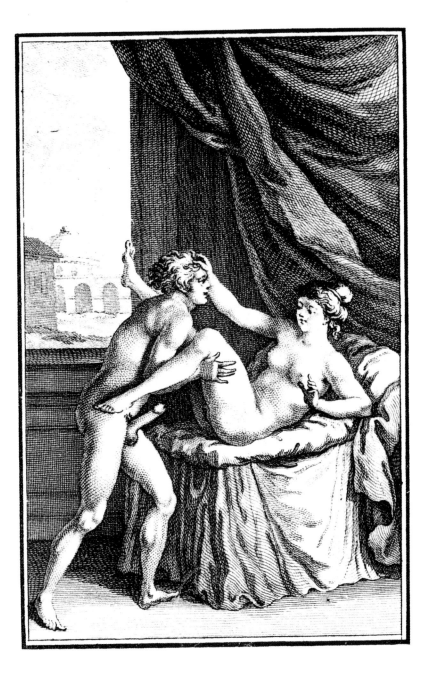

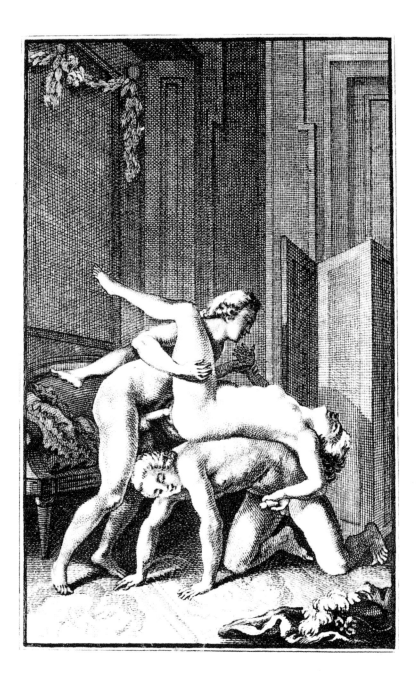

Borel and **Elluin** Engravings for *A Woman of Pleasure* by John Cleland, 1776

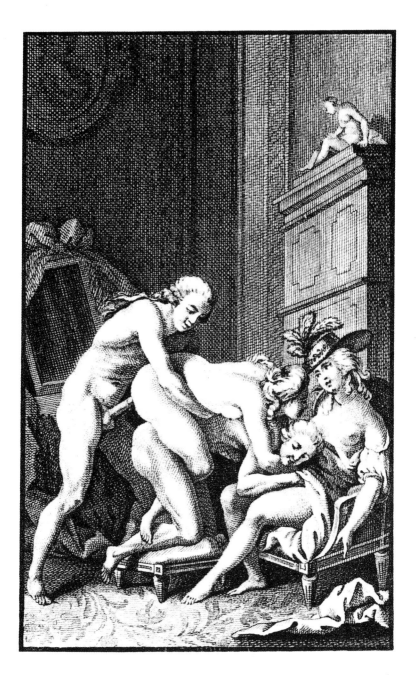

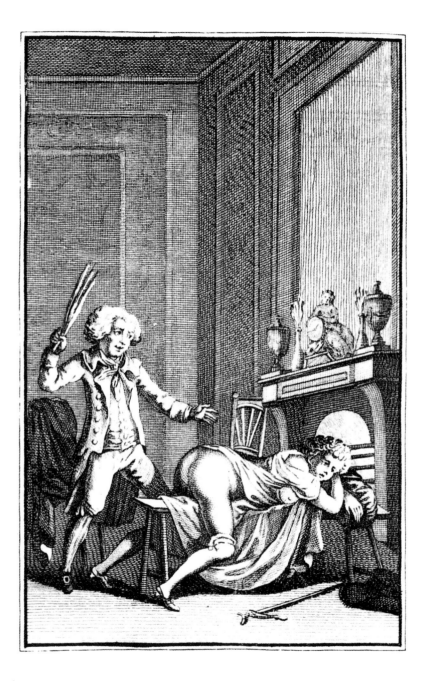

Borel and **Elluin** Engravings for *A Woman of Pleasure* by John Cleland, 1776

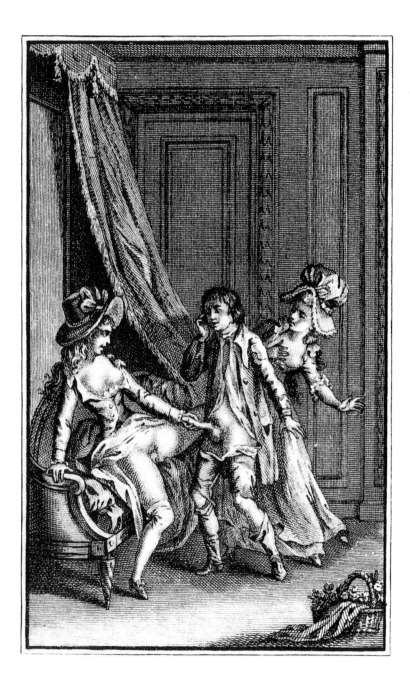

Borel and **Elluin** Engravings for *The Confederation of Nature or The Art of Reproduction*, 1780

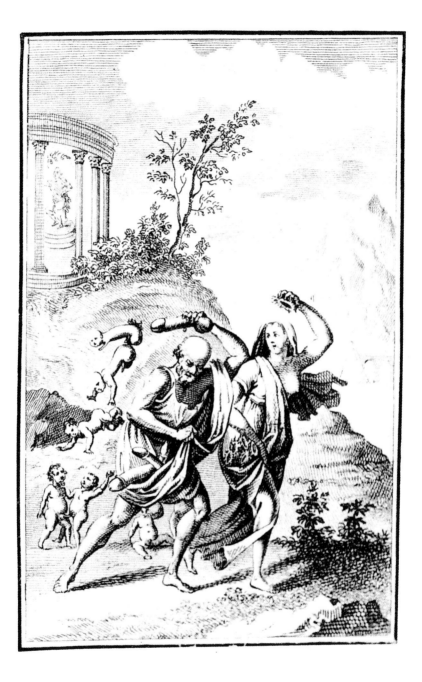

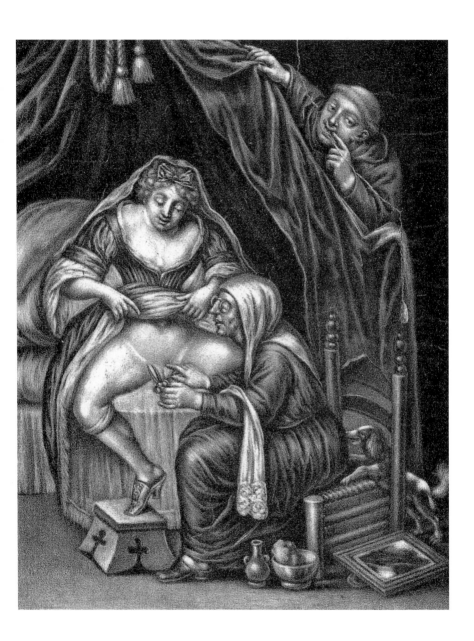

Anonymous The Depilation by the Procuress, Holland, c. 1700

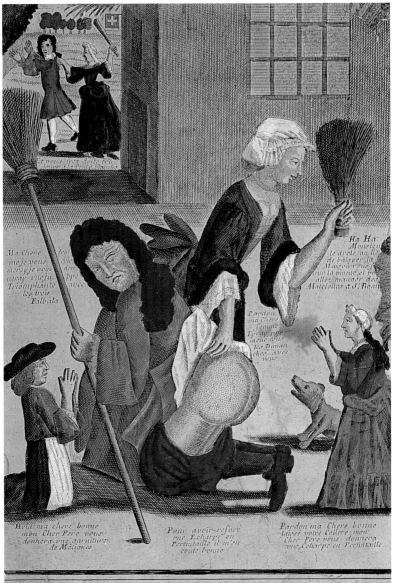

Anonymous She wears the trousers, France, c. 1705

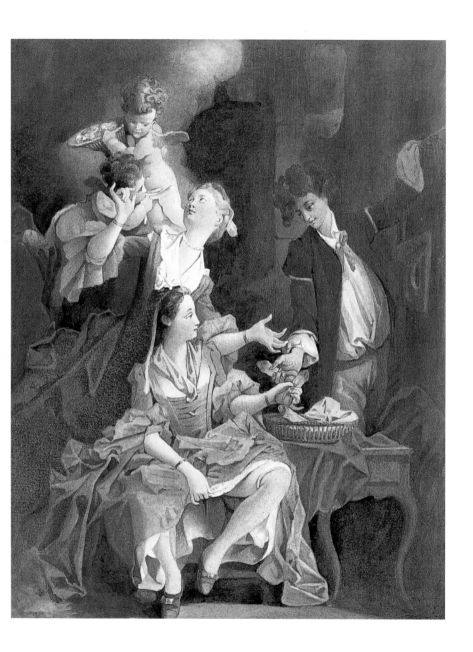

Anonymous The Love of Dildos. After a painting by François Boucher hung in the boudoir of the Marquise de Pompadour, c. 1750

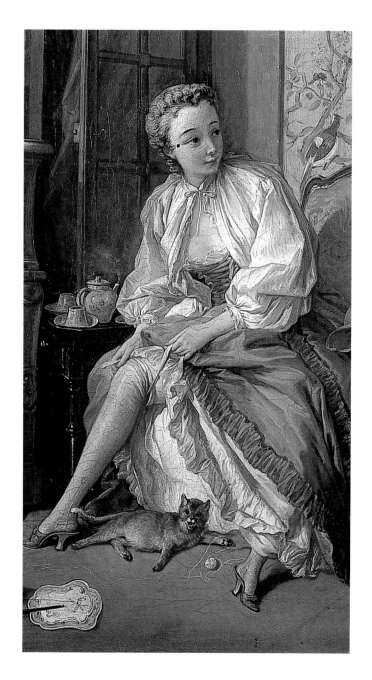

François Boucher La toilette (detail), 1742

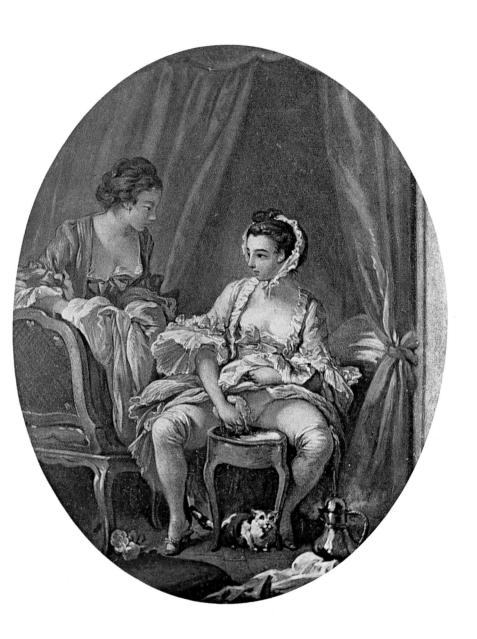

François Boucher La toilette intime, 1741

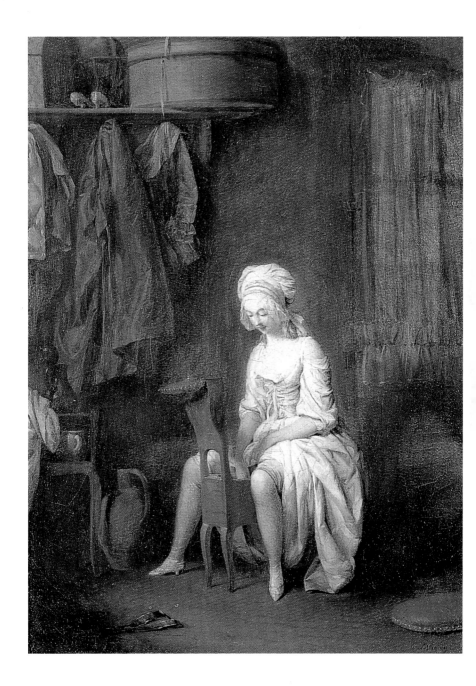

Jean-François Garneray (1755–1837) La toilette intime

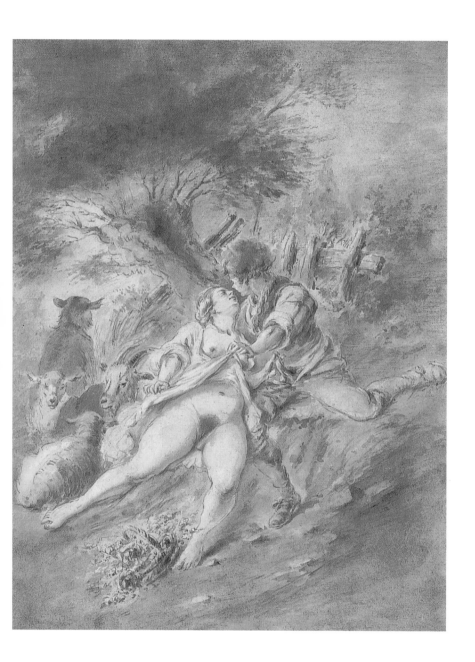

Jean-Baptiste Marie Huet (1745–1811) The Lovers' Hour

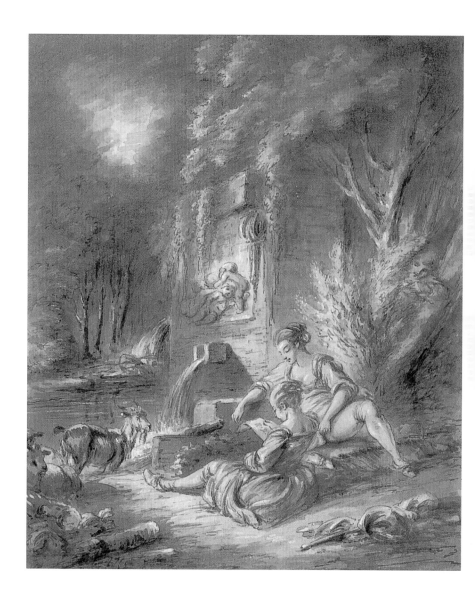

François Boucher (1703–1770) The Confidential Message ('indecent' version)

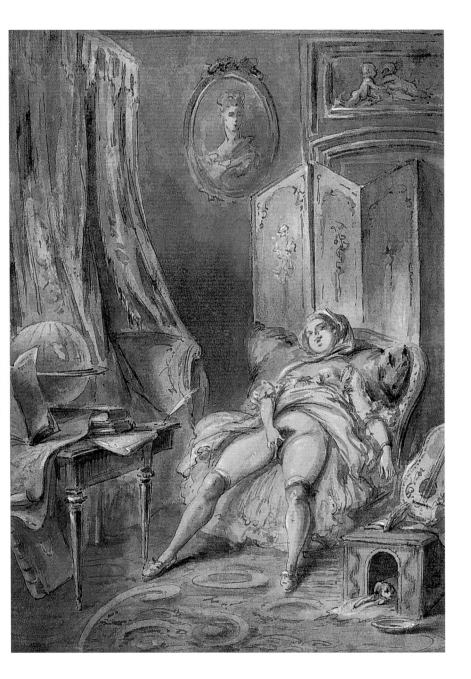

Pierre-Antoine Baudouin (1723–1769) Solitary pleasure

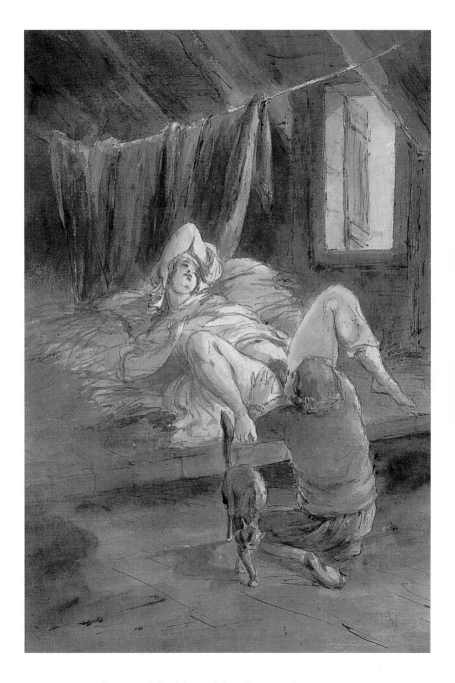

Anonymous Refined pleasure in love, France, c. 1780

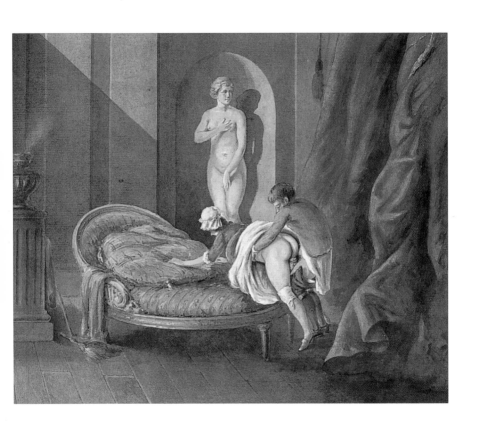

Jean-Frédéric Schall (1752–1825) The Interruption

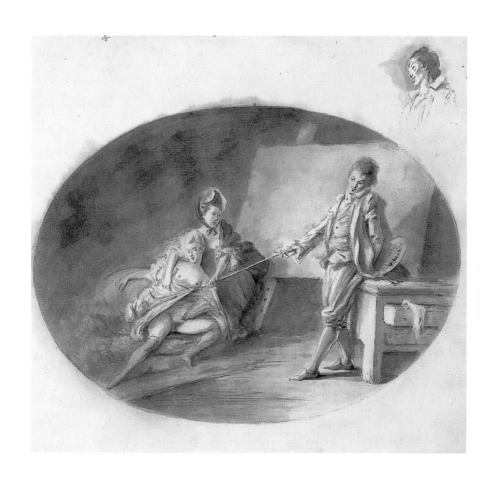

Jean-Honoré Fragonard (1723–1769) A Model's Debut

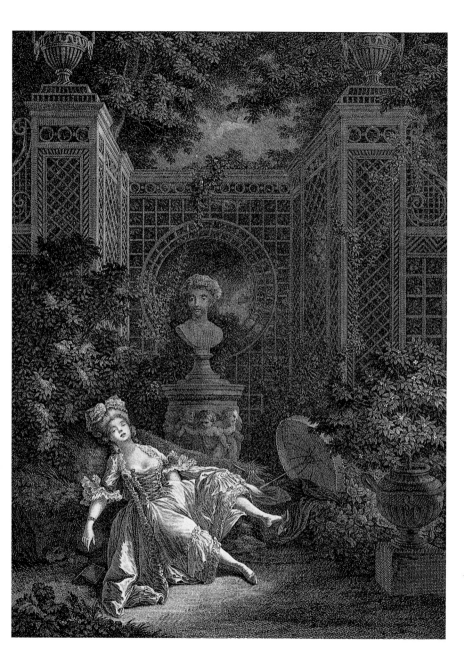

Emmanuel de Ghendt (1738–1815) Midday Heat, engraving after Pierre-Antoine Baudouin

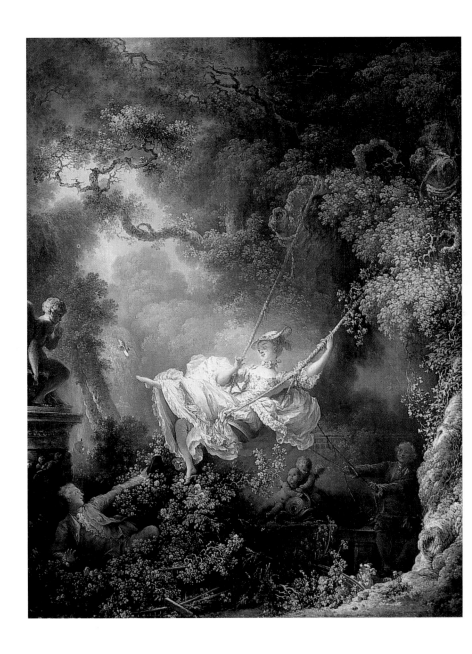

Jean-Honoré Fragonard The Luck of the Swing, 1766

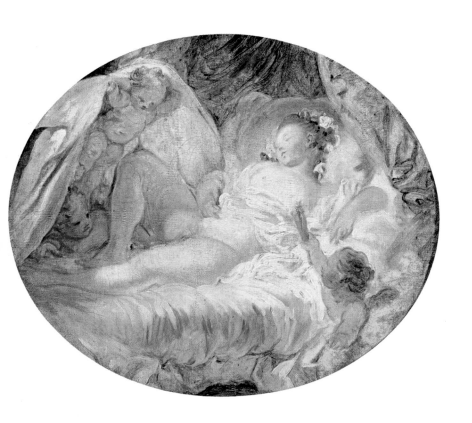

Jean-Honoré Fragonard Dream of Love, 1768

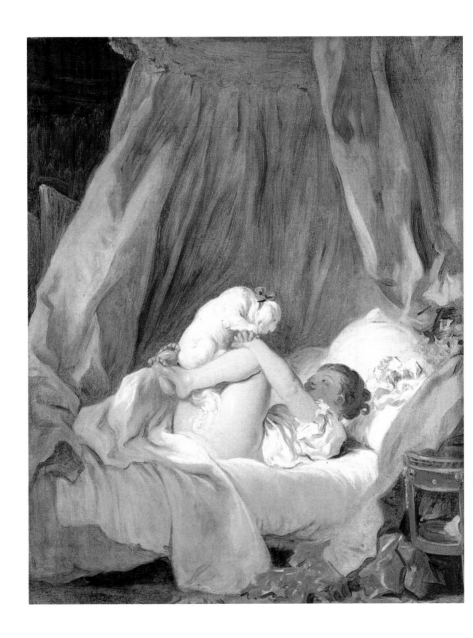

Jean-Honoré Fragonard The Gimblette, 1770

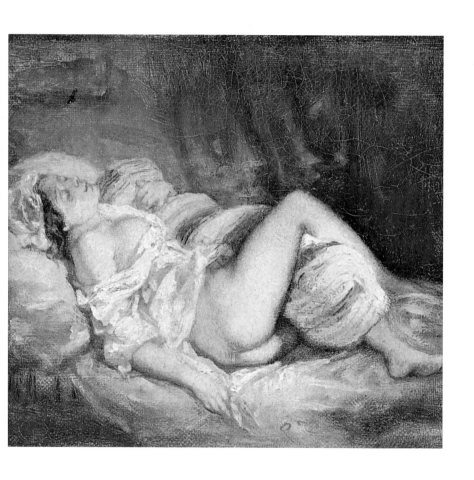

Jean-Honoré Fragonard Dream of Love, 1768

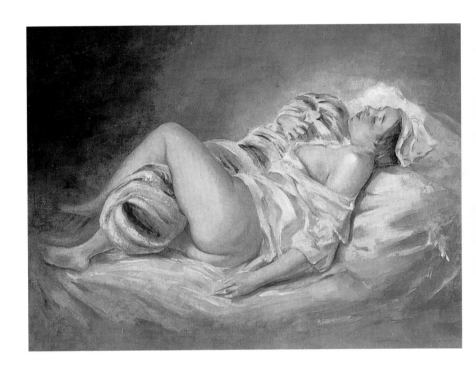

Nicolas F. O. Tassaert (1800–1874) A Spicy Dream

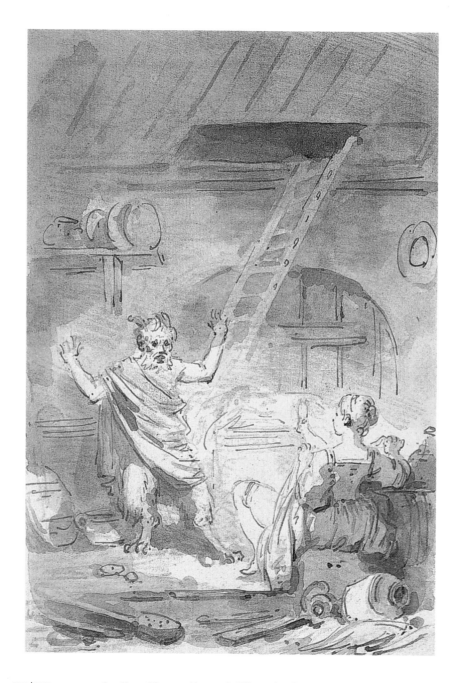

Jean Honoré Fragonard (1732–1806) Illustrations for the *Tales* of La Fontaine

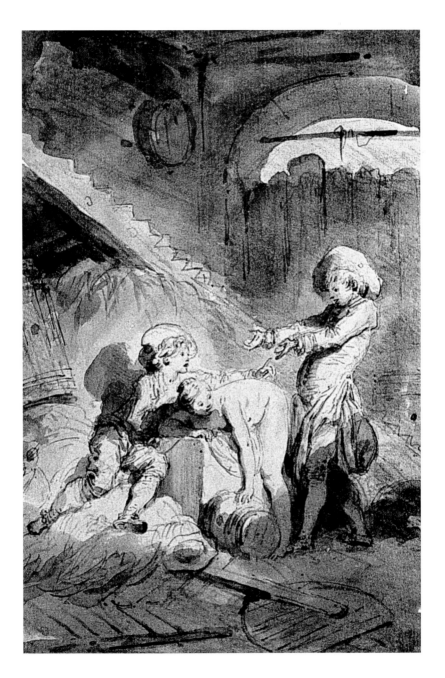

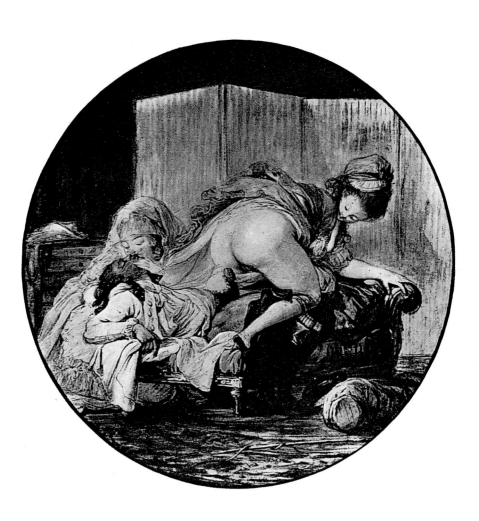

Attributed to **François Boucher (1703–1770)** The Attempt

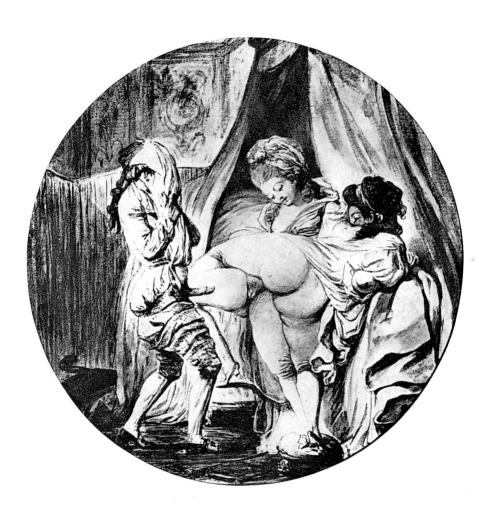

Attributed to **François Boucher (1703–1770)** Don't Look

The Libertine Revolt

For Camus, the "Rebel" is the Marquis who gave his name to sadism. Sade brought together into a single system the arguments of 18th Century libertine thought, creating a titanic engine of war that leads directly to the monumental upheaval of the French Revolution. The conclusion of Sade's revolt was a resounding and universal "No!" In his dreams of universal destruction, he is our contemporary. For him "Virtue and vice commingle in the grave like everything else". God is a great criminal whom Sade wishes to emulate. In this context, anything is permitted. Permitted in the name of what? In the name of the instinct that predominates among those whom prison walls confine: the sexual instinct.

Die Revolte des Libertins

Für Camus war jener Marquis, dem der Sadismus seinen Namen verdankt, der Mensch in der Revolte schlechthin. De Sade vereinigte in einer gewaltigen Kriegsmaschinerie die Argumente freigeistigen Denkens des ausgehenden 18. Jahrhunderts, die zu den großen Umwälzungen der Französischen Revolution führten. Für ihn war die Revolte die absolute Verneinung. Er träumte von der universellen Zerstörung, und darin ist er unser Zeitgenosse. Bei de Sade »verschmelzen Tugend und Laster im Sarg«. Gott ist ein großer Verbrecher, und er möchte sich mit ihm messen. Daher ist alles erlaubt. In wessen Namen? Im Namen des Geschlechtstriebes, der bei dem am stärksten ist, der hinter Gefängnismauern lebt.

La révolte libertine

L'homme révolté – selon Camus – est ce marquis qui donna son nom au sadisme. Sade, en effet, rassemble, en une seule et énorme machine de guerre, les arguments de la pensée libertine propre au XVIIIe siècle finissant et qui mène tout droit au grand chambardement que sera la Révolution Française. De la révolte, Sade tire le non absolu. Son rêve est celui de la destruction universelle et en celà, il est notre contemporain. Pour lui, «la vertu et le vice, tout se confond dans le cercueil.» Dieu est un grand criminel et Sade veut rivaliser avec lui. Dès lors tout est permis. Au nom de quoi? Au nom de l'instinct le plus fort chez celui qui vit entre les murs d'une prison: l'instinct sexuel.

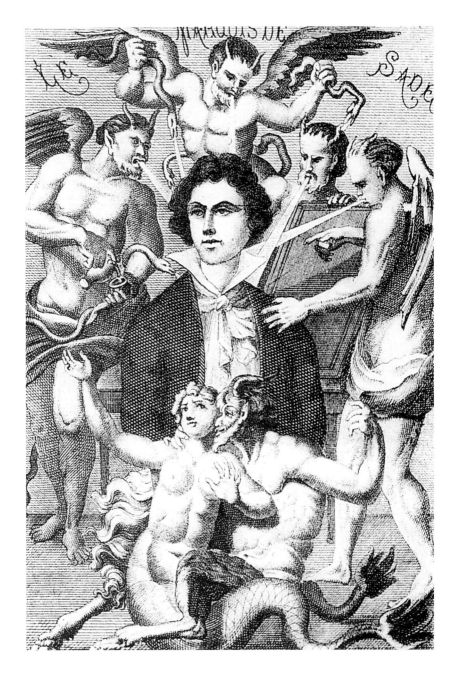

H. Biherstein Portrait of Donatien Alphonse François Marquis de Sade (1740–1808), c. 1850

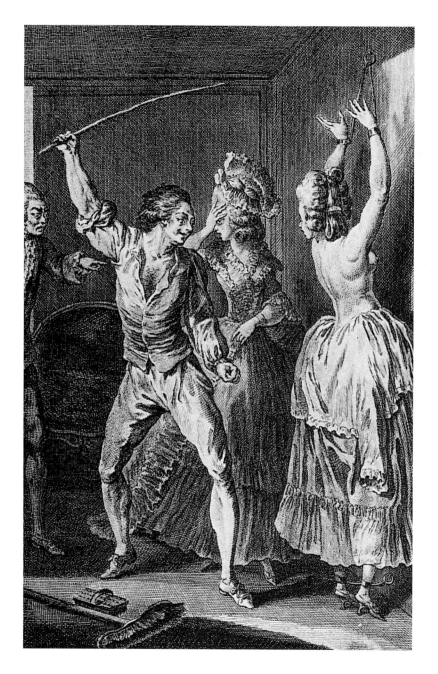

Louis Binet Punishment. Engraving for the *The Peasant Debauched* by Restif de la Bretonne, 1775

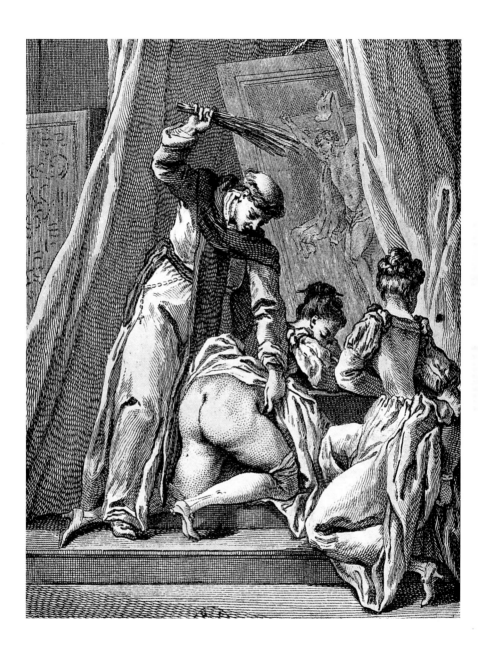

Charles Monnet (1732–1808) The Flagellation of the Penitents. Engraved by d'Ambrun

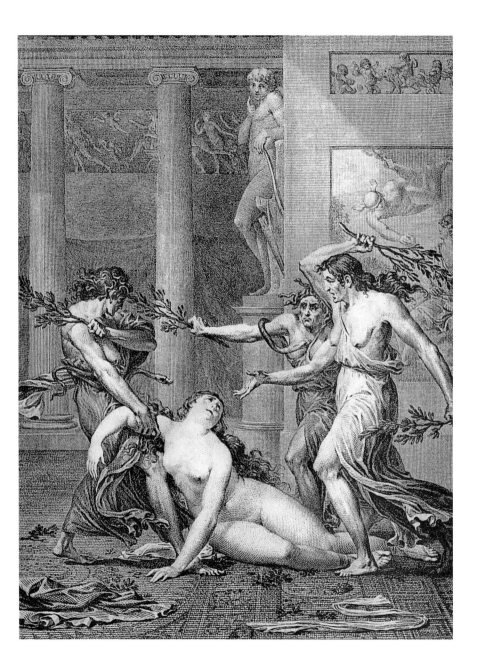

Moreau le Jeune The Woman and the Birch. Engraving for the works of La Fontaine, 1826

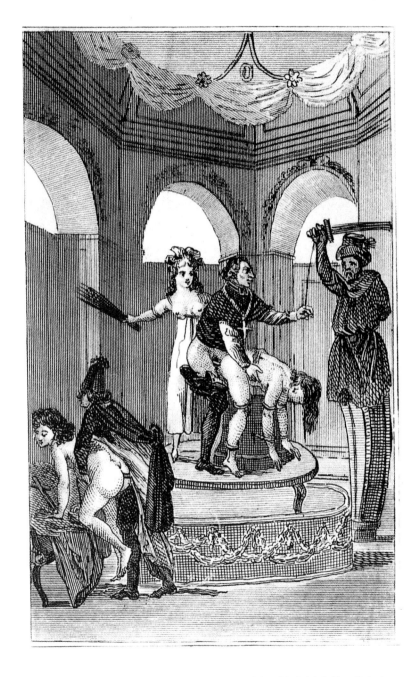

Engravings accompanying the 1797 Dutch edition of de Sade's *La Nouvelle Justine or The Misfortunes of Virtue*

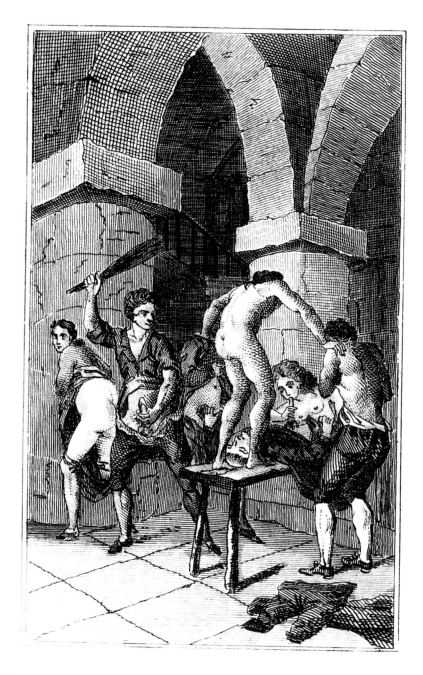

Engravings accompanying the 1797 Dutch edition of de Sade's *La Nouvelle Justine or The Misfortunes of Virtue*

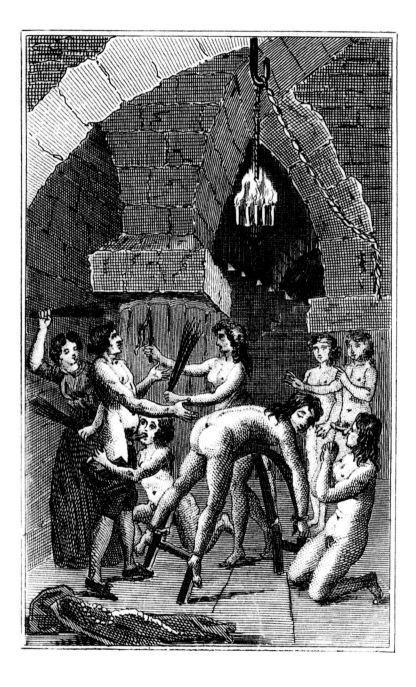

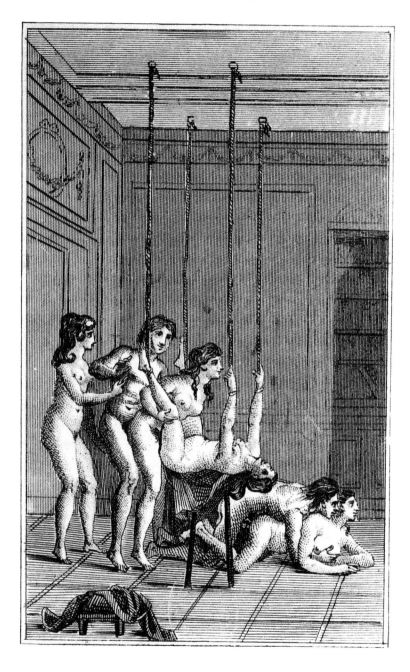

Engravings accompanying the 1797 Dutch edition of de Sade's *La Nouvelle Justine or The Misfortunes of Virtue*

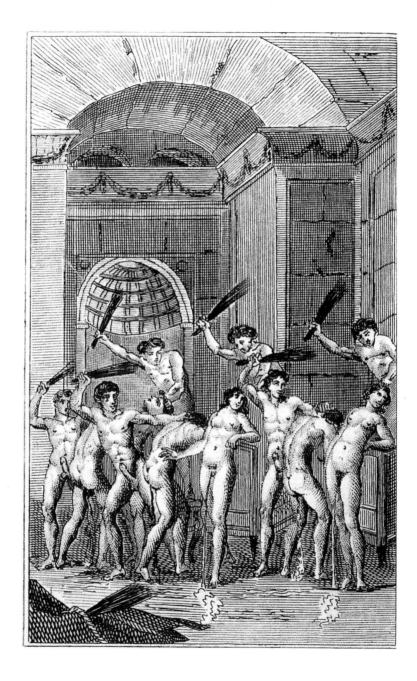

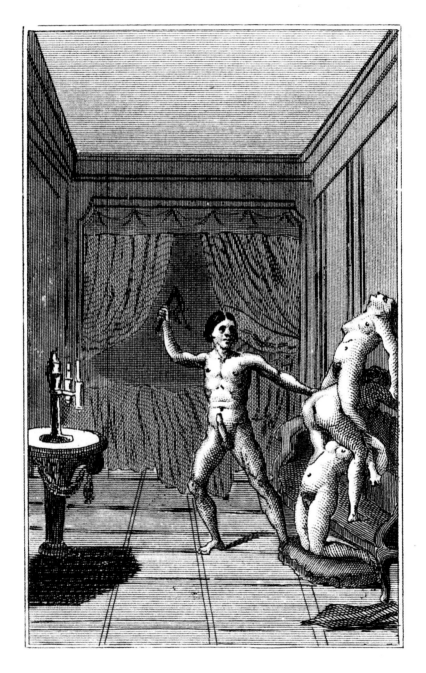

Engravings accompanying the 1797 Dutch edition of de Sade's *La Nouvelle Justine* or *The Misfortunes of Virtue*

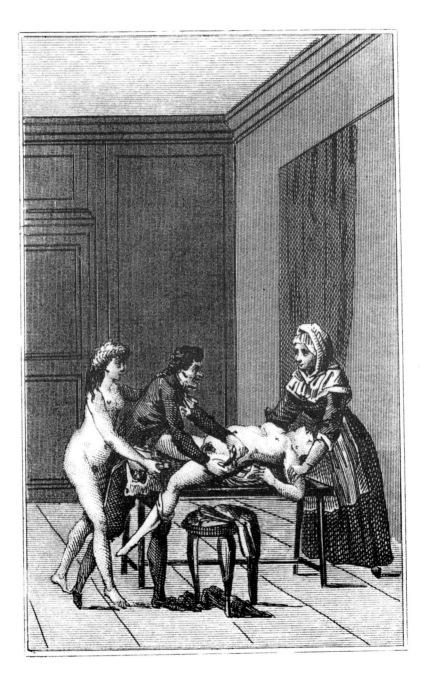

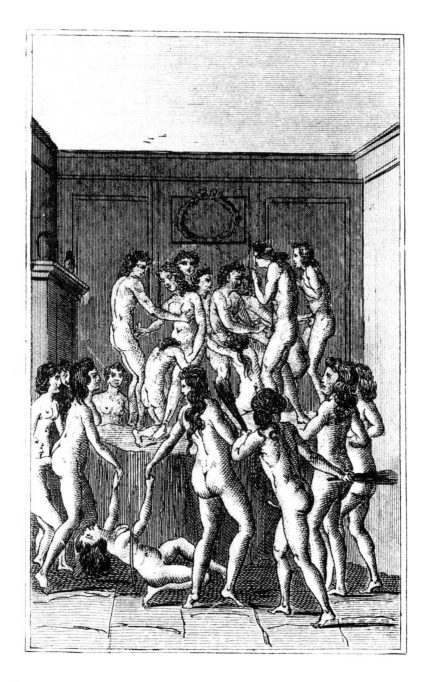

Engravings accompanying the 1797 Dutch edition of de Sade's *La Nouvelle Justine*
or The Misfortunes of Virtue

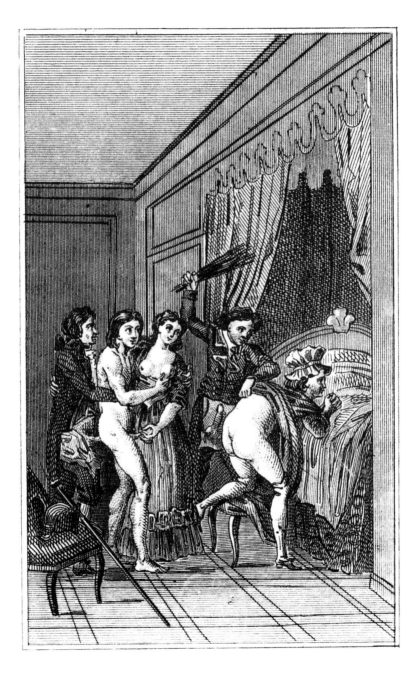

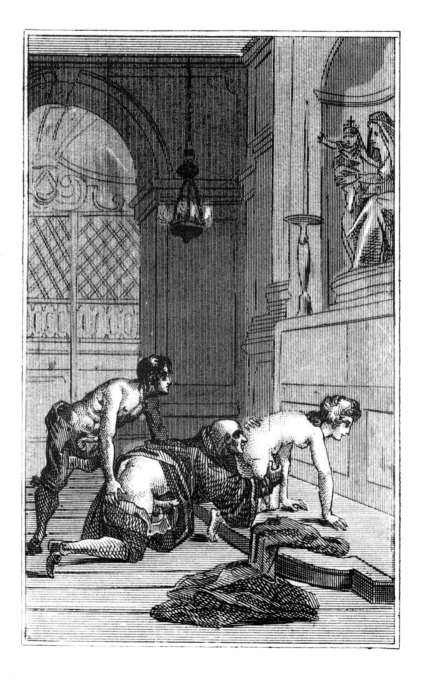

Engravings accompanying the 1797 Dutch edition of de Sade's *La Nouvelle Justine or The Misfortunes of Virtue*

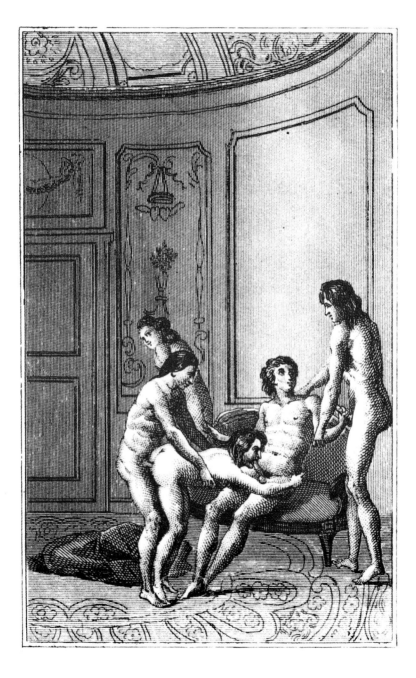

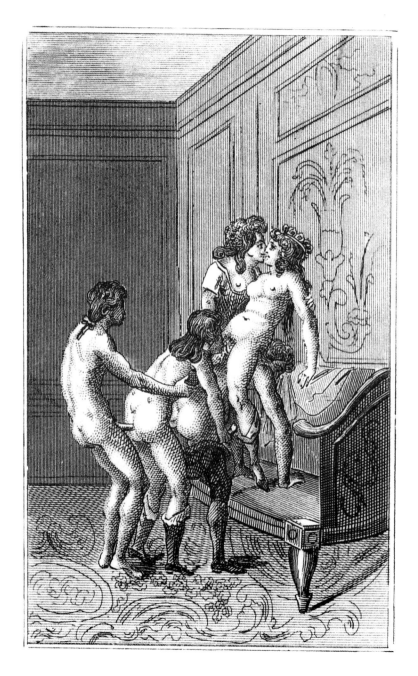

Engravings accompanying the 1797 Dutch edition of de Sade's *La Nouvelle Justine
or The Misfortunes of Virtue*

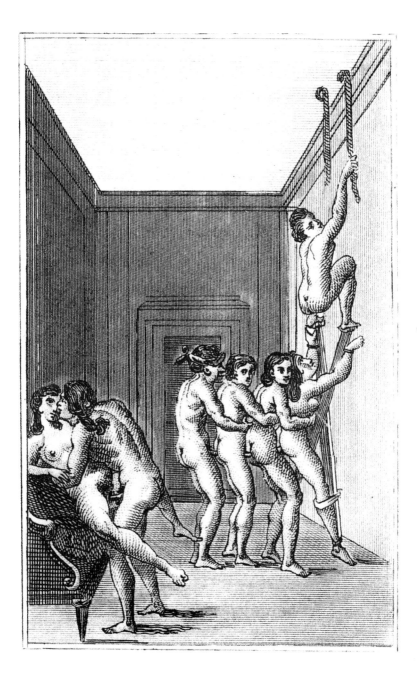

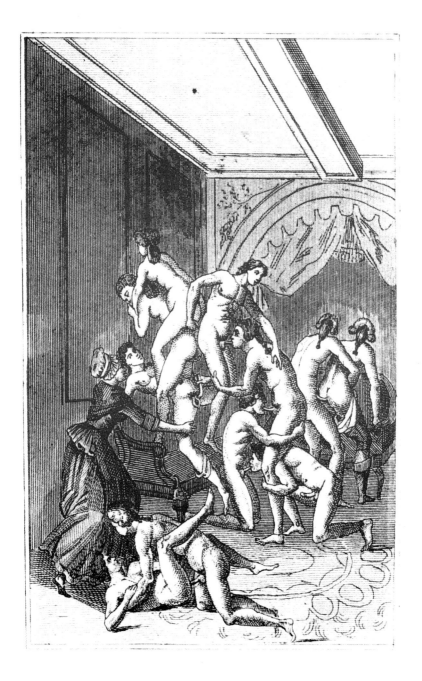

Engravings accompanying the 1797 Dutch edition of de Sade's *La Nouvelle Justine or The Misfortunes of Virtue*

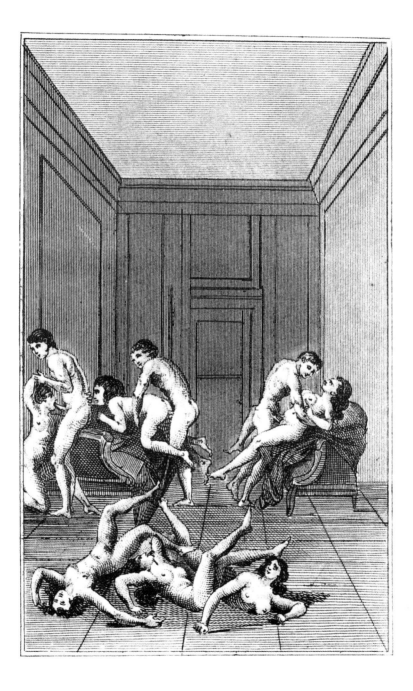

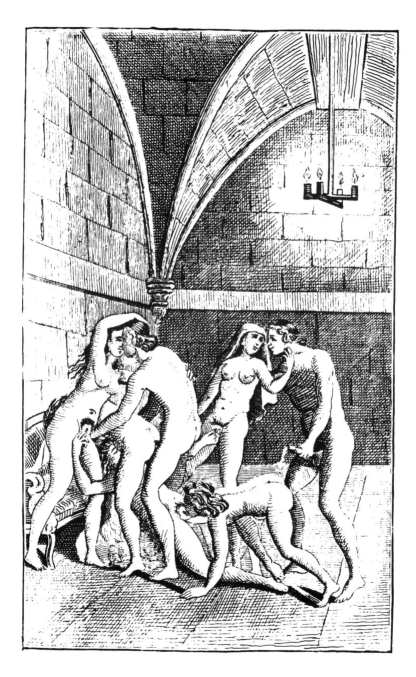

Engravings accompanying the 1789 Dutch edition of de Sade's *The Story of Juliette,*
her sister, or The Prosperity of Vice (Sequel to *La Nouvelle Justine*)

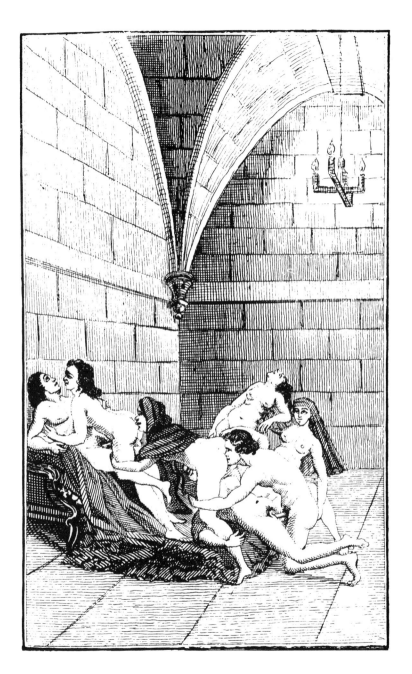

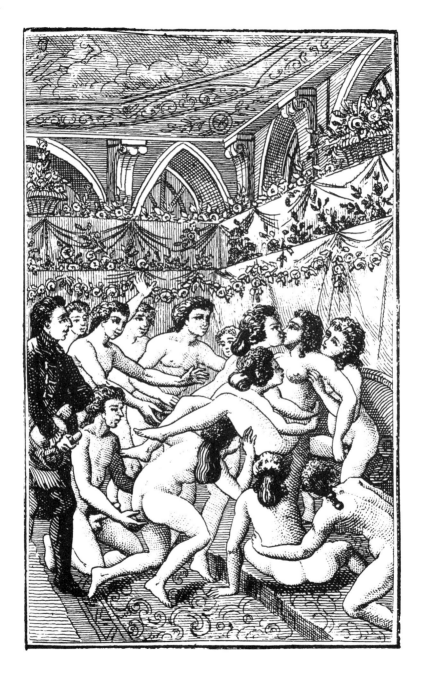

Engravings accompanying the 1789 Dutch edition of de Sade's *The Story of Juliette, her sister, or The Prosperity of Vice* (Sequel to *La Nouvelle Justine*)

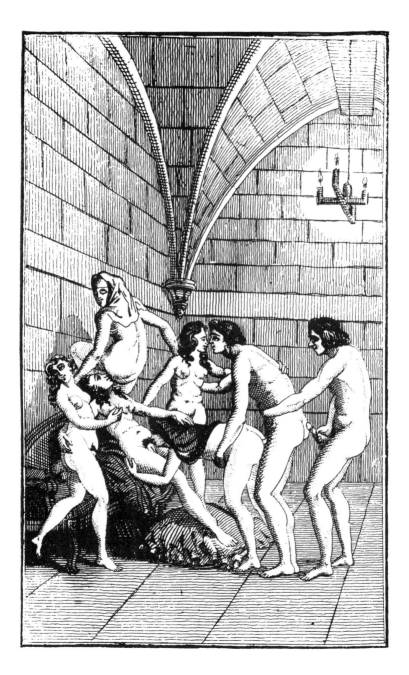

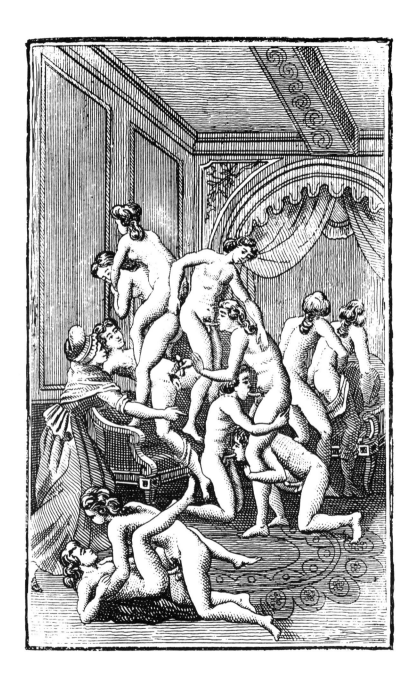

Engravings accompanying the 1789 Dutch edition of de Sade's *The Story of Juliette, her sister, or The Prosperity of Vice* (Sequel to *La Nouvelle Justine*)

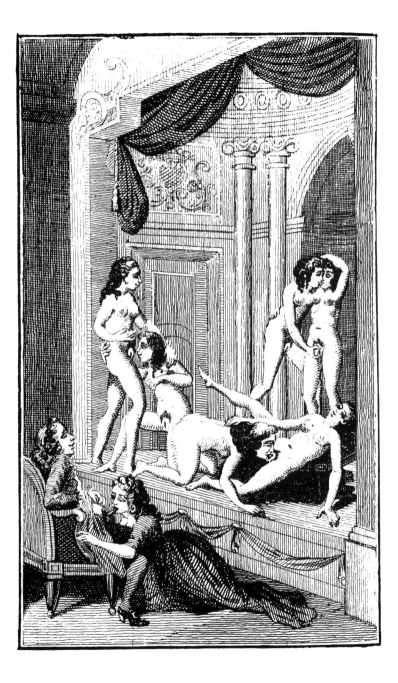

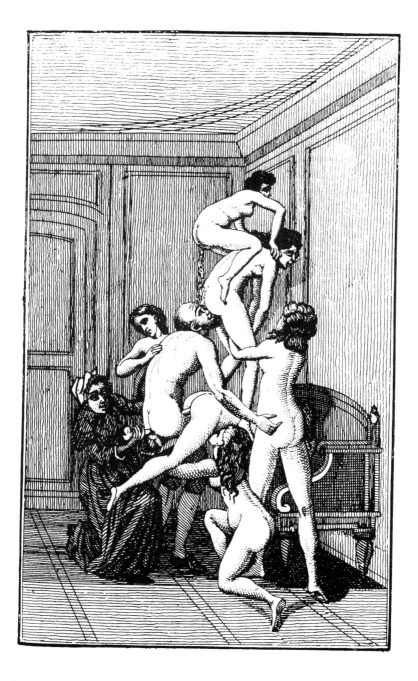

Engravings accompanying the 1789 Dutch edition of de Sade's *The Story of Juliette, her sister, or The Prosperity of Vice* (Sequel to *La Nouvelle Justine*)

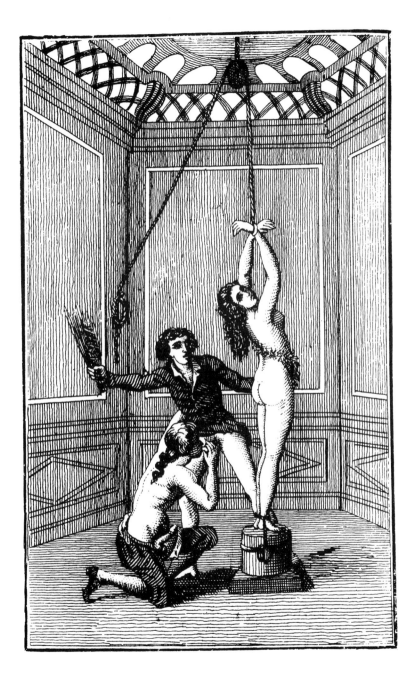

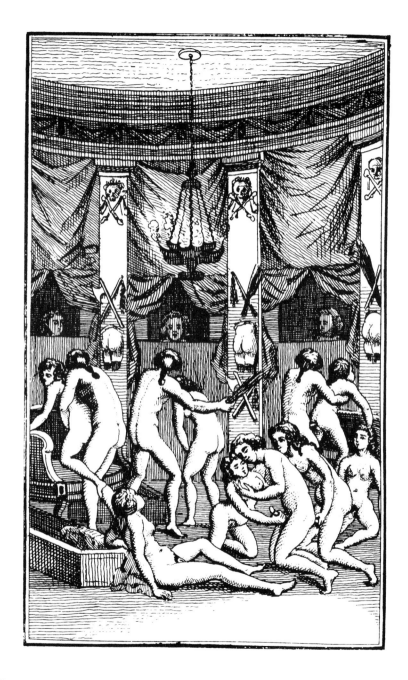

Engravings accompanying the 1789 Dutch edition of de Sade's *The Story of Juliette, her sister, or The Prosperity of Vice* (Sequel to *La Nouvelle Justine*)

Engravings accompanying the 1789 Dutch edition of de Sade's *The Story of Juliette, her sister, or The Prosperity of Vice* (Sequel to *La Nouvelle Justine*)

Engravings accompanying the 1789 Dutch edition of de Sade's *The Story of Juliette,
her sister, or The Prosperity of Vice* (Sequel to *La Nouvelle Justine*)

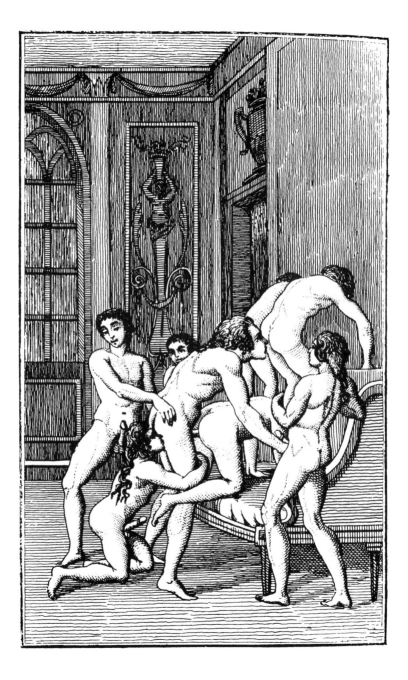

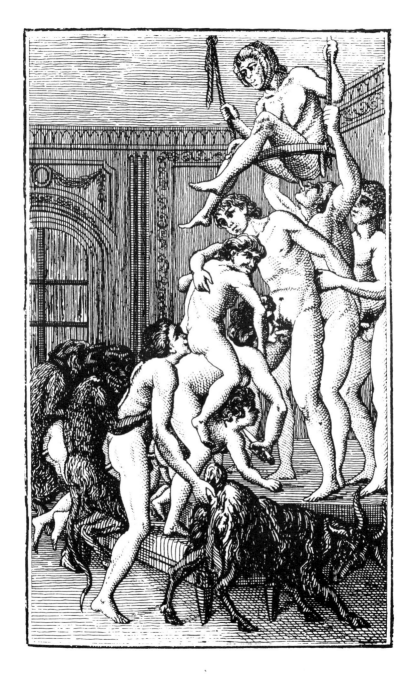

Engravings accompanying the 1789 Dutch edition of de Sade's *The Story of Juliette,
her sister, or The Prosperity of Vice* (Sequel to *La Nouvelle Justine*)

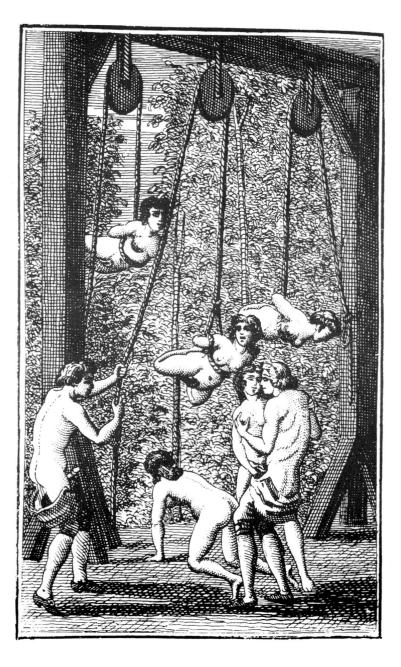

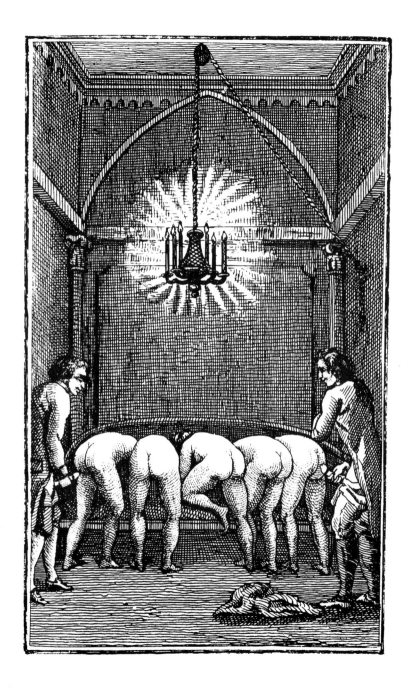

Engravings accompanying the 1789 Dutch edition of de Sade's *The Story of Juliette, her sister, or The Prosperity of Vice* (Sequel to *La Nouvelle Justine*)

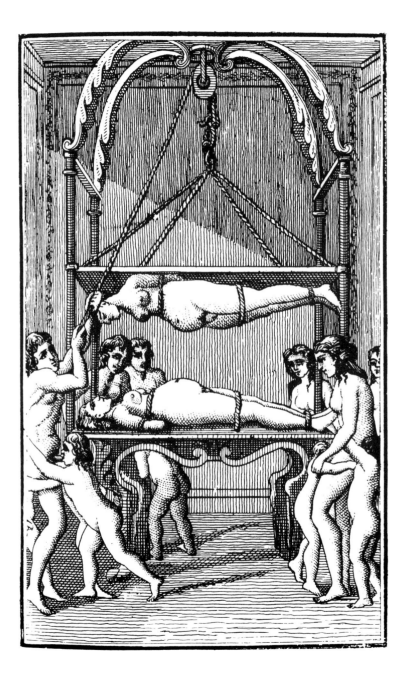

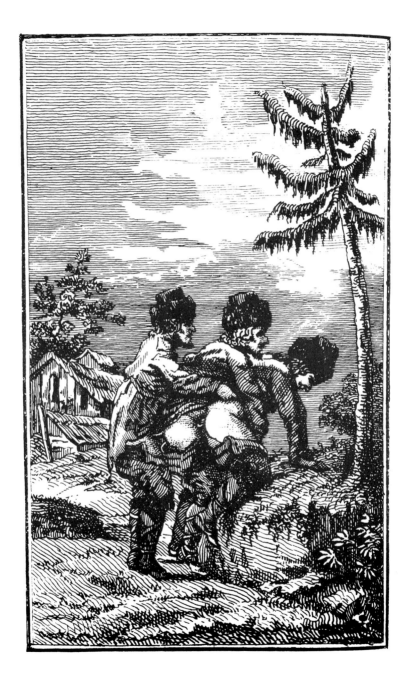

Engravings accompanying the 1789 Dutch edition of de Sade's *The Story of Juliette,
her sister, or The Prosperity of Vice* (Sequel to *La Nouvelle Justine*)

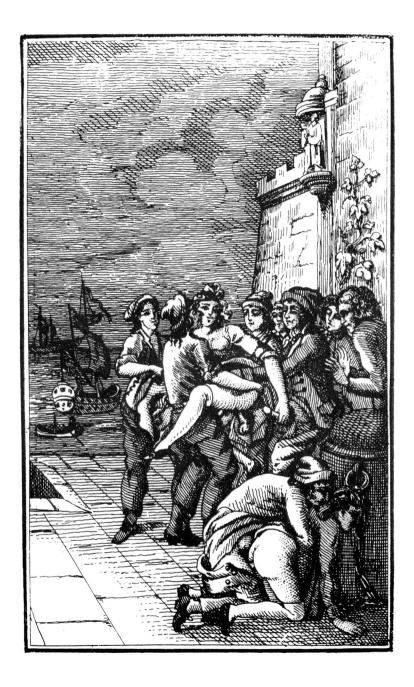

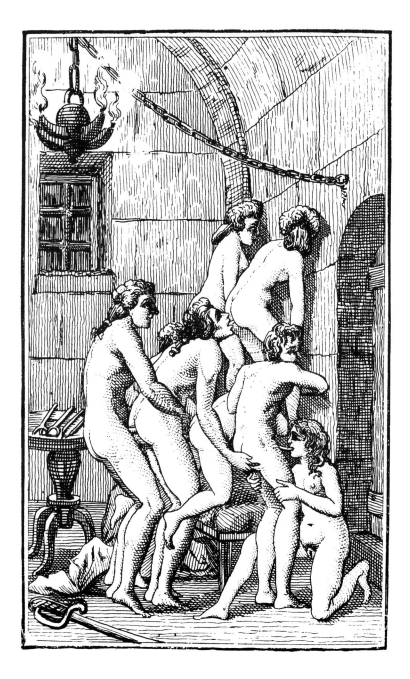

Engravings accompanying the 1789 Dutch edition of de Sade's *The Story of Juliette, her sister, or The Prosperity of Vice* (Sequel to *La Nouvelle Justine*)

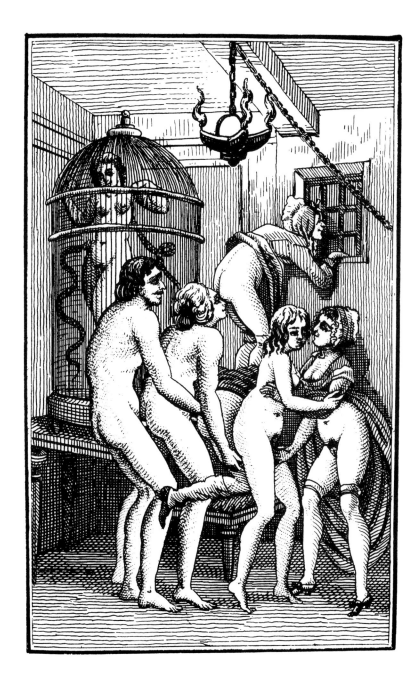

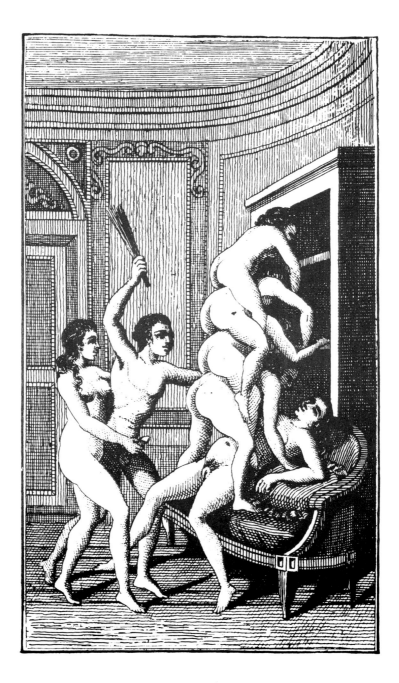

Engravings accompanying the 1789 Dutch edition of de Sade's *The Story of Juliette, her sister, or The Prosperity of Vice* (Sequel to *La Nouvelle Justine*)

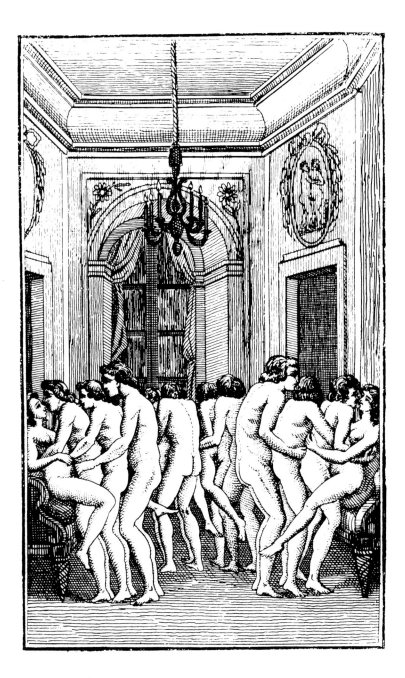

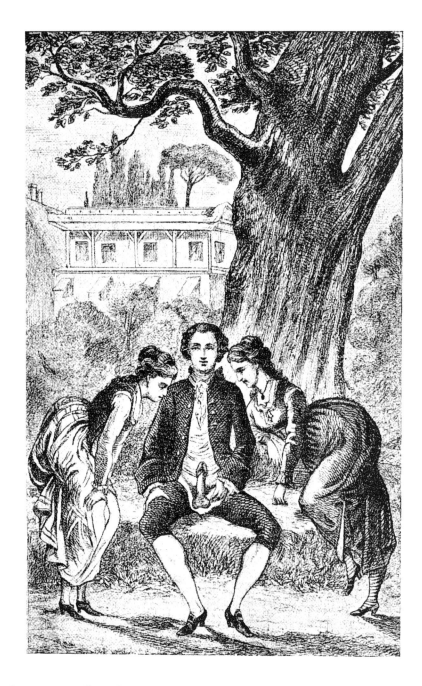

Chauvet Engravings for the posthumously published *Memoirs* of Casanova (1725–1798)

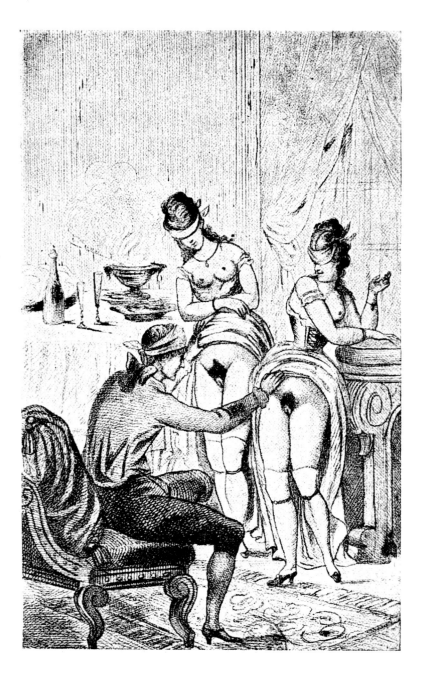

Chauvet Engravings for the posthumously published *Memoirs* of Casanova (1725–1798)

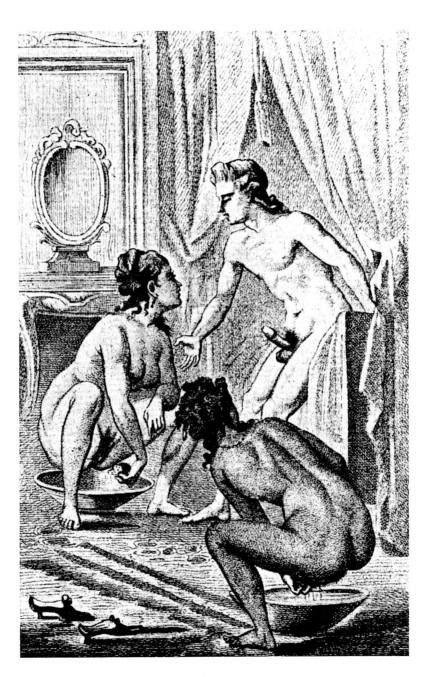

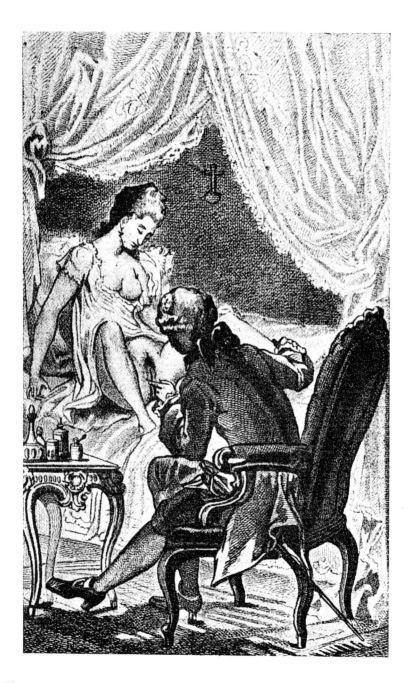

Chauvet Engravings for the posthumously published *Memoirs* of Casanova (1725–1798)

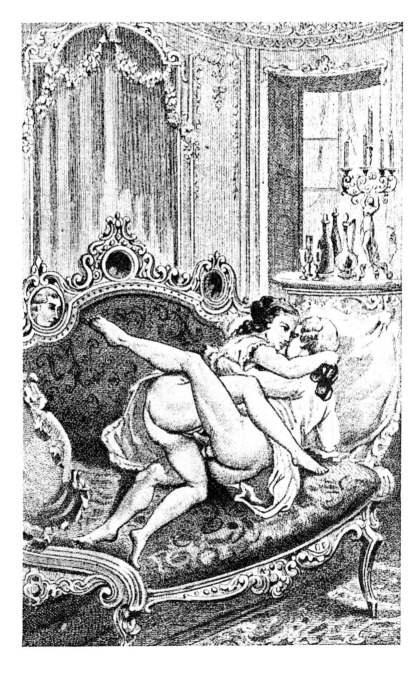

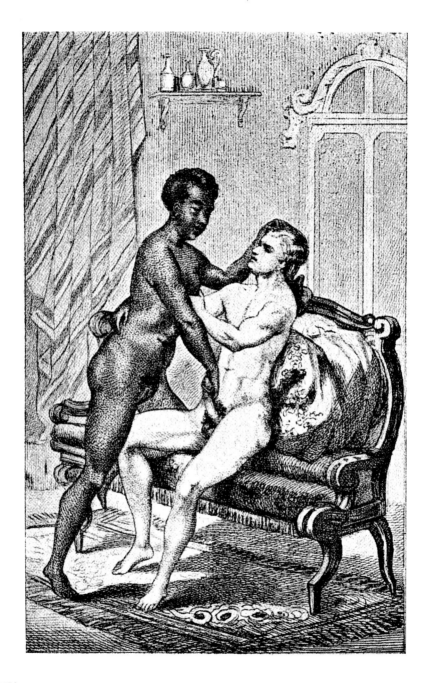

Chauvet Engravings for the posthumously published *Memoirs* of Casanova (1725–1798)

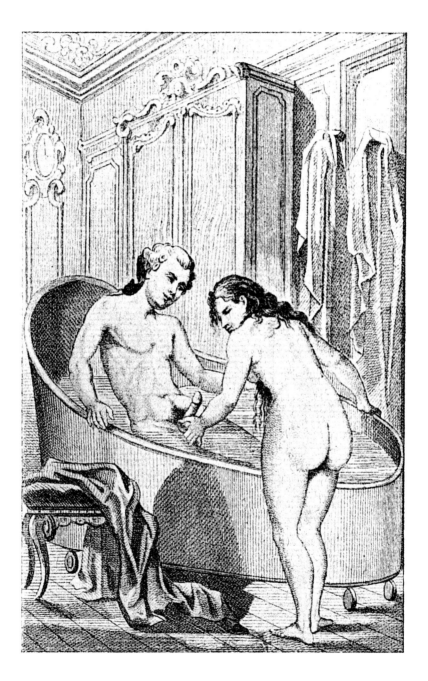

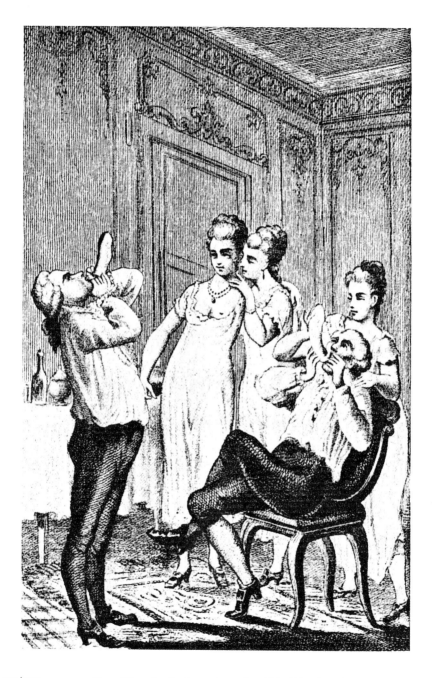

Chauvet Engravings for the posthumously published *Memoirs* of Casanova (1725–1798)

Chauvet Engravings for the posthumously published *Memoirs* of Casanova (1725–1798)

Chauvet Engravings for the posthumously published *Memoirs* of Casanova (1725–1798)

Chauvet Engravings for the posthumously published *Memoirs* of Casanova (1725–1798)

Ah mon ami tu te trompe met donc chaque chose a sa place.

Revolutionary prints 1789–1792 (contemporary captions): The Chimney Sweep or Against Our Gunners

III
Erotica
Revolutionnaria

Revolution and Depravity
The French Revolution brought freedom of expression and the right
to obscenity. But it was a short respite, and soon Robespierre set
about restoring the tyranny of virtue. Hidden in tin boxes soldered
shut, documents survived; they speak volumes about the hidden
ribaldry and farce of the revolutionary turmoil. "Liberty, you're
fucking me up the arse...", "It's in there up to the haft... Yes, haf' the
National Guard are in there", "A man must 'stand up' for his rights...".
But the Revolution was also the 'servants' uprising', the 'Rogues'
Ball', when the chambermaids and lackeys imitated their masters,
straddling dukes and raping duchesses.

Revolution, Sittenverfall
Die Revolution bescherte den Menschen das Recht auf freie Mei-
nungsäußerung und auf Obszönität. Die Atempause war allerdings
von kurzer Dauer, denn schon Robespierre wollte die Diktatur der
Tugend wiedereinführen. Da sind sie nun also, die in einer Weiß-
blechbüchse hermetisch eingeschweißten und so vor der Zerstörung
geretteten Dokumente, die Zeugnis ablegen von der lustvollen, aber
verborgenen Seite der revolutionären Erschütterung. Da heißt es:
»Freiheit, bist mir scheißegal...«. Selbst die Nationalgarde blies ins
gleiche Horn: »Der Phallus als Menschenrecht...«. Aber die Revolution
ist auch der »Aufstand der Bediensteten«, der »Ball der fidelen
Gesellen«, auf dem die Zimmermädchen und die Lakaien ihre Herr-
schaften nachahmen, wo sie auf den Herzögen reiten und sich mit
Lust daranmachen, die Herzoginnen zu schänden.

Révolution, dépravation...
La Révolution a apporté la liberté d'expression et le droit à l'obscénité.
Le répit durera peu et déjà Robespierre voudra rétablir la dictature
de la vertu. Enfermés dans des boîtes de fer blanc soudées hermé-
tiquement, voici les documents, sauvés de la destruction, qui témoig-
nent de la joyeuse face cachée de la convulsion révolutionnaire. C'est
«Liberté tu me fout en Cul...», «Il y est jusqu'à la Garde... Nationale»,
«Les droits phallus de l'homme...» Mais la Révolution, c'est aussi
l'«insurrection des domestiques», le «bal des lurons», quand les
femmes de chambre et les laquais imitent les maîtres, chevauchent
les ducs et se mettent à violer les duchesses.

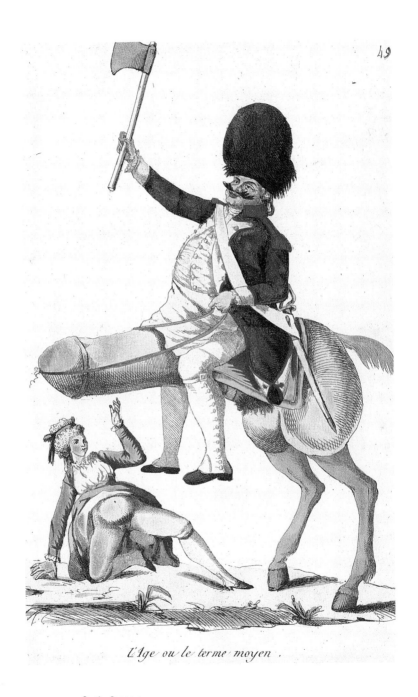

L'Age ou le terme moyen.

On the Sappers

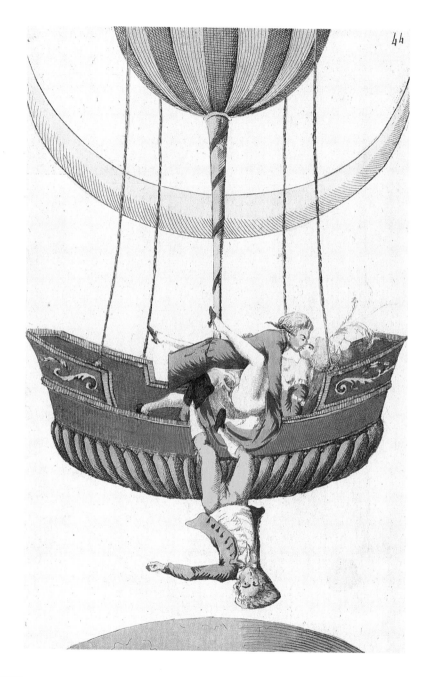

The Fall of Nicodemus or Opportunity Makes the Thief

Par Permission.

de Monseigneur le Lieutenant général

de Potiss on fait à savoir ;

Qu'il est arrivé dans cette Ville un Poisson d'une espèce
extraordinaire ; cet animal porte 11 pouces de longueur ;
ayant la tête de carpe, les pâtes de l'oie, les ailes de l'ai-
gle luxurieux, et la queue d'un homme : cet animal a été
péché dans le Canal de Versailles, et présenté à Mad^e la
Motte ; et aux autres dames d'honneurs qui en ont eu soin
pendant son absence. Les hommes pourront le voir gratis,
et les dames le verront à la seule condition de les faire
cracher une fois ; on le voit dans les Boudoirs du Palais Royal
à Paris.

Allusion to the *Collier de la Reine* affair

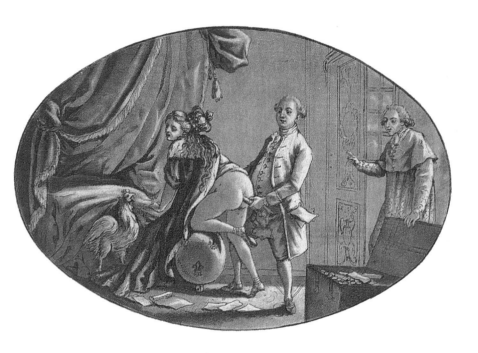

A Last Blessing for Mr Necker (Prime Minister)

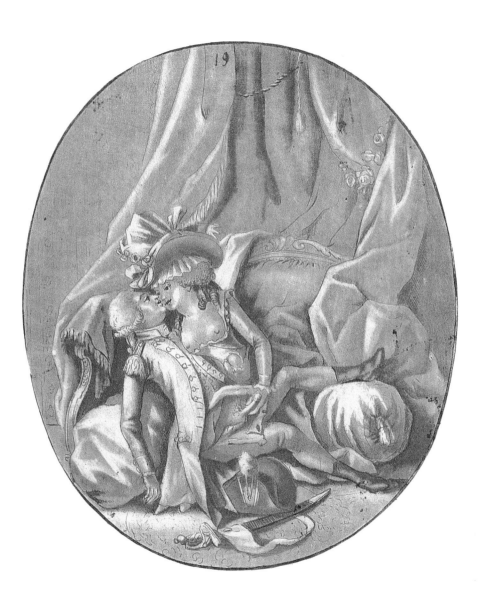

General La Fayette and Marie-Antoinette

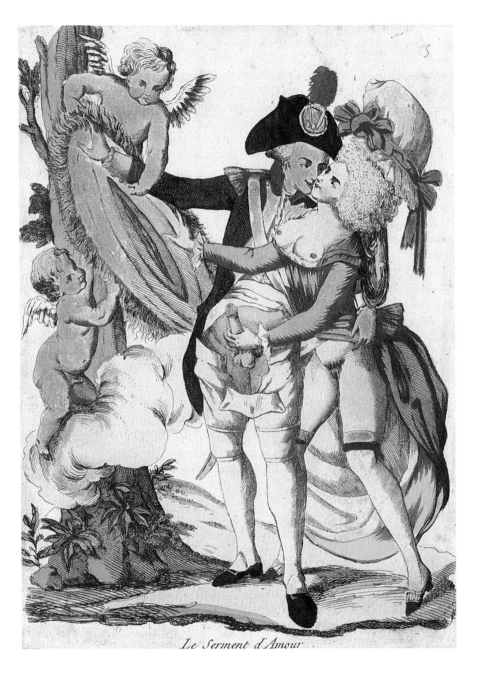

Le Serment d'Amour

Satire on the Oath of Fidelity to the Nation, the Law and the King, decreed by the National Assembly

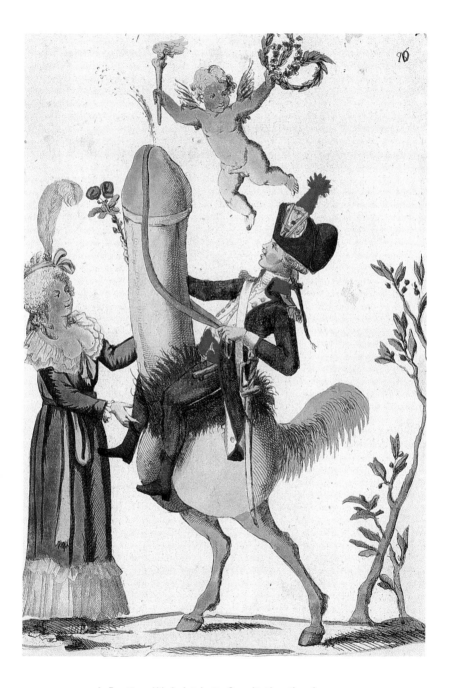

La Fayette and Marie-Antoinette. Sequel to the satires above

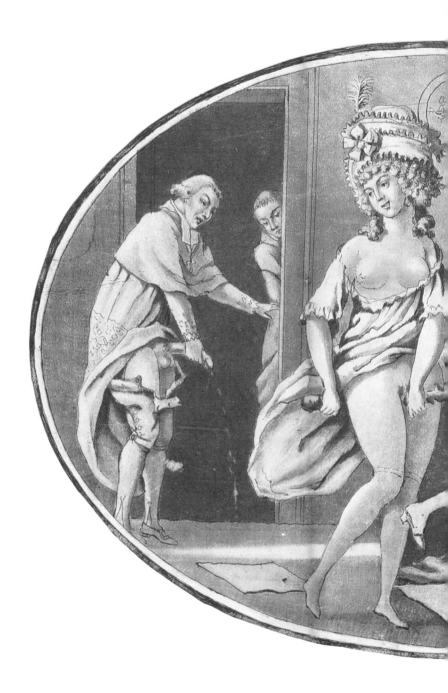

Ah, cursed Liberty, you fuck me up the arse. At least put some pommade on

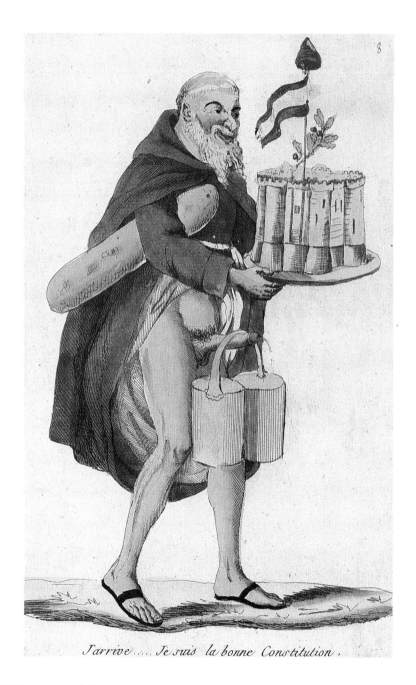

J'arrive..... Je suis la bonne Constitution.

Oh, what a good decree. Joke about the rights of man

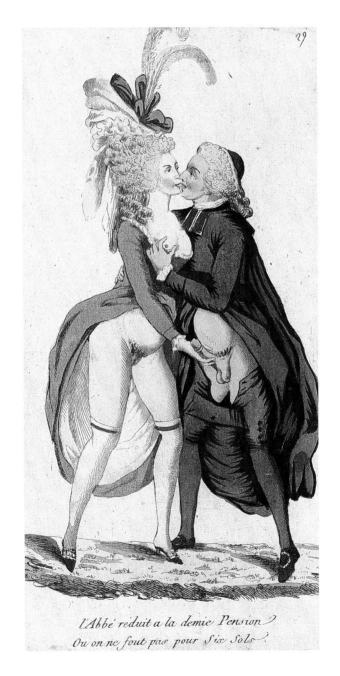

l'Abbé réduit a la demie Pension
Ou on ne fout pas pour Six Sols.

Satire against the clergy dispossessed and stripped of the means to come
by their pleasures

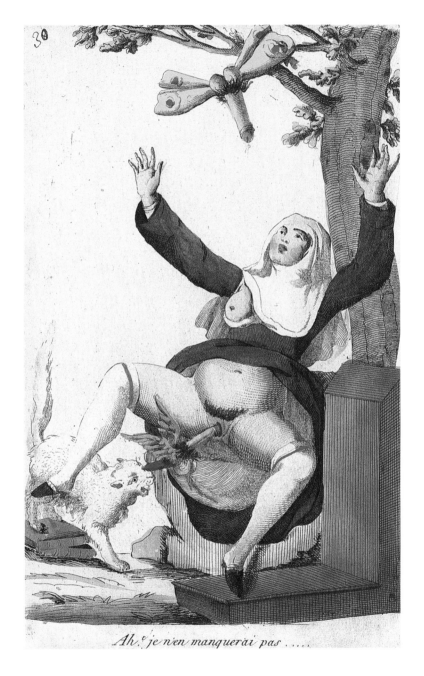

Ah, je n'en manquerai pas

Satire against the nuns when their cloisters had just been opened

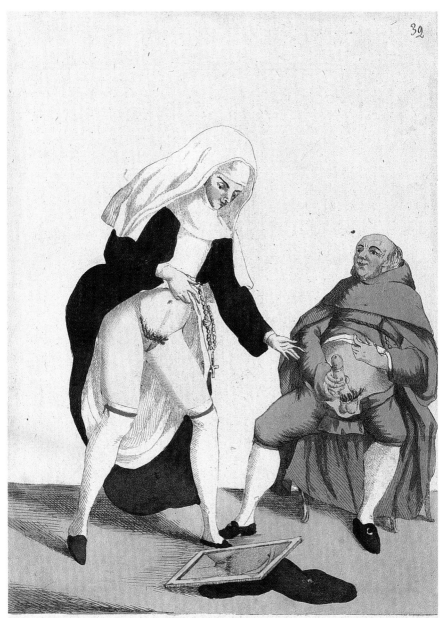

Ah Quel Vit pour mon Con: ou le Moine pressé.

Sequel to the satires against the religious orders

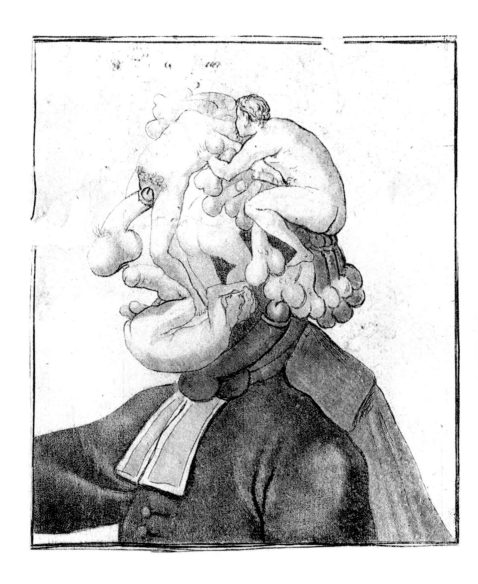

Against the Abbé Mauri: His Portrait is alive/His portrait as a prick (*en vie/en vit*)

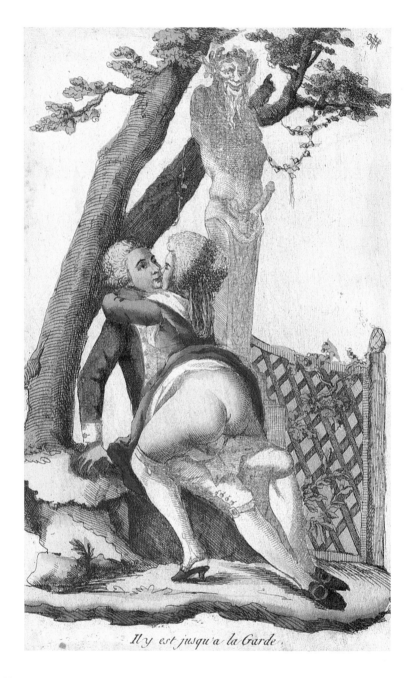

Il y est jusqu'a la Garde.

Joke about the Garde Nationale

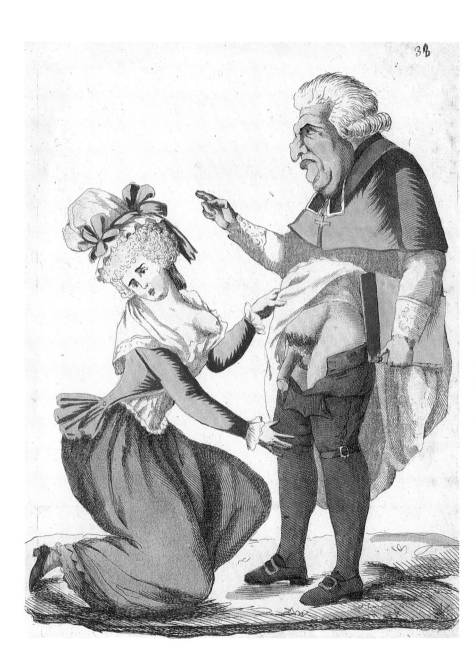

Against Mr de Juigné, Archbishop of Paris

The Aristocrat in C(o)unter-Revolution; the noble and the churchman interchangeable in execration

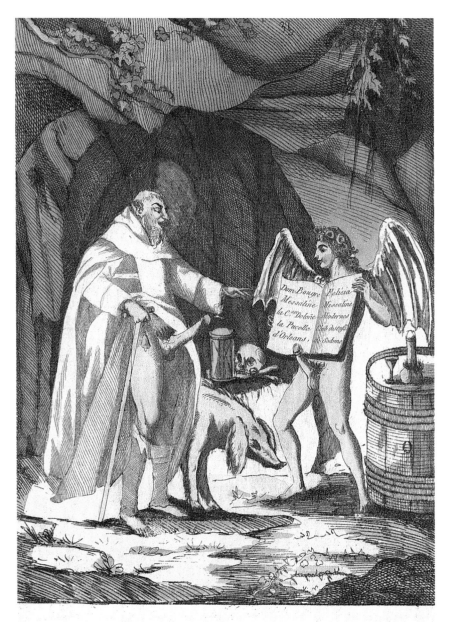

Le Voluptueux Anachorete,

31

Sequel to the obscene jokes about friars

l'Abbé consultant sa bonne avanture.

Sequel to the satires against the nuns

l'Exemple n'i fait rien .

Sequel to the caricatures of friars

Ce n'est pas pour toi Minet

Sequel against the friars

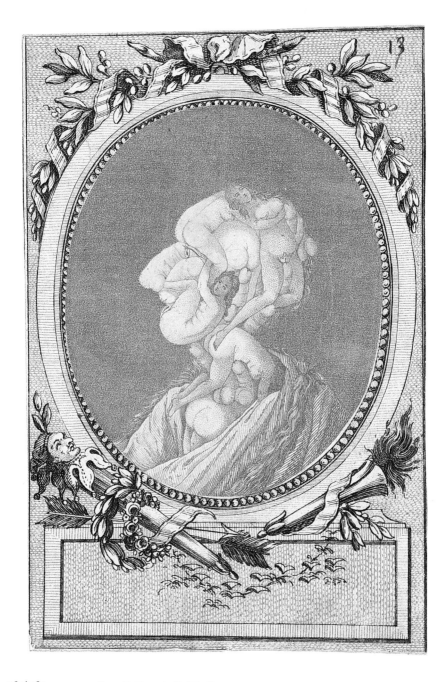

Sequel to the portrait of the Queen

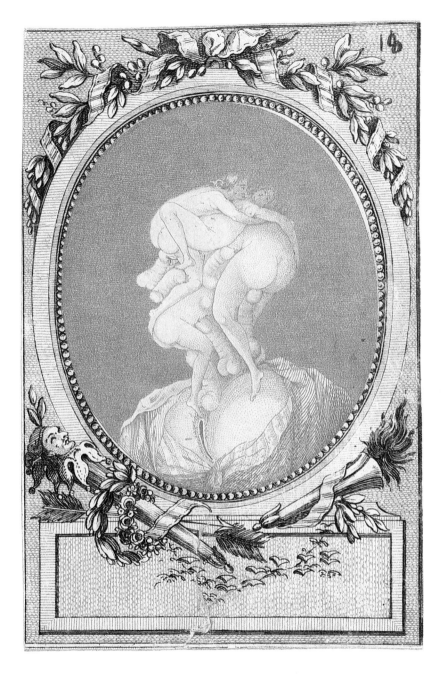

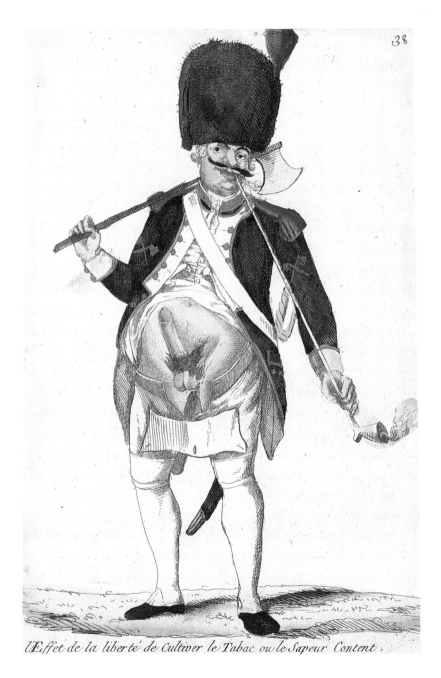

L'Effet de la liberté de Cultiver le Tabac ou le Sapeur Content.

Joke about the Sappers of the Garde Nationale

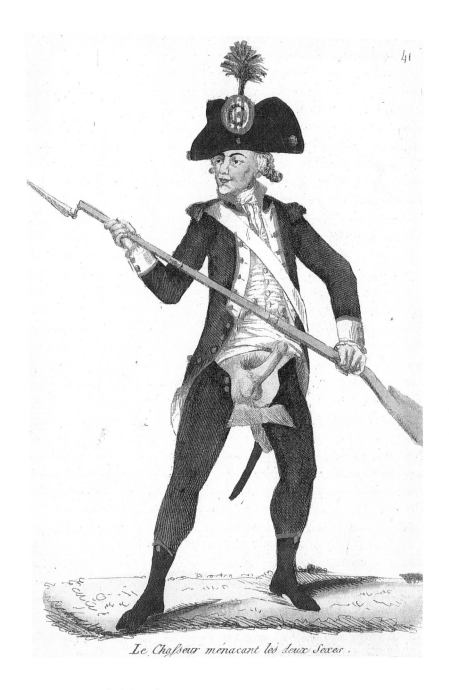

Le Chasseur menaçant les deux Sexes.

Against our *chasseurs*

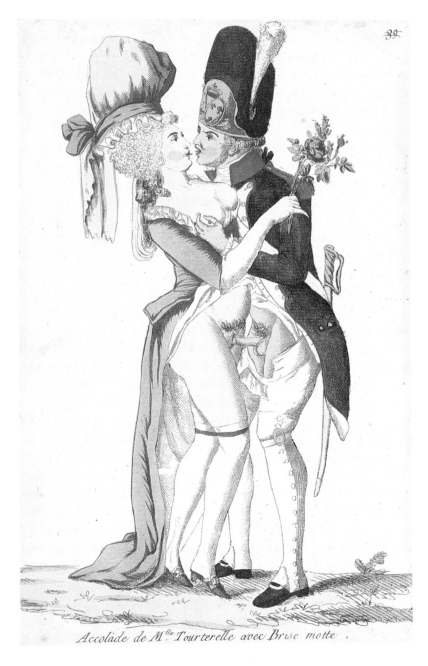

Accolade de M.ᵈˡᵉ Tourterelle avec Brise motte.

Obscene caricature of our national troops

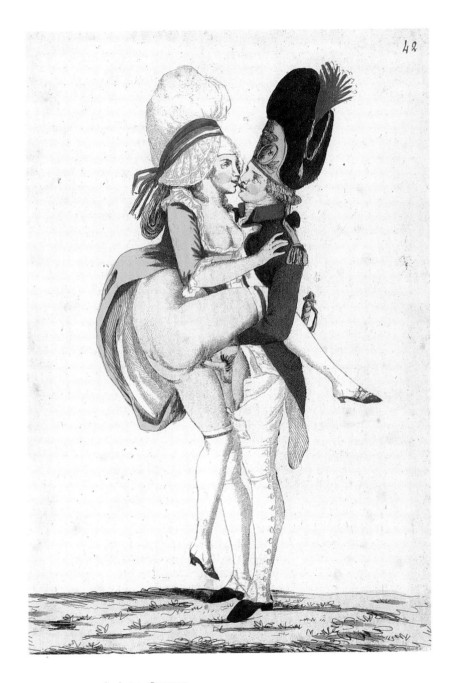

Against our Dragoons

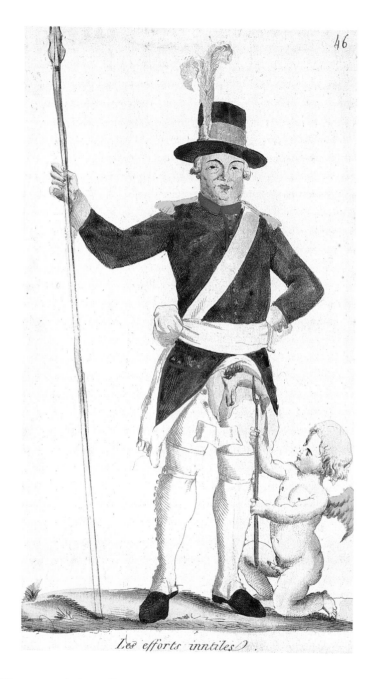

Les efforts inutiles.

Against our Veterans

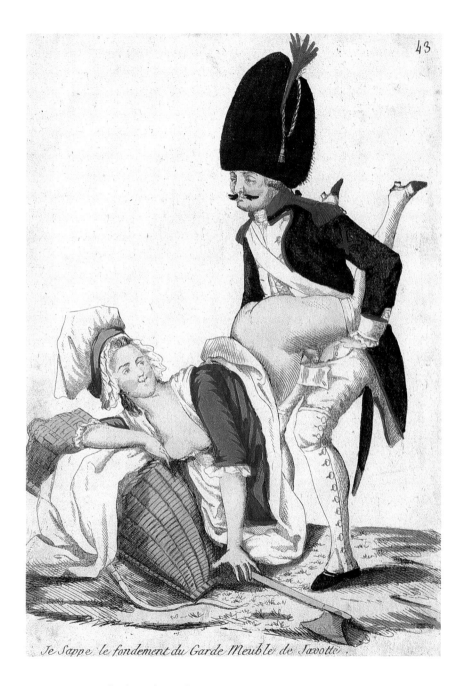

Je Sappe le fondement du Garde Meuble de Javotte.

Another against our Sappers

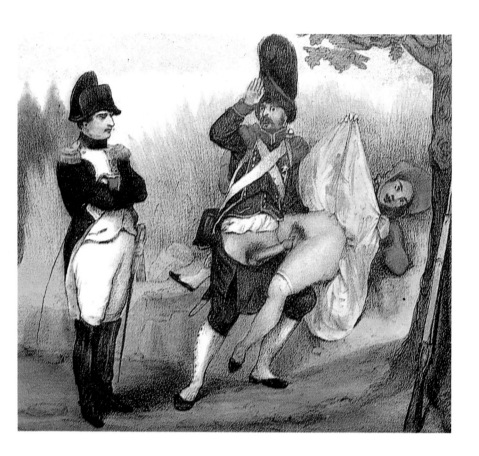

Anonymous Emperor, this is the Canteen Woman of the 2nd Hussars, France, c. 1830

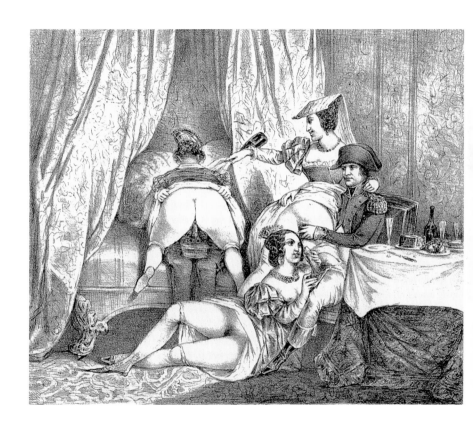

Anonymous Bonaparte in Italy (1796-1797 campaign), c. 1830

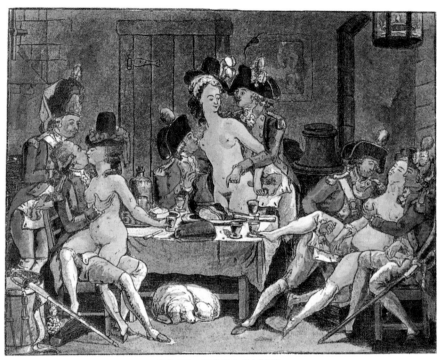

LA VEILLEE DU CORPS DE GARDE .

William C. B. *Les Bigarrures.* Sequence of compositions from the time of the Directory,
1799, (English? French? Vivan Denon, author of *No Tomorrow*, who founded the Musée

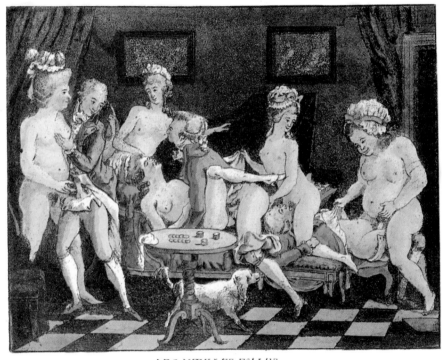

LES VIEILLES FOLLES

du Louvre under Napoléon after taking part in Bonaparte's Egyptian Expedition, has been suspected.)

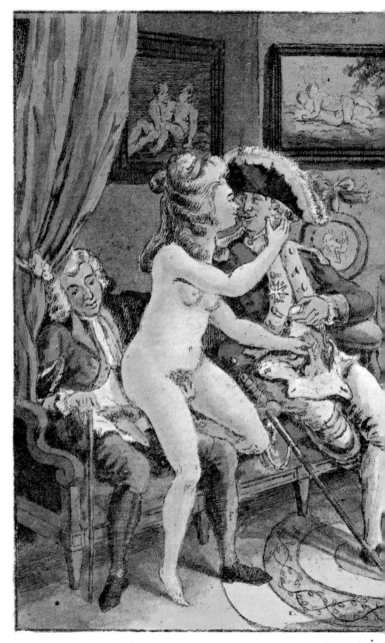

LES VIE

William C. B. *Les Bigarrures.* Sequence of compositions from the time of the Directory, 1799

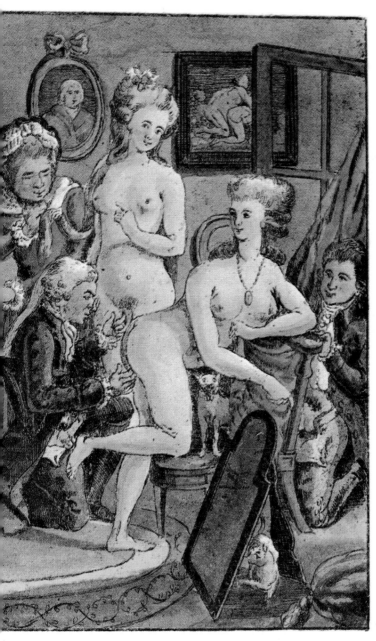

FO IX.

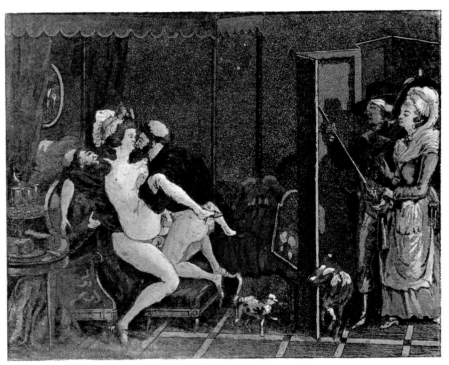

LE TROUBLE-FÊTE.

William C. B. *Les Bigarrures.* Sequence of compositions from the time of the Directory, 1799

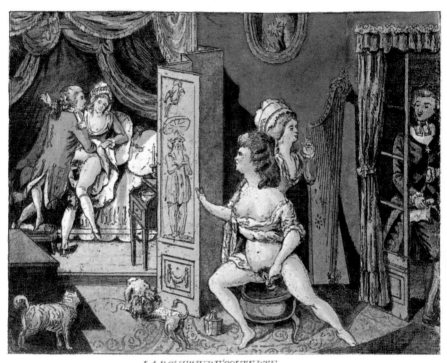

LA ROUERIE DÉCOUVERTE

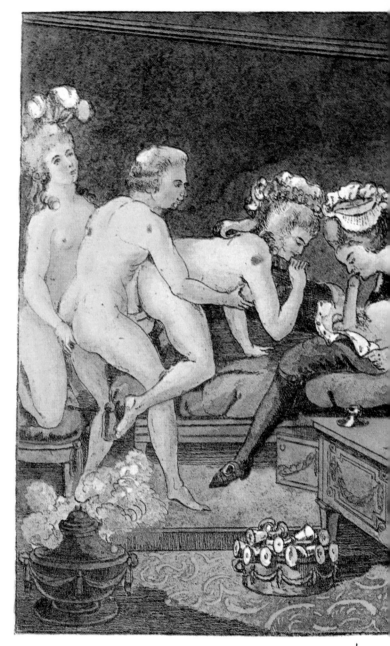

LA VEILLÉE I.

William C. B. *Les Bigarrures.* Sequence of compositions from the time of the Directory, 1799

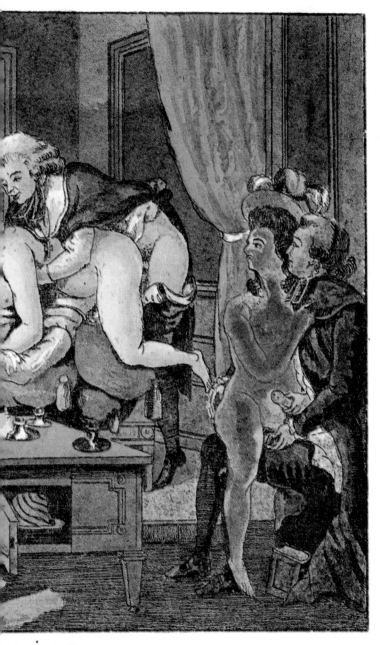

CHAPITRE .

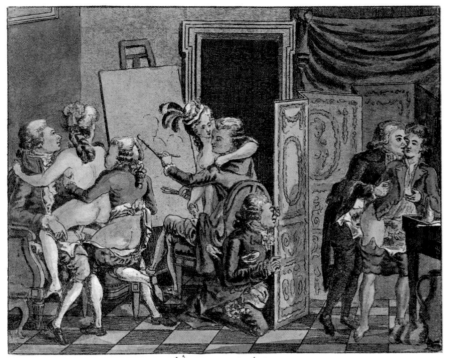

L'ÉCOLE ITALIENNE.

William C. B. *Les Bigarrures.* Sequence of compositions from the time of the Directory, 1799

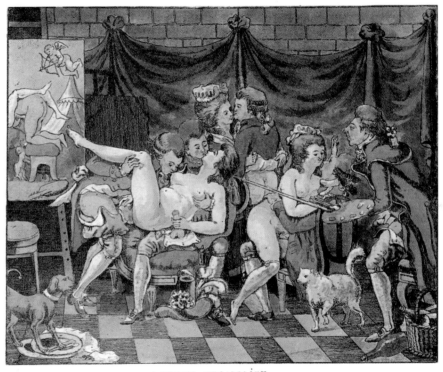

LECOLE FRANCAISE .

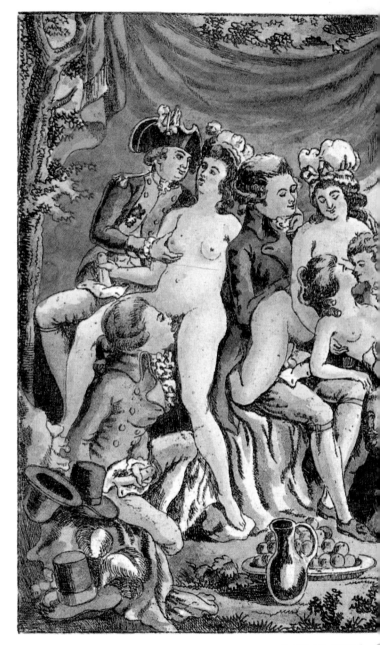

LE DOUX A

William C. B. *Les Bigarrures*. Sequence of compositions from the time of the Directory, 1799

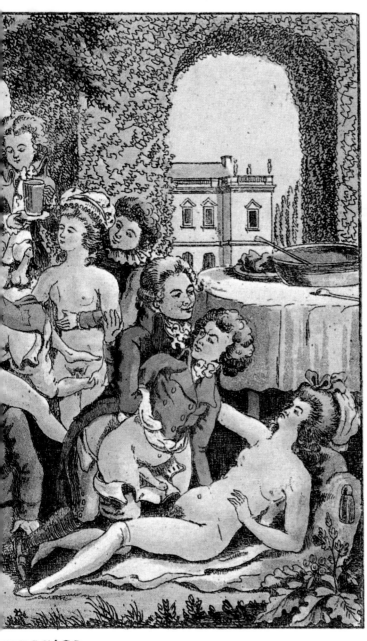

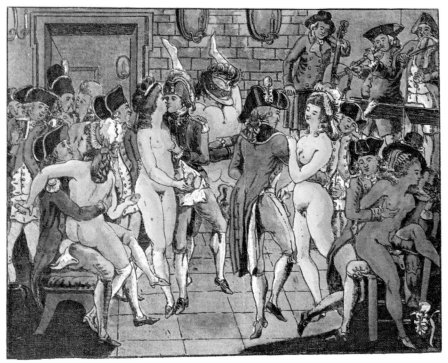

LE BAL DES LURONS

William C. B. *Les Bigarrures.* Sequence of compositions from the time of the Directory, 1799

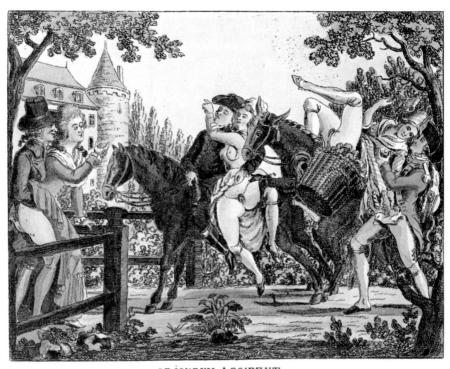

LE JOYEUX ACCIDENT.

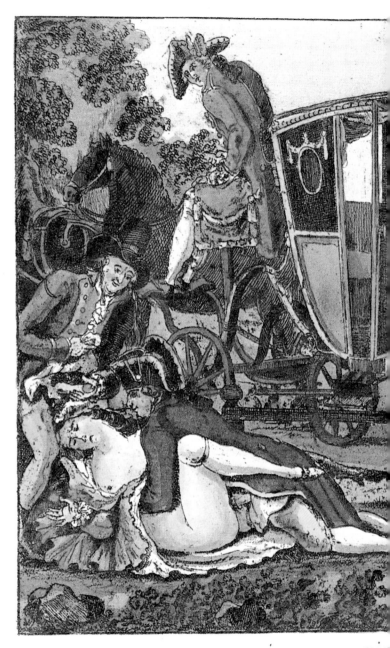

L'INSURRECTIO

William C. B. *Les Bigarrures*. Sequence of compositions from the time of the Directory, 1799

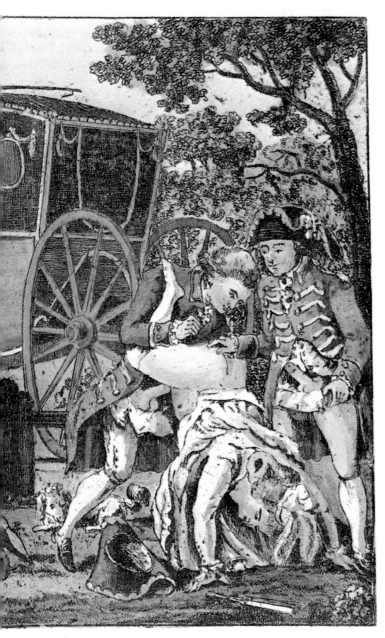

OMESTIQUE.

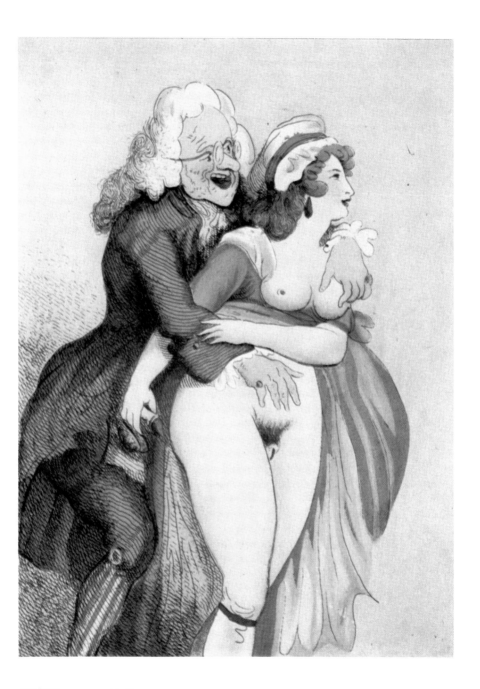

The Protector

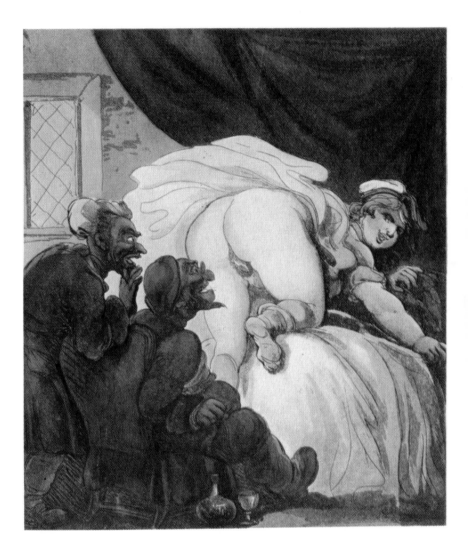

Thomas Rowlandson (1756–1827) Sequence of caricatures of the sexual practices of the English aristocracy taken from publications, 1808–1817

Susanna and the Elders

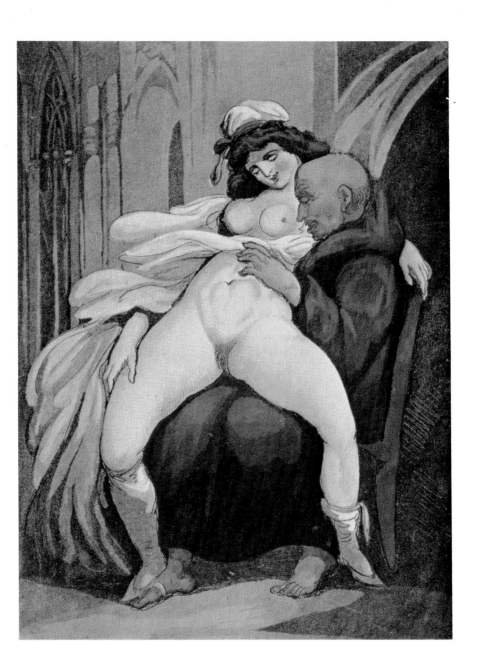

The Clergyman Quenched

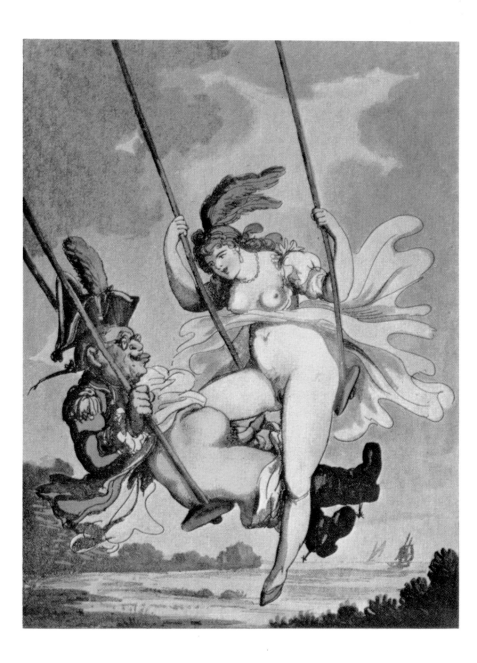

Playing on the Swing

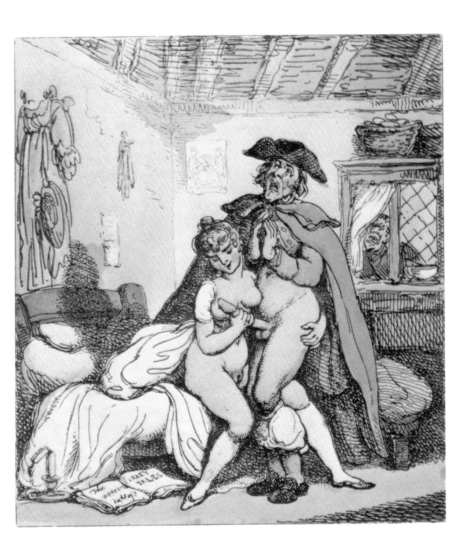

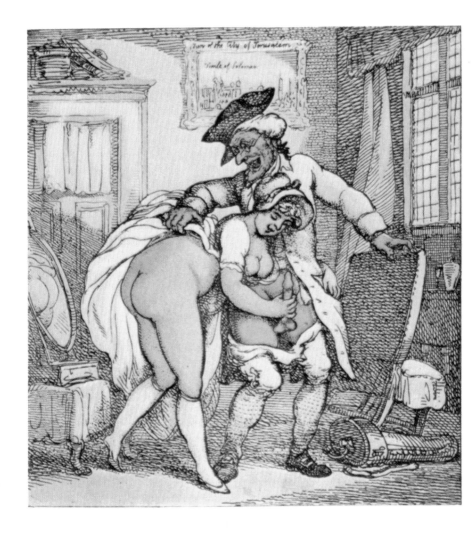

The Swerve

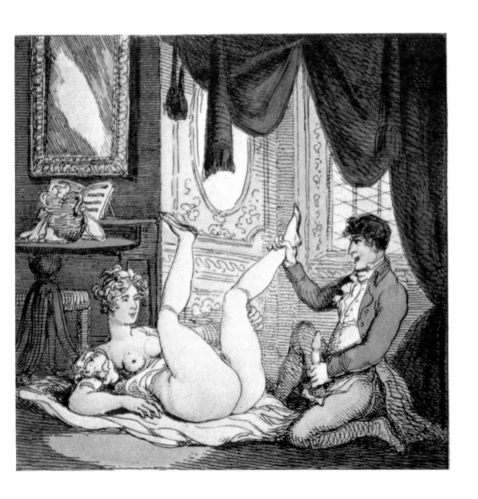

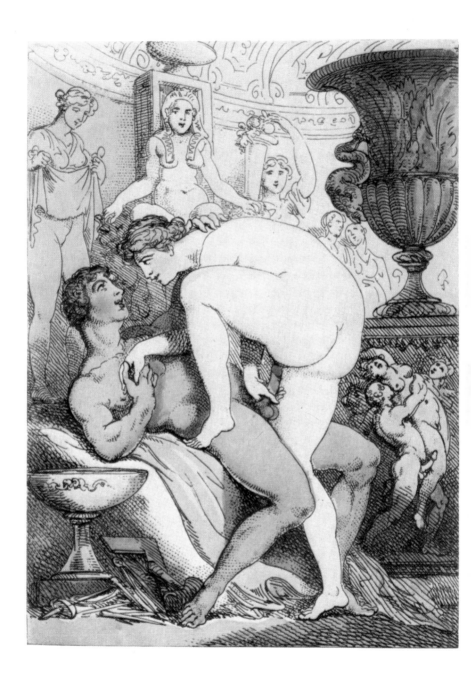

The Modern Pygmalion

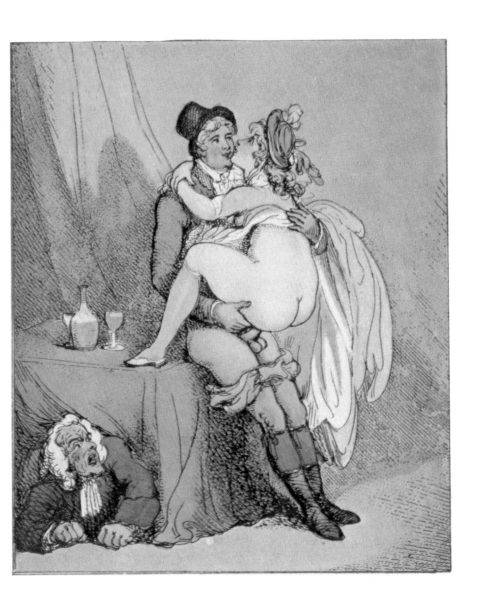

The Rightful Lover comes out of the Wings

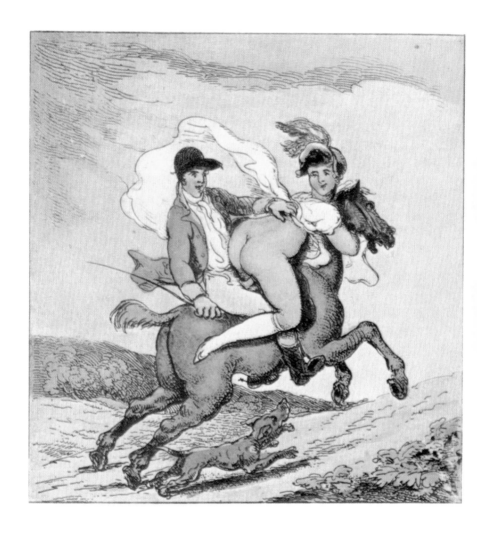

New Exploit in the Art of Equestrianism

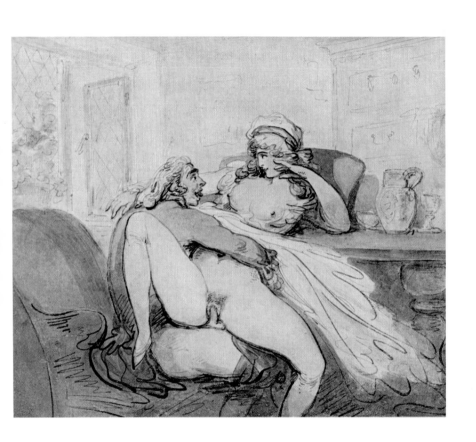

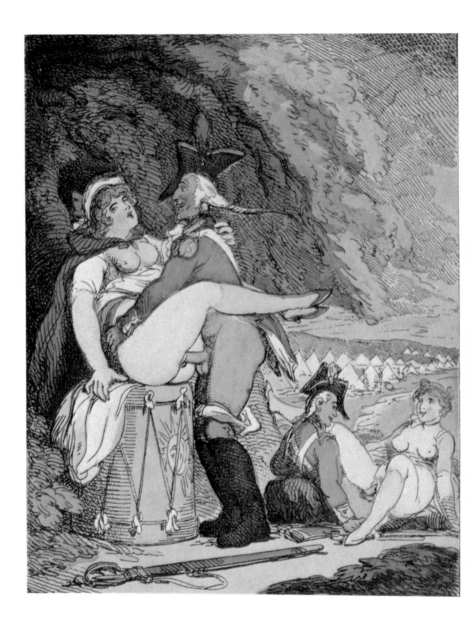

On the Battlefield

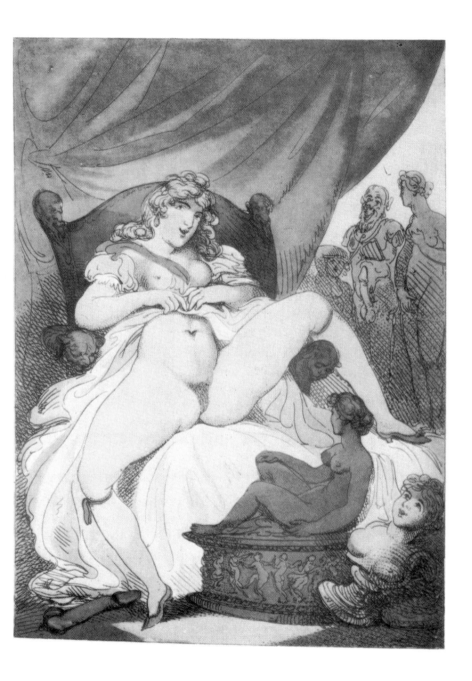

Solitary diversion

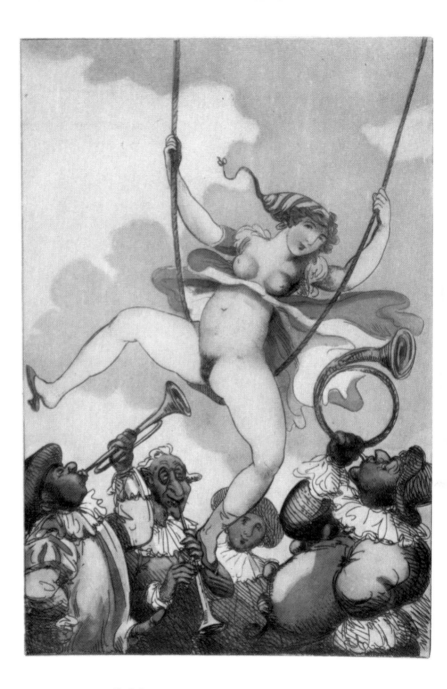

The Swing

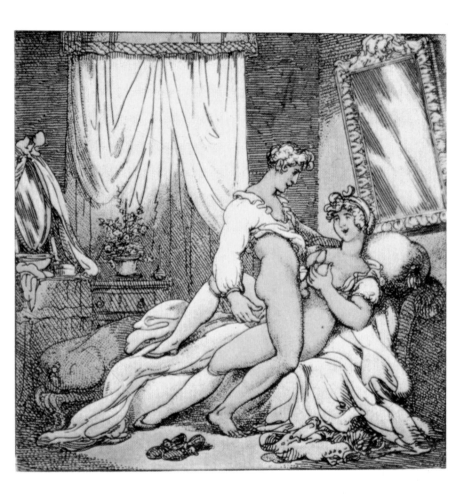

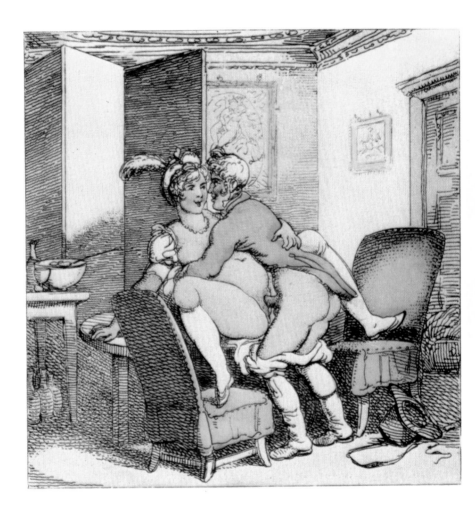

New Posture for a Gentleman

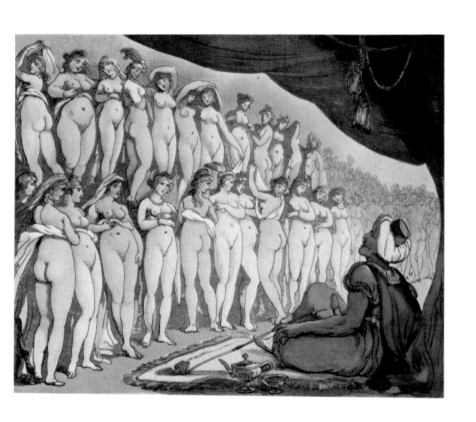

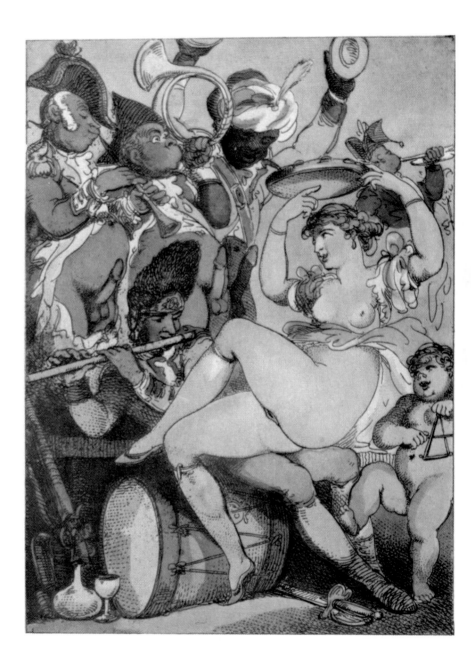

The Tambourine

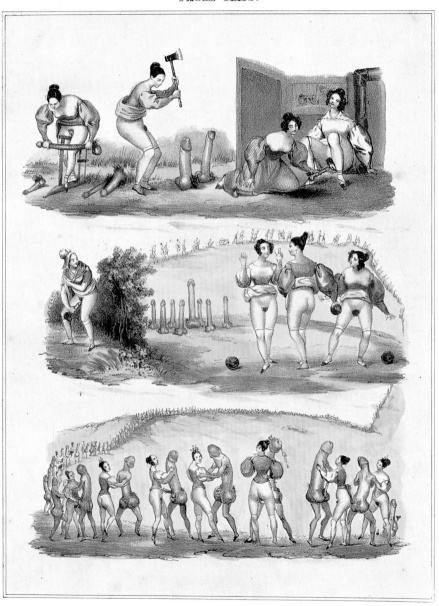

Eugène Le Poitevin (1806–1870) Lithography for the *Pastimes* series

IV
Erotica
Romantica

Pulling the Devil by the Tail

Romanticism brought back to life the medieval figure of Satan. The sorcerers dance around Goya's great black he-goat, while in the paintings of Delacroix, Faust and Mephistopheles gallop in tandem. Artists took up the theme of the erotico-diabolic, ascribing to the devil a lubriciousness and ribaldry for which he had not previously been noted. The theological intentions of the demonic Gothic gargoyles were put aside; Romanticism was returning to pagan sources, to Pan, to the Cabiri, to the phallus. Gigantic, turgescent, Herculean, ready for combat, the phallus is the true hero of these images, which were intended to set off frank, joyful laughter.

Den Teufel am Schwanz packen

Die Romantik ließ die Gestalt des mittelalterlichen Satans auferstehen. Bei Goya tanzen die Hexenmeister um den großen schwarzen Ziegenbock, während sich Faust und Mephisto auf den Gemälden Delacroix' einträchtig tummeln. Die Künstler stürzten sich auf das Thema der teuflischen Erotik und verpaßten dem Dämon einen geilen und schlüpfrigen Charakter, den er bis dahin nicht hatte. In der Romantik heißt es: weg mit den theologischen Absichten, die sich in den dämonischen Fratzen der gotischen Wasserspeier manifestieren. Hier haben wir es mit der Rückkehr zu den heidnischen Quellen zu tun, zu Pan, zu den Kabiren, zum Phallus. Gigantisch, schwellend, kampfbereit, ein Herkules, ist der Phallus in der Tat der wahre Held dieser Bilder, die ein freies und lustvolles Lachen entfesseln sollen.

Le diable par la queue

Le Romantisme a fait revivre la figure du Satan médiéval. Les sorciers tournent autour du grand bouc noir de Goya tandis que Faust et Méphistophélès caracolent de concert sur les toiles de Delacroix. Des artistes se sont attaqués au thème érotico-diabolique donnant au démon un caractère lubrique et égrillard qu'il n'avait pas jusquelà. Avec le Romantisme, foin des intentions théologiques des gargouilles gothiques démoniaques. Il s'agit d'un retour aux sources païennes, à Pan, aux cabires, au phallus. Gigantesque, turgescent, herculéen, prêt au combat, le phallus est en effet le véritable héros de ces images destinées à déchaîner un rire franc et joyeux.

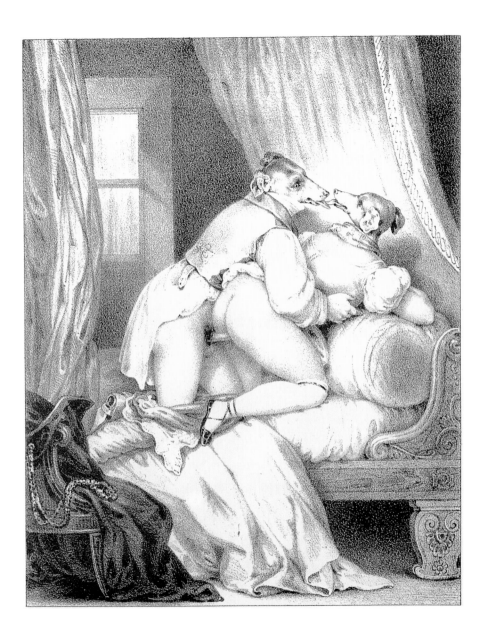

Jean J. Grandville Dog Love, 1831–1835

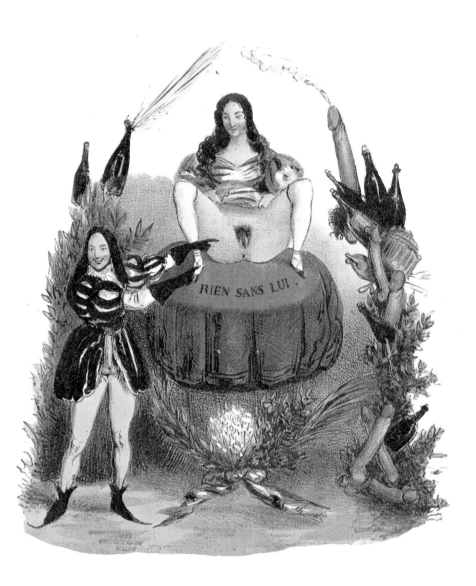

Sequence of anonymous engravings for the *Musée des Familles*, 1840: Without it nothing

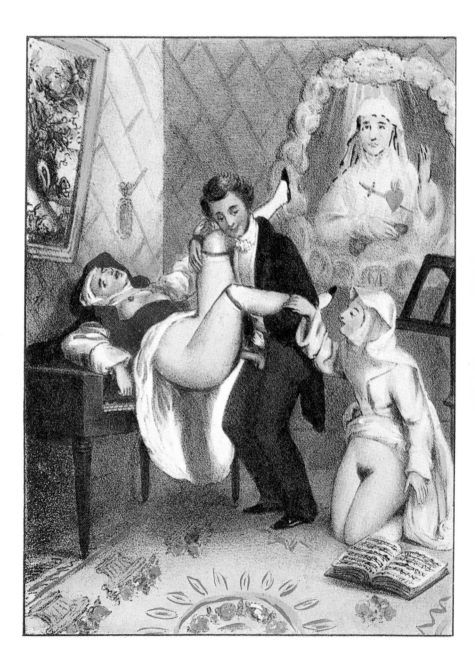

The Music Master

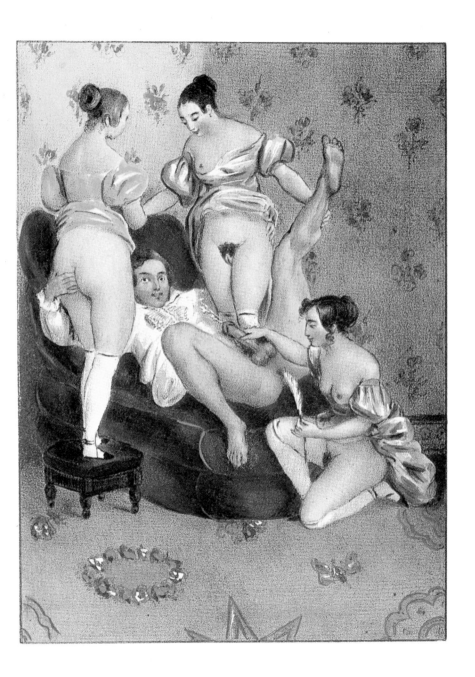

God what a come

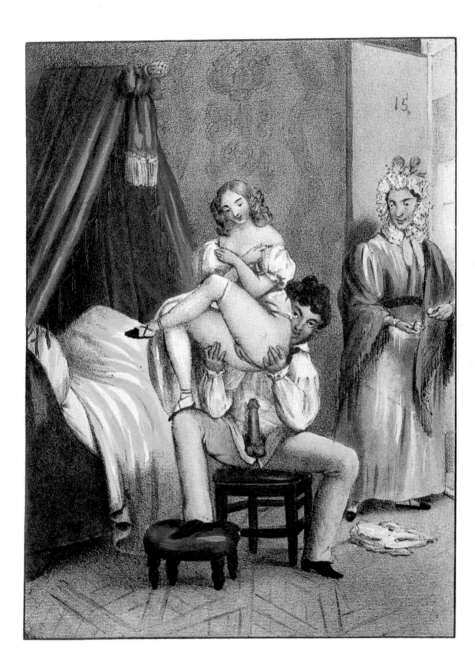

The good mother

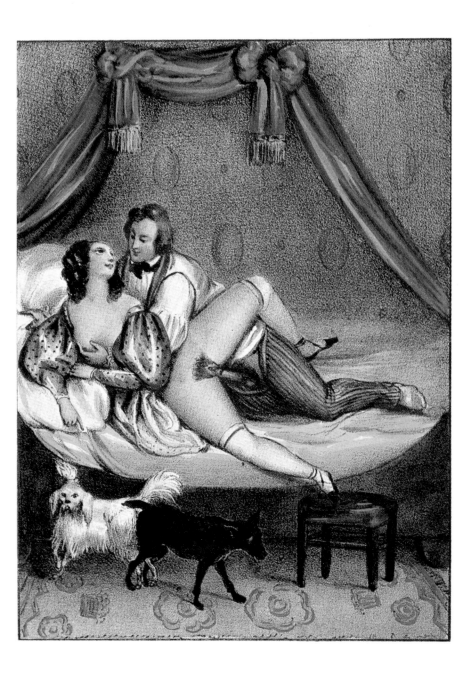

The good example

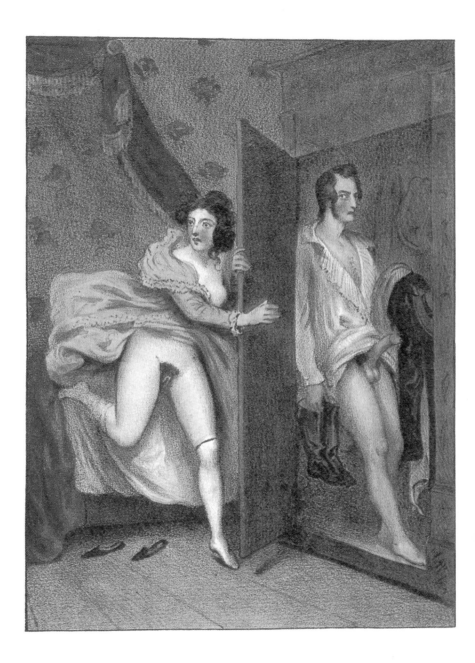

It is he !!

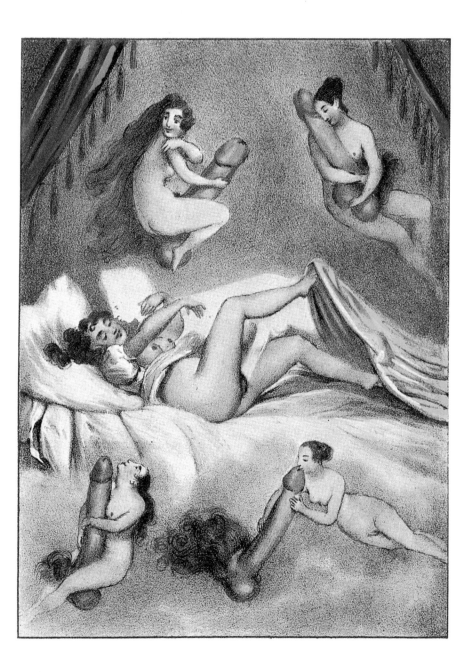

The Virgin's Dream

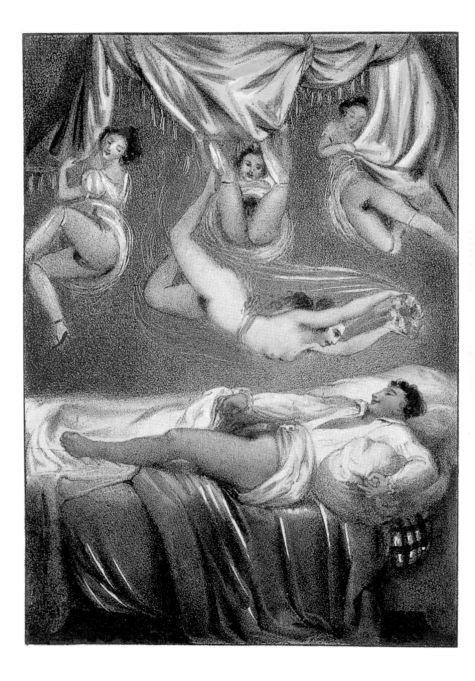

The Wet Dream

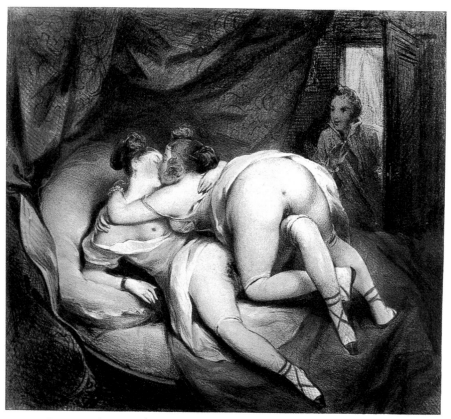

Epuisée, abattue, Fanny laissa tomber ses bras pâles, elle restait insensible comme une belle morte. la Comtesse délirait, le plaisir la tuait et ne l'achevait pas.

Sequence of lithographies attributed to **Achille Deveria** for the obscene novel by Alfred de Musset: *Gamiani or A Night of Excess*, c. 1848

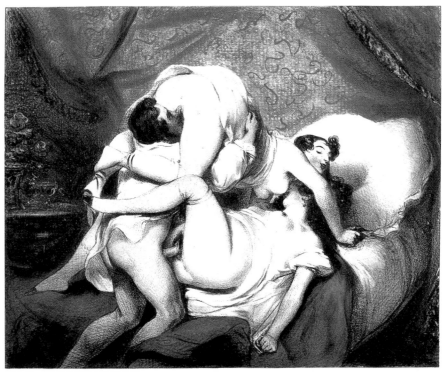

Sans rien perdre de ma position, je parvins à saisir fortement les cuisses de la Comtesse, et les tenant élevées au dessus de ma tête, je portai à loisir, une langue active et dévorante sur sa partie en feu.

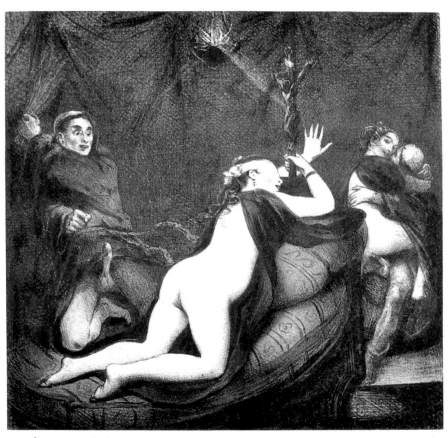

À travers le bruit de mes coups, j'entendais confusément des cris, des éclats, des mains frappant sur des chairs, c'étaient aussi des rires insensés, rires nerveux, convulsifs, précurseurs de la joie des sens.

Sequence of lithographies attributed to **Achille Deveria** for the obscene novel by Alfred de Musset: *Gamiani or A Night of Excess*, c. 1848

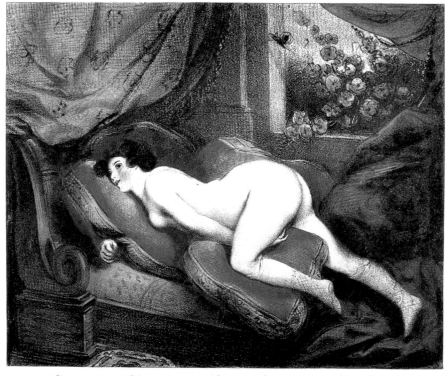

Je m'arrête, je frémis, il me semble que je fonds que je m'abîme, ah! m'écriai-je
mon dieu, ah! ah! d je me relevai subitement épouvantée, j'étais toute mouillée.

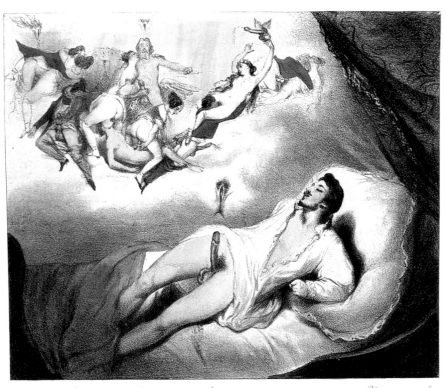

*Mes souvenirs classiques se mêlant un instant à mes rêves, je vis Jupiter en feu,
Junon maniant sa foudre, je vis tout l'Olympe en rut dans un désordre, un pêle-mêle
étranges.*

Sequence of lithographies attributed to **Achille Deveria** for the obscene novel by Alfred
de Musset: *Gamiani or A Night of Excess*, c. 1848

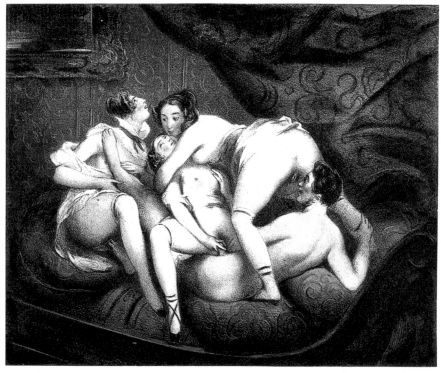

Et voilà que chacun se meut, s'agite, s'excite au plaisir, je dévore des yeux cette scène animée; m.. deux mains battent une gorge brûlante ou se portent frénétiques sur des charmes plus secrets encore.

Sequence of lithographies attributed to **Achille Deveria** for the obscene novel by Alfred de Musset: *Gamiani or A Night of Excess*, c. 1848

Sequence of lithographies attributed to **Achille Deveria** for the obscene novel by Alfred
de Musset: *Gamiani or A Night of Excess*, c. 1848

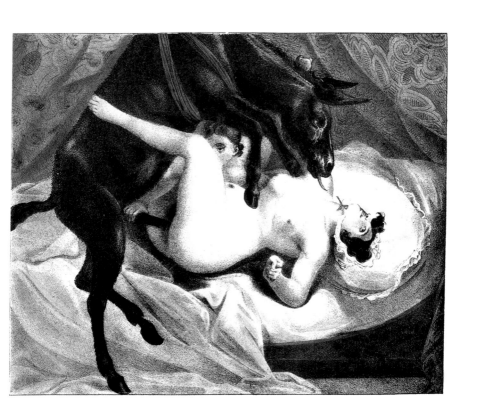

Sequence of lithographies attributed to **Achille Deveria** for the obscene novel by Alfred
de Musset: *Gamiani or A Night of Excess*, c. 1848

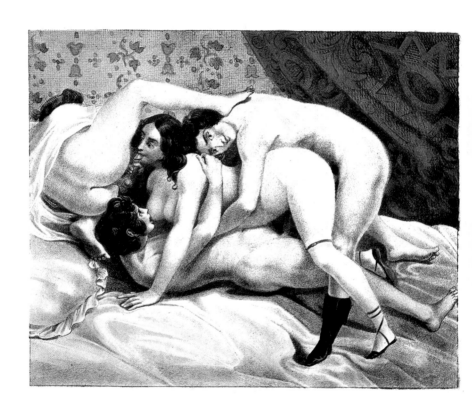

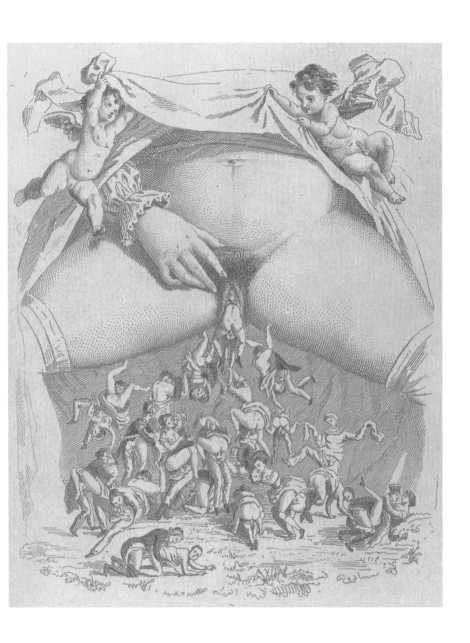

Jules Adolphe Chauvet The Centre of the World, c. 1848

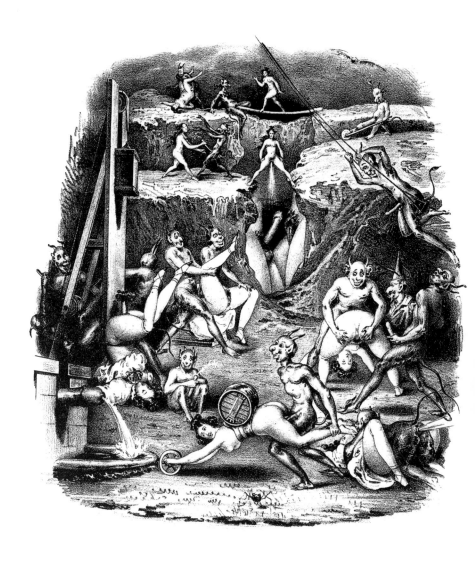

Achille Deveria Diabolico Foutro Manie. Sequence of lithographies on the history of morals under Louis-Philippe, c. 1835

Achille Deveria Diabolico Foutro Manie, c. 1835

Achille Deveria Diabolico Foutro Manie, c. 1835

Achille Deveria Diabolico Foutro Manie, c. 1835

Achille Deveria Diabolico Foutro Manie, c. 1835

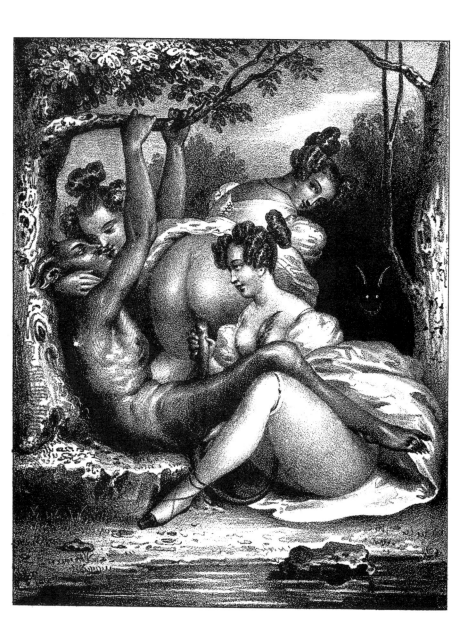

Achille Deveria Diabolico Foutro Manie, c. 1835

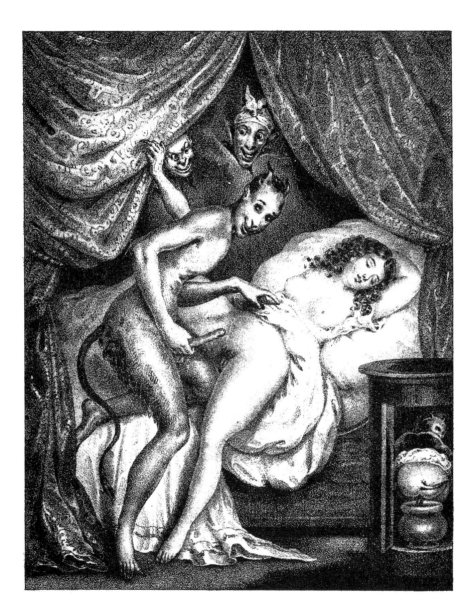

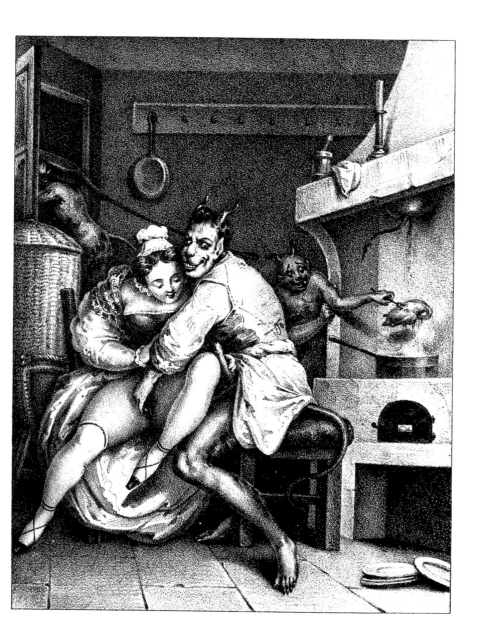

Achille Deveria Diabolico Foutro Manie, c. 1835

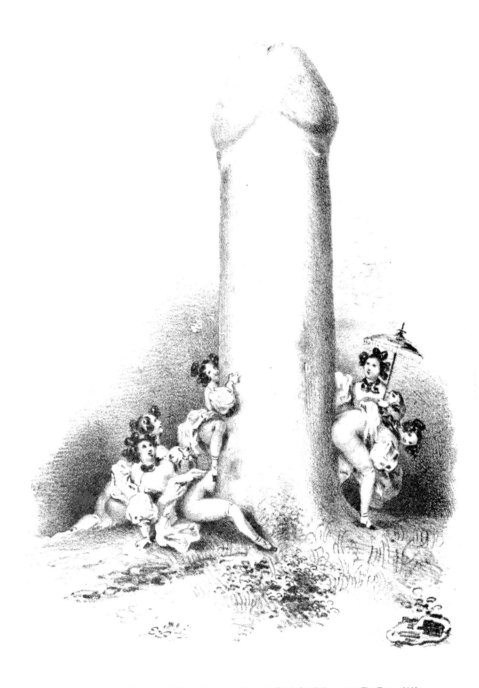

Eugène Le Poitevin from the sequence *Erotic Deviltries*, 1832: The Tree of Life

Everyone shall have one

Pulling the Devil by the tail

The New Cup and Ball, with the new way of using it

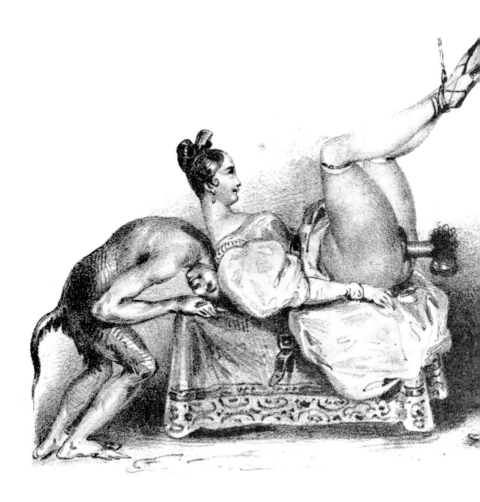

Deflowering

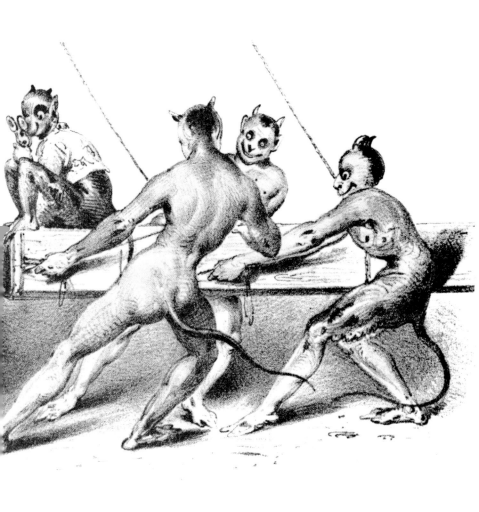

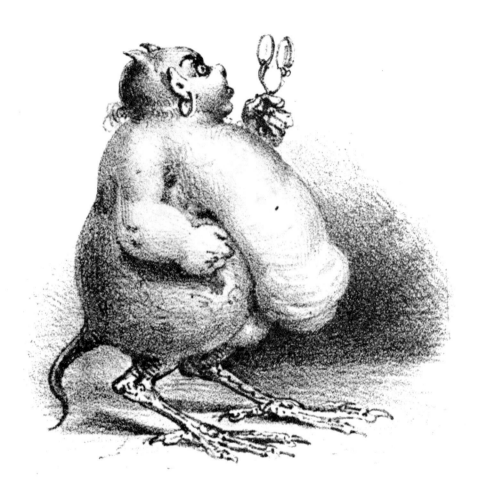

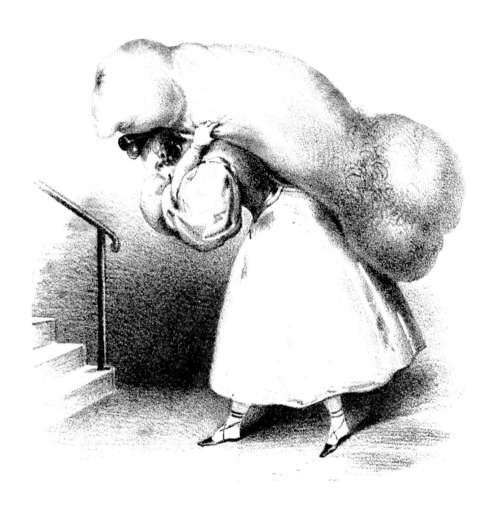

A Trouvaille

It's Biting

The Swimming School

The Great Hunt

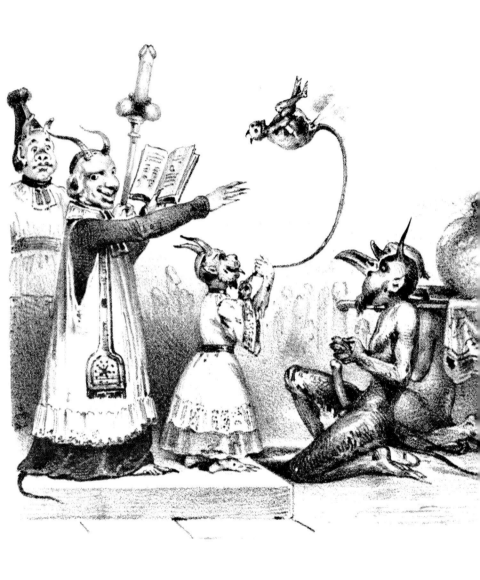

The Loss of a Member

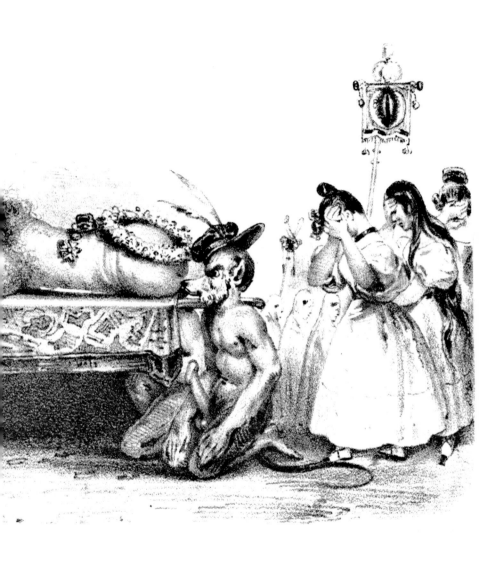

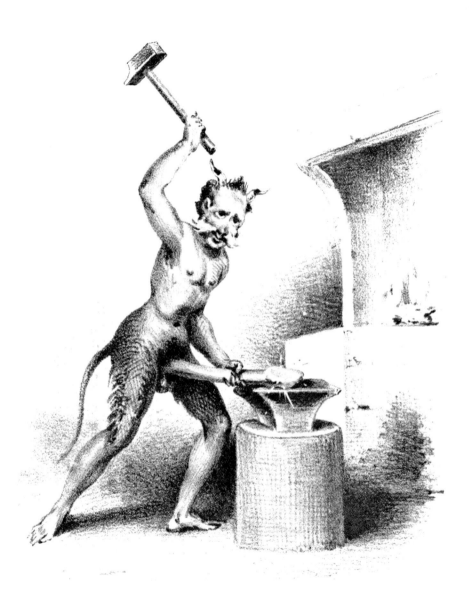

Bitch of a Prick

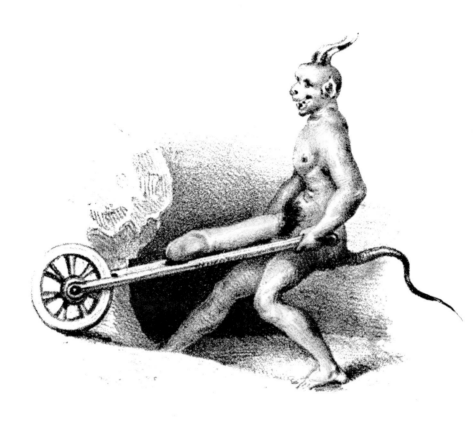

A Large Affair

Diabolic Dew

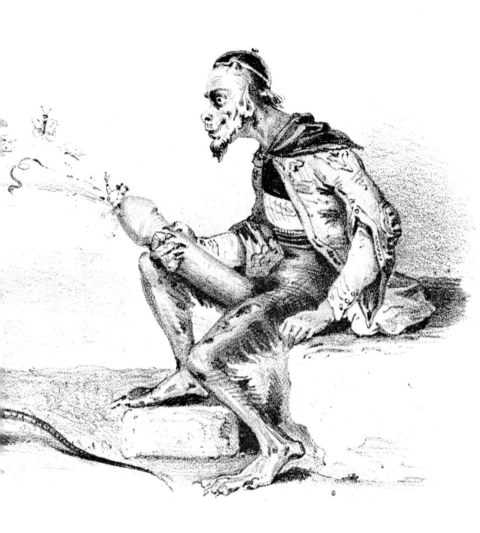

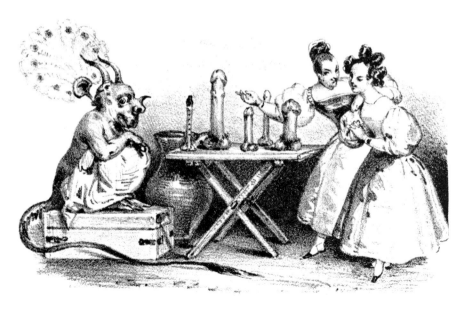

462 | 463 The Unruly Fountain
The Choice in the Shop

Good and Evil

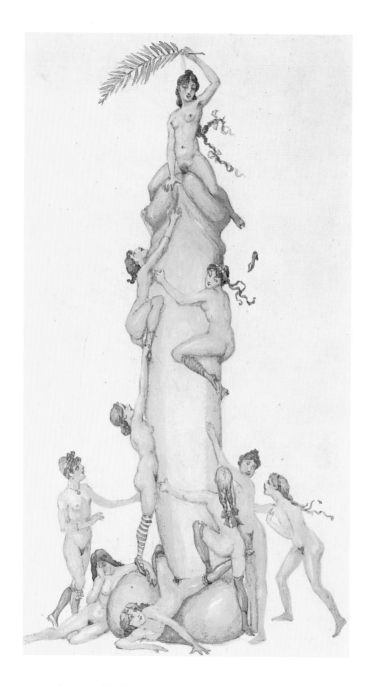

Anonymous The Big Stake, Holland, c. 1900

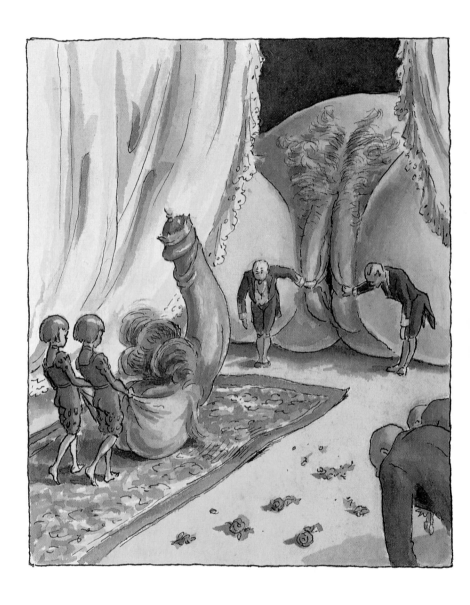

Anonymous The Sovereign's Entrance, Germany, c. 1900

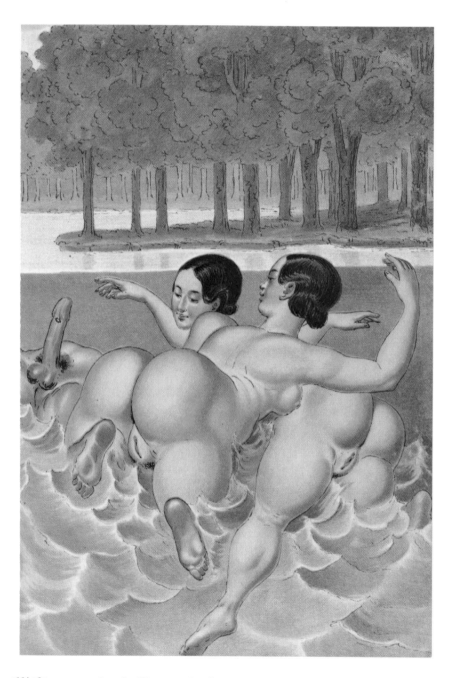

Peter Fendi Sequence of erotic scenes, c. 1835

Peter Fendi Sequence of erotic scenes, c. 1835

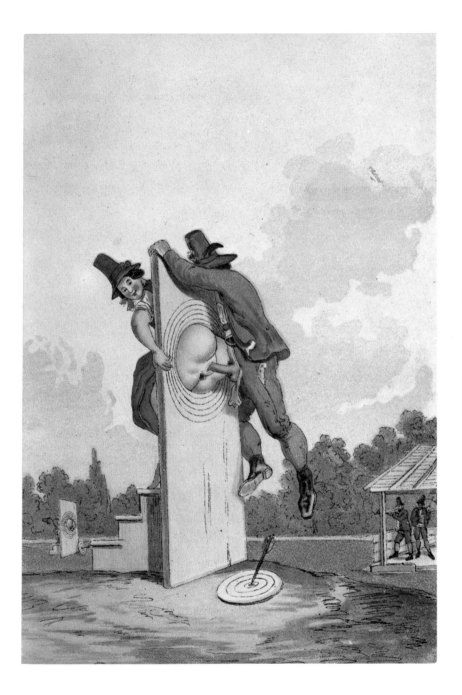

Peter Fendi Sequence of erotic scenes, c. 1835

Peter Fendi Sequence of erotic scenes, c. 1835

Peter Fendi Sequence of erotic scenes, c. 1835

Peter Fendi Sequence of erotic scenes, c. 1835

Peter Fendi Sequence of erotic scenes, c. 1835

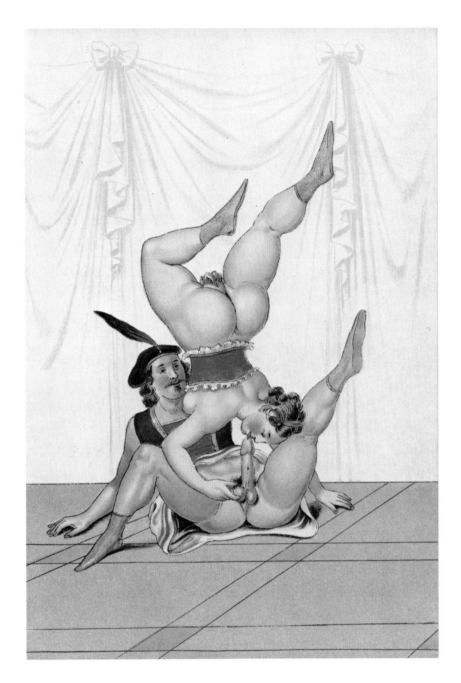

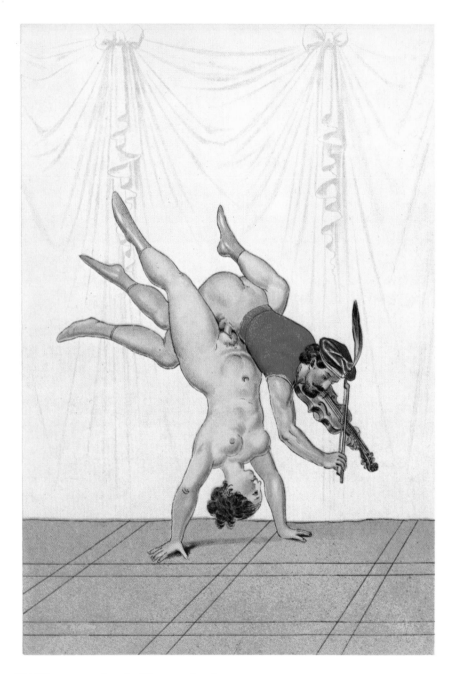

Peter Fendi Sequence of erotic scenes, c. 1835

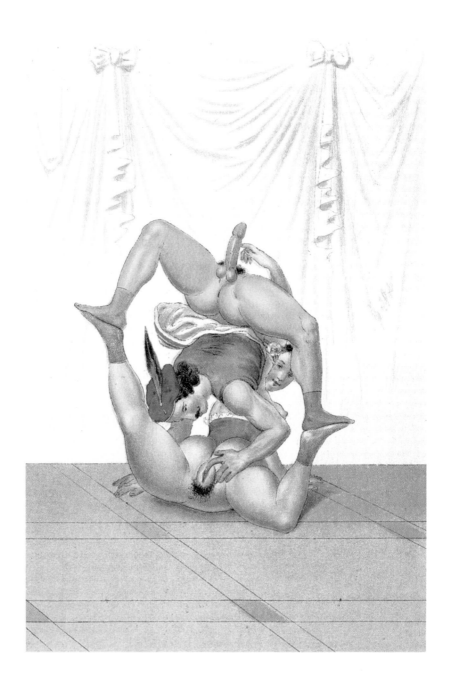

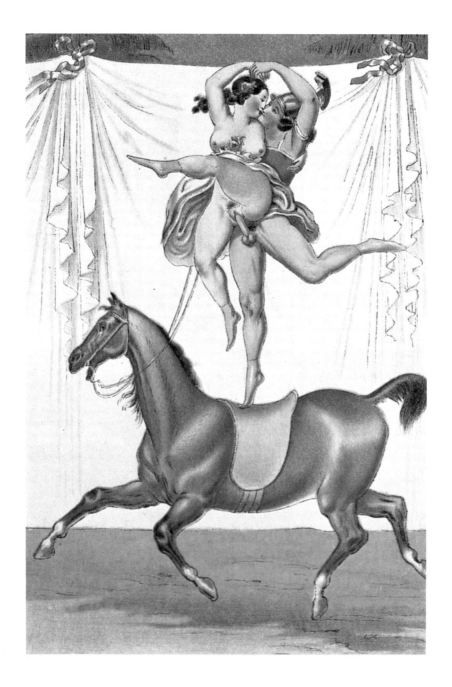

Peter Fendi Sequence of erotic scenes, c. 1835

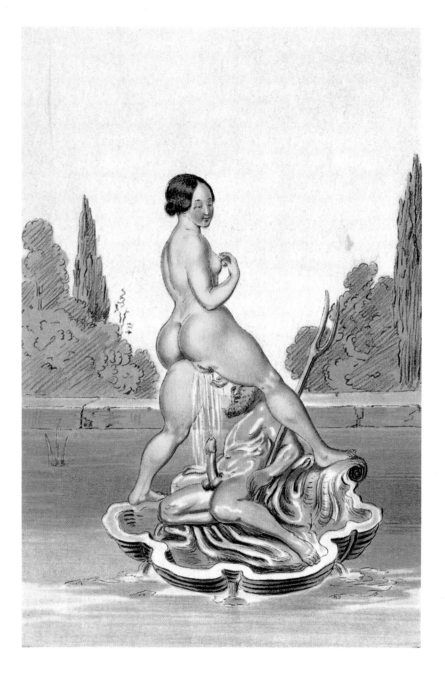

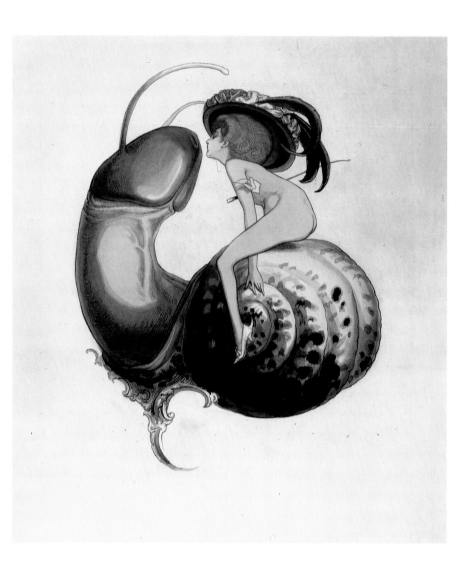

　　Franz von Bayros Sweet Snail, c. 1909

V
Erotica
Artis Novae

The Dandies of Art Nouveau

At the end of the 19th Century, confronted with an Industrial Revolution, which had enthroned the power of the bourgeoisie, Romanticism took on an extreme form: decadence. In the name of decorum, Victorian society required that the debauchery to which it was secretly addicted be passed over in silence. A new race of artists focused on the object of this repression: sexuality. Their strategy? Dandyism: making the most scabrous subject as beautiful as possible. The female body was evoked in terms of the tarantula lurking at the heart of the luxuriant exotic flower. For woman was now seen as being essentially demonic. It was the devil that had bestowed on her the gift of temptation.

Die Dandys des Jugendstil

Ende des 19. Jahrhunderts, angesichts der industriellen Revolution, angeführt von einer mächtig gewordenen Bourgeoisie, entwickelte die Romantik ihre extremste Ausprägung, die Dekadenz. Im Namen des Anstands bewahrte die viktorianische Gesellschaft Stillschweigen über die heimlichen Schandtaten des Bourgeois. Eine neue Künstlergeneration stürzte sich auf den Gegenstand dieser Repression: auf die Sexualität. Ihre Seele? Das Dandytum. Ihr Anliegen: das Anstößigste so schön wie möglich darzustellen. Den weiblichen Körper als Giftspinne zu zeigen, die im Inneren der schönsten exotischen Blüten nistet. Denn die Frau ist dämonisch, vom Teufel mit der Gabe der Verführung ausgestattet.

Les dandys du style nouille

A la fin du XIXe siècle, la décadence est une forme extrême du Romantisme, face à la révolution industrielle que mène une bourgeoisie devenue toute puissante. Au nom de la décence, les conventions de la société victorienne imposent le silence sur les turpitudes auxquelles elle se livre en secret. Une nouvelle race d'artistes s'attaque à l'objet de cette répression: la sexualité. Son arme? Le dandysme. Rendre le sujet le plus scabreux aussi beau que possible. Evoquer le corps féminin et ses attributs à l'image des mygales vénéneuses nichées au cœur des plus belles fleurs exotiques. Car la femme est d'essence diabolique. C'est le démon qui l'a pourvue du don de tentation.

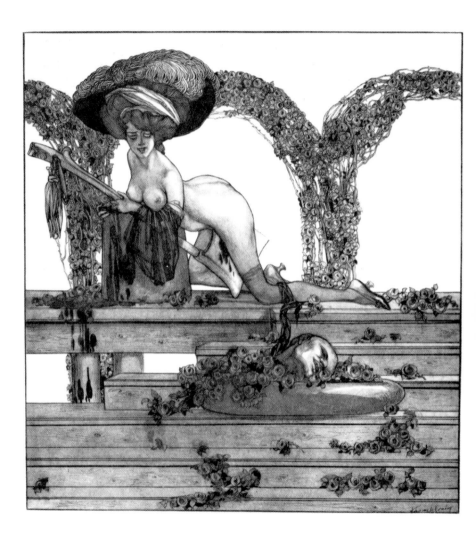

Franz von Bayros (1866–1924) Illustration for the Boudoir of Madame CC, c. 1900

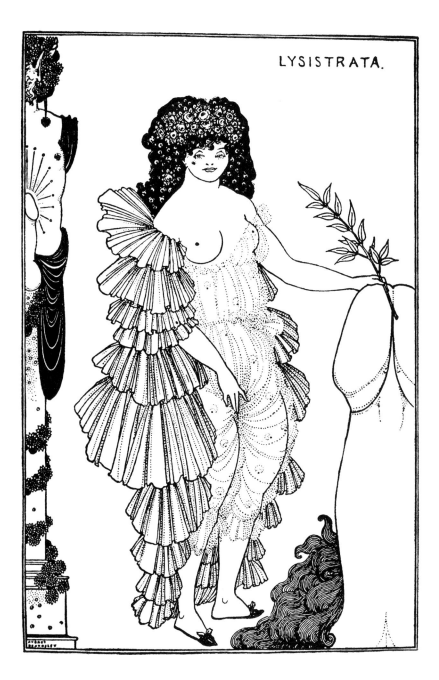

LYSISTRATA.

Aubrey Beardsley Frontispiece for the sequence of illustrations for Aristophanes'
Lysistrata: Lysistrata Shielding her Coynte. 1896

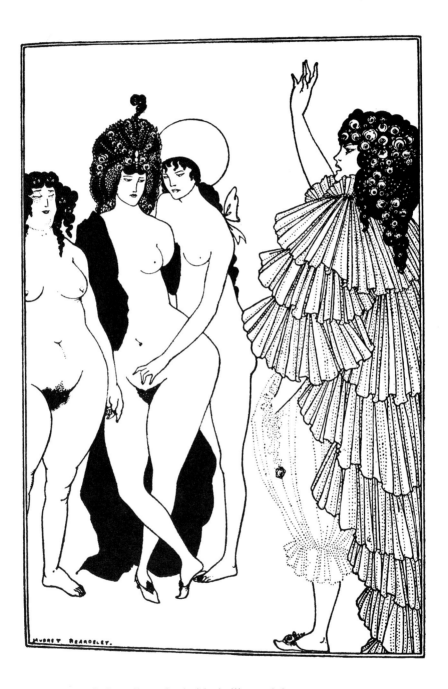

Lysistrata Haranguing the Athenian Women, 1896

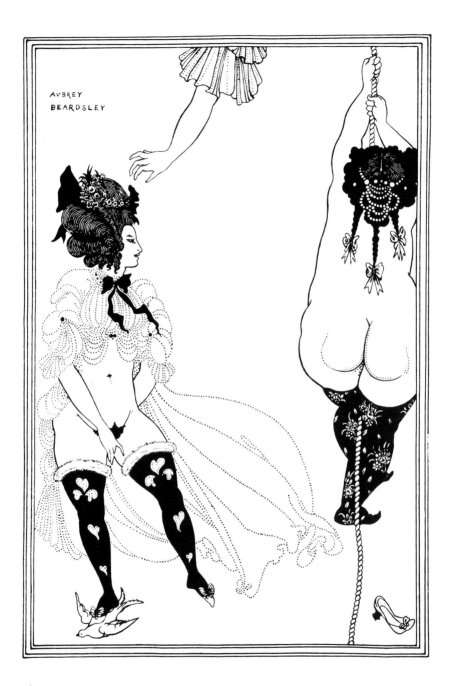

AUBREY
BEARDSLEY

Two Athenian Women in Distress, 1896

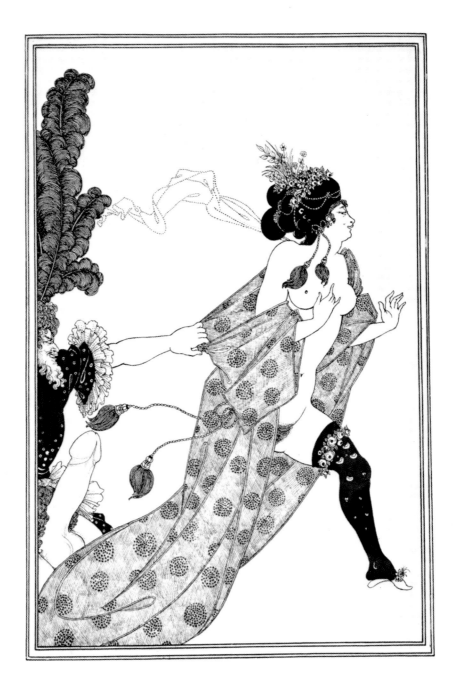

Cinesias Entreating Myrrhina to Coition, 1896

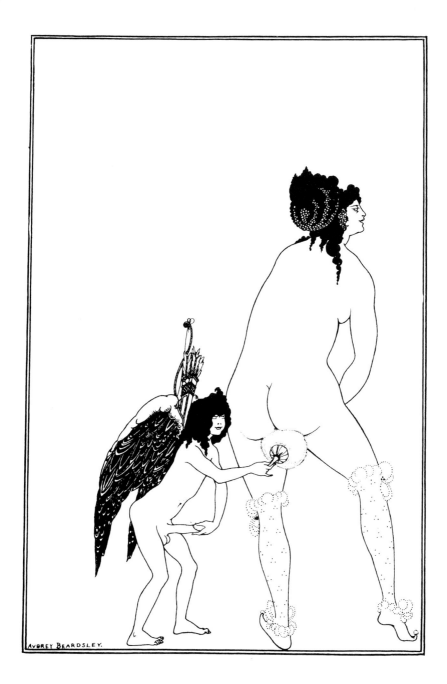

AUBREY BEARDSLEY.

The Toilet of Lampito, 1896

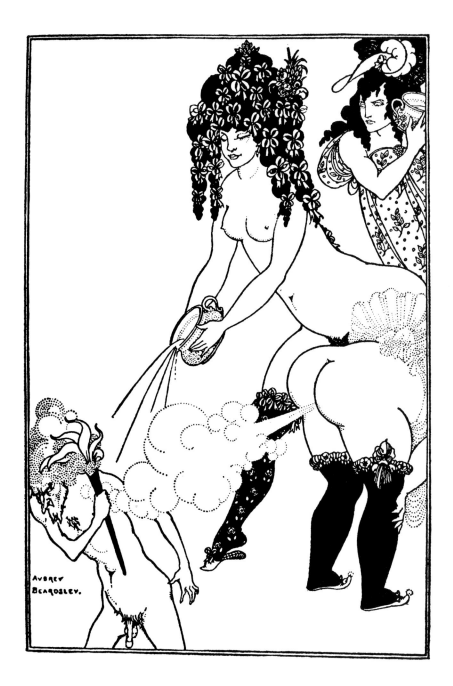

Lysistrata Defending the Acropolis, 1896

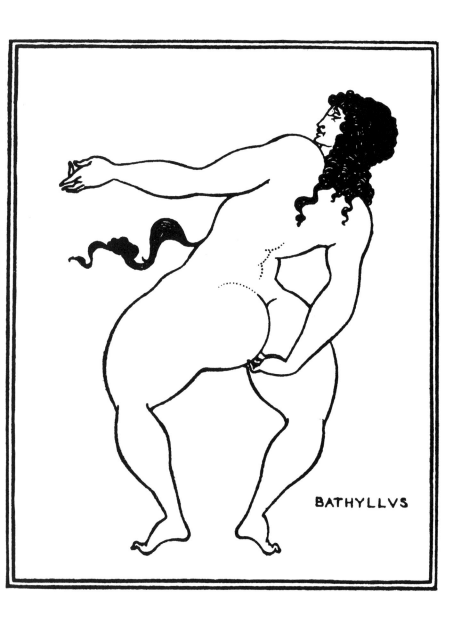

BATHYLLVS

Bathyllus Taking the Pose, 1896

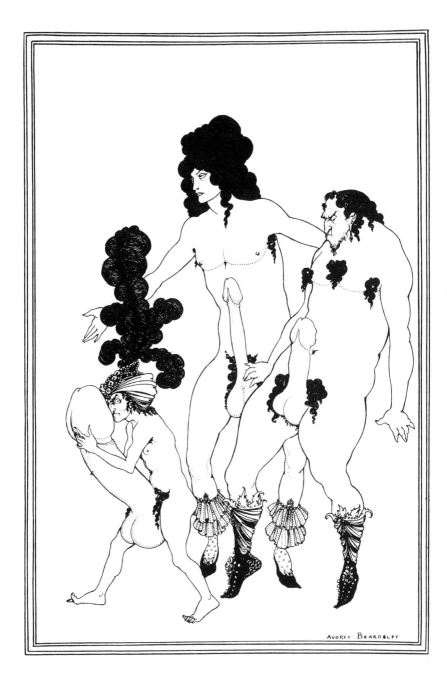

The Lacedaemonian Ambassadors, 1896

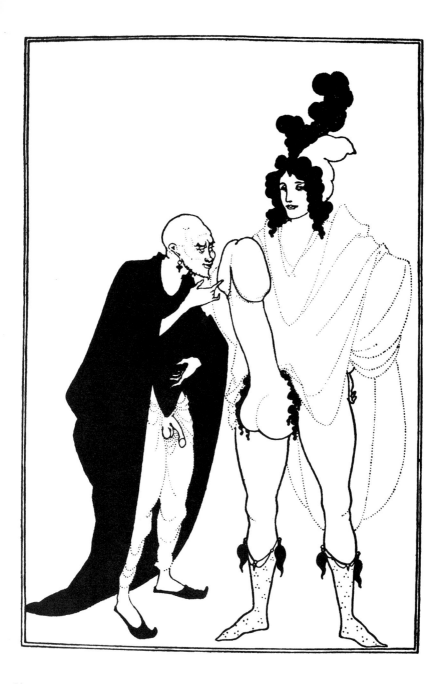

The Examination of the Herald, 1896

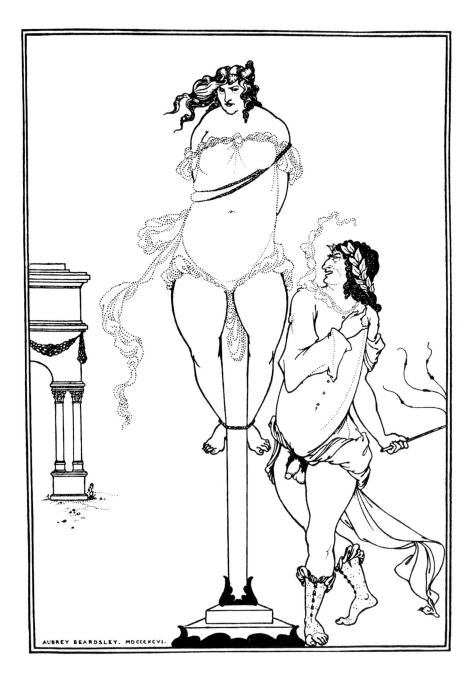

Juvenal whipping a woman. Drawing to illustrate Juvenal and Lucian, 1897

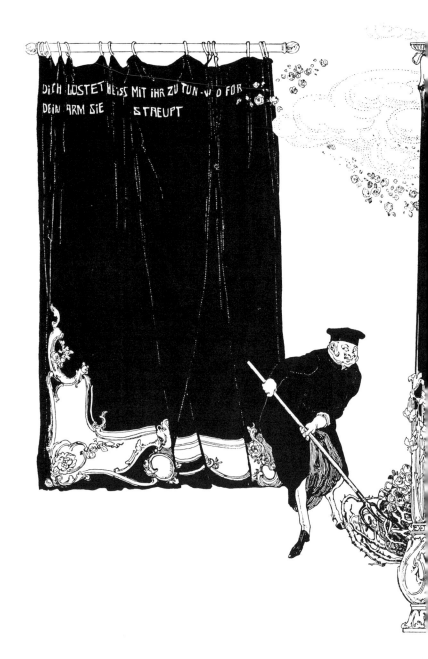

Text within image:
DICH LÜSTET HEISS MIT IHR ZU TUN · WO FÜR
DEIN ARM SIE STREUPT

Franz von Bayros (1866–1924) Frontispiece for the sequence of Amorous Drawings by the
Marquis von Bayros, 1907

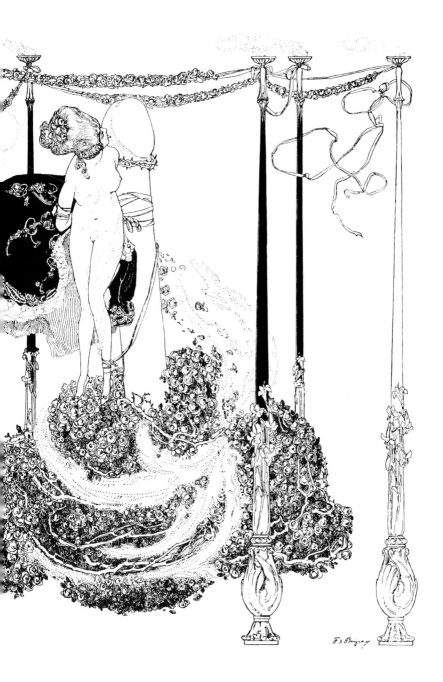

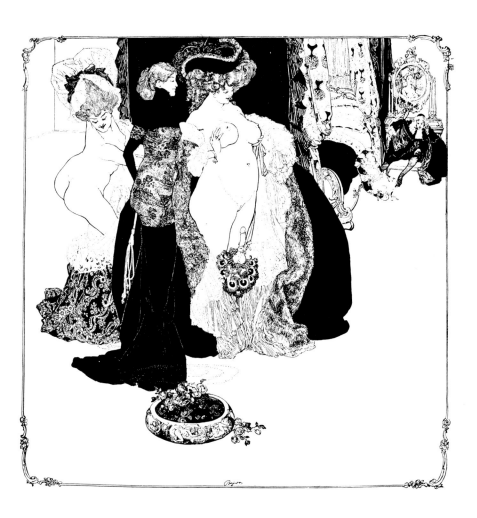

Franz von Bayros Amorous Drawings, 1907: The Little Harem

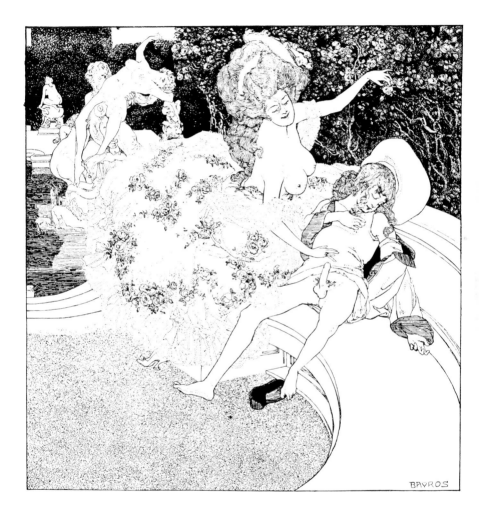

The Dream

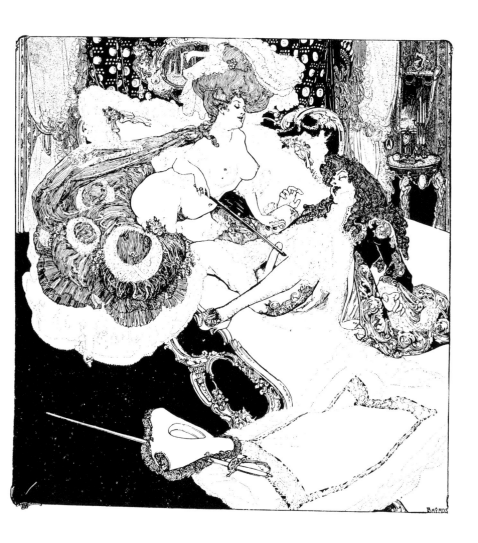

Andante con fantasia

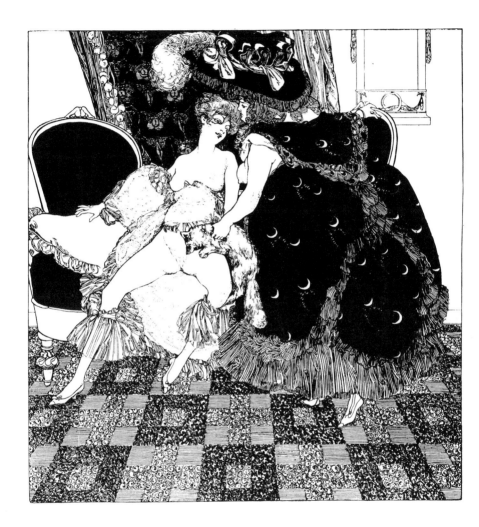

The Initiation

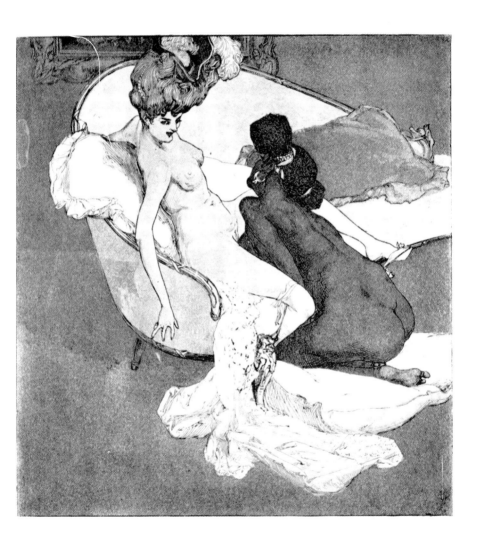

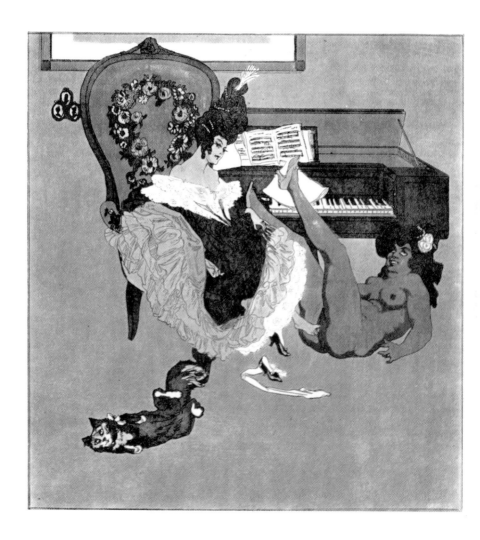

La Bonbonnière The Piano Teacher

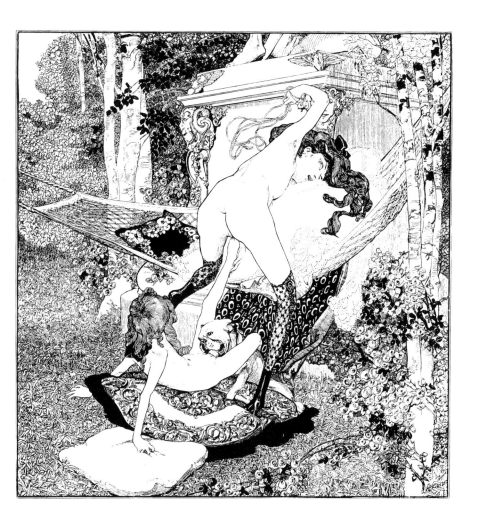

La Grenouillère Altruism. When he licks your cunt, you forget to move your toe in mine!

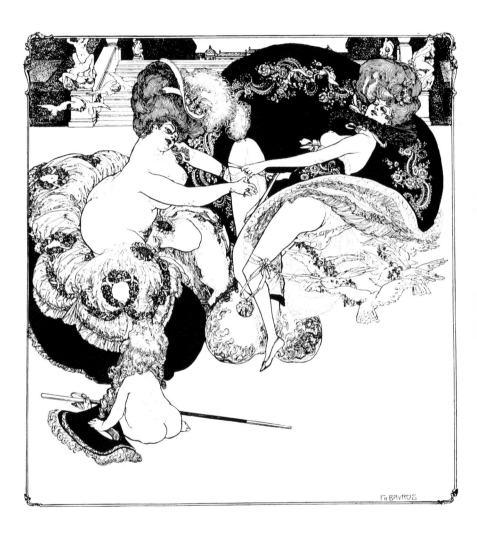

Round dance

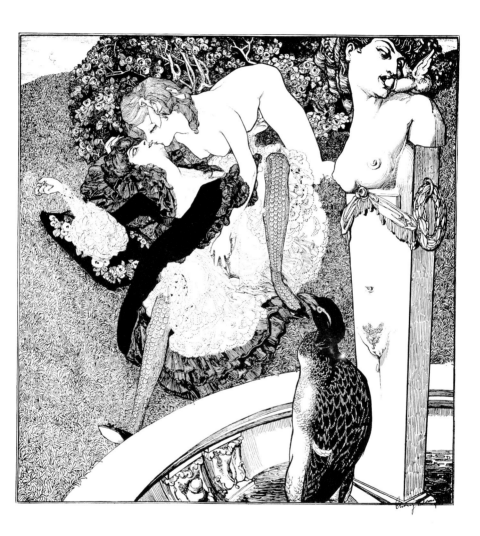

La Grenouillère Anything Is Possible! If it's not twins this time, I'll never have children!

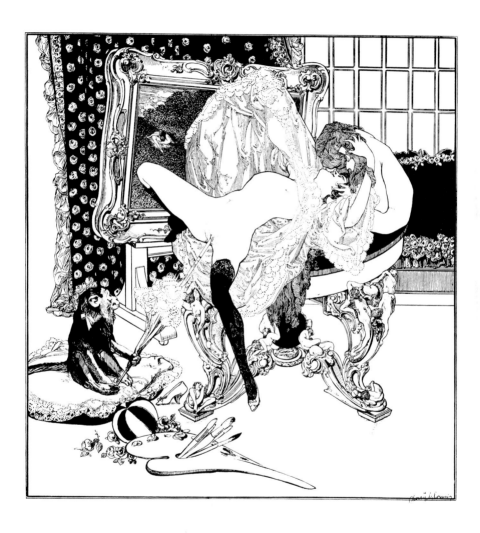

La Grenouillère In the studio. Oh, darling, it's as if your tongue and the ivory handle of my parasol were meeting within my body! Ah! I'm coming!

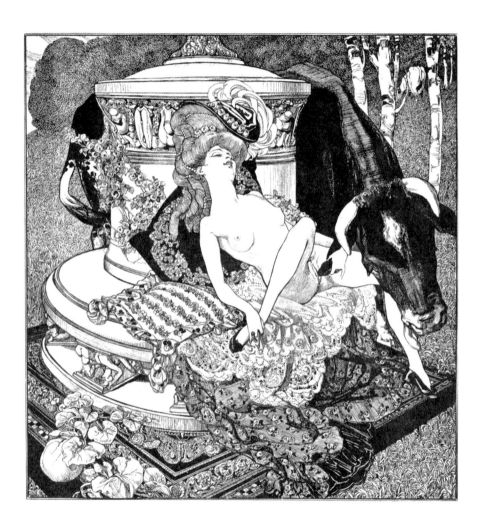

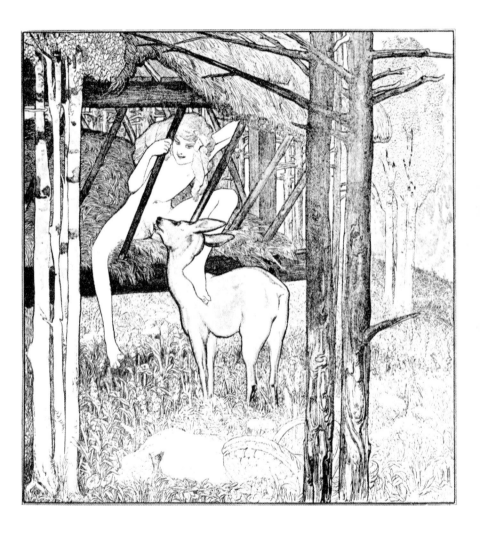

Oh what a charming little place

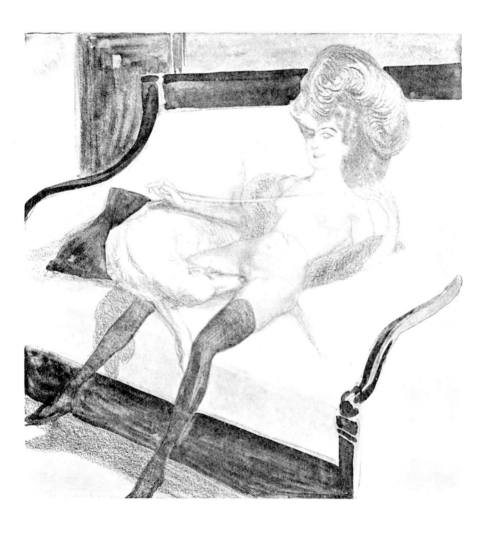

The Blue Feather

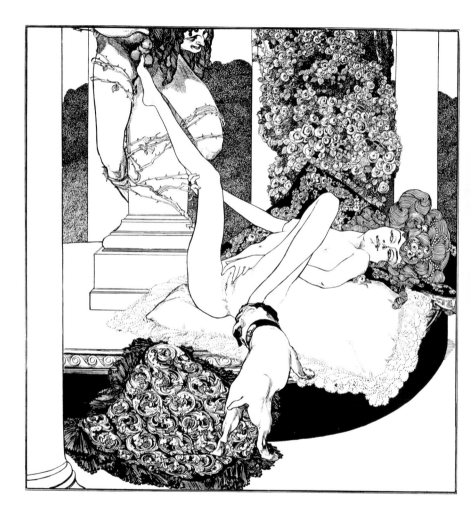

Tantalus

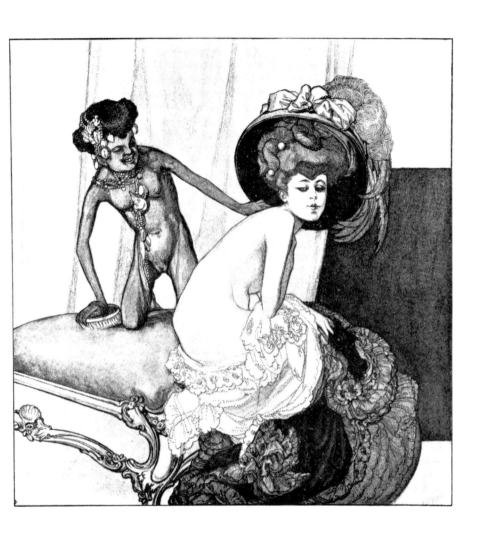

The Garden of Aphrodite. The Maidservant

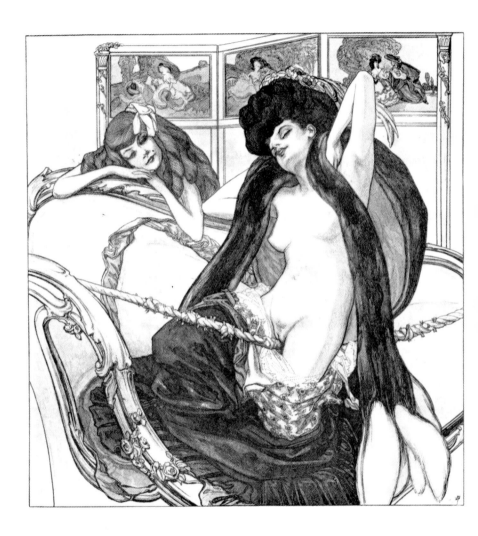

The Garden of Aphrodite. The Love Swing

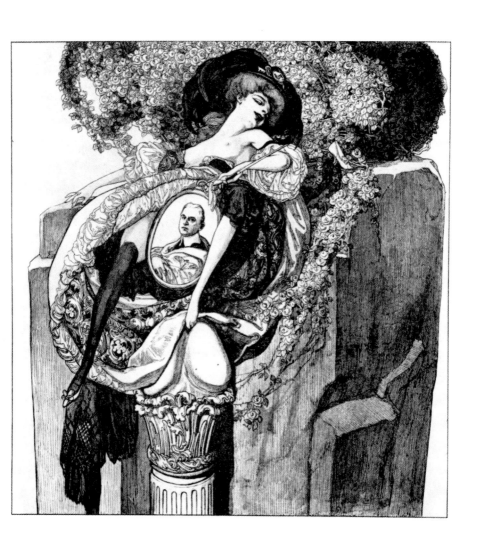

The Garden of Aphrodite. Recollection

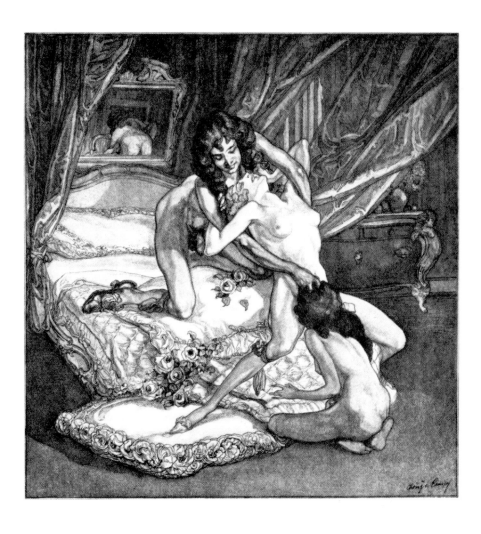

The Boudoir of Mme CC. Hold her tight, the selfish little brat, otherwise she'll forget me completely and I'm about to come!

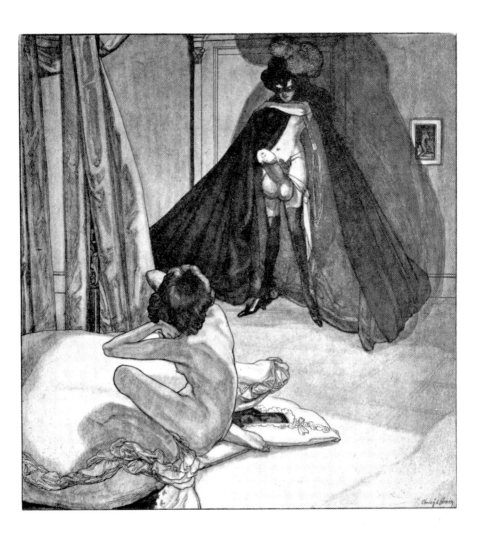

The Boudoir of Mme CC. The Five Senses – Sight

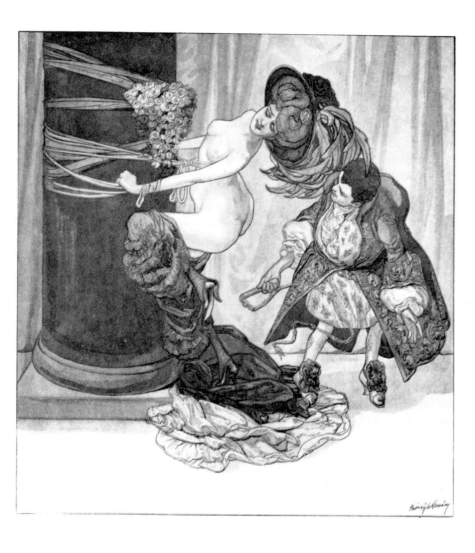

The Boudoir of Mme CC. The Five Senses – Touch

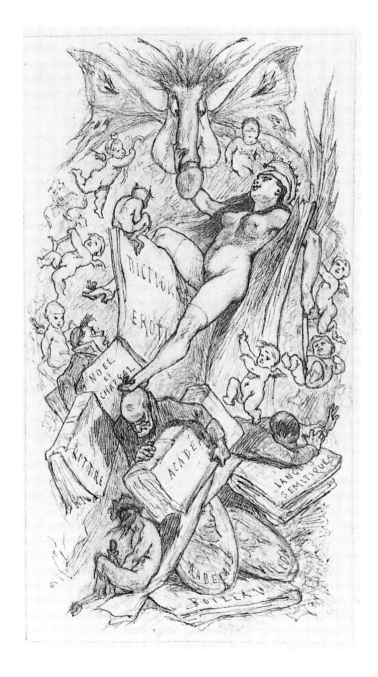

Félicien Rops Erotic Glossary of the French Language, 1861

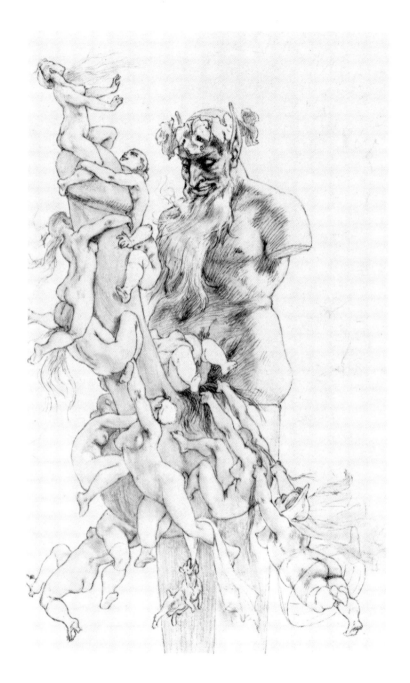

Félicien Rops The Satiric Parnassus, 1864

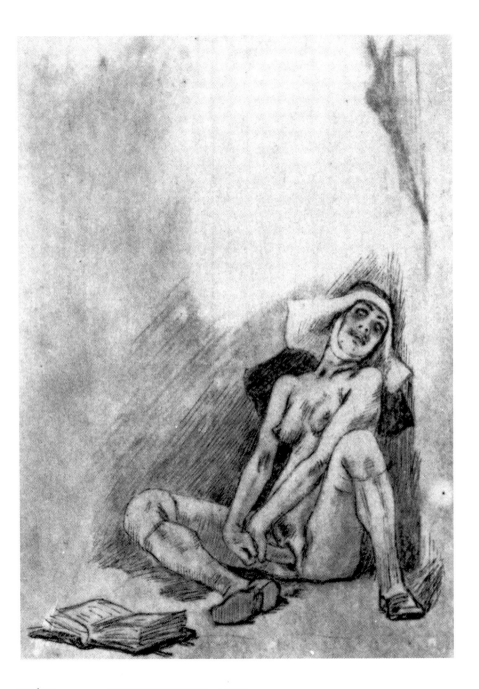

Félicien Rops Saint Theresa, c. 1860

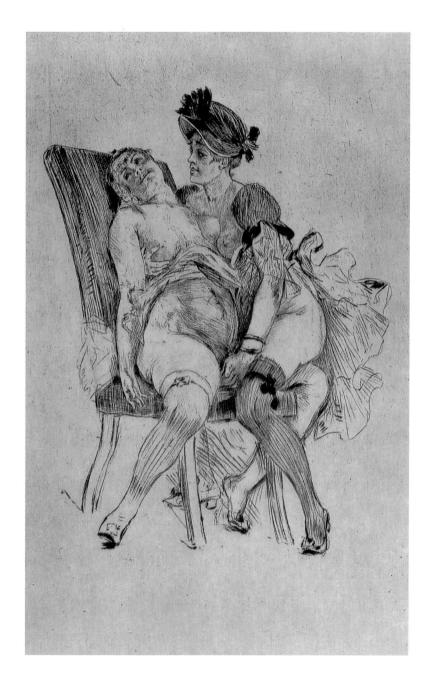

Félicien Rops A Visit, c. 1860

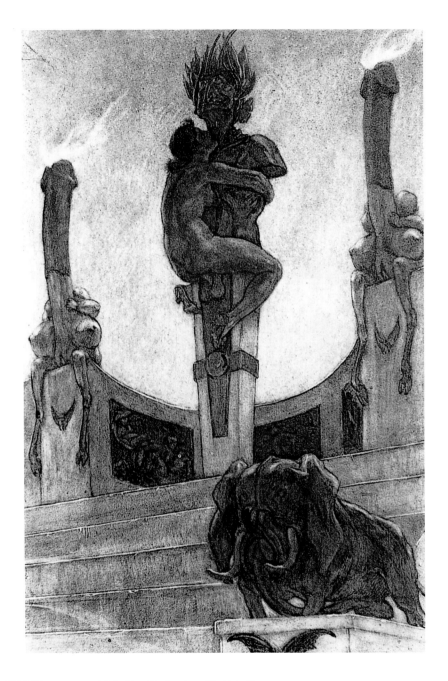

Félicien Rops The Satanists – The Idol, 1882

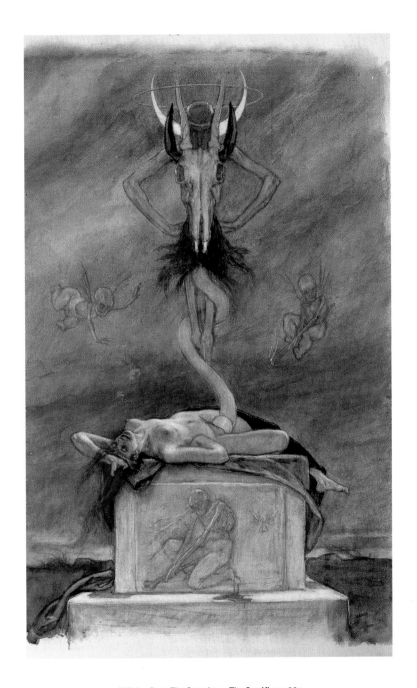

Félicien Rops The Satanists – The Sacrifice, 1882

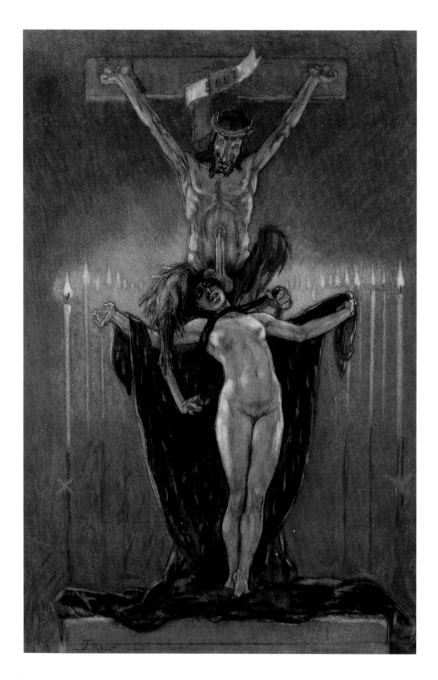

Félicien Rops The Satanists – Calvary, 1882

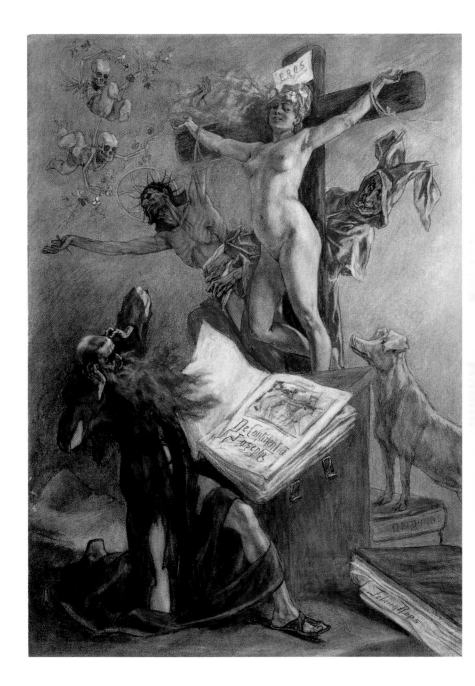

Félicien Rops The Temptation of Saint Anthony, 1878

Tout est grand chez les Roys !
Bossuet.

Félicien Rops Louis XIV – Tout est grand chez les Roys! (Bossuet), c. 1893

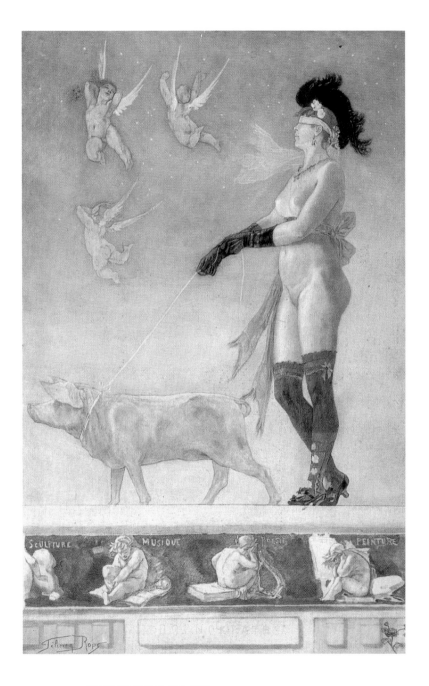

Félicien Rops Pornokrates, 1878

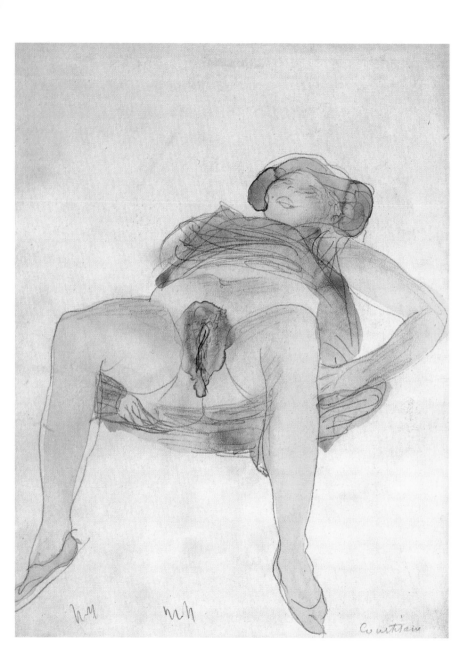

Auguste Rodin Courtesan, c. 1900

VI
Erotica
Moderna

The Origin of the World

"Does it smell under the arms?" Thus Picasso, anxiously exhibiting a nude. We are a long way from Boucher, who said of the female form "One should scarcely be aware that it encloses bones". The female sex had been closed for 2000 years. Now it was to be opened again... Courbet made it the subject of an entire painting. Rodin opened the lips of the sex in the clay of his statues, spreading the thighs of his *Iris* to reveal what he called "the eternal Tunnel". This primitive grotto is indeed the origin of the world. The sublime passage between these thighs leads, via the pleasures of love, from woman to Genesis, from the fleshly to the sacred. Artists shape this into an "open Sesame", an open portal to another world.

Der Ursprung der Welt

»Stinkt das nach Achselschweiß?« fragte Picasso besorgt, als er einen Akt vorführte. Damit ist er weit entfernt von Boucher, der über den weiblichen Körper sagte:»Man darf nicht einmal ahnen, daß er Knochen enthält.« Nach 2000 Jahren hatte man das Geschlecht der Frau wiederentdeckt ... Courbet machte es zum einzigen Gegenstand eines Gemäldes. Rodin versah seine Frauenstatuen mit einer Spalte und die Schenkel der Iris weit gespreizt über dem, was er »den ewigen Tunnel« nannte. Diese ursprüngliche Höhle ist sehr wohl der Ausgangspunkt der Welt. Diese göttliche Schenkelhöhle führt uns von der Frau zur Schöpfungsgeschichte, vom Fleischlichen über die Liebeslust zum Heiligen. Die Künstler erschaffen daraus ein»Sesam-öffne-dich«, ein offenes Tor zu einer anderen Welt.

L'origine du monde

«Est-ce que ça sent sous les bras?» demande avec anxiété Picasso en montrant un nu. On est loin de Boucher qui disait du corps féminin: «On ne doit presque pas se douter qu'il renferme des os.» On a rouvert le sexe de la femme fermé depuis 2000 ans... Courbet l'a pris pour unique objet d'un tableau. Rodin a fendu ses statues, écarquillant les cuisses d'Iris sur ce qu'il appelle «le Tunnel éternel». Cette grotte primitive est bien à l'origine du monde. Cet entrecuisse sublime nous mène de la femme à la Genèse, de la chair au sacré, via le plaisir amoureux. Les artistes en font un «sésame», une porte ouverte sur un autre monde.

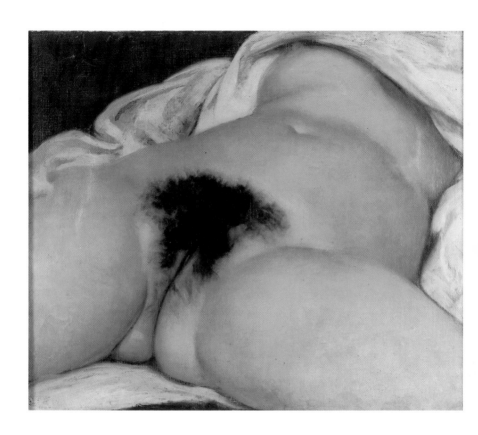

Gustave Courbet The Origin of the World, 1866

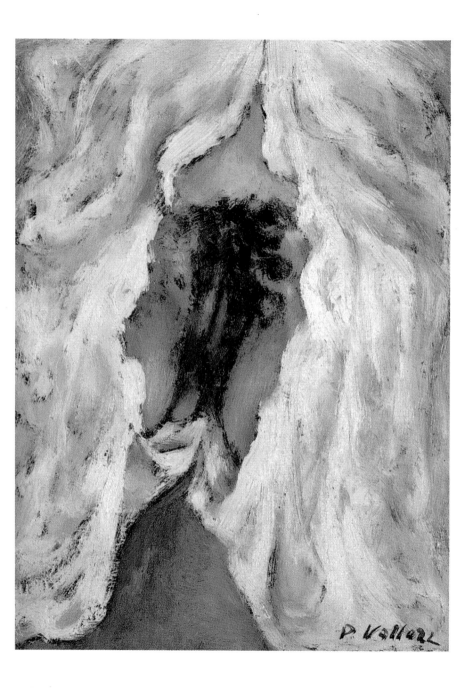

Paolo Vallorz Portrait of Alexandra, 1970

The Erotic Harvest

Modern art? "It's like the street saleswomen," says Picasso. "You want two breasts? Fine! Here are two breasts... The important thing is that the man looking on should have everything he needs to hand. Then, with his eyes, he can put them where he wants them". But things are not always that easy. Perhaps in Fontana's razor slashes we may discover something like the female sex. And if we are to believe Reich's "orgasm theory", Pollock's ejaculations are heroic. But alongside the avant-garde, there will always be the army of little-known artisans, who every season deliver the erotic harvest upon which our myriad fantasies may feed.

Die Paradiesäpfel

Die moderne Kunst? »Das ist wie bei den Händlern der Vierjahreszeiten«, antwortete Picasso. »Sie möchten zwei Brüste? Bitte sehr, hier sind zwei Brüste... Was man dazu braucht, ist, daß der Herr, der sich das anschaut, alles zur Hand hat, was er benötigt. Dann rückt er sie selbst zurecht mit seinen Augen.« Das ist nicht immer so offensichtlich, denn es gibt auch noch das (weibliche) Geschlecht in Form der Schlitze, die Fontana mit dem Rasiermesser in seine Leinwände schnitt, und nach jedem Pollock sollte es, gemäß der »Theorie des Orgasmus« von W. Reich, die schönsten Samenergüsse geben. Aber neben der Avantgarde wird es immer ein Heer von Unbedeutenden, von Kunsthandwerkern geben, die in jeder Saison erotische Ernte liefern, aus der sich unsere vielfältigen Phantasien speisen.

Pommes d'amour

L'art moderne? «C'est comme les marchandes de quat'saisons», répond Picasso: «Vous voulez deux seins? Eh bien! Voilà deux seins... Ce qu'il faut, c'est que le monsieur qui regarde ait sous la main toutes les choses dont il a besoin. Alors il les mettra lui-même à leur place, avec ses yeux.» Pas toujours évident, bien qu'il y ait du sexe (féminin) dans les fentes au rasoir de Fontana et qu'après tout Pollock, selon la «théorie de l'orgasme» de W. Reich, a de belles éjaculations. Mais il y aura toujours, à côté de l'avant-garde, l'armée des obscurs, des artisans, pour livrer chaque saison, la récolte érotique qui nourrit librement nos multiples fantasmes.

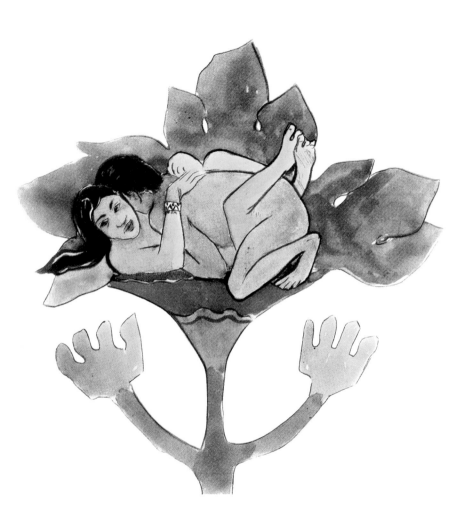

Paul Gauguin Maori lovers, 1891

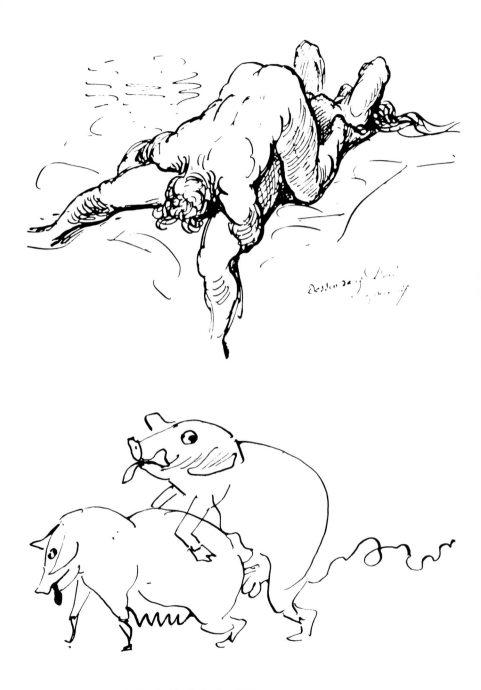

Gustave Doré Erotic drawing, 1869
Henri de Toulouse-Lautrec (1864–1901) Love Pigging It

Henri de Toulouse-Lautrec (1864–1901) The Good Girl: she brings a tisane to her flu-ridden but not shapeless father

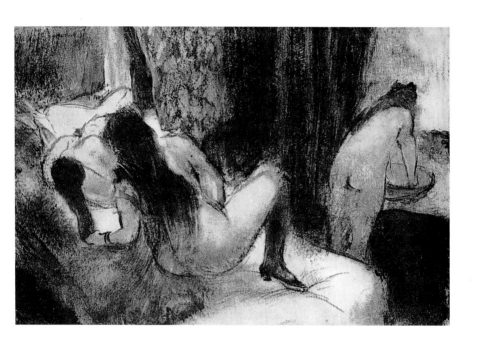

Edgar Degas The Double Caress, 1879

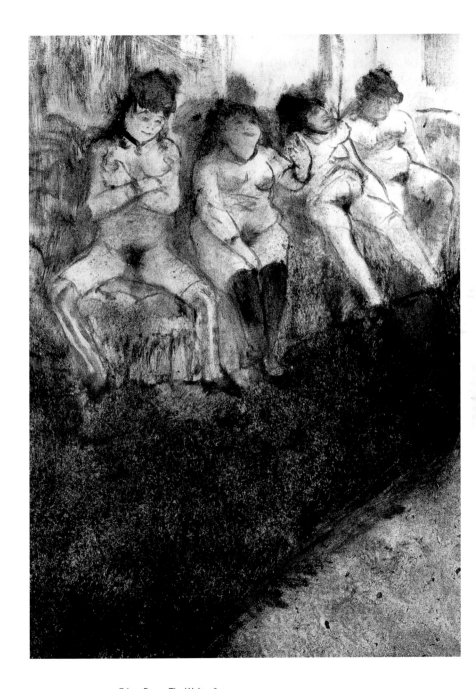

Edgar Degas The Wait, 1879

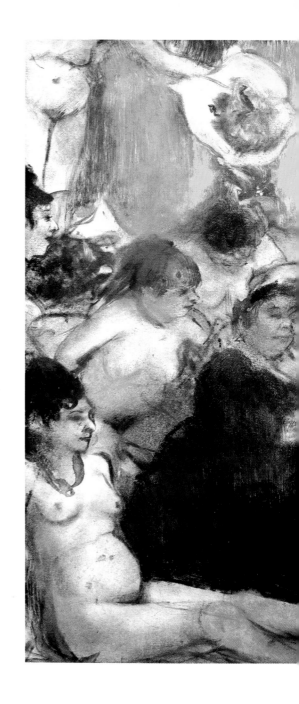

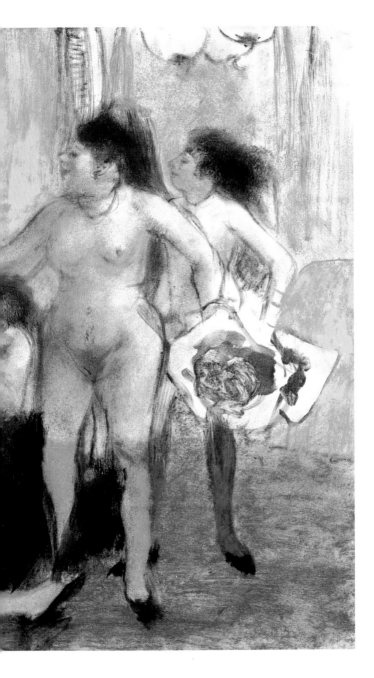

Edgar Degas The Proprietresses's Party, 1878-1879

Honoré Daumier At Home with the Peasants, c. 1834

Jean-François Millet Lovers (by the author of the famous *Angelus*, dedicated to his friend Louise), 1863

Honoré Daumier Pleasure at home, c. 1832-1835

Honoré Daumier The hours do not chime for happy folk, c. 1832–1835

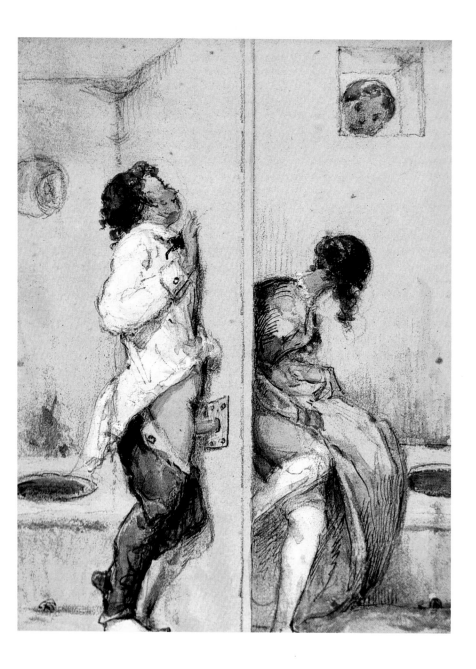

Paul Gavarni The Places...of Pleasure, c. 1840

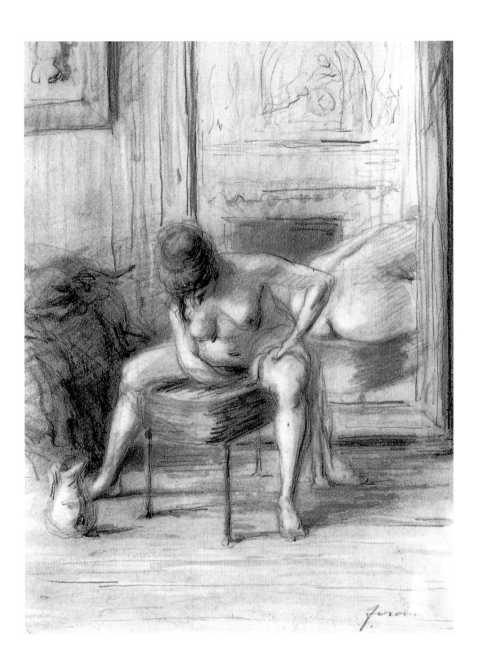

Jean-Louis Forain The Bidet, c. 1880

LA GRANDE

DANSE MACABRE

Dea vifa

3ᵐᵉ DIXAIN

Martin Van Maele The Great *Danse Macabre* of the Quick (Prick), c. 1907. Turn of the century sequence referring to the industrial revolution and Victorian morality

Résultats complets des
Courses.
à l'U.V.F.

Martin Van Maele The Great *Danse Macabre* of the Prick, c. 1907

est ainsi que
Roland
épousa la belle
Aude

Martin Van Maele The Great *Danse Macabre* of the Quick (Prick), c. 1907

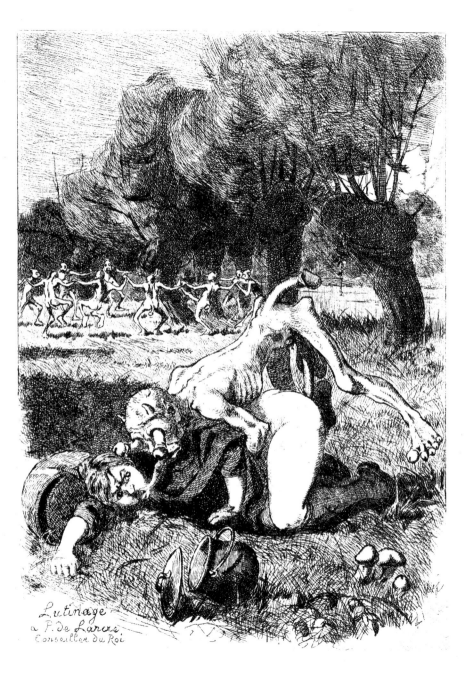

Lutinàge
à F. de Larère
Conseiller du Roi

Martin Van Maele The Great *Danse Macabre* of the Quick (Prick), c. 1907

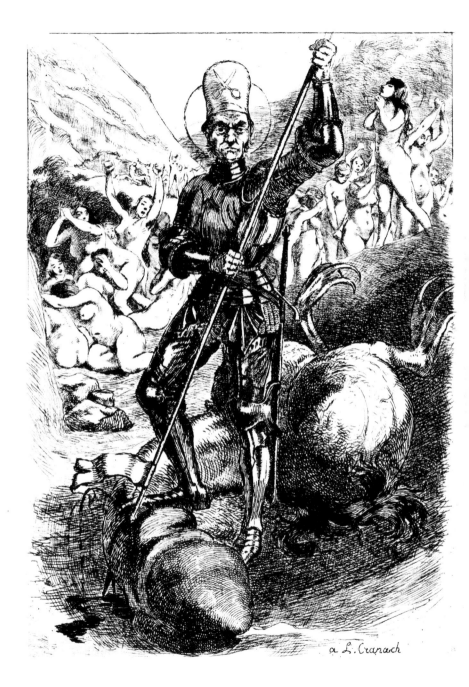

a L. Cranach

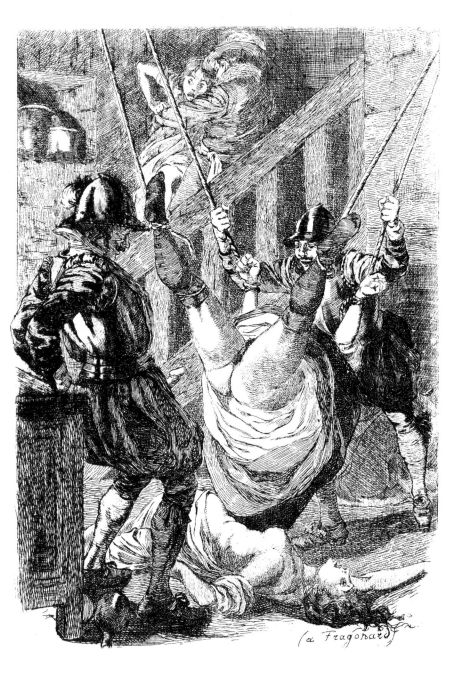

(a Fragonard)

Martin Van Maele The Great *Danse Macabre* of the Quick (Prick), c. 1907

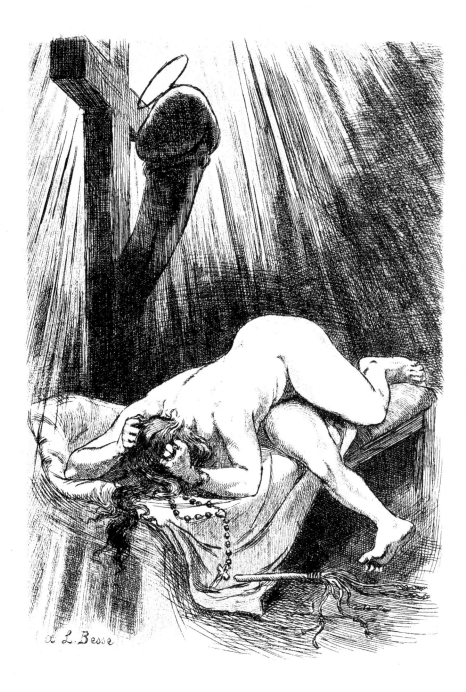

a L. Besse

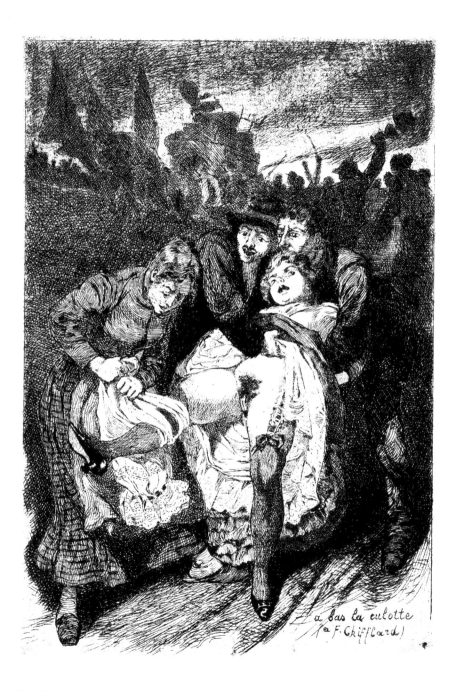

à bas la culotte
(a F. Chifflard)

Martin Van Maele The Great *Danse Macabre* of the Quick (Prick), c. 1907

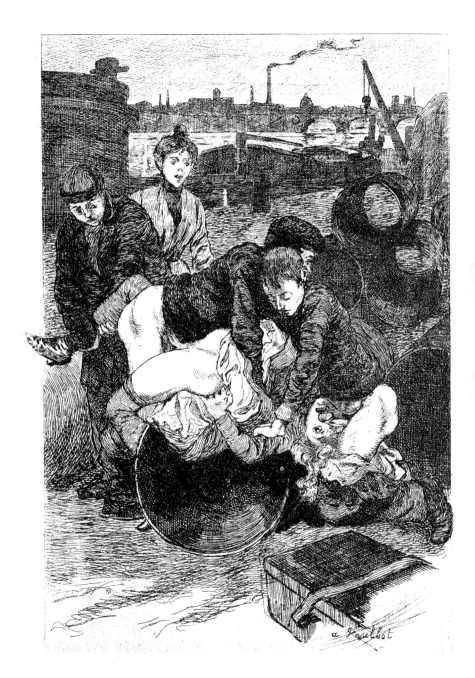

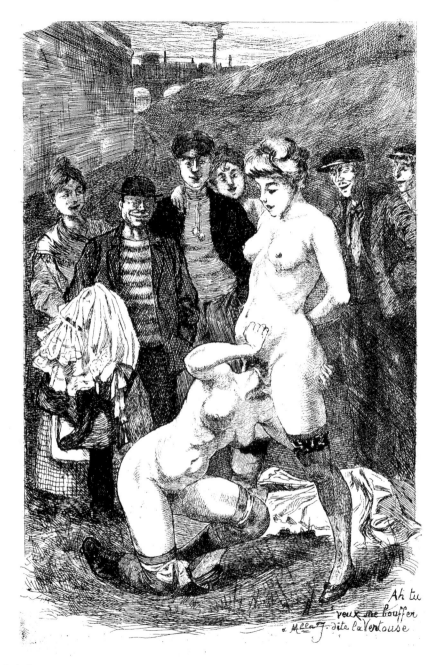

Martin Van Maele The Great *Danse Macabre* of the Quick (Prick), c. 1907

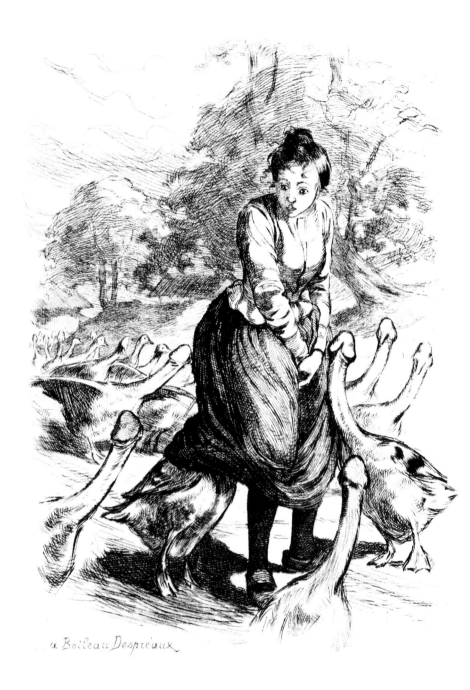

a Boileau Despréaux

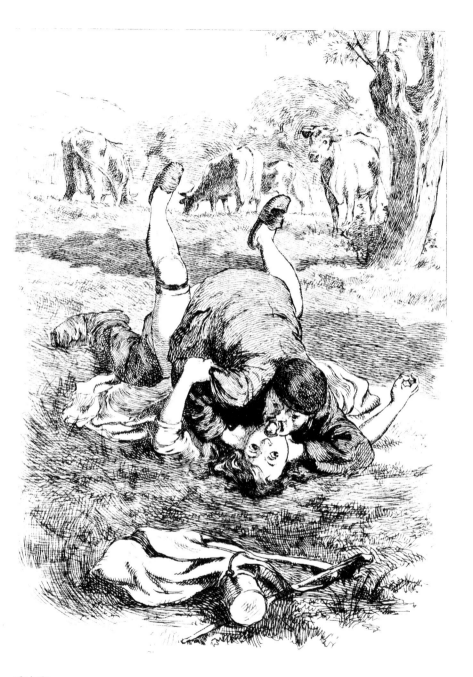

Martin Van Maele The Great *Danse Macabre* of the Quick (Prick), c. 1907

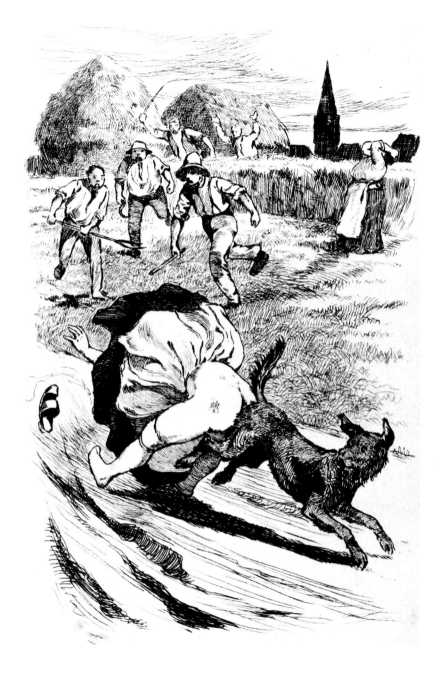

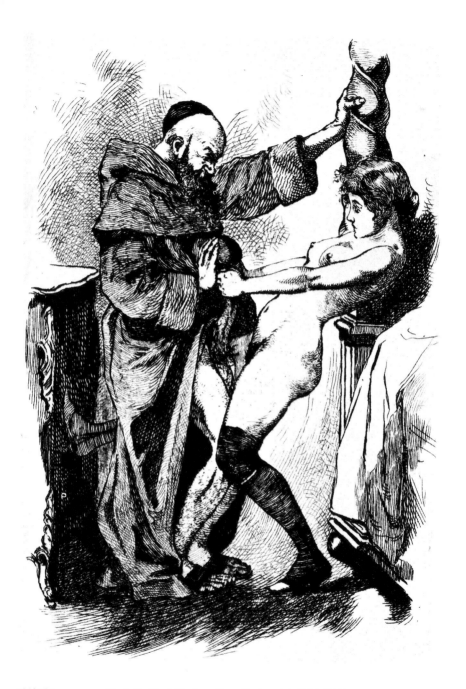

Martin Van Maele The Great *Danse Macabre* of the Quick (Prick), c. 1907

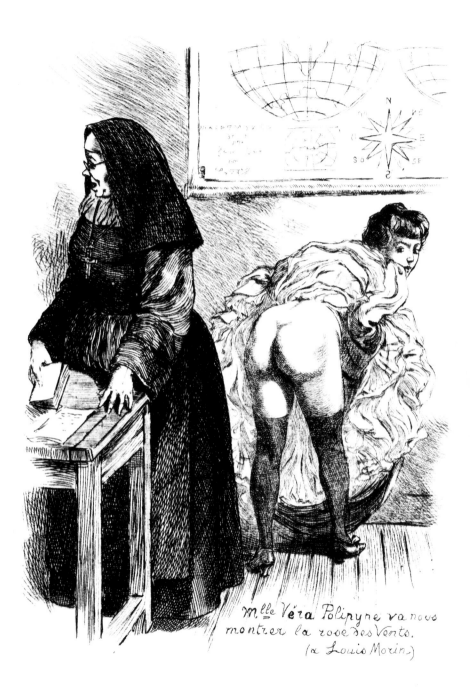

M^lle Véra Polipyne va nous
montrer la rose des Vents.
(a Louis Morin)

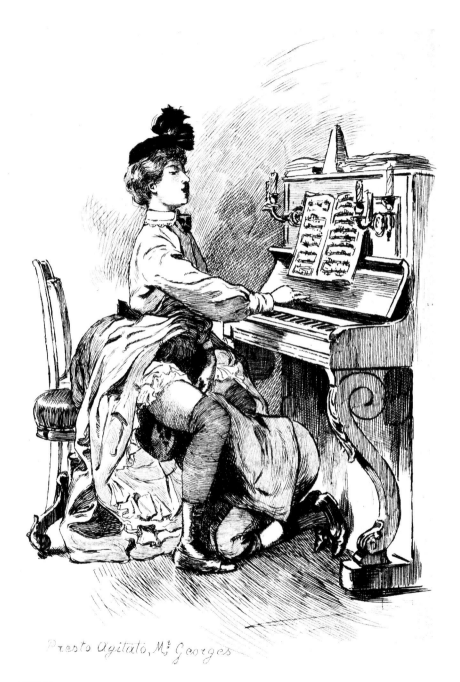

Presto Agitato, M. Georges

Martin Van Maele The Great *Danse Macabre* of the Quick (Prick), c. 1907

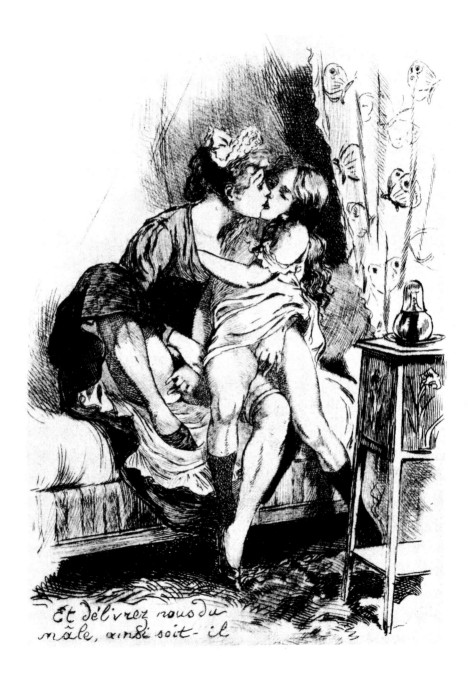

Et délivrez nous du
mâle, ainsi soit-il

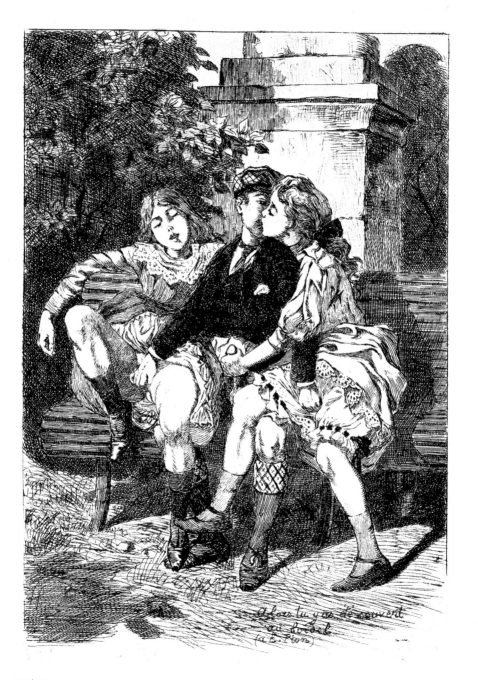

Martin Van Maele The Great *Danse Macabre* of the Quick (Prick), c. 1907

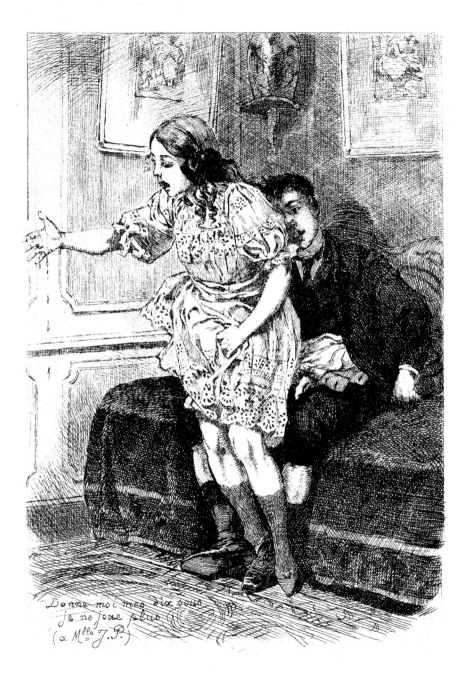

Donne moi mes dix sous
je ne joue plus
(a Mlle J. P.)

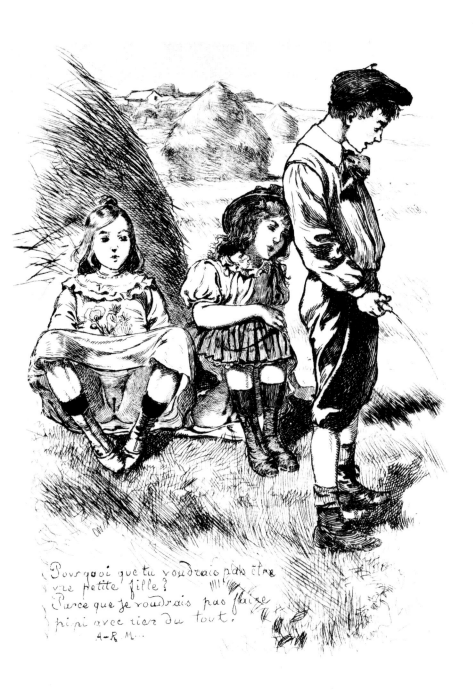

Pourquoi que tu voudrais pas être
une petite fille?
Parce que je voudrais pas faire
pipi avec rien du tout.
A-R.M...

Martin Van Maele The Great *Danse Macabre* of the Quick (Prick), c. 1907

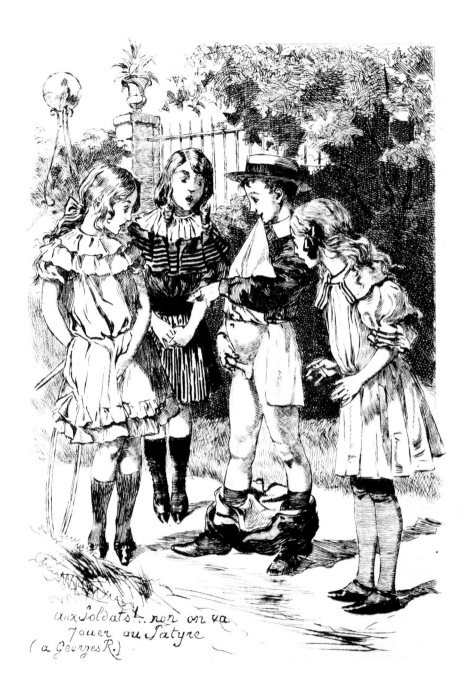

aux Soldats!.. non on va
Jouer au Satyre
(a Georges R.)

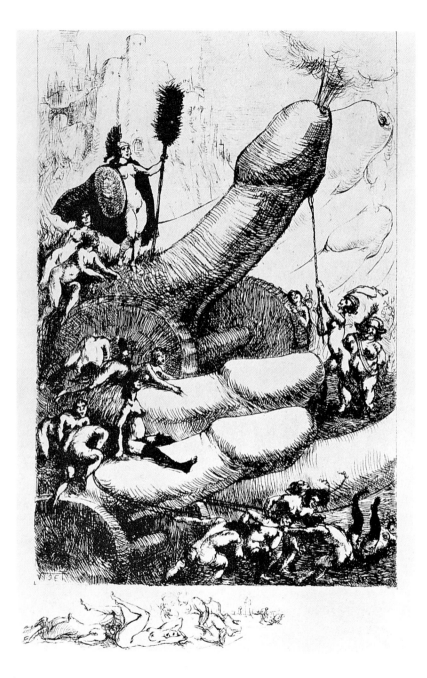

Viset Illustrations for various erotic books, c. 1900

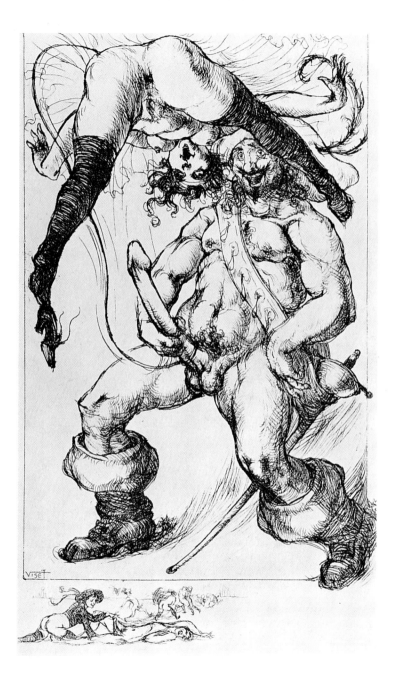

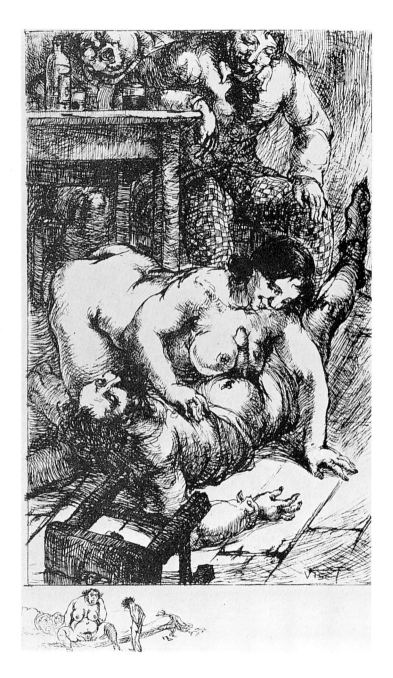

Viset Illustrations for various erotic books, c. 1900

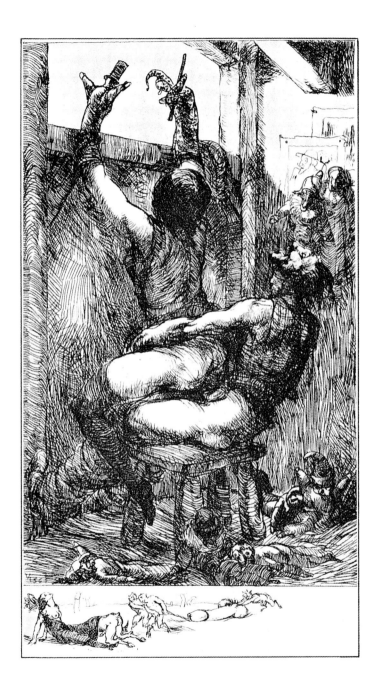

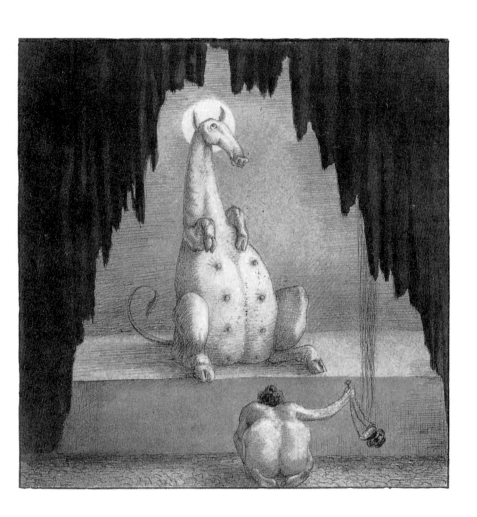

Alfred Kubin Adoration, 1901-1902

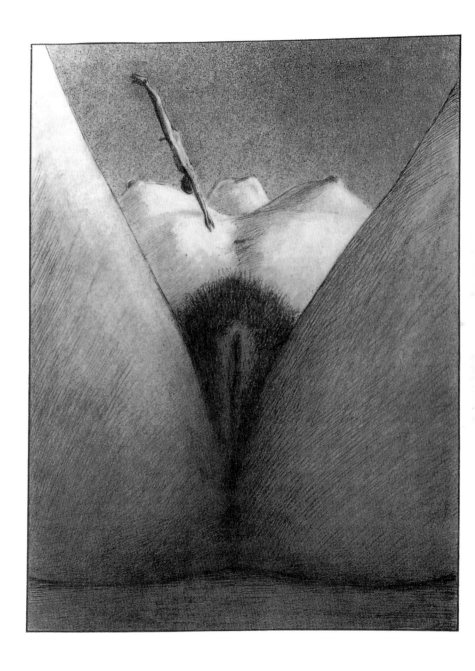

Alfred Kubin Death Leap, 1901-1902
▶ **Alfred Kubin** Lubricity, 1901-1902

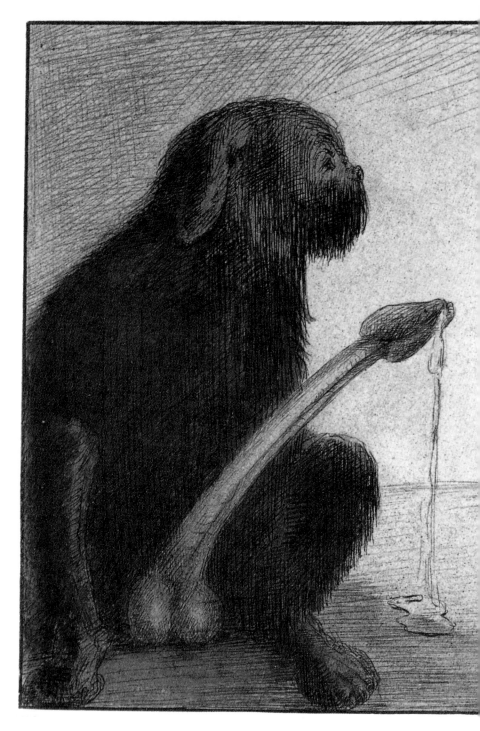

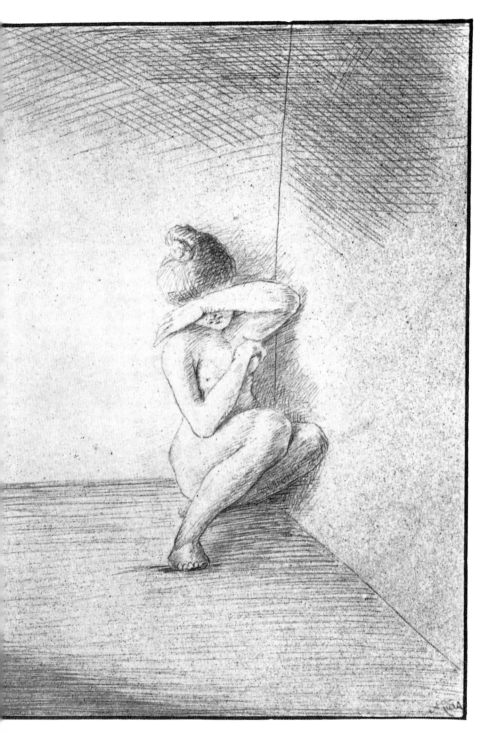

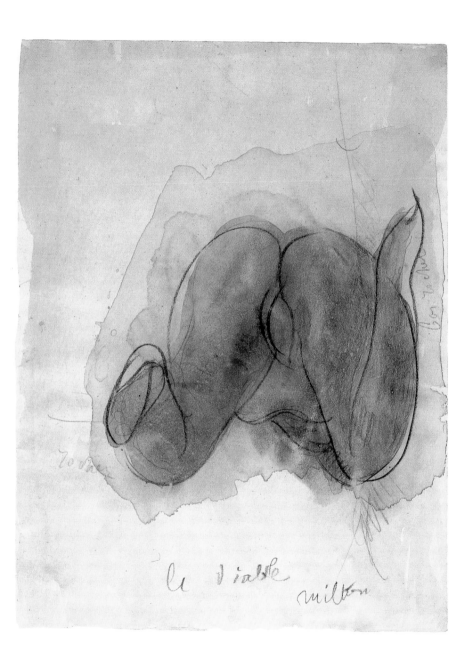

Auguste Rodin The Devil or Milton, c. 1900

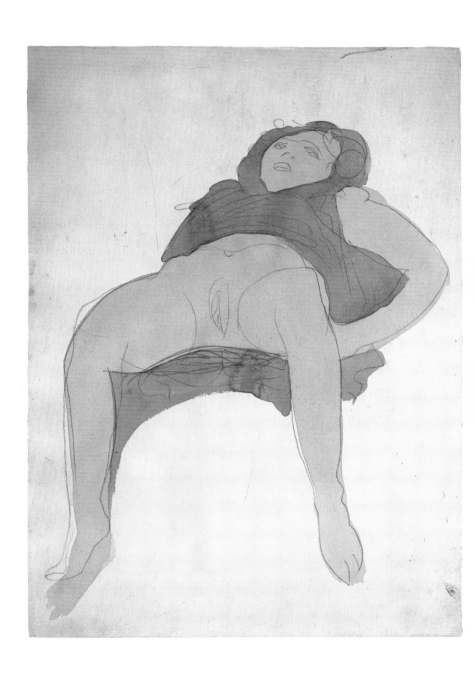

Auguste Rodin Woman on her back, front view, clothes hitched up over her open legs, c. 1900

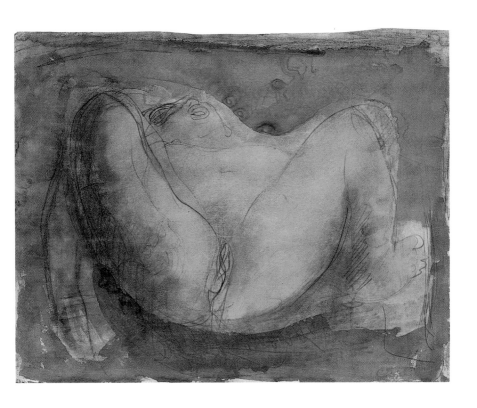

Auguste Rodin Before Creation; c. 1900

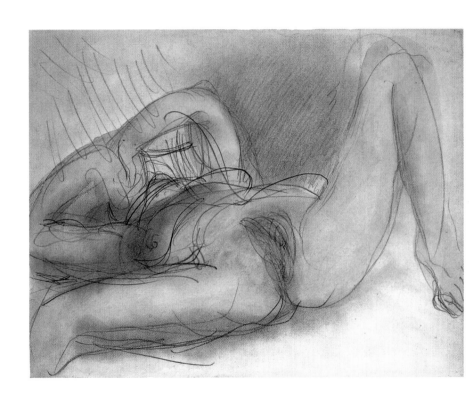

Auguste Rodin Nude woman on her back, front view, hands masking face and legs spread wide, c. 1900

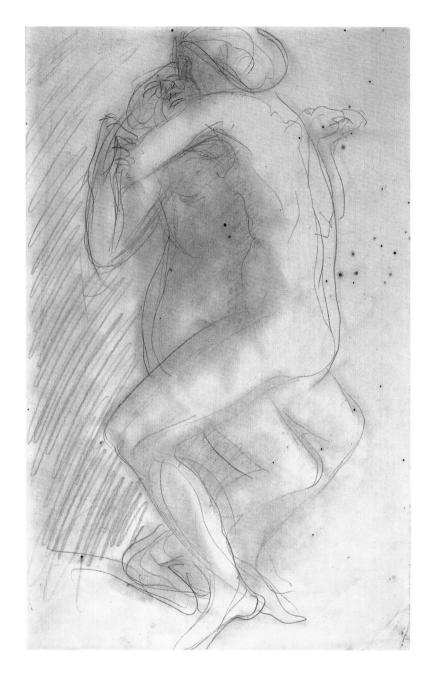

Auguste Rodin Sapphic Couple, c. 1900

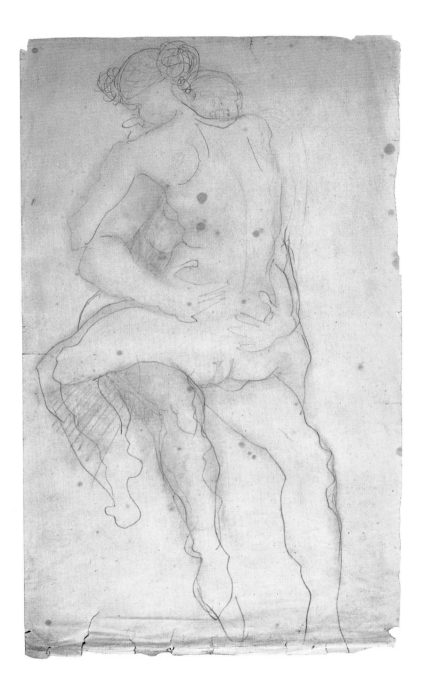

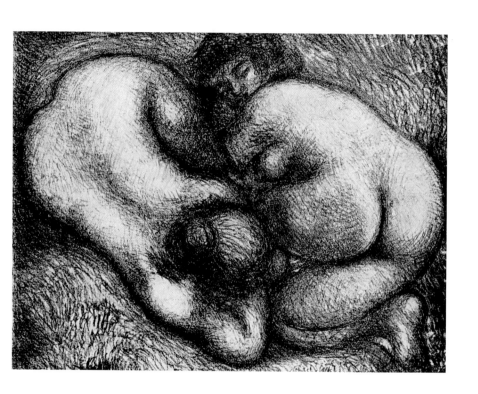

Aristide Maillol Sixty-nine, c. 1930

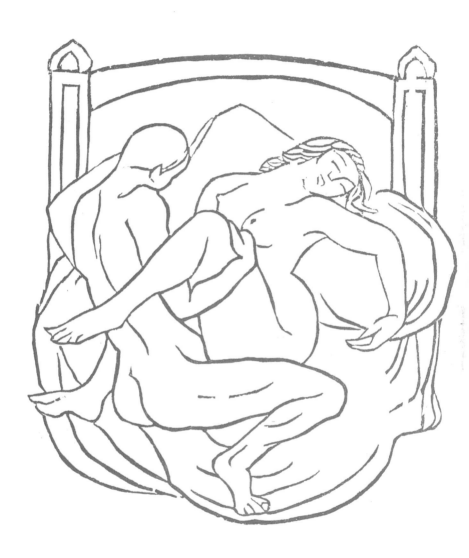

Aristide Maillol Deeper in, 1939

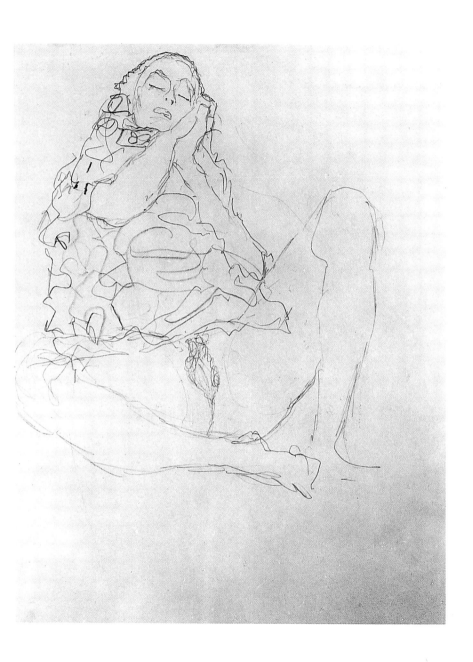

Gustav Klimt Seated nude with closed eyes, 1913

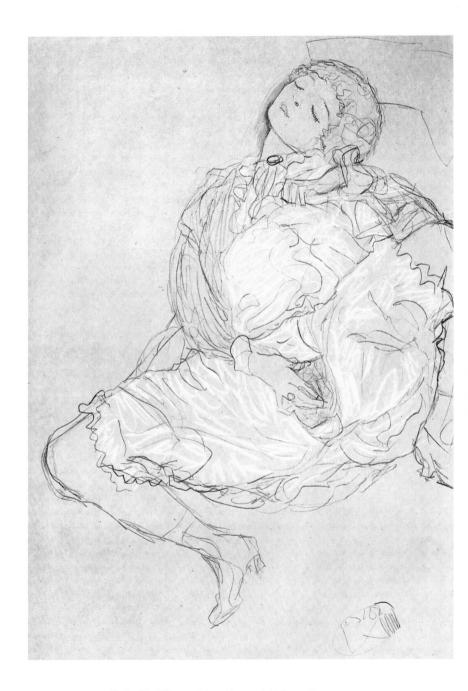

Gustav Klimt Woman sitting with spread thighs, 1916-1917

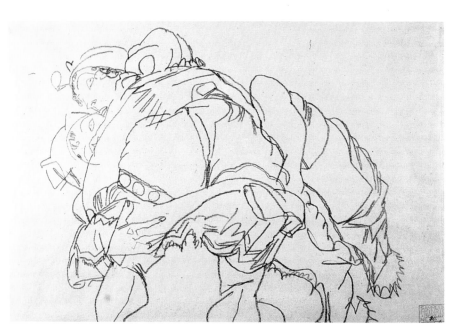

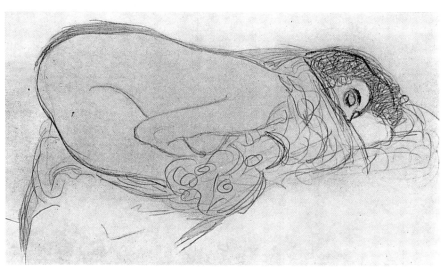

Egon Schiele Sapphic Couple, 1914
Gustav Klimt Offering. Study for Leda, 1918

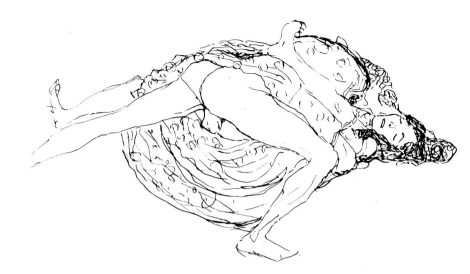

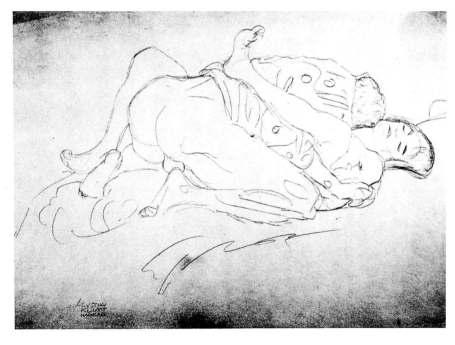

Gustav Klimt Two Lovers, 1914
Gustav Klimt Right-wing Lovers, 1914

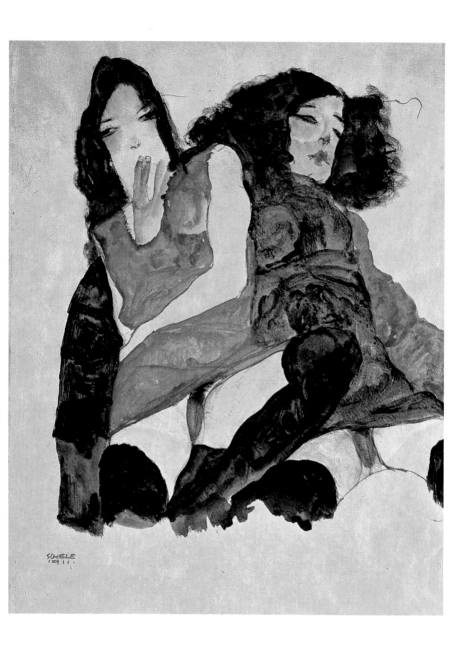

Egon Schiele Sapphic Couple, 1911

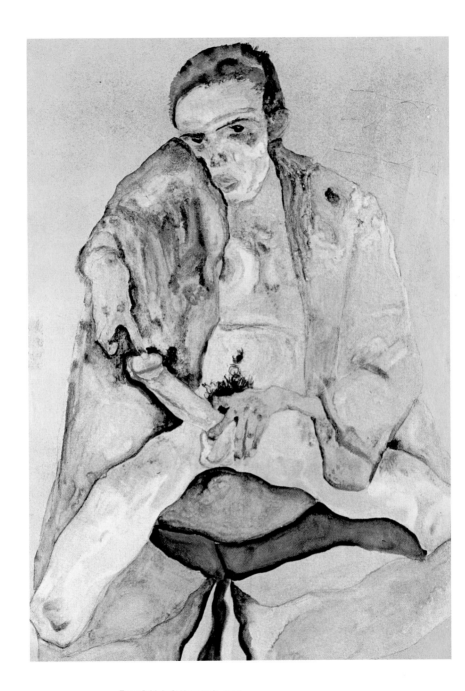

Egon Schiele Self-portrait, 1918

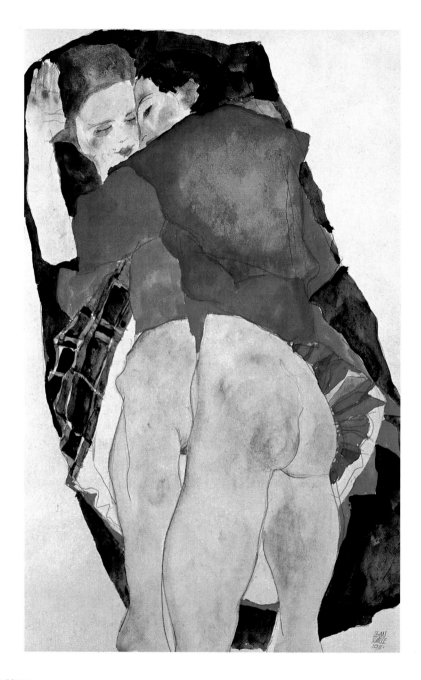

Egon Schiele Sapphic Couple, 1911

Michael von Zichy The Penile Gamut, c. 1900

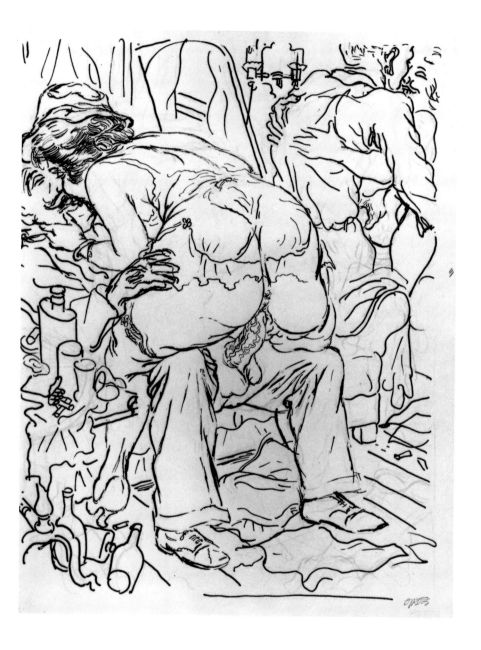

George Grosz Two Caricatures, late 20s

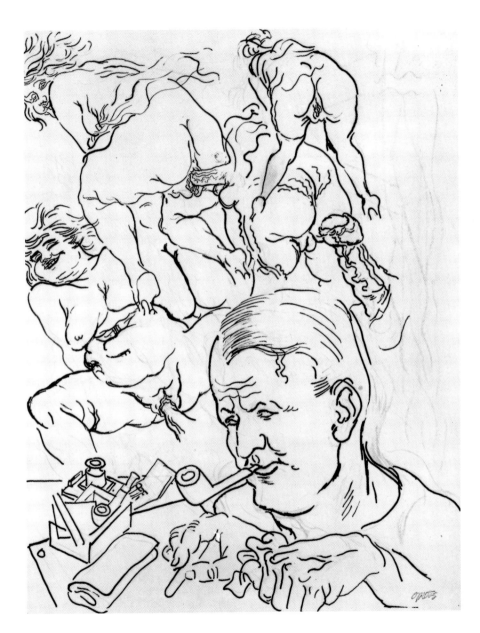

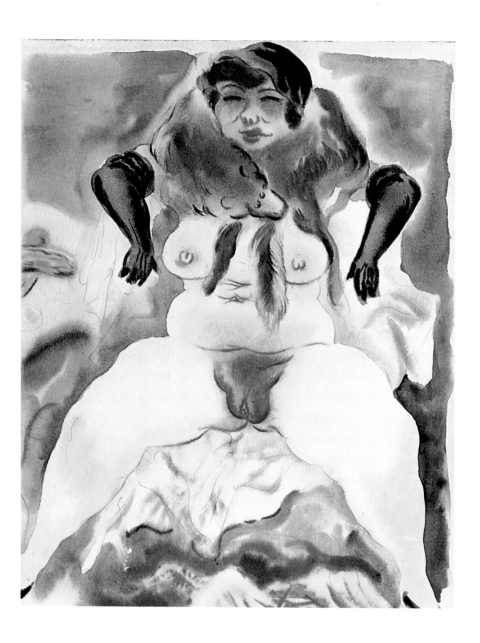

George Grosz Series of watercolours and drawings with social implications,
late 20s – early 30s

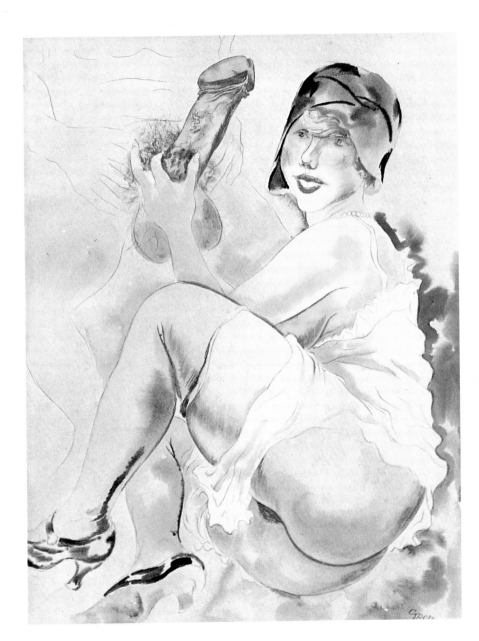

George Grosz Series of watercolours and drawings with social implications,
late 20s – early 30s

George Grosz Series of watercolours and drawings with social implications,
late 20s – early 30s

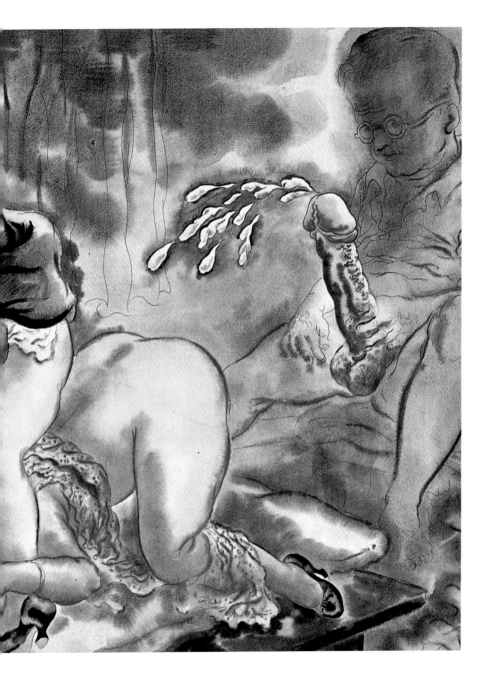

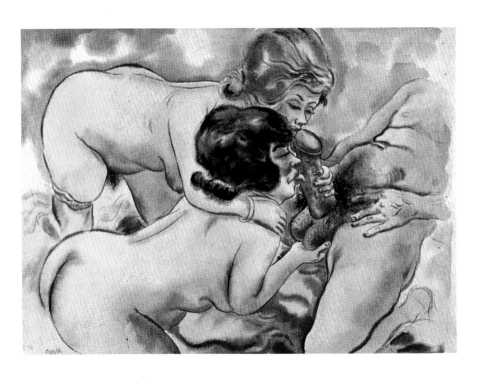

George Grosz Series of watercolours and drawings with social implications,
late 20s – early 30s

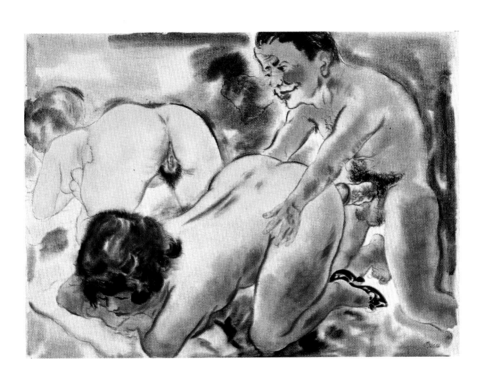

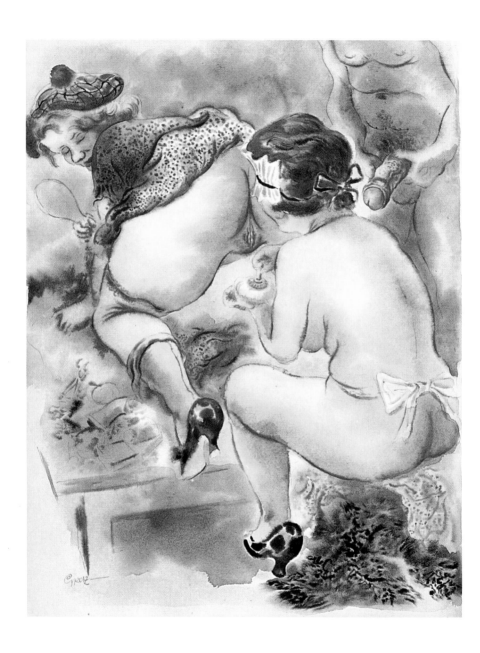

George Grosz Series of watercolours and drawings with social implications,
late 20s – early 30s

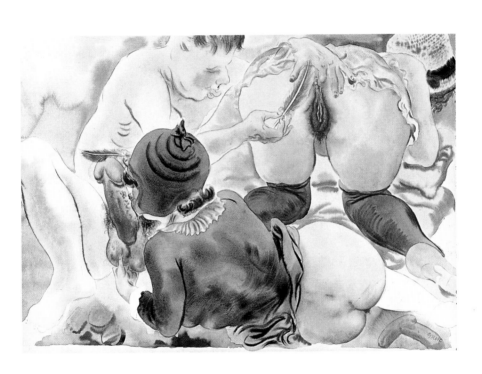

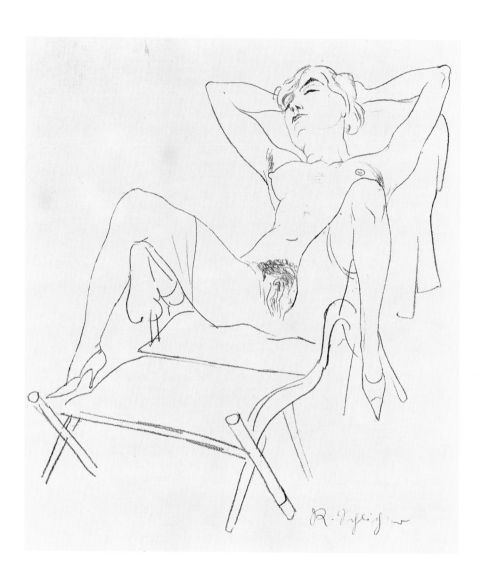

Rudolf Schlichter Free and Easy, early 20s

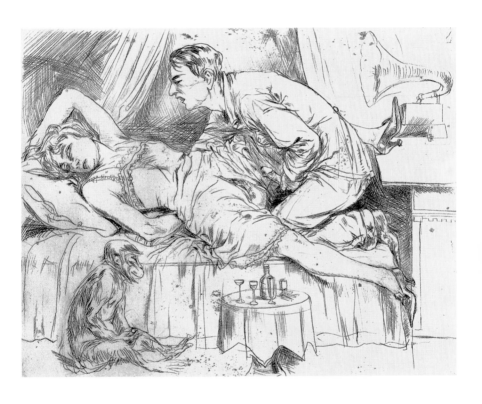

Rudolf Schlichter Bordello Fantasy, early 20s

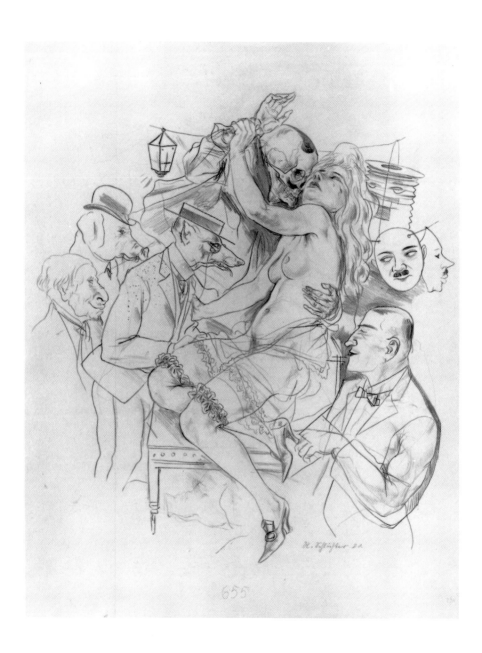

Rudolf Schichter Orgy at the Bordello, 1920

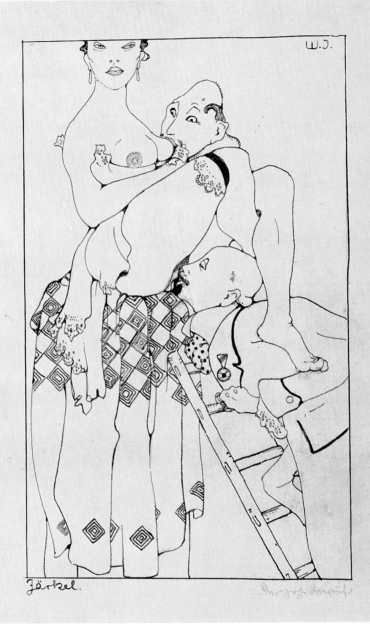

Willy Jaeckel In a High Position, early 20s

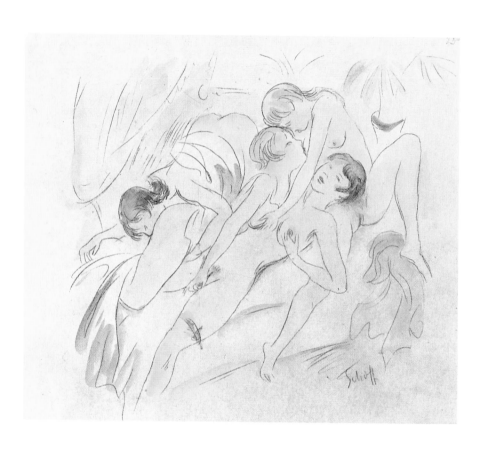

Otto Schoff In the Girls' School, 20s

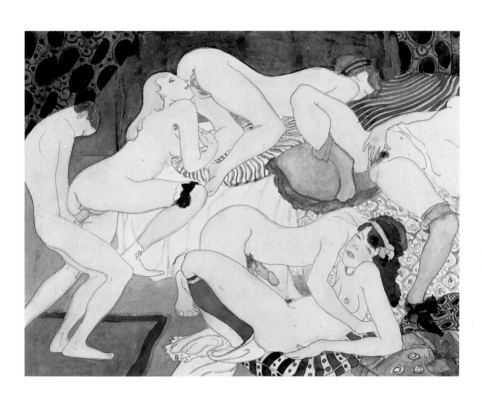

Willy Jaeckel Orgy, c. 1930

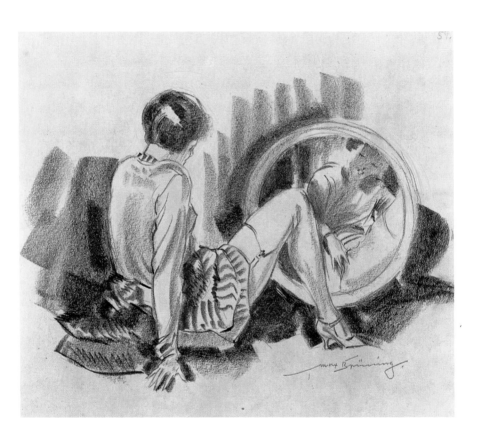

Max Brüning Look into the Mirror, c. 1925

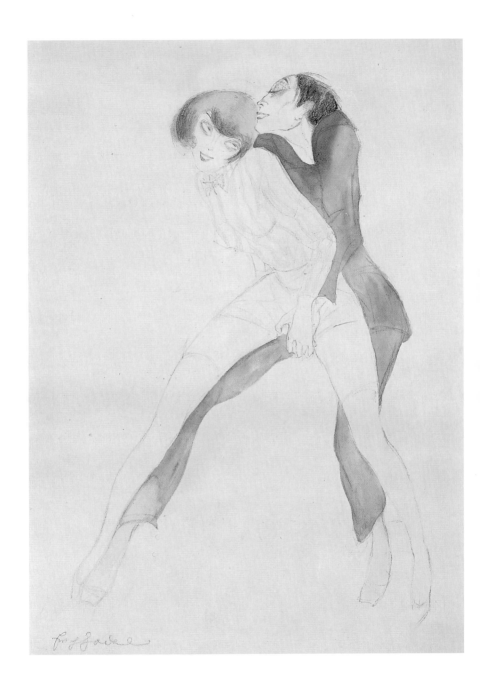

Erich Godal With the Same Rhythm, c. 1925

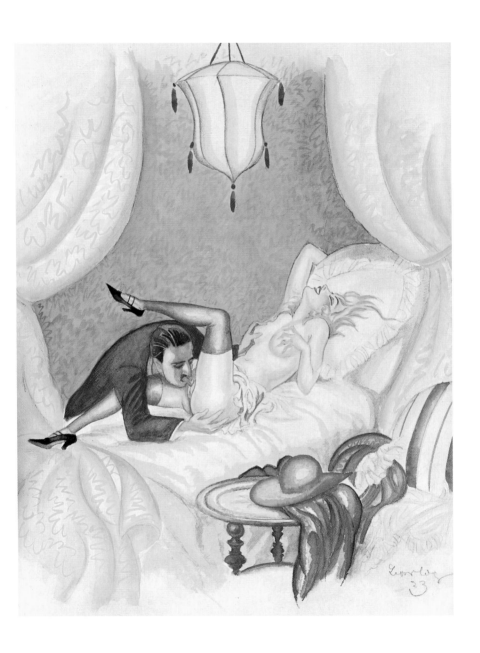

Barlog The Red Hat, 1923

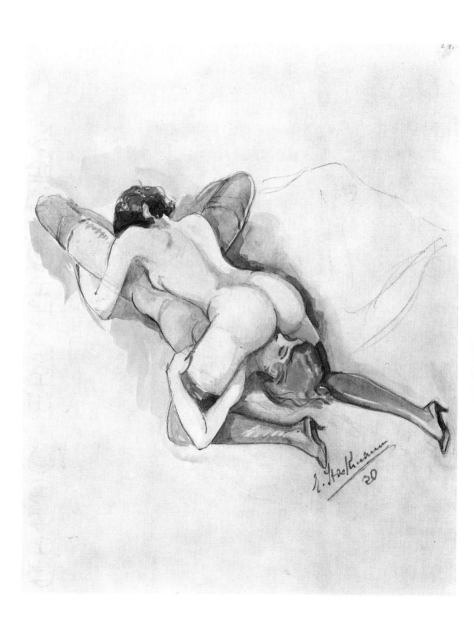

Helmuth Lesbian Pleasures, 1920

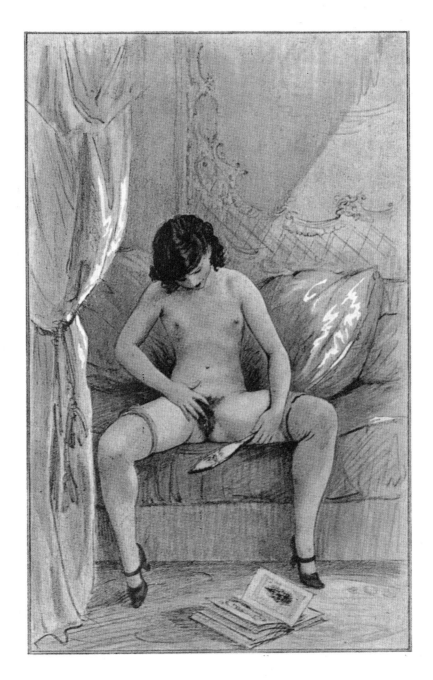

Anonymous (Paul-Emile Bécat?) Illustrations for *An Up-to-date Young Lady*, a best-seller of the 20–30s by Helena Varley

Anonymous (Paul-Emile Bécat?) Illustrations for *An Up-to-date Young Lady*,
a best-seller of the 20–30s by Helena Varley

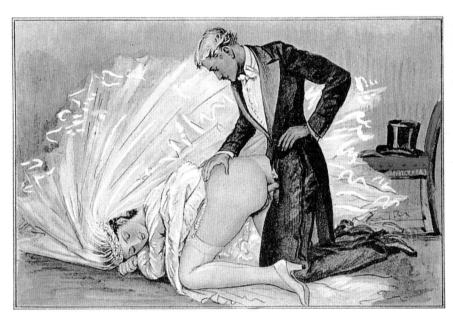

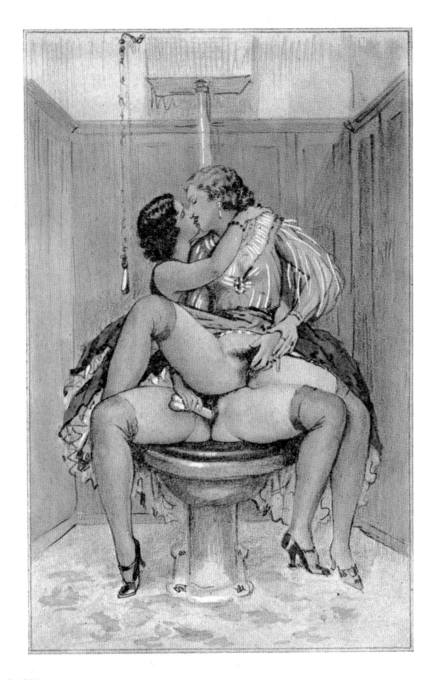

Anonymous (Paul-Emile Bécat?) Illustrations for *An Up-to-date Young Lady*,
a best-seller of the 20–30s by Helena Varley

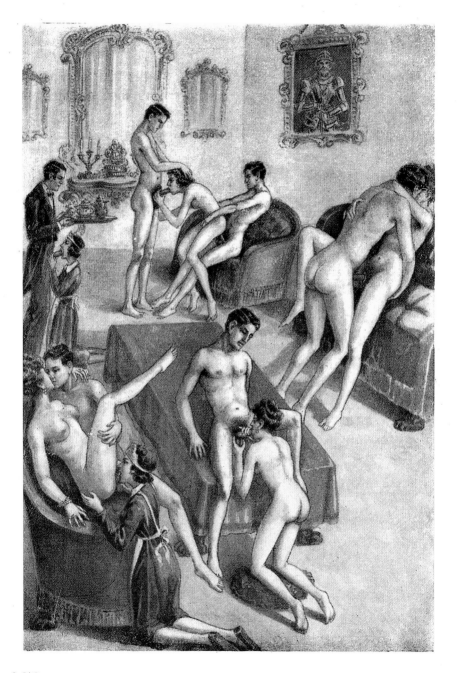

Anonymous Illustrations for *The Paradise of Flesh* by an anonymous Italian author, 20–30s

Anonymous Illustrations for *The Paradise of Flesh* by an anonymous Italian author, 20–30s

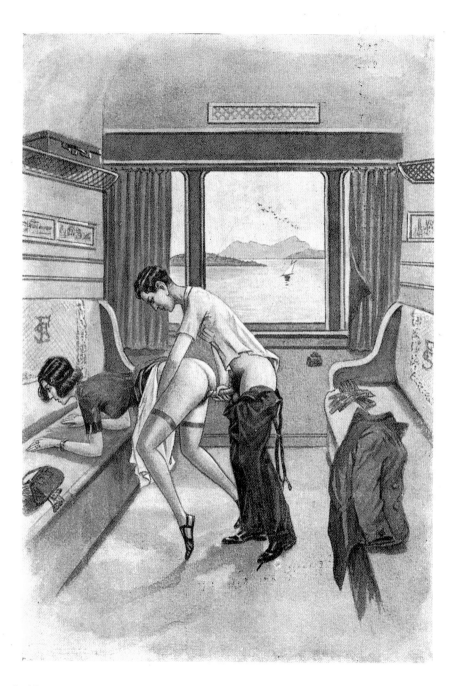

Anonymous Illustrations for *The Paradise of Flesh* by an anonymous Italian author, 20–30s

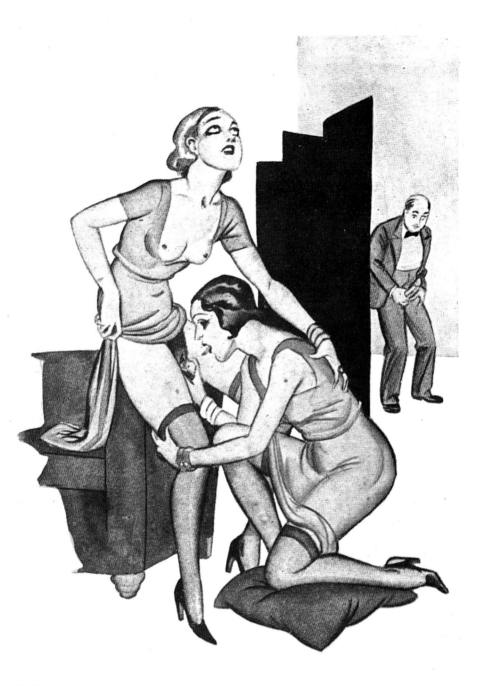

Anonymous Illustrations for *The Book of Lust* by Pierre Lacombière, 20–30s

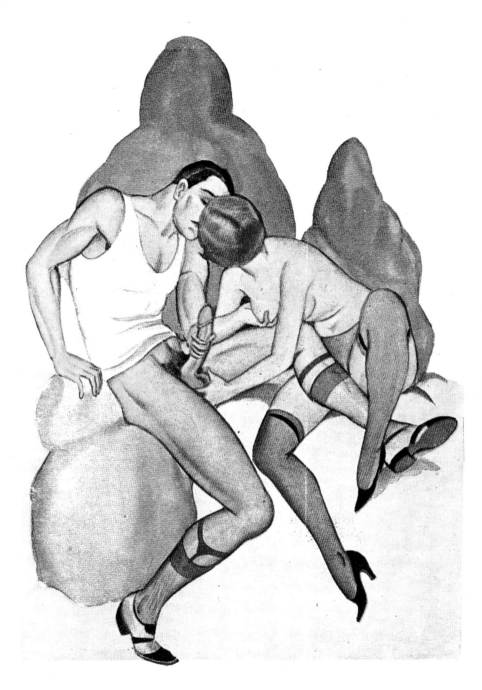

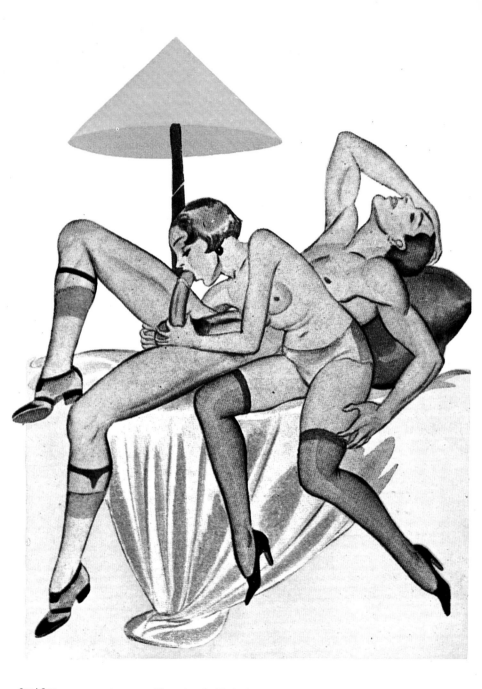

Anonymous Illustrations for *The Book of Lust* by Pierre Lacombière, 20–30s

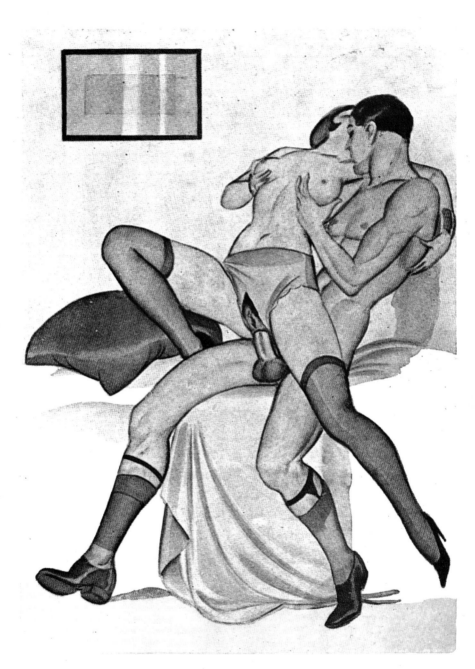

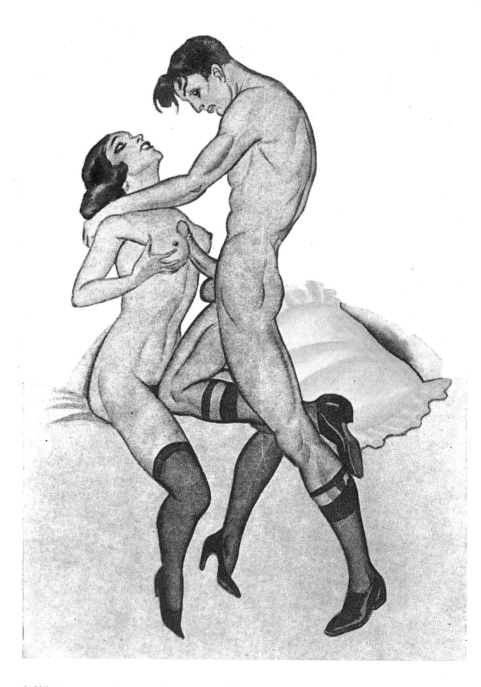

Anonymous Illustrations for *The Book of Lust* by Pierre Lacombière, 20–30s

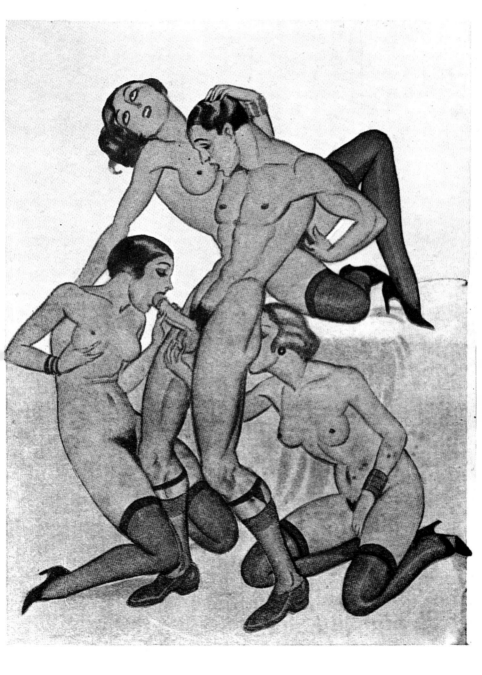

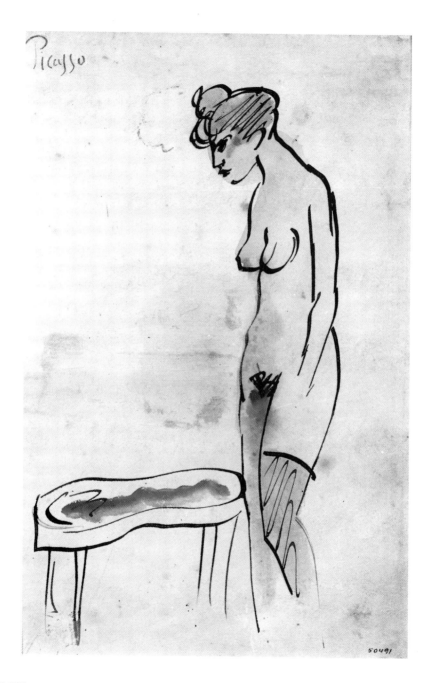

Pablo Picasso Feminine Figure or The Bidet, 1902-1903

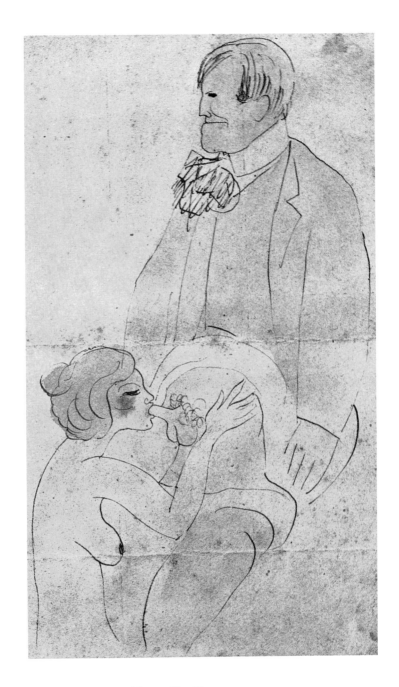

Pablo Picasso Woman of Easy Virtue, 1903

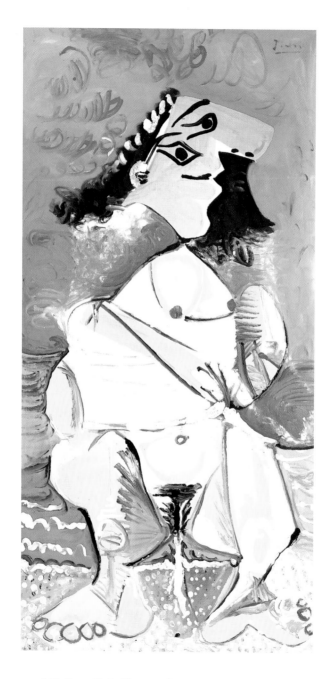

Pablo Picasso Pissing Woman, 1965

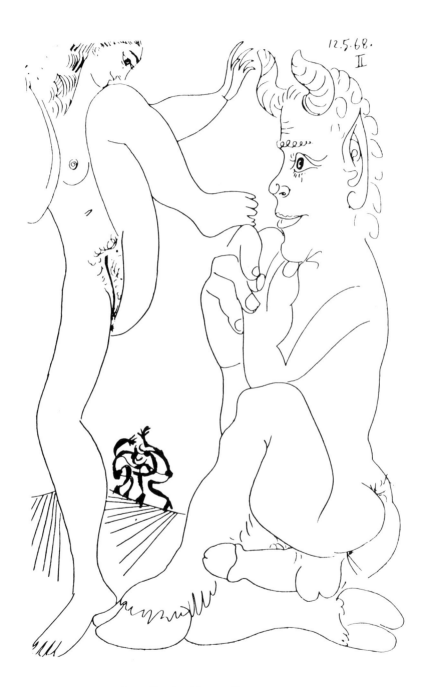

Pablo Picasso Nymph and Satyr, 1968

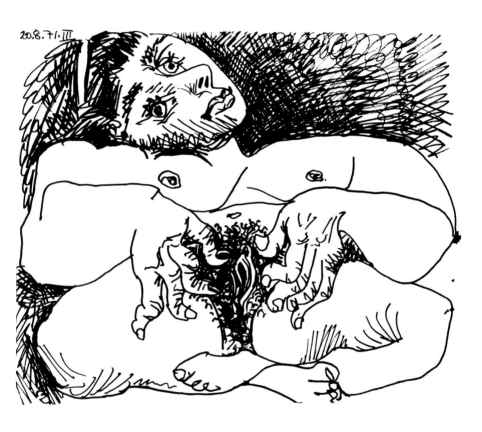

20.8.71.III

Pablo Picasso Two Drawings of Women's Sexes, 1971

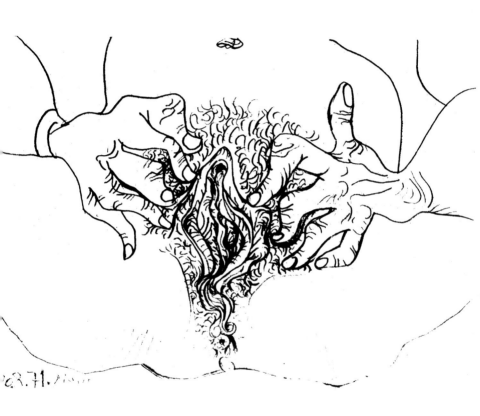

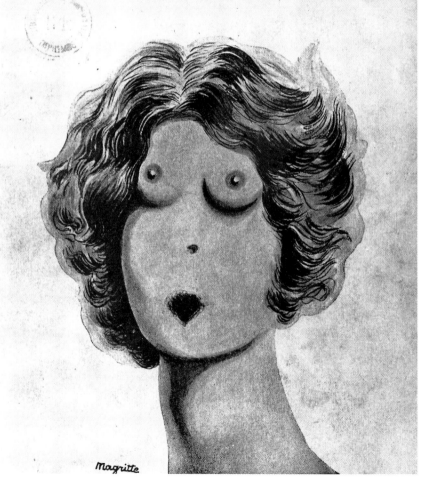

ANDRÉ BRETON

QU'EST-CE QUE LE
SURRÉALISME?

Magritte

René Magritte Rape or Debauch. Cover of André Breton's *What is Surrealism?*, 1934

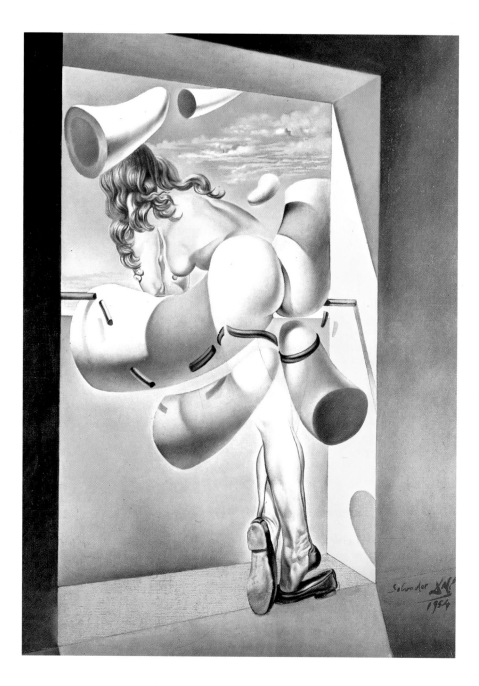

Salvador Dalí Young Virgin Auto-Sodomized by her Own Chastity, 1954

198. *La serrure.* — 199. *Le bouton de porte.* — 200. *La clé.*
— 201. *La sonnette.* — 202. *Le cadenas.* — 203. *Le verrou.*

Salvador Dalí Plate excerpted from the *Treatise of erotic systems and the thousand masturbatory ways from the Romans to Dalí*, 1969

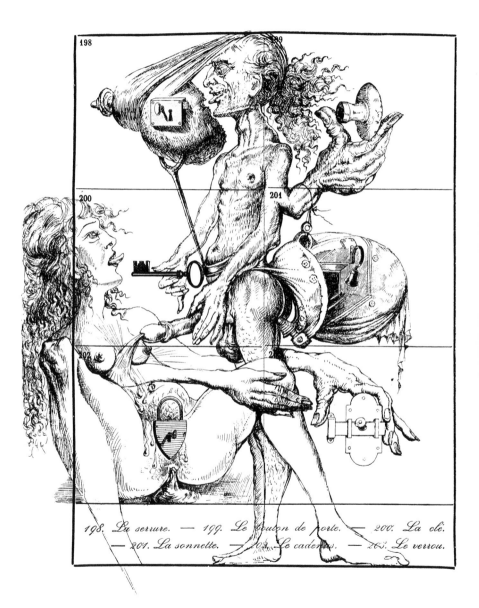

198. *La serrure.* — 199. *Le bouton de porte.* — 200. *La clé.*
— 201. *La sonnette.* — 202. *Le cadenas.* — 203. *Le verrou.*

130. Le lion rugit.

131. Le bœuf mugit.

132. Le chien aboie

133. L'agneau bêle.

134. Le rossignol chante.

135. La grenouille coasse.

Salvador Dalí Plate excerpted from the *Treatise of erotic systems and the thousand masturbatory ways from the Romans to Dalí*, 1969

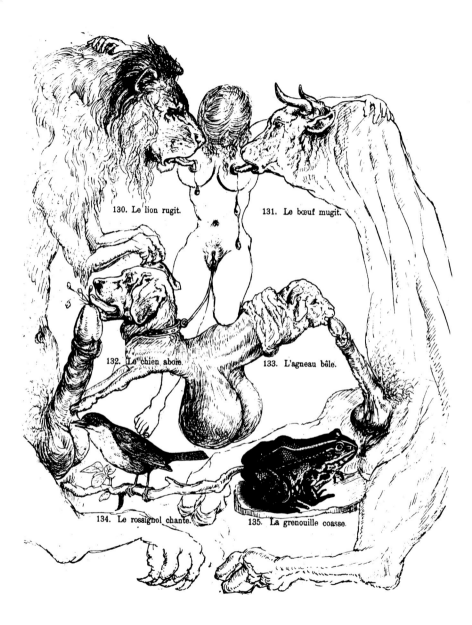

130. Le lion rugit.

131. Le bœuf mugit.

132. Le chien aboie.

133. L'agneau bêle.

134. Le rossignol chante.

135. La grenouille coasse.

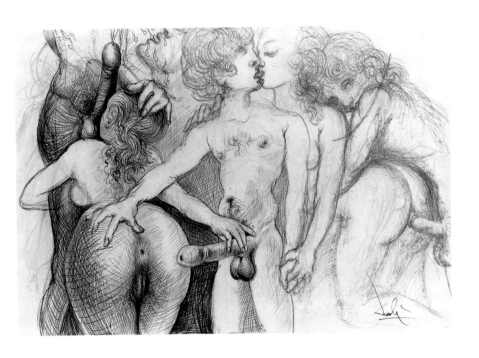

Salvador Dalí Erotic Scene with Seven Figures, c. 1966

André Masson Erotic Land, 1939

André Masson Erotic Drawing, 1937

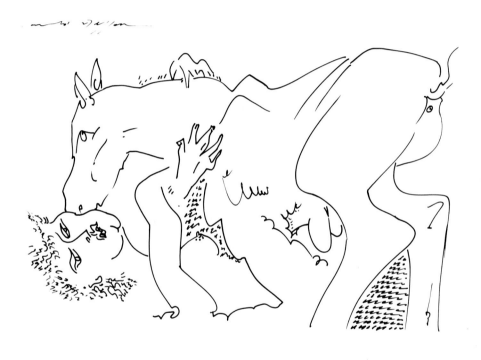

André Masson Erotic Drawing, 1938

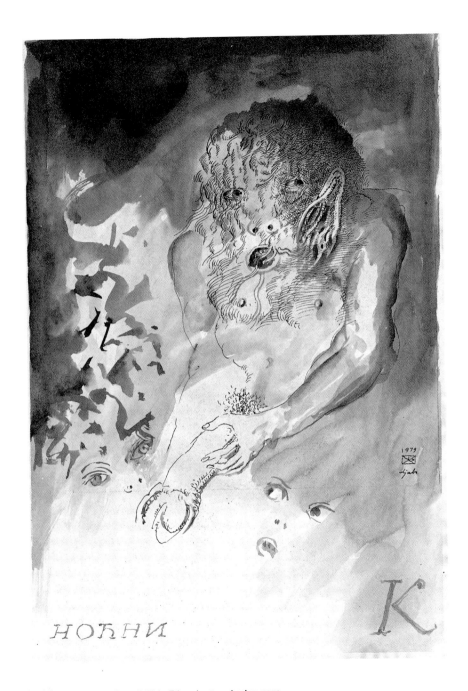

НОЋНИ

Popovic Ljuba Triumphant awakening, 1979

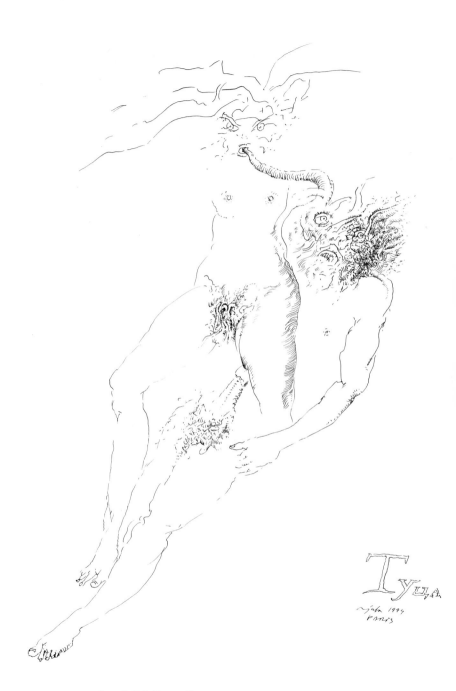

Popovic Ljuba Toutsanié, 1994

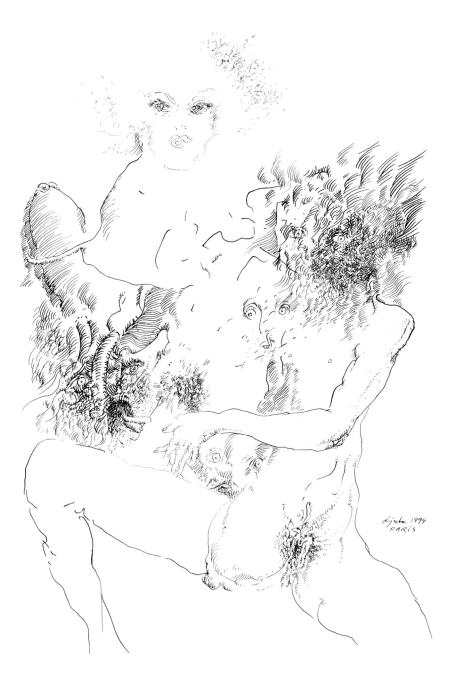

Popovic Ljuba Ingrid's old age, 1994

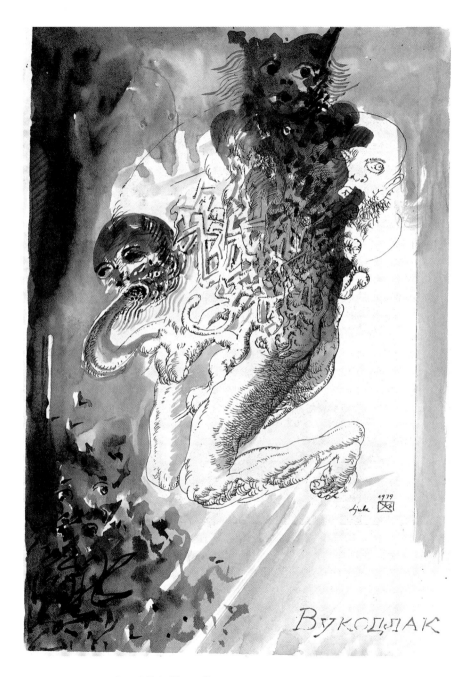

ВУКОДЛАК

Popovic Ljuba Werewolf, 1979

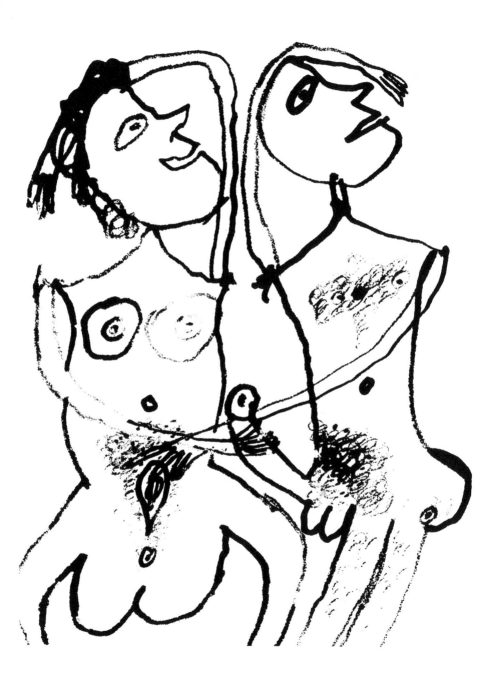

Jean Dubuffet Games I, plate V, of Labonfam Abeber, 1949

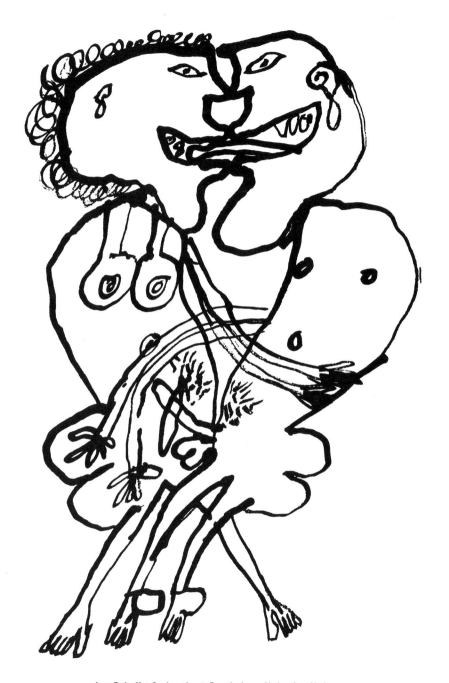

Jean Dubuffet Conjugation 1. Frontispiece of Labonfam Abeber, 1949

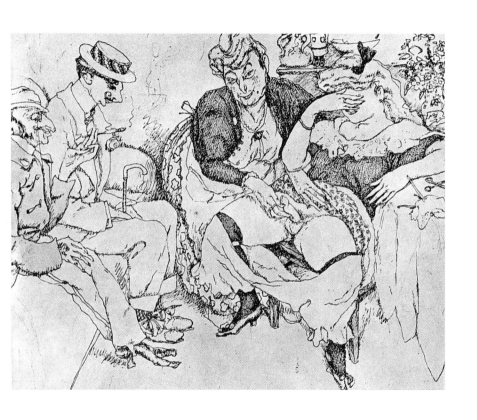

Jules Pascin Scene in a specialised Paris brothel. From the *Erotikon* portfolio, published
in 1933

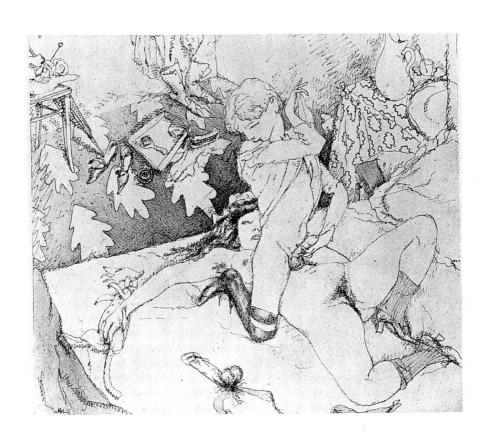

Jules Pascin Private scenes. From the *Erotikon* portfolio, published in 1933

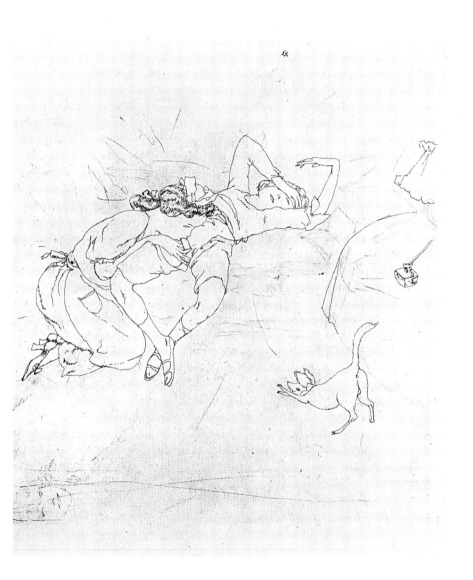

Jules Pascin Private scene. From the *Erotikon* portfolio, published in 1933

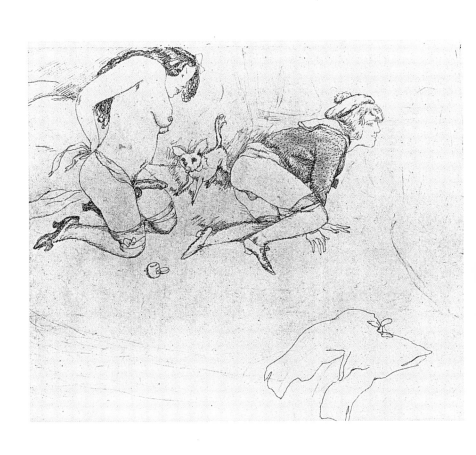

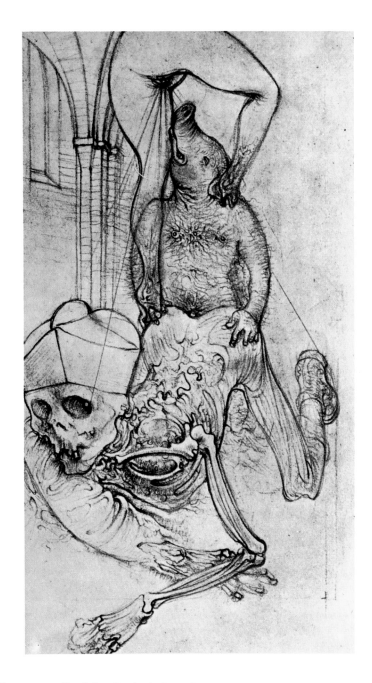

Hans Bellmer Drawing for George Batailles' *Story of the Eye*, 1950

Hans Bellmer Appropriation, 1944

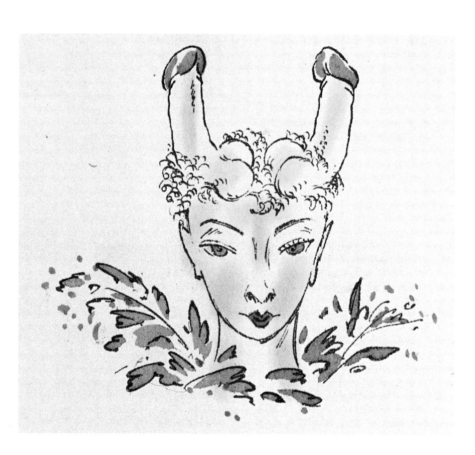

Anonymous Illustrations for Pierre Louÿs's *Three Daughters of their Mother*, 20s

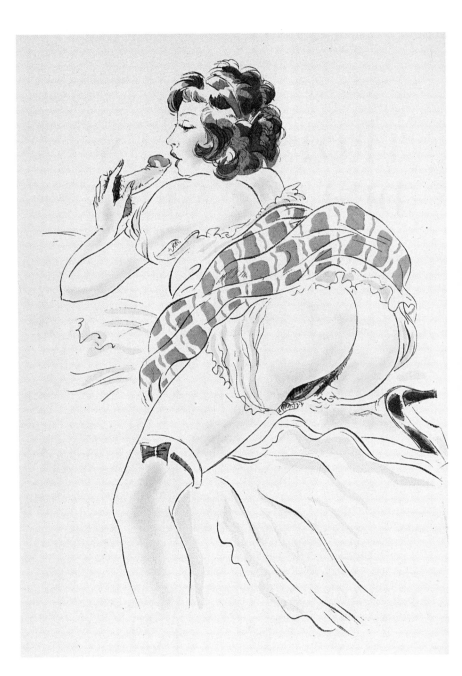

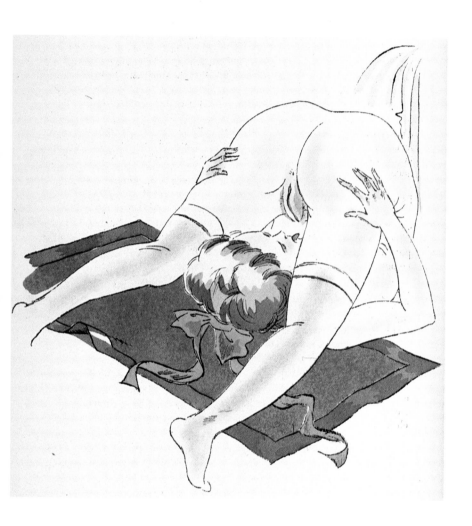

Anonymous Illustrations for Pierre Louÿs's *Three Daughters of their Mother*, 20s

Anonymous Illustrations for Pierre Louÿs's *Three Daughters of their Mother*, 20s

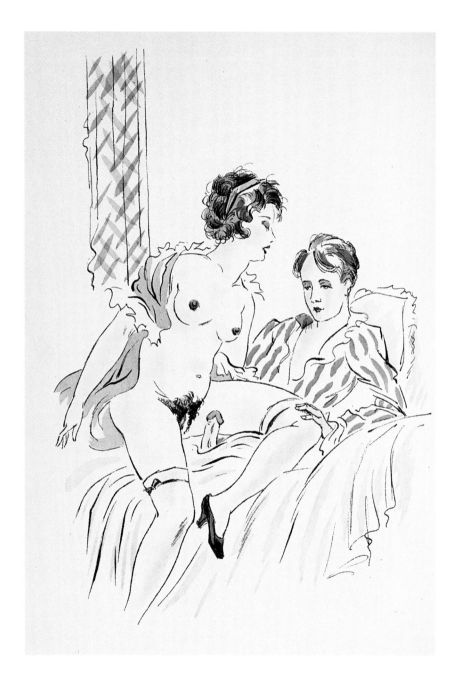

Anonymous (Vertès?) Illustrations for *Pybrac* by Pierre Louÿs, 20s

Anonymous (Vertès?) Illustrations for *Pybrac* by Pierre Louÿs, 20s

Anonymous (Vertès?) Illustrations for *Pybrac* by Pierre Louÿs, 20s

Anonymous (Vertès?) Illustrations for *Pybrac* by Pierre Louÿs, 20s

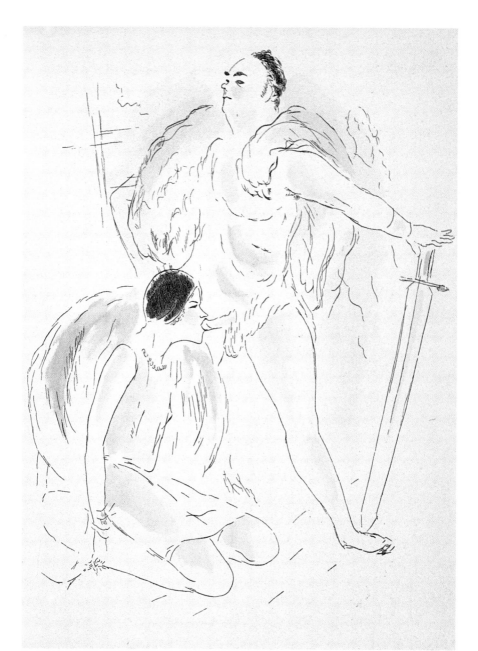

Anonymous (Vertès?) Illustrations for *Pybrac* by Pierre Louÿs, 20s

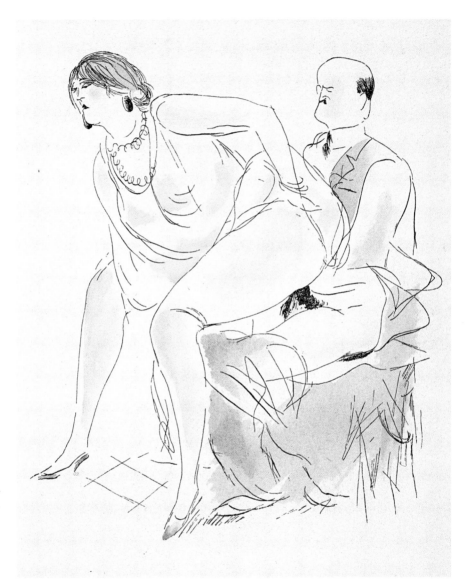

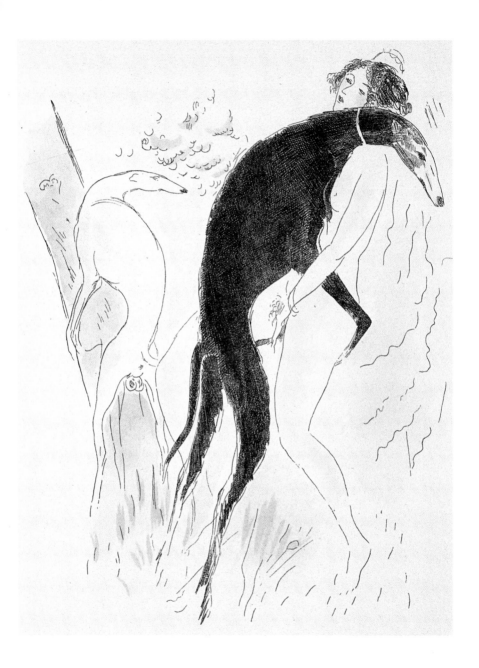

Anonymous (Vertès?) Illustrations for *Pybrac* by Pierre Louÿs, 20s

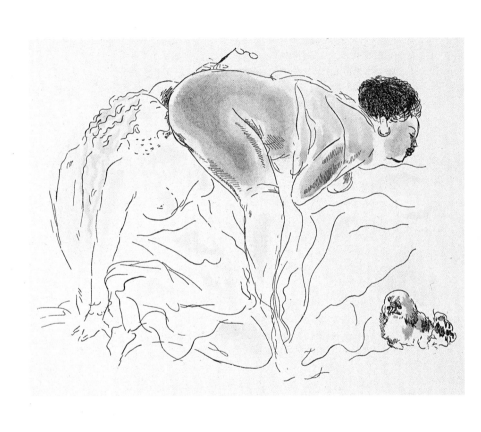

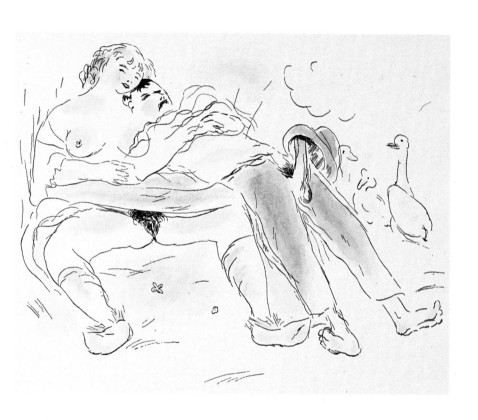

Anonymous (Vertès?) Illustrations for *Pybrac* by Pierre Louÿs, 20s

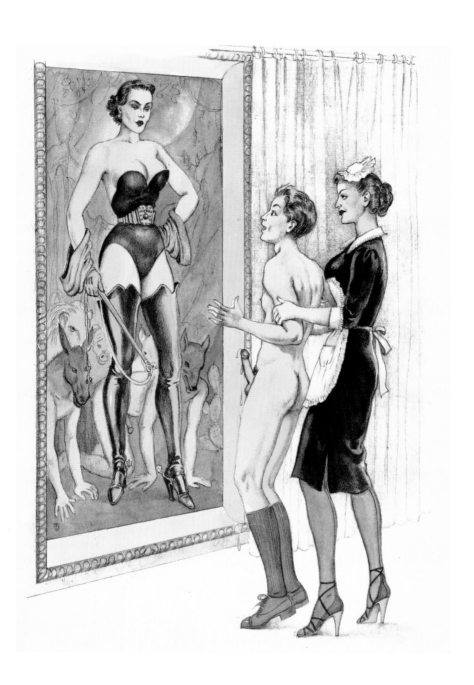

Bernard Montorgueil Illustrations and texts from works variously entitled *The Four Thursdays, Dressage, A Piquante Brunette*, 30s

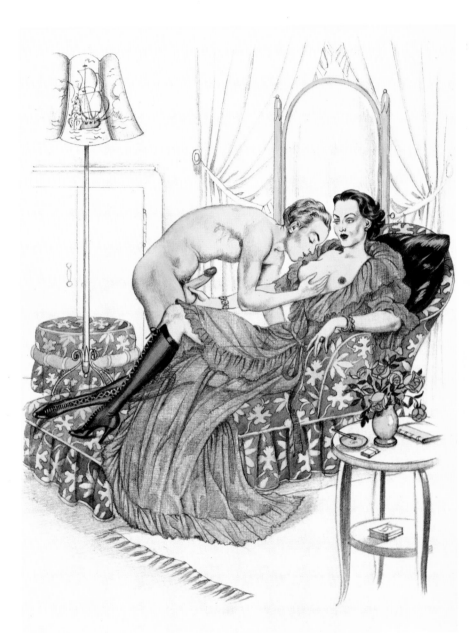

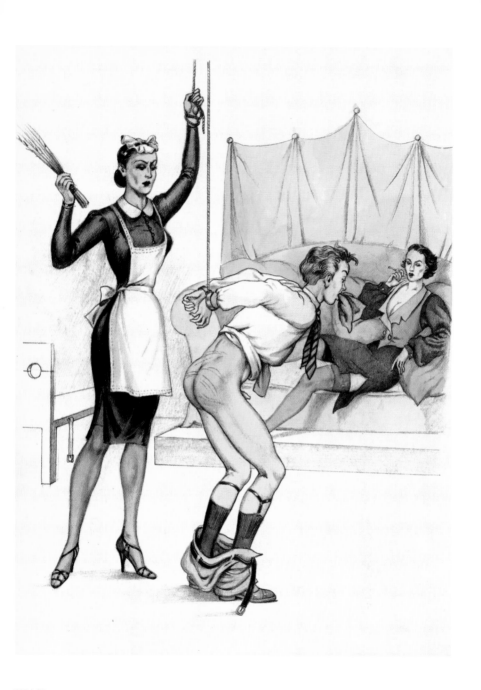

Bernard Montorgueil Illustrations and texts from works variously entitled *The Four Thursdays, Dressage, A Piquante Brunette*, 30s

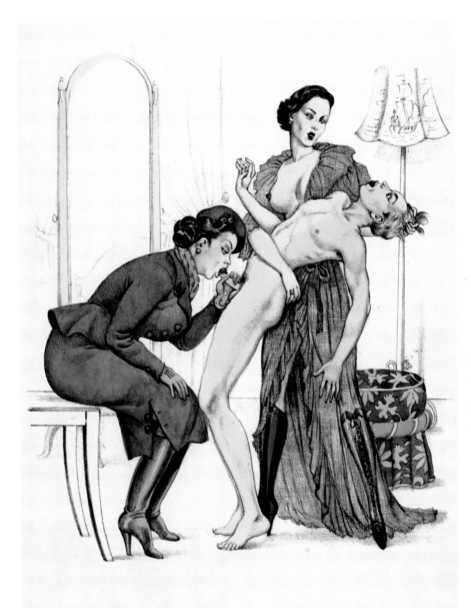

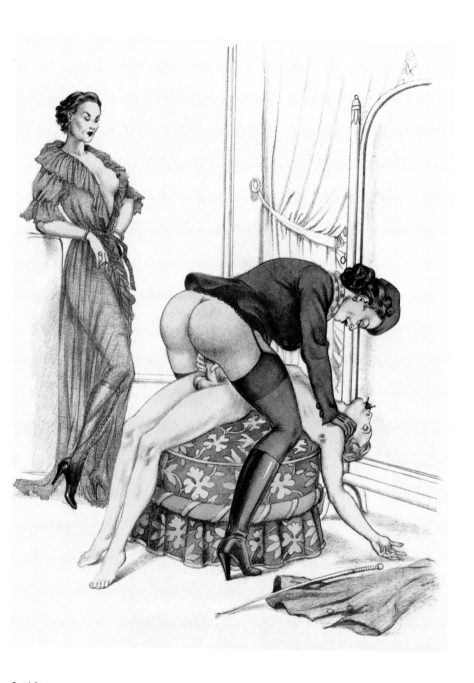

Bernard Montorgueil Illustrations and texts from works variously entitled *The Four Thursdays, Dressage, A Piquante Brunette*, 30s

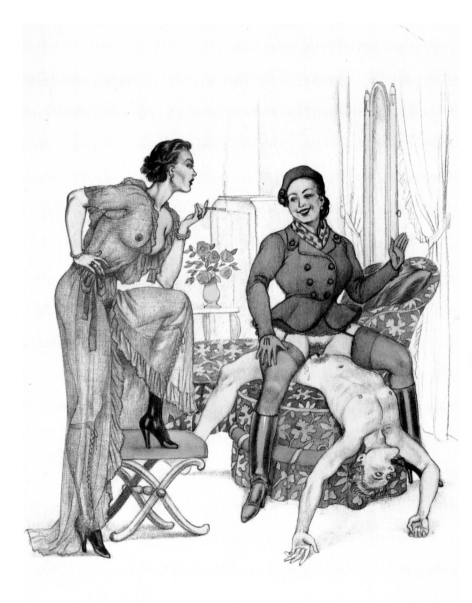

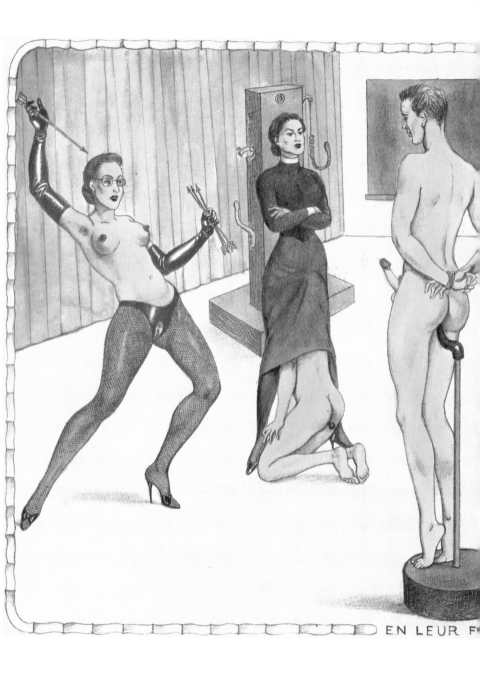

EN LEUR F

Bernard Montorgueil Illustrations and texts from works variously entitled *The Four Thursdays, Dressage, A Piquante Brunette*, 30s

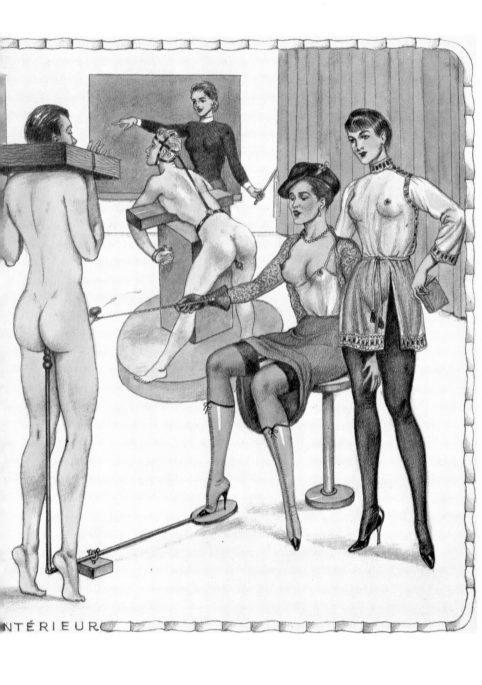

NTÉRIEUR

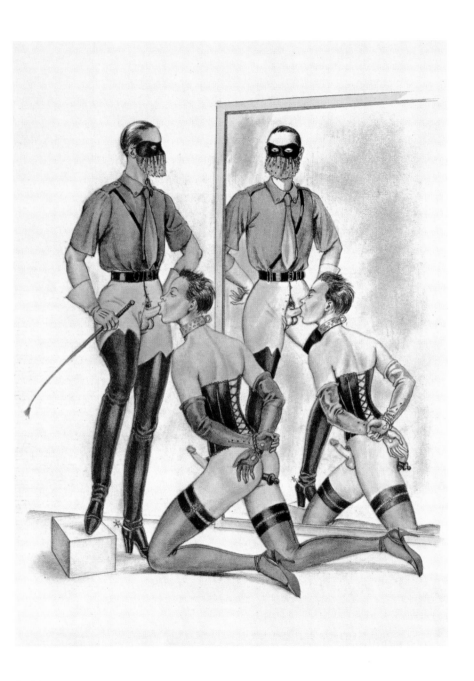

Bernard Montorgueil Illustrations and texts from works variously entitled *The Four Thursdays, Dressage, A Piquante Brunette*, 30s

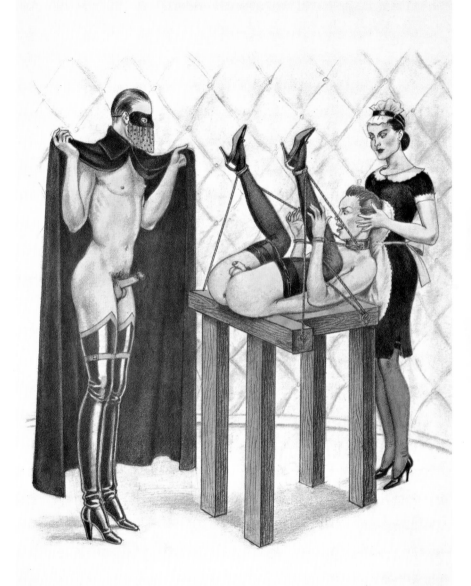

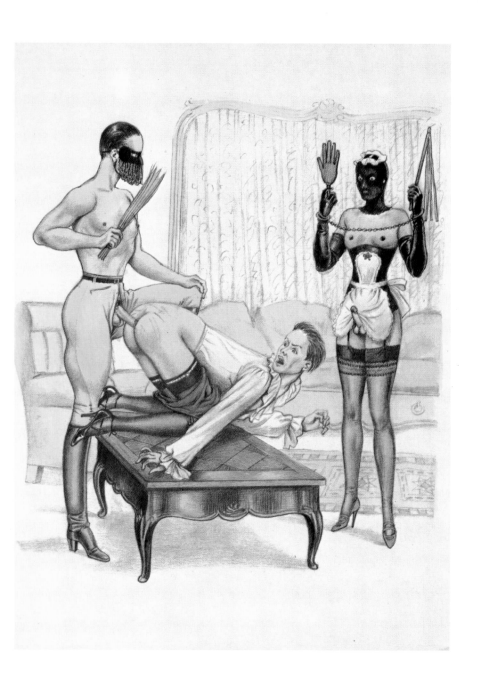

Bernard Montorgueil Illustrations and texts from works variously entitled *The Four Thursdays, Dressage, A Piquante Brunette*, 30s

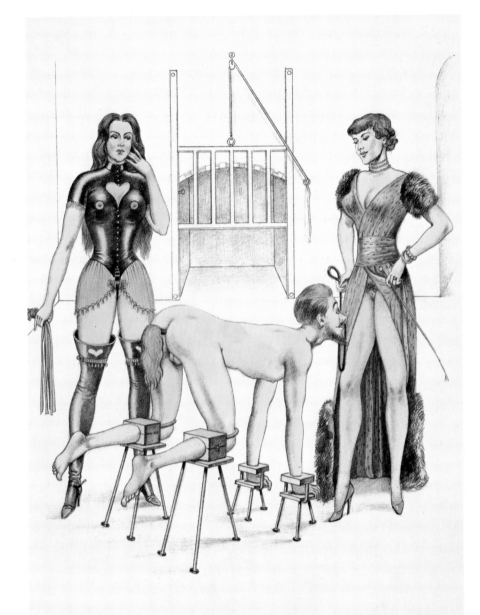

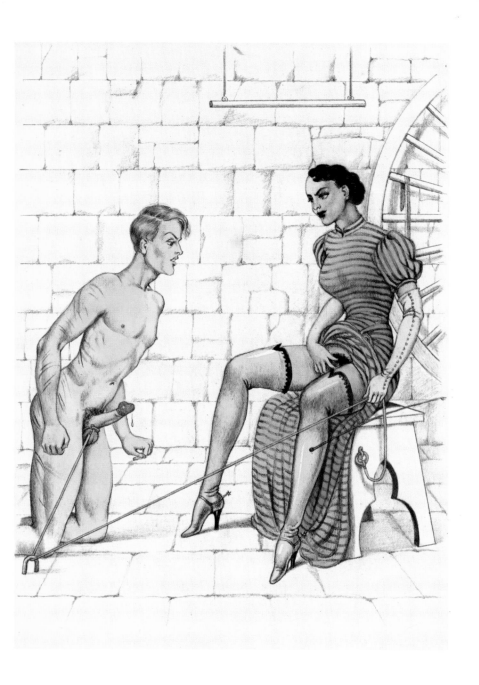

Bernard Montorgueil Illustrations and texts from works variously entitled *The Four Thursdays, Dressage, A Piquante Brunette*, 30s

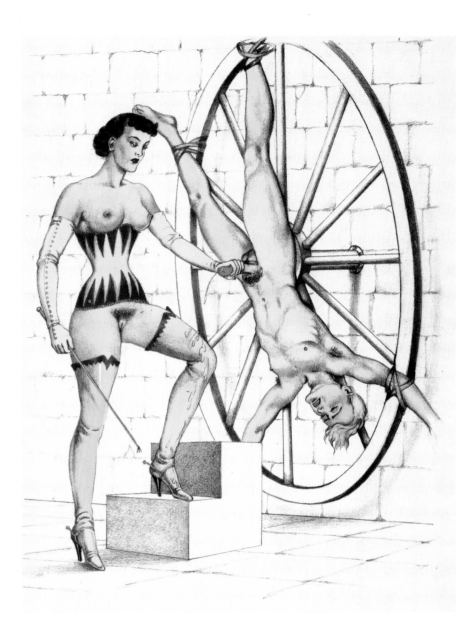

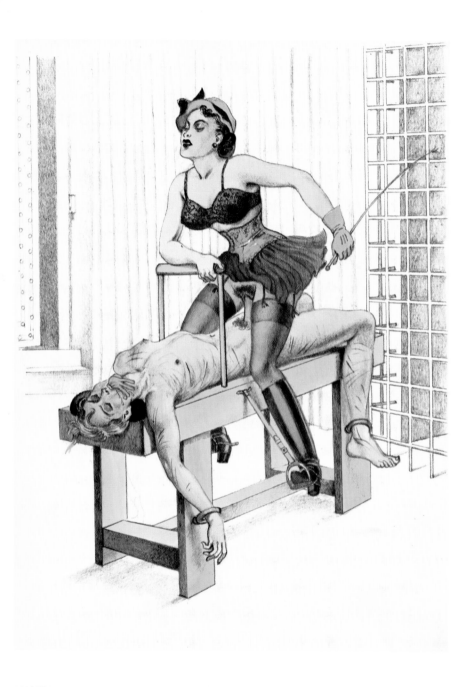

Bernard Montorgueil Illustrations and texts from works variously entitled *The Four Thursdays, Dressage, A Piquante Brunette*, 30s

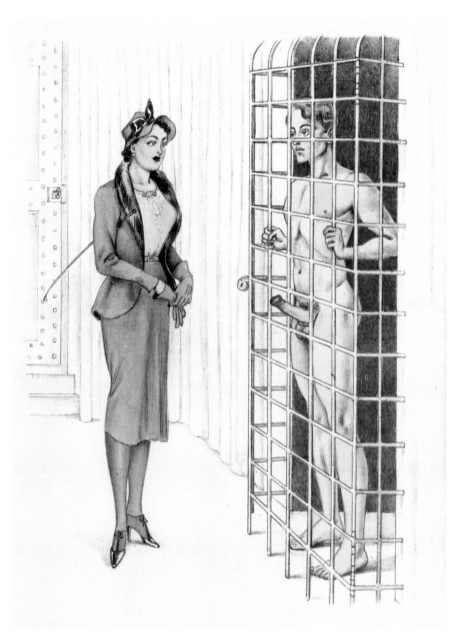

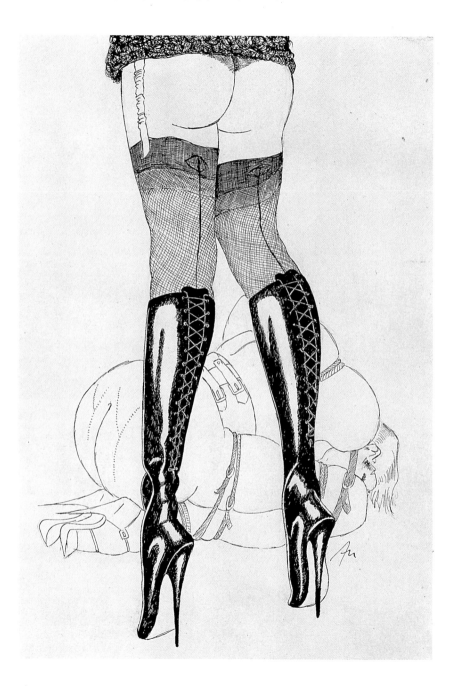

Anonymous Mistress and Slave, c. 1930

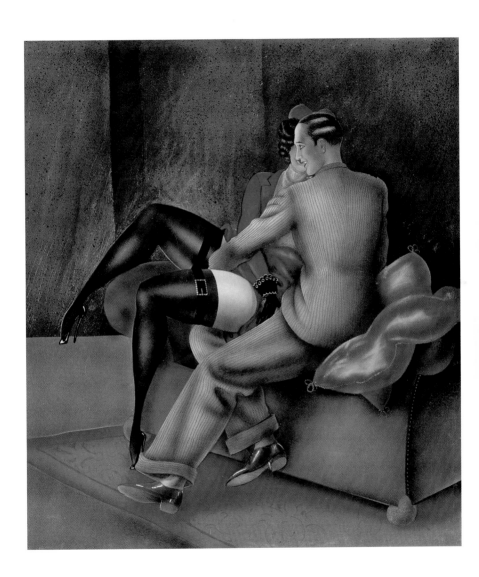

Carlo In the *Séparée*, c. 1930

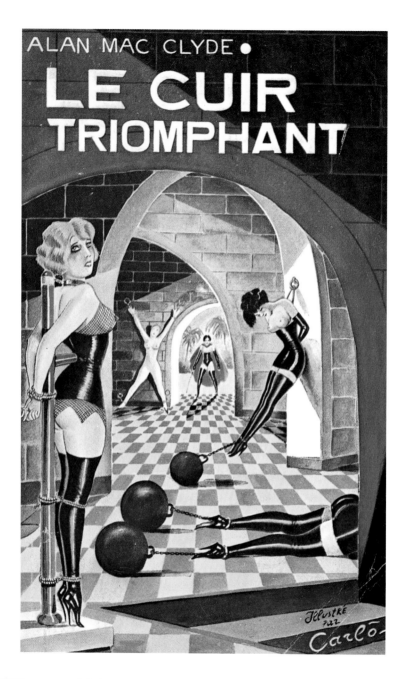

Carlo Cover of *Triumphant Leather*, 30s

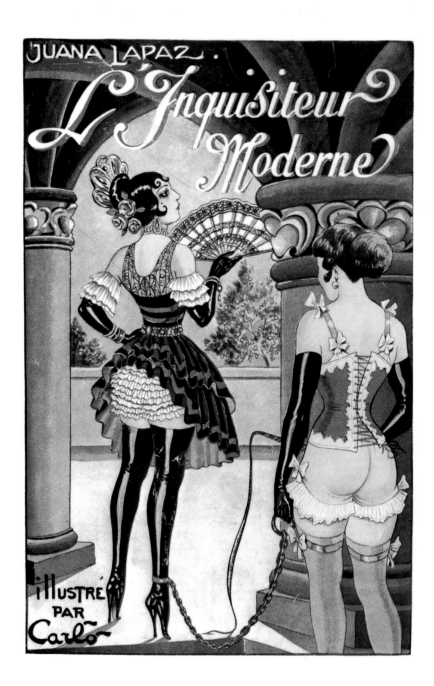

Carlo Cover of *The Modern Inquisitor*, 30s

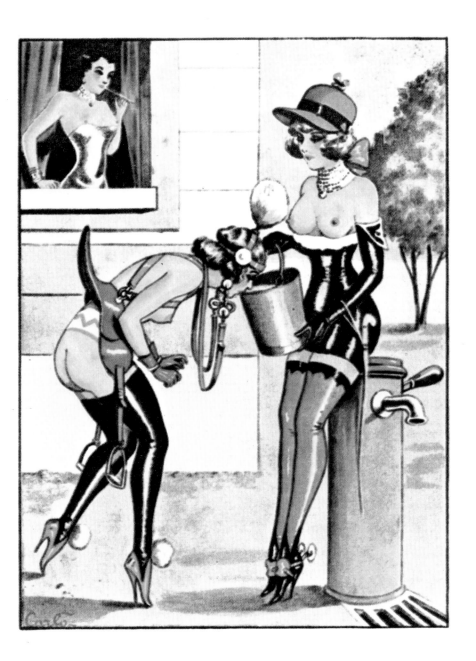

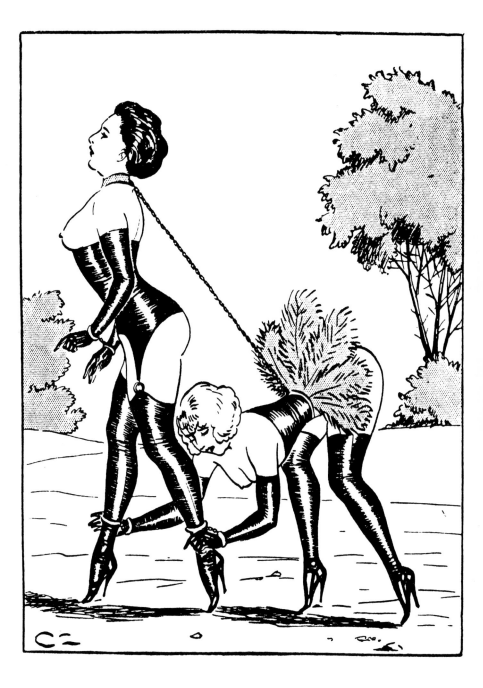

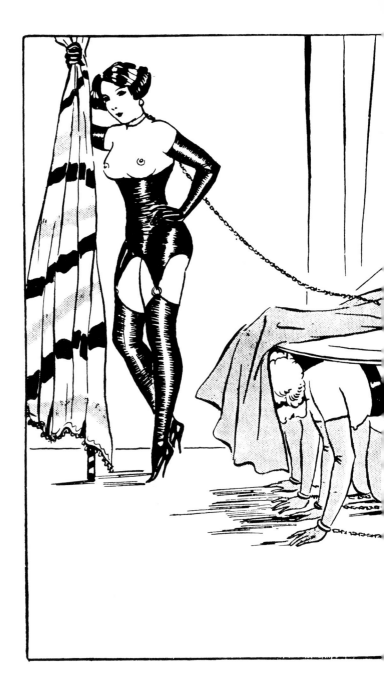

Carlo Illustrations for *Triumphant Leather*, 30s

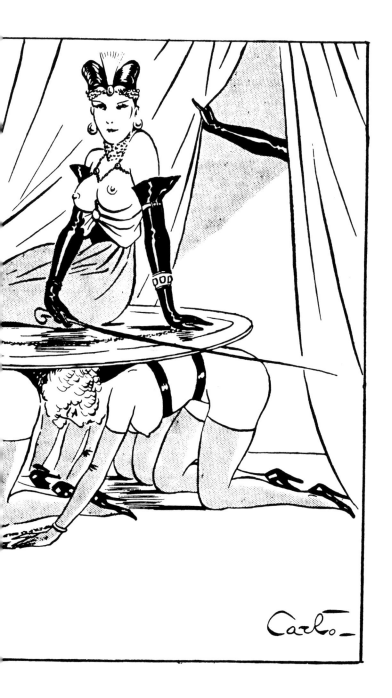

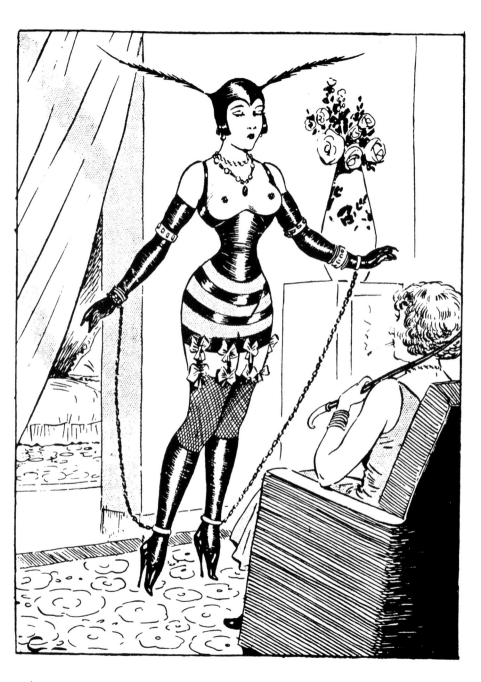

Carlo Illustrations for *Triumphant Leather*, 30s

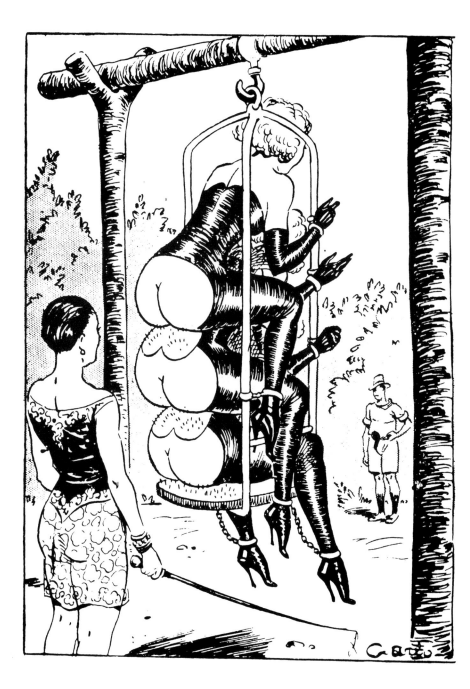

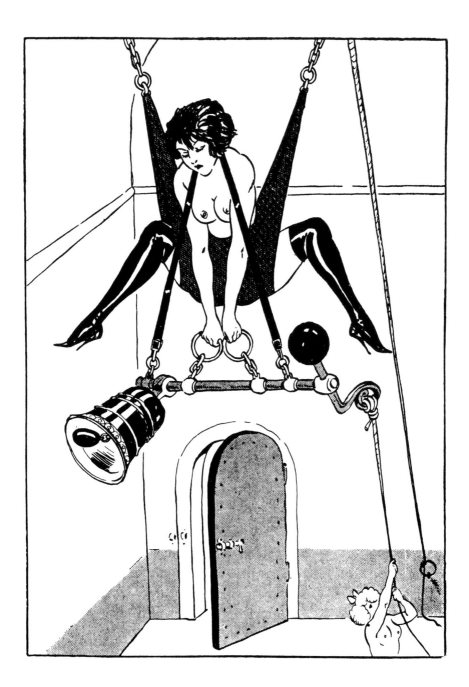

Carlo Illustrations for *Triumphant Leather*, 30s

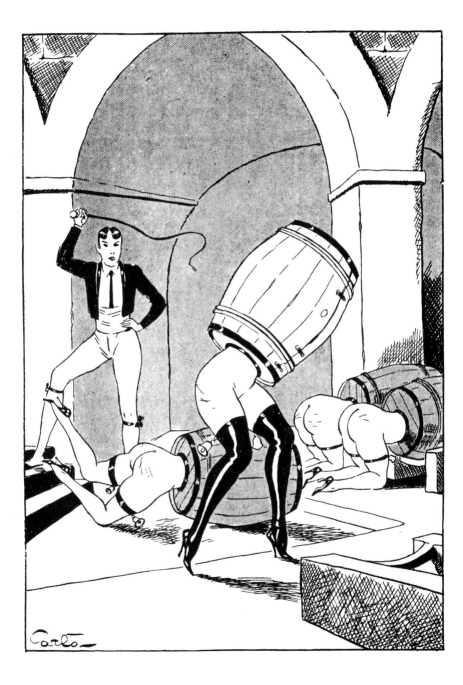

Anonymous (Jean Cocteau) Illustrations for Jean Genet's *Querelle of Brest*, 1947

Anonymous (Jean Cocteau) Illustrations for Jean Genet's *Querelle of Brest*, 1947

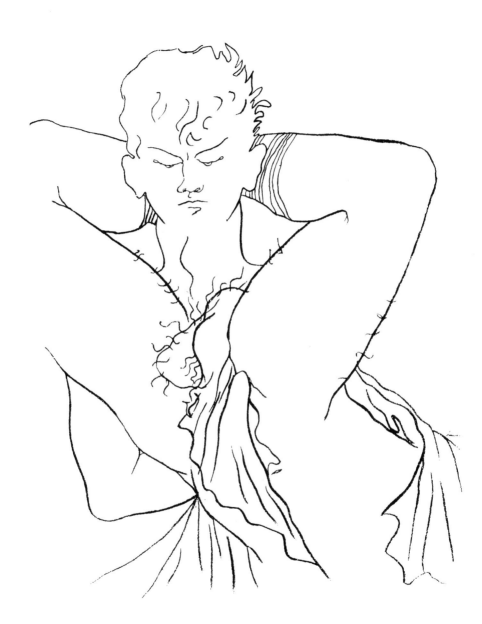

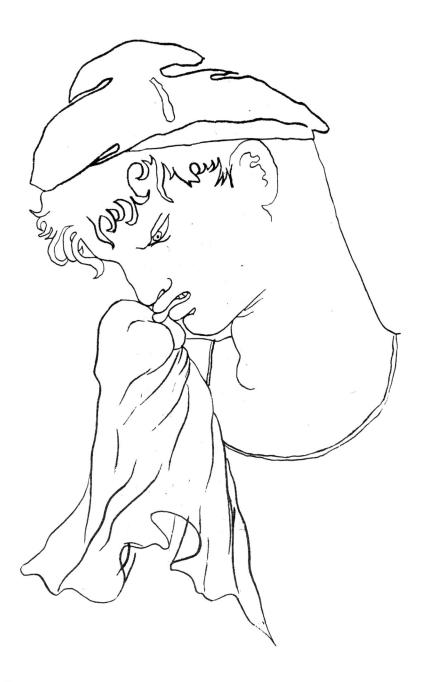

Anonymous (Jean Cocteau) Illustrations for Jean Genet's *Querelle of Brest*, 1947

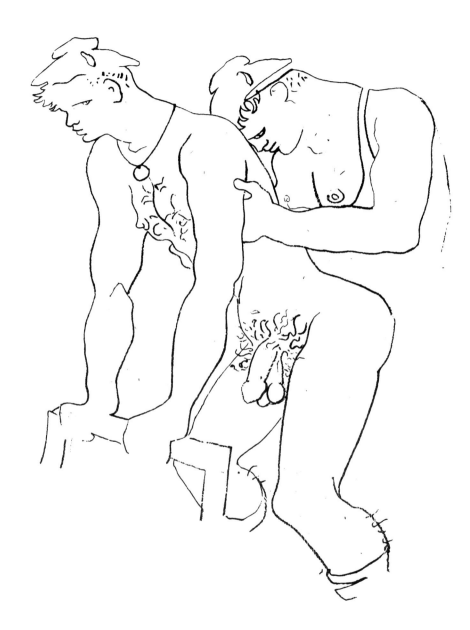

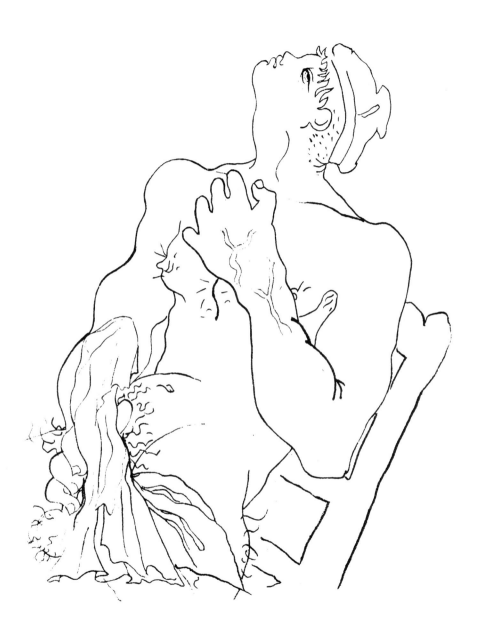

Anonymous (Jean Cocteau) Illustrations for Jean Genet's *Querelle of Brest*, 1947

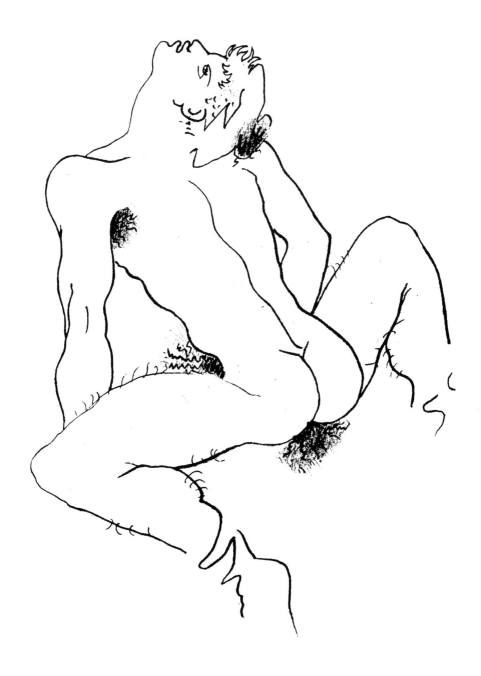

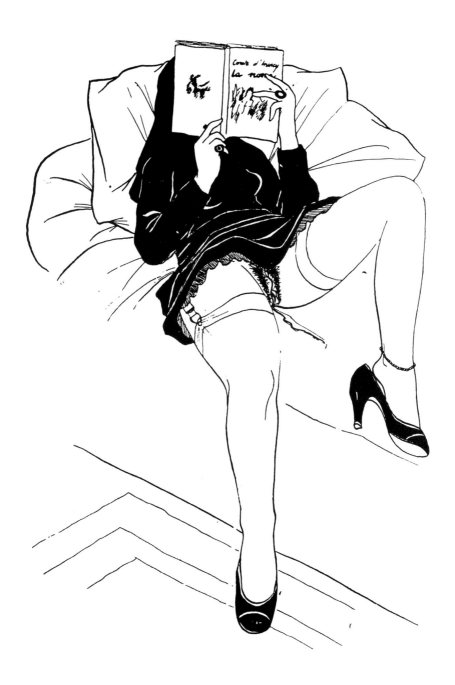

Anonymous (Foujita?) Illustrations for *The Nun*, 40s

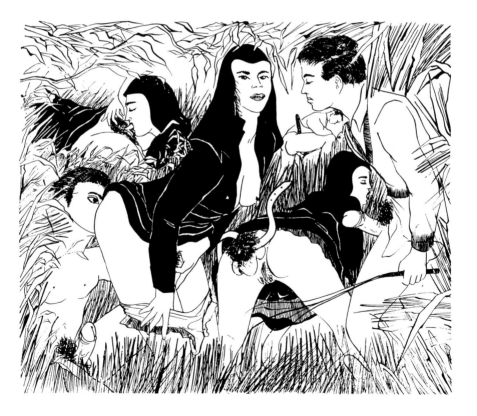

Anonymous (Foujita?) Illustrations for *The Nun*, 40s

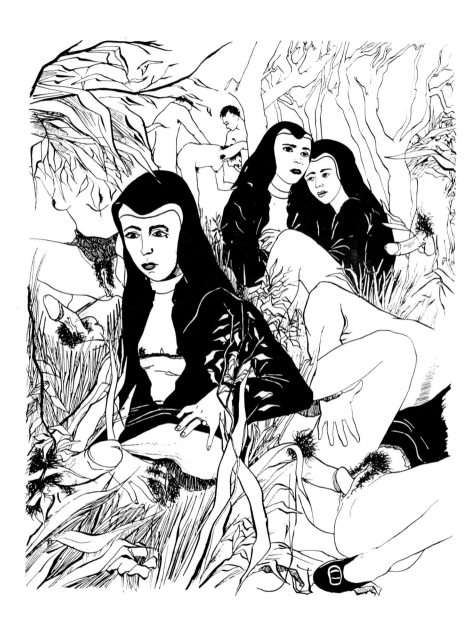

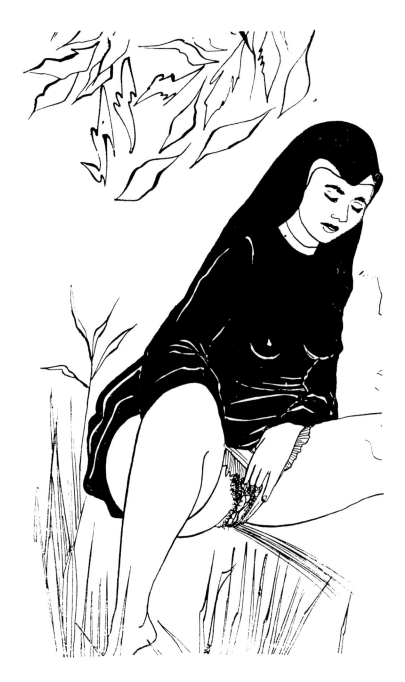

Anonymous (Foujita?) Illustrations for *The Nun*, 40s

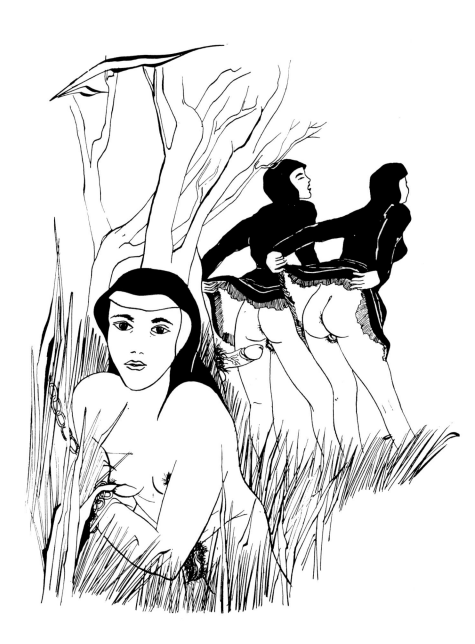

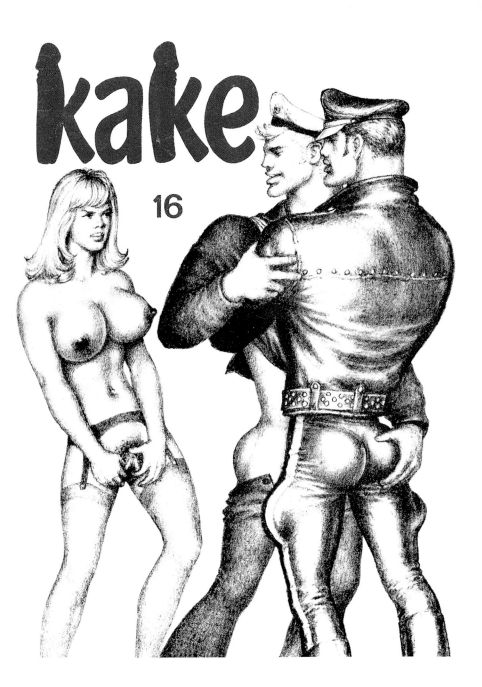

Tom of Finland Kake, comic-strip hero, 1975

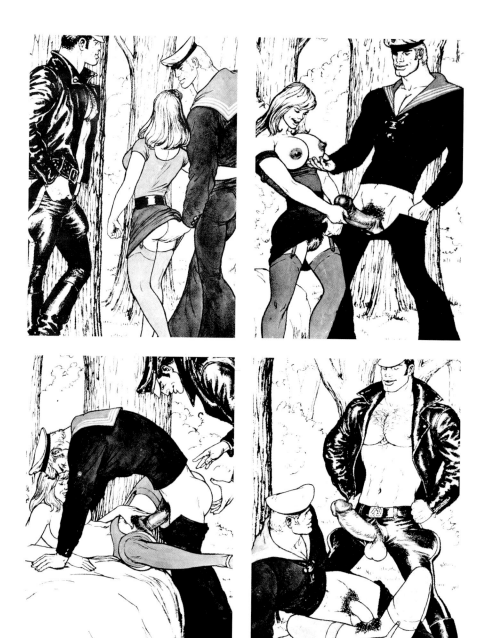

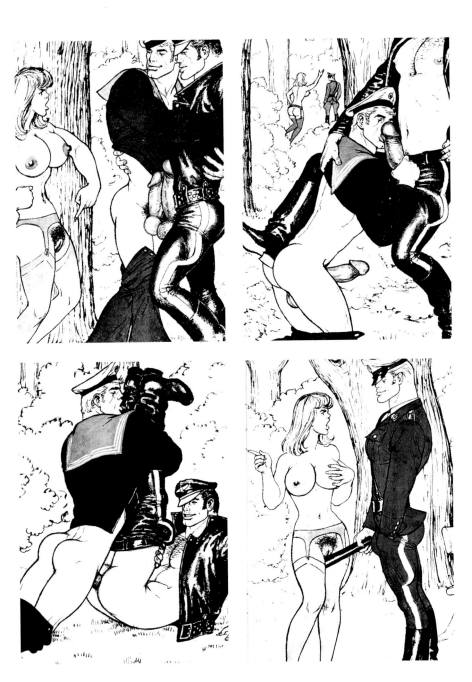

Tom of Finland Kake, comic-strip hero, 1975

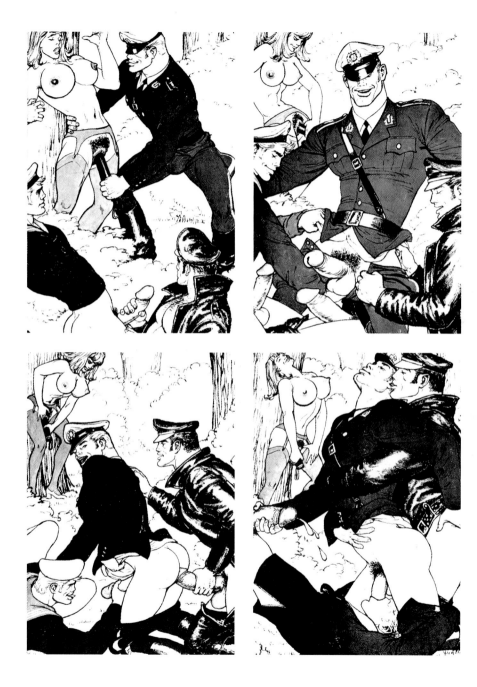

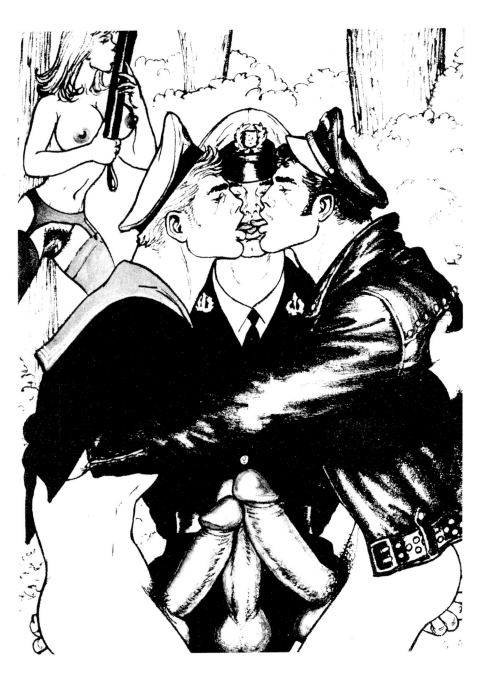

Tom of Finland Kake, comic-strip hero, 1975

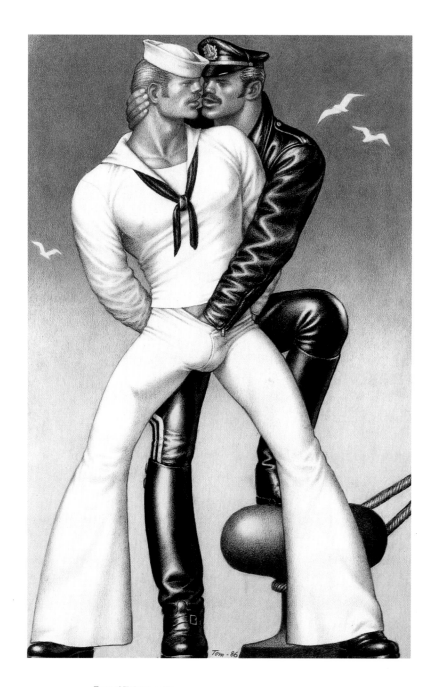

Tom of Finland, 1986

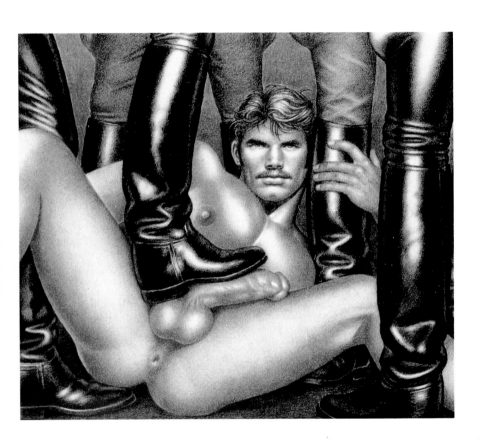

Tom of Finland, 1981

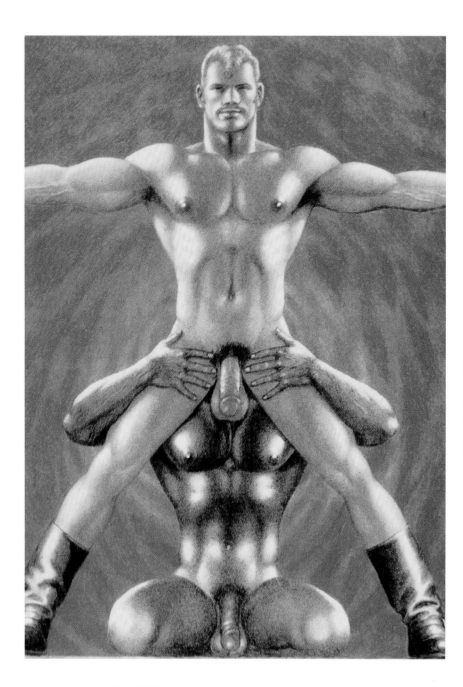

Tom of Finland, 1979

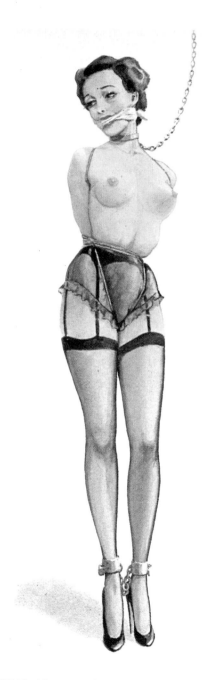

John Willie The Adventures of Gwendoline, 1946

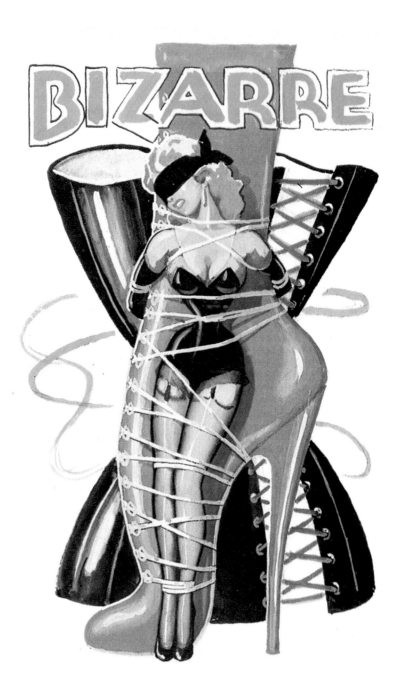

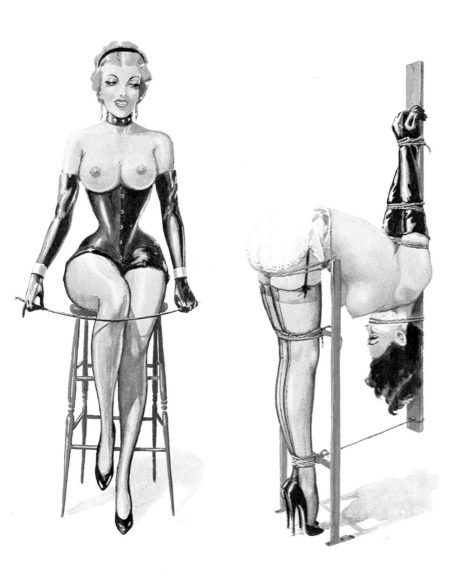

John Willie The Adventures of Gwendoline, 1946

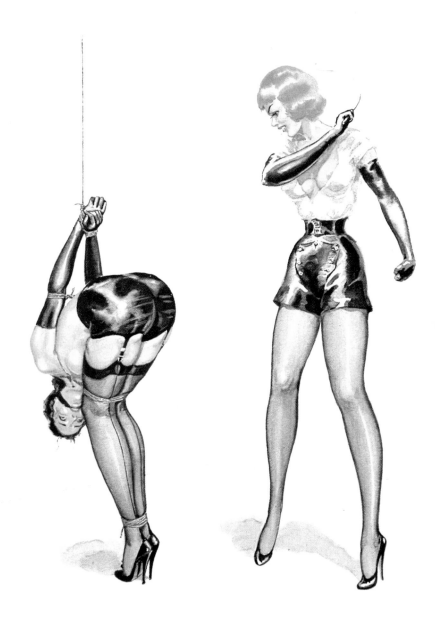

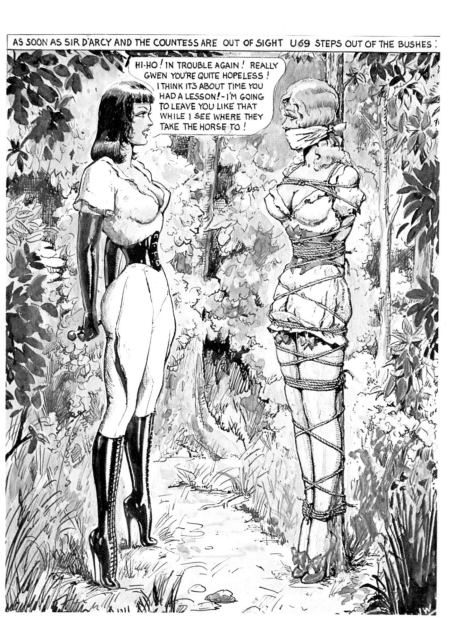

John Willie The Adventures of Gwendoline, 1946

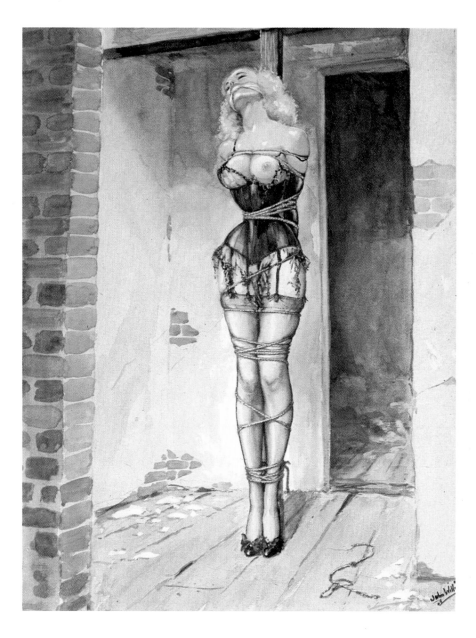

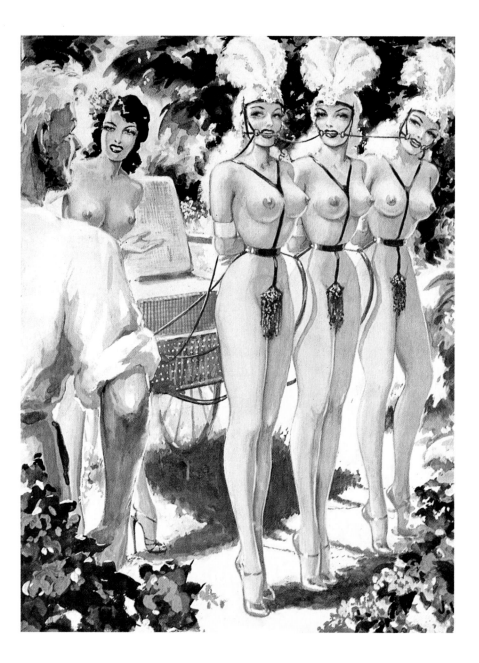

John Willie The Adventures of Gwendoline, 1946

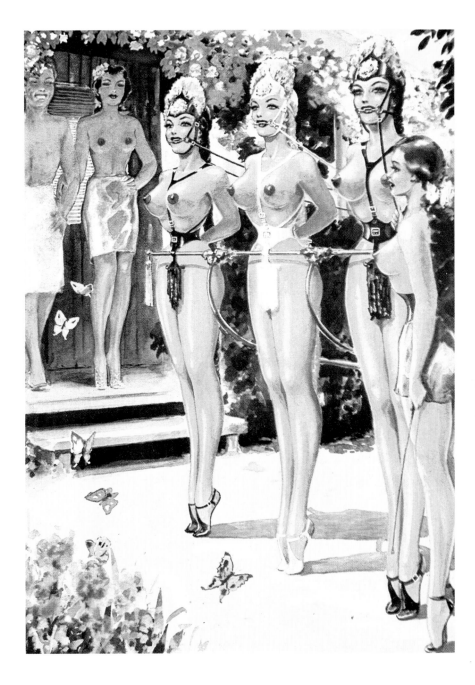

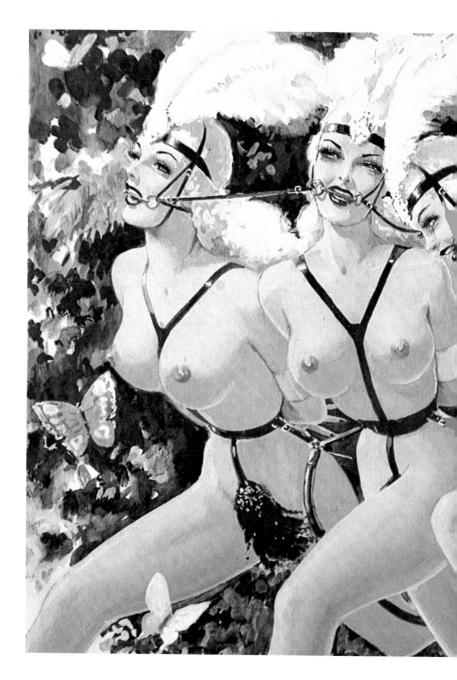

John Willie The Adventures of Gwendoline, 1946

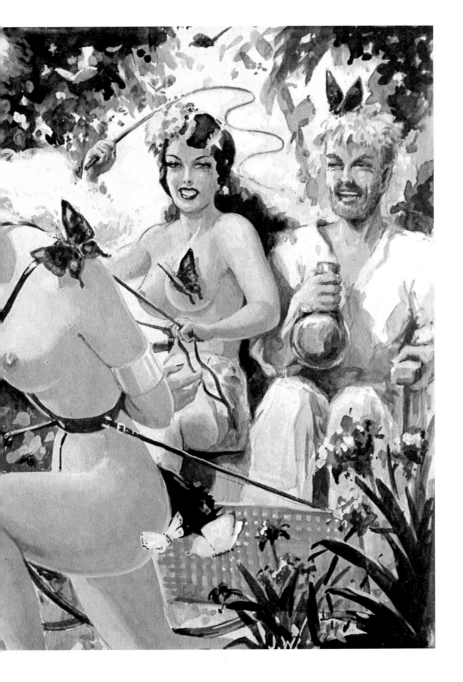

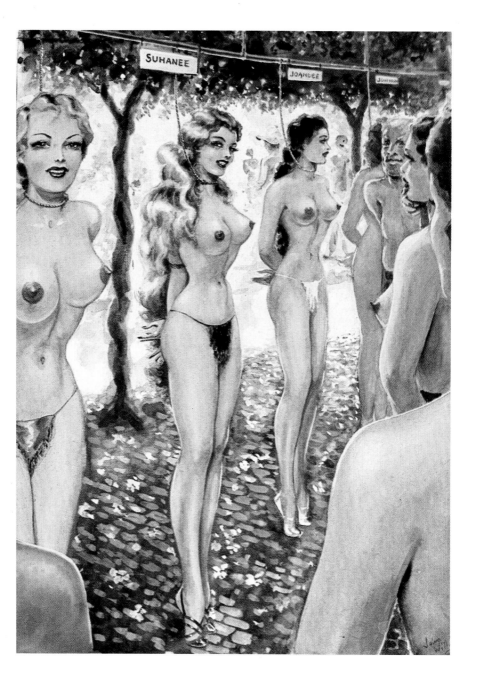

John Willie The Adventures of Gwendoline, 1946

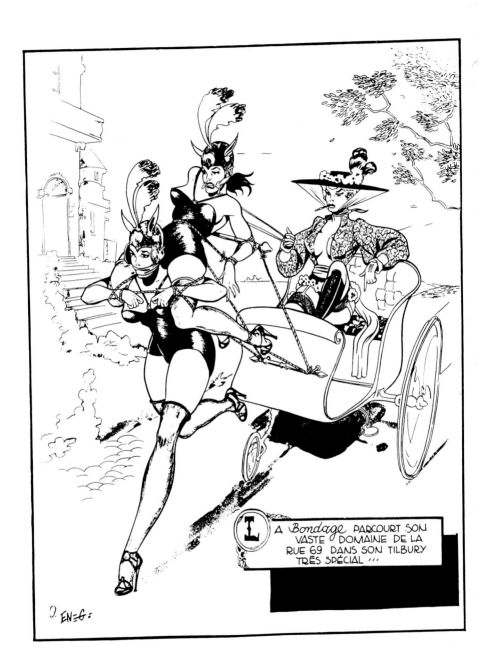

Eneg Madame La Bondage, 50s

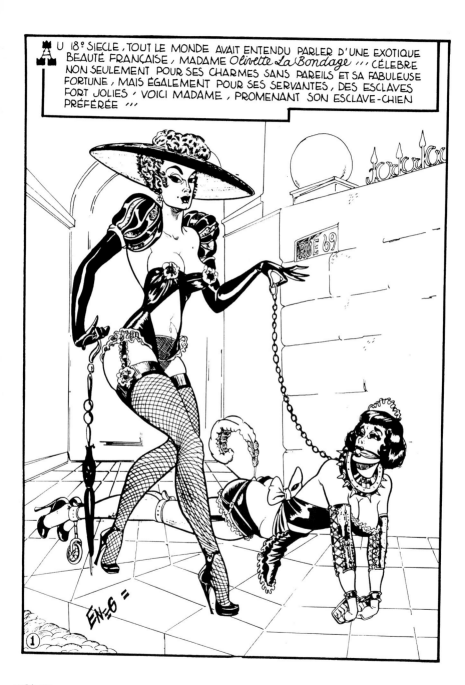

AU 18° SIECLE, TOUT LE MONDE AVAIT ENTENDU PARLER D'UNE EXOTIQUE BEAUTÉ FRANÇAISE, MADAME *Olivette La Bondage* ···· CÉLEBRE NON SEULEMENT POUR SES CHARMES SANS PAREILS ET SA FABULEUSE FORTUNE, MAIS ÉGALEMENT POUR SES SERVANTES, DES ESCLAVES FORT JOLIES · VOICI MADAME, PROMENANT SON ESCLAVE-CHIEN PRÉFÉRÉE ···

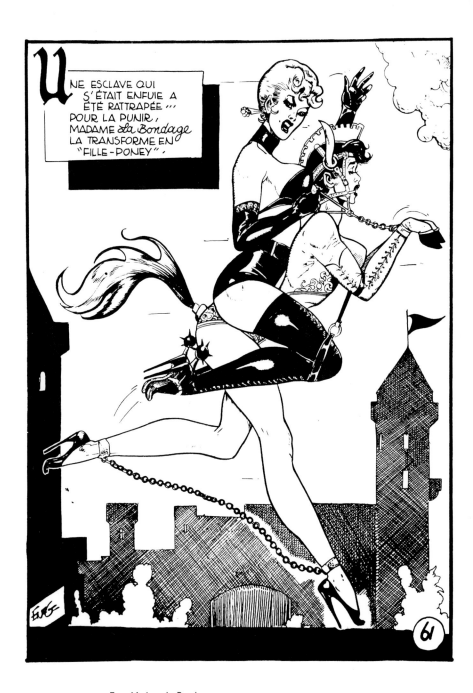

Eneg Madame La Bondage, 50s
▶ **Stanton** The Return of Gwendoline, 1976

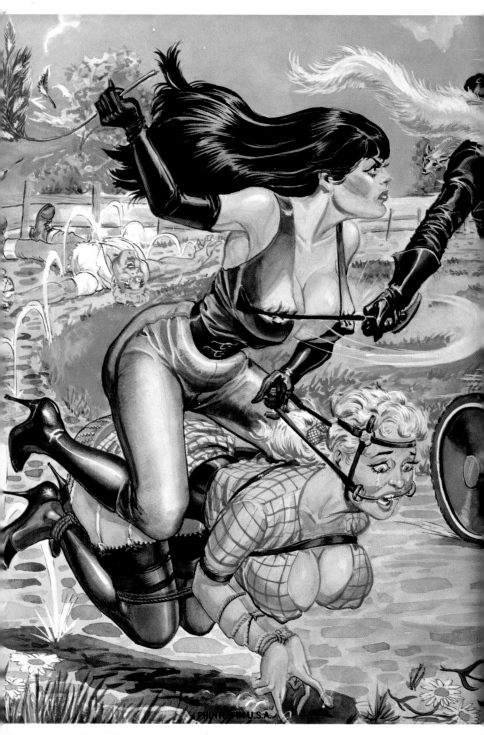

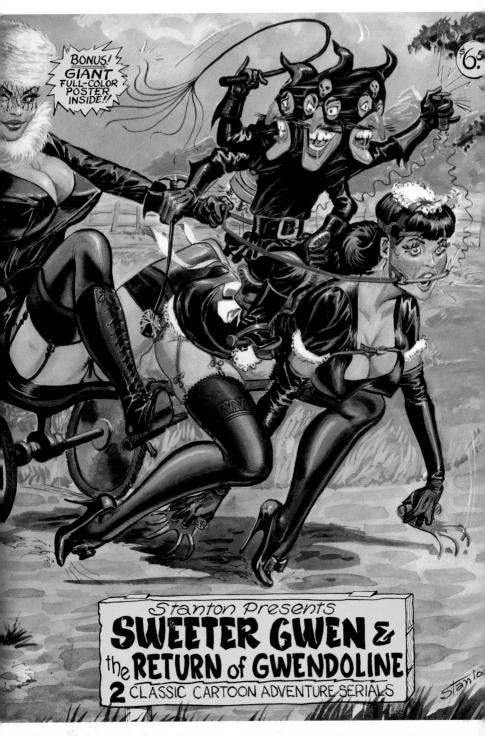

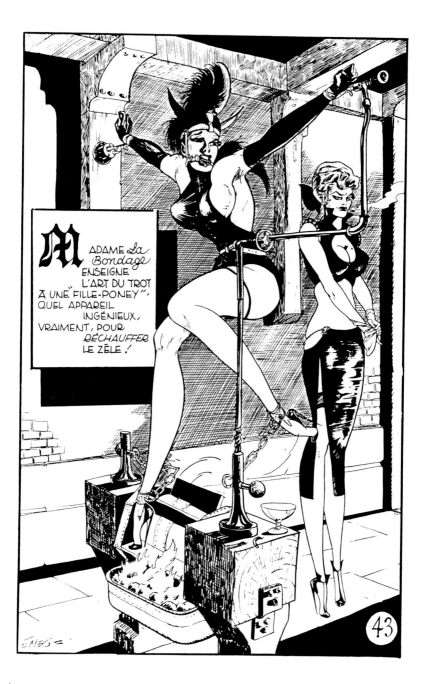

ADAME *La Bondage* ENSEIGNE L'ART DU TROT À UNE "FILLE-PONEY". QUEL APPAREIL INGÉNIEUX, VRAIMENT, POUR RÉCHAUFFER LE ZÈLE !

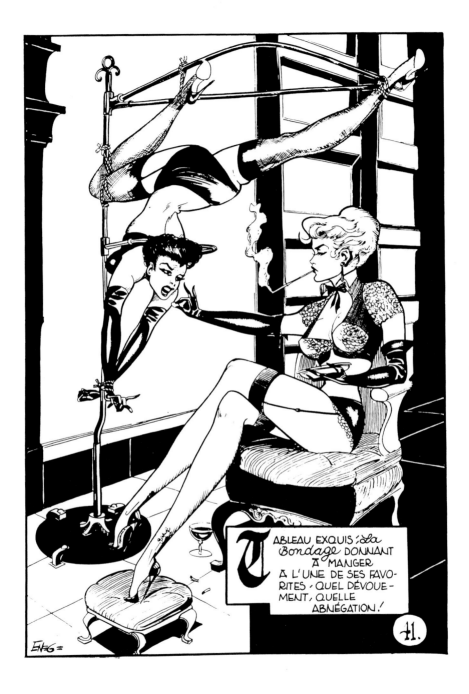

TABLEAU EXQUIS : La Bondage DONNANT À MANGER À L'UNE DE SES FAVO-RITES . QUEL DÉVOUE-MENT, QUELLE ABNÉGATION !

41.

ENEG=

Index

Acknowledgements

The author and publisher would like to thank the Fondation
Jean Dubuffet, Mr Jardot and Mr Laurens of the Galerie
Louise Leyris, Mme Dina Vierny, the artists Popovic Ljuba and
Paolo Vallorz, the photographers Carol des Cordes, Luc and
Lala Joubert, the engraver René Dupont and all those who
have given their help anonymously for their invaluable aid.

Illustration for Pierre Louÿs's *Three Daughters of their Mother*, 20s

Copyright